Cubism in the Shadow of War
The Avant-Garde and Politics in Paris 1905–1914

Cubism *in the Shadow of War*

The Avant-Garde and Politics in Paris
1905–1914

David Cottington

Yale University Press
New Haven and London

For Linsey, Andy and Joe

Designed by Laura Church
Printed in Hong Kong

Library of Congress Cataloging-in-Publication Data

Cottington, David.
 Cubism in the shadow of war: the avant-garde and politics in Paris
1905–1914 / David Cottington.
 p. cm.
 Includes bibliographical references and index.
 ISBN 0-300-07529-4 (cloth)
 1. Cubism – France – Paris. 2. Arts, French – France – Paris.
3. Arts, Modern – 20th century – France–Paris. I. Title.
NX549.P2C68 1998
700'.4112'0944361 – DC21 98-15163
 CIP

A catalogue record for this book is available from
The British Library

Frontispiece: Pablo Picasso, *Verre et bouteille de Suze* (detail), 1912. Pasted papers, gouache and charcoal, 64.5 × 50 cm. St Louis: Washington University Gallery of Art. University purchase, Kende Sale Fund, 1946.

Contents

Part Two
CONSTRUCTIONS OF CUBISM

Acknowledgements

During the many years that it has taken me to write this book I have received support and encouragement of many different kinds, for which I am most grateful. Research grants from the British Academy and the Leverhulme Trust enabled me to deepen my understanding of its subject, and to develop my ideas about cubism, beyond those presented in the doctoral thesis from which it has grown. Falmouth College of Arts has been generous in its provision of funding for repeated brief raids on the libraries and museum archives of Paris, as the writing has progressed, and for the acquisition of photographs.

One of the compensations of taking forever to complete this project is that it has given me time to discuss my ideas with, and to learn from, many colleagues and friends, to whom I am greatly indebted. With characteristic generosity, Christopher Green has provided both support and provocation for these ideas over many years; the late Daniel Robbins, also, was an inspiration for them as well as sharing my scholarly enthusiasms. Others who have been subjected to them on numerous occasions include Mark Antliff, Colette Giraudon, Tag Gronberg, Patricia Leighten, Paul Overy, Pascal Rousseau and especially Jeffrey Weiss, to whom I owe a special debt for the insights and encouragement he has given me throughout the writing of this book. I am particularly grateful to him, as well as to Penny Florence, Matthew Rampley, Christopher Short and Nedira Yakir, for reading sections of it in draft, and for their valuable comments; needless to say, such shortcomings as remain despite their diligence are entirely my own.

Also, I benefited greatly from opportunities to develop sections of my argument at three symposia, and to test them in discussion with co-participants in these: many thanks, therefore, to William Rubin for the 'Picasso and Braque: Pioneering Cubism' symposium at MOMA New York in 1989; to Eve Blau, Phyllis Lambert and Nancy Troy for that on 'Architecture and Cubism' at the Canadian Centre for Architecture in Montreal in 1993; and to Richard Thomson and Michael Casson for the 'Monet to Matisse' symposium at the National Gallery of Scotland, Edinburgh, in October 1994. Publications that resulted from the last two events include earlier versions of parts of chapters three, five and seven of this book: these are Eve Blau and Nancy Troy (eds), *Architecture and Cubism*, Montreal, Cambridge, Mass. and London: Canadian Centre for Architecture and MIT Press, 1997, and Richard Thomson (ed.), *Framing France: The Representation of Landscape in France, 1870–1914*, Manchester and New York: Manchester University Press, 1998.

In Paris, the following were of invaluable help at various stages of my research: Pierre Alibert, Christian Derouet, Pierre Georgel and Anne-Marie Zucchelli in providing access to archival material relating to several cubist painters; Gilbert Gruet and Maurice Jardot in opening the archives of their galleries to me. Michel-André Stalter generously shared with me his research on the work of Le Fauconnier. I am indebted to Jean Masurel for valuable information on the collecting habits of Roger Dutilleul and others, and to Anne Varichon for kindly providing pre-publication information from her catalogue raisonné of the work of Albert Gleizes. Christophe Prochasson was enlightening on aspects of intellectual debates in the pre-1914 decade, and Maurice Braud equally so on the aesthetic interests of Marcel Sembat.

Elsewhere, I received additional assistance for which I am grateful. In Carpentras Didier Sevin, and in Amsterdam the late F.J. Sandbergen, were equally generous in enabling me to view their archives relating to, and collections of paintings by, Le Fauconnier; also in Amsterdam, Arnold Ligthart shared the results of his research on the same artist.

It is safe to say that this book would not have appeared without the unflagging support of Gillian Malpass at Yale University Press; for this, and for her valuable advice at key stages of its writing, I am indebted to her, as I am to Laura Church for the diligence with which she designed and supervised the book.

Above all, however, I am indebted to Linsey Cottington for her constant encouragement and her patience with this project, and to Andy and Joe for putting up with its competition with their demands on my time and energies.

Introduction

European modernism in the first years of this century . . . flowered in the space between a still usable classical past, a still indeterminate technical present, and a still unpredictable political future. Or, put another way, it arose at the intersection between a semi-aristocratic ruling order, a semi-industrialised capitalist economy, and a semi-emergent, or -insurgent, labour movement.

Perry Anderson[1]

The conflicts between artists and intellectuals over the definition of culture are only one aspect of the interminable struggles among the different fractions of the dominant class to impose the definition of the legitimate stakes and weapons of social struggles; in other words, to define the legitimate principle of domination, between economic, educational or social capital . . .

Pierre Bourdieu[2]

In December 1912 the French Chamber of Deputies debated cubism. Jules-Louis Breton, a Socialist, protested in the name of the artistic patrimony of France against the inclusion in that year's Salon d'Automne of the 'jokes in very bad taste' that were the cubists' paintings; noting that some of these were by members of a large contingent of foreign artists, he demanded that the Radical government in future refuse to allow the Grand Palais to be used for such manifestly anti-artistic and anti-national displays. In reply Marcel Sembat, also a Socialist, defended the principle of artistic freedom and warned against governmental interference in cultural disputes. The Fine Arts minister Léon Bérard responded by assuring the Chamber of his commitment to a policy of non-intervention in artistic matters; privately, however, he put pressure on the president of the Société du Salon d'Automne, Frantz Jourdain, to ensure that in future its exhibitions would include fewer foreigners and, if possible, no cubists. The debate was the climax to a brief but intense campaign of lobbying, launched two months earlier by a Paris city councillor, himself an amateur photographer and regular exhibitor at the Salon des Indépendants, and carried forward by several newspapers; this wider debate raised issues of nationalism, social order and popular taste, and cubism was frequently equated with political subversion.

This book is, among other things, an attempt to understand the reason for that campaign and debate, to disentangle the meanings cubism held for their participants and their constituencies, the ways in which those meanings were constructed, and alternatives obscured. It is an attempt not to discover the 'true' or 'essential' meaning of cubism, since the idea that there was one such is a misapprehension, now rightly discredited, but to understand the field of signification within which it was constructed, to replace the present conception of it as punctual and final in its moment of emergence – our cubism, as if this were already determinate in 1914 – with recognition of the uncertainty of its actuality in that moment. But the book also has a broader purpose. The relation between avant-garde and political discourse has conventionally been over-simplified, where it has not been caricatured or ignored, in histories of modernism; my aim is to take account of, and to explore, through the example of cubism, the complex, over-determined and shifting character of this relation.

Perry Anderson's triangular formulation of the discursive force-field within which modernism was constructed provides one frame of reference for this enquiry, for it offers a succinct reminder of the multiplicity of factors that made up that conjuncture, and an understanding of the character of modernism itself as heteronomous and conflicted. His formulation is, however, incomplete. First, because it is a generalisation – necessarily perhaps, given the level of abstraction of his argument – an outline proposition about a pan-European construct whose validity needs to be tested against its specific instances in individual countries and metropolitan centres, and whose suggested intersections need to be more precisely plotted; part of my purpose is thus to map it onto a specific country and city, those of France and Paris, at a paradigmatic time for modernism. Second and more importantly, because it leaves out of account two factors that were comparable in significance to that of the semi-emergent labour movement, and related to it in complex ways, namely emergent feminism and a newly consolidated avant-garde formation. Part of my purpose is thus to acknowledge this process of consolidation as an integral aspect of the settlement of the post-Dreyfus Radical Republic, and to acknowledge the gendered character of the avant-garde; to explore the relation of this to a wider crisis of masculinity in France and its implications for cubism.

The conventional and by now clichéd label of 'Belle Epoque' has for too long obscured, at the general level, the sharp contradictions and deep-seated conflicts in French society that structured the fifteen years before August 1914 and, in particular, the complex politics that differentiated its several phases. The contradictions and conflicts were many. In a period in which the economy was booming, the franc was stable and property values were rising, the secure and rising *rentier* income of the bourgeoisie made a strong contrast with the steady proletarianisation of many in work, as growth in consumer demand led to the mechanisation of production, and consequent de-skilling in many trades. At the same time, the unprecedented opportunities for advancement that modernisation and an economic upswing produced came up against the habitual entrepreneurial and social caution of a rigidly hierarchical society. As the socialist and feminist movements took shape and gained momentum

in response to these interrelated threats and opportunities, the conflict between classes and genders deepened; and the threat of conflict between nations increased as imperialist rivalries over North African territories tested diplomatic goodwill.

Within this conjuncture, two moments stand out as decisive. The first was that of 1905–06: the closing, with the exoneration of Captain Dreyfus, of the eponymous Affair with which the new century had opened, but also the collapse of the parliamentary Bloc des Gauches, which brought to an end the spirit of collaboration between classes (or fractions of them) and of artistic and intellectual engagement with politics that had been one product of the Affair, and replaced it with one of mutual suspicion and autonomism; the moment, too, of the first Moroccan Crisis, which raised the prospect of imminent war with Germany. The second was, of course, 1914; not, however, so much the outbreak of the First World War itself as the rapid emergence, within days of that event, of the *union sacrée*, the extraordinary reconciliation of almost all the opposed positions which that decade had generated, the collapse of those mutual suspicions into the unity of patriotism. Unexpected as this unity was, with the benefit of hindsight it is clear that it had been in preparation over many months; disastrous product of that Belle Epoque, the war cast a long shadow over much of it, and brought about, as it approached through 1913 and 1914 with apparent inevitability, a rapprochement – gradual for some, eleventh-hour for others – between hitherto hostile ideological camps.

The artistic avant-garde as a formation and avant-gardism as a strategy and an ideology were both consolidated in the decade which these moments bracketed. In ways which this book will explore, the sense of a collective identity and a distinctive cultural role which self-styled avant-garde artists shared in the pre-war decade (their claim to the term was first staked at this time) was at once a product of its broader dynamic and an agent in its unfolding. The formation was not monolithic, however. Brought into being by those social and cultural factors which positioned Radicalism, and its 'official philosophy' of one-nation republicanism, solidarism, at the centre of the pre-war political economy, it was a composite and unstable social matrix, fractured not only, like the Republic, by ideological antagonisms and class interests, but additionally by the pressures of its substantially cosmopolitan character and a rapidly evolving institutional and art-market framework. The artistic initiatives that coalesced into and around the cubist movement – the aesthetic concerns and pictorial innovations that emerged from studio practice and, as these became notorious, the contestation for the terms in which they should be understood – were engendered across all of these, and shaped accordingly. Not only was it the first avant-garde grouping to encompass two distinct and (almost) mutually exclusive art market orientations, one towards the salons and the other towards the private galleries, but this division coincided substantially with that between its French and its non-French members. Among the consequences were differences in the studio practices of its subgroups, in the character of their avant-gardism and their response to the nationalist appeal.

Yet this emergent avant-garde did not stand in ideological opposition to the dominant class of the Republic. The differences and antagonisms were inseparable, as

Bourdieu insists, from wider social struggles – among fractions of that class for the definition of the terms of its dominance, as well as between classes and between the sexes. Indeed, as I shall show, the avant-garde was both structured in large part by the intersection of the same dominant and counter discourses that articulated those wider struggles, and instrumental in shaping and disseminating these. Thus the discourse of nationalism: checked on the political level by the outcome of the Dreyfus Affair and victory of the Dreyfusard forces, nationalist agitation after 1905 found its expression on a cultural level, in an effort of elaboration and dissemination of a doctrine, an ethic and an aesthetic for which the concepts of tradition and classicism were cardinal points of reference, the writers Charles Maurras and Maurice Barrès the principal standard-bearers and groups such as Action Française the militants. The literary and artistic avant-garde milieux, increasingly overlapping as the dealer–critic art market grew and evolved, were among the primary sites of this effort, particularly after 1905. For most writers and artists, the cubists among them, the notions of tradition and classicism could not be separated from a nationalism whose contours and lineage were most vigorously constructed by the ideologues and activists of the right. In turn, the artistic and polemical efforts of avant-gardists underwrote the broadening of the nationalist appeal beyond the marginal confines of right-wing doctrine, and provided support for institutions and groups that were politically or culturally dominant in the liberal Republic. The coalition of those groups which placed solidarism at the centre of pre-war politics drew heavily on the imagery and cultural genealogies with which artists in and beyond the avant-garde milieux enriched the discourse of a traditionalist nationalism.

Solidarism was an attempt to reconcile an attachment to tradition with the economic necessity of modernisation, however – to moderate the expansionary demands of capitalism in the interests of social peace – and in drawing upon the discourse of nationalism it gave to this an inflection that distinguished it from that of traditionalism, that was as open to the future as to the past: the establishment of national cultural genealogies was balanced by a cautious embrace of notions of progress. Instrumental to its one-nation republicanism were initiatives to modernise traditional industries and to broaden the popular base of mainstream culture, both of which came together in efforts to revitalise the French decorative arts industries, in part by re-orienting them towards popular craft traditions. Within and beyond the avant-garde formation, this initiative of *l'art social* engendered a debate around the concept of decoration comparable to that over classicism, which drew together questions of democracy, taste, tradition and progress into a discourse that, increasingly in the pre-war decade, challenged traditionalism for the definition of nationalism. The imperatives of economic competition and the rapid expansion of consumerism, led by the department stores, steadily strengthened solidarism's purchase on that definition, not least within the milieux of the avant-garde; by 1912 so many avant-garde artists were turning to decorative work – among them several cubists, whose architectural and decorative ensemble of the *Maison cubiste* was shown at that year's Salon d'Automne – that one critic complained of the almost exclusively decorative preoccupations that contemporary work displayed.

Growing fears of international and inter-class conflict ensured that traditionalist and solidarist discourses were dominant in the literary and artistic avant-garde formation as they were in society at large, and contributed crucially to the pre-war hegemony of Radicalism. Yet the reality of any hegemony is that it is never total or exclusive, and the artistic avant-garde was also one of the primary sites of resistance to nationalist pressures; first because of its cosmopolitan character – the émigrés who were preponderant in many of its milieux had little incentive to rally to the tricolore – and second, because the collapse in 1905 of the Bloc des Gauches left its participants with a diminished interest in politics. For the émigrés, self-referentiality and isolation encouraged a notion of the artist as necessarily estranged; for those whose attempts at class collaboration had ended in disillusionment, the idealism that had driven them was transferred to aesthetic practice. For both, resistance was grounded in the values of art in and for itself, as uniquely free from commodification and instrumentality. This was the discourse of aestheticism. Building on the aestheticism of the 1890s to make of it a corner-stone for avant-gardism, it yet differed from its predecessor in that its resistance to nationalist ideology and bourgeois culture had no connection with wider political struggles against these: whereas fin-de-siècle aestheticism was in close sympathy with anarchism, that before 1914 was distanced from the revolutionary syndicalism which had replaced anarchism as the main motor of a working-class political activism. The avant-gardism of pre-war aestheticism did not complement that activism but replaced it – indeed, was a condition of its dislocation from it.

As a consequence, when the deepening anti-militarism of the socialist and syndicalist movements opened a gulf between them and the rest of the nation, aestheticist avant-garde artists found themselves on the side of the majority, and as the hegemony of nationalist discourse became all but complete, the terms of its definition of France's cultural lineage encroached steadily on aestheticism's points of anchorage. This dynamic was registered within the cubist movement: even as the aestheticism of the gallery cubists was securing its ascendancy, some of their spokespersons were seeking a rapprochement with the dominant culture of *le tout-Paris*, and finding common cause with nationalism: 'French culture affirmed everywhere as dominant, that is the formula of our artistic imperialism', declared the magazine *Montjoie!*, which emerged from the widening milieu of cubism and published the work of its members – and was edited by an Italian.[3] Within months the leading figure of that milieu, Apollinaire, who was of uncertain nationality but certainly not French, enlisted in the army of the Republic.

If the dominance of nationalism did not exhaust the range of discourses within the avant-garde formation, neither did aestheticism exhaust the range of resistances. From the collapse of the Bloc des Gauches until its capitulation to the *union sacrée*, the syndicalist movement articulated not only a vigorous opposition to nationalism but also a parallel, if more muted, critique of art: both were weapons of the bourgeoisie, instruments of the exploitation of the proletariat. From about 1910 to beyond 1914, a small group of writers and artists who shared this allegiance developed its implications for innovative artistic practice in half a dozen or so little

magazines. Against the clamour of dominant nationalism, this counter-discourse was barely audible, but the fact that it was articulated at all reveals the limits of the former and suggests something of its contours. Puzzling over the role that they, as avant-gardists, might play in the fostering of a proletarian culture independent of that of the bourgeoisie, these left-wing intellectuals rejected both the efforts of the enthusiasts of *l'art social* to teach bourgeois culture to the people and the equation of aestheticism with revolutionary practice. Ironically, their hostility to that aestheticism prevented them from imagining alternatives to dominant culture; what motivated and united them was not modernism but anti-nationalism, and the gulf that separated syndicalists from the nationalist majority was reproduced in the incomprehension with which these writers and artists greeted the work of the most aesthetically radical artists such as the cubists. When that gulf closed with the *union sacrée*, what closed also was the possibility of developing in Paris that exchange between revolutionary politics and the potentially revolutionary aesthetics of cubism that – briefly – charac-terised wartime and post-war modernism elsewhere in Europe.

This is the conjuncture which the following chapters examine, and the dynamic which they trace. As such, it is not a history of cubism in any conventional sense that they offer, so much as the opposite of one. There is no attempt here to provide an account, far less a comprehensive narrative, of cubism's evolution either as a style or as a movement – indeed, this book omits many more of the participants in this than it includes. Instead, it presents an argument for an understanding of cubism's history as fundamentally heteronomous, constructed across – and ultimately constrained by – the particular discourses which gave meanings to the experience of modernity in pre-war Paris. It is this argument, and a concern to give appropriate weight and specificity to those discourses, that has directed both the book's structure and its particular selection of case studies. The aspects of cubist art and the cubist movement which I discuss are proposed as primary instances of that fundamental heteronomy, and of how these discourses worked to shape it in different and complex ways. The conservative modernism of Le Fauconnier's paintings, the aestheticism of Picasso's *papiers-collés*, the decorative art initiative of the Maison Cubiste, as well as the tensions and contradictions which are inscribed in *Du Cubisme*, the movement's only manifesto, which are among the subjects of Part 11, are examined in relation to the field of forces identified in Part 1. Together they reveal cubism as a contradictory and unstable constellation of interests and practices, some aspects of which were complicit with hegemonic forces and others opposed to them, but all of which were shaped by them.

Part One

Gathering Shadows

Chapter 1

Conflicts and Contradictions of the Radical Republic

Mapping the Avant-Garde

In the spring of 1910 Roland Dorgelès, a young Montmartre artist fresh out of the Ecole des Beaux-Arts, tied a paintbrush to a donkey's tail, enticed the animal to swish a few paint-loaded strokes across a piece of canvas and exhibited the result at that year's Salon des Indépendants, under the title *Et le soleil se coucha sur l'Adriatique*, and over the pseudonym Joachim-Raphael Boronali. Few critics seem to have thought the work interesting enough to mention; luckily for them perhaps, since two weeks into the exhibition Dorgelès published a full account of his spoof in the Parisian *humoriste* periodical *Fantasio*.[1] The press reaction was extensive and for the most part (though by no means unanimously) one of hilarity, guaranteeing the affair an instant notoriety that spread as far as Russia (in 1912 a group of Moscow artists held an exhibition of radically experimental works under the banner 'The Donkey's Tail') and that has lasted up to the present, retailed gleefully by successive chroniclers of the Belle Epoque.[2]

Dorgelès's spoof is of interest for more than its humour, however, for it also reveals a number of characteristics of the artistic avant-garde, which have been too often overlooked. As a symptom, perhaps, of post-modernist uncertainties over its continued vitality or even existence, there has been a great deal written about the avant-garde in recent years; common to this writing, almost without exception, has been the adoption of three fundamental assumptions as to its nature, and each of these the Boronali affair calls into question.[3] The first assumption is that the avant-garde defined itself, from its origins, as oppositional with regard to dominant or mainstream culture, and committed to modernist cultural practices; that the two terms 'avant-garde' and 'modernism' are, if not interchangeable, at least in close relation to each other, and opposed *per se* to that mainstream.[4] Dorgelès's practical joke indicates, however, that in pre-1914 Paris the dividing line between those cultural producers who accepted modernist principles and those who did not ran right through the avant-garde, rather than between it and dominant culture. Dorgelès was associated with the *humoriste* artists and illustrators, inheritors of the mantle of the 'Incohérents' of the 1880s. Their use of visual puns and verbal ambiguities as tactics of derision and absurdity to mock the pretensions of bourgeois art represented, it has

been argued, the concept of the avant-garde at its purest, and anticipated Dada by a quarter of a century.[5] Yet his joke was aimed, not at bourgeois ideas of art, but at painters who worked in the fauvist and post-fauvist style that was then at the leading edge of avant-garde innovation. By his own later account his intention was to ridicule artists whom he saw as talentless and defend values that he saw as threatened – values which, by implication, he shared with those detractors of artistic innovation and supporters of dominant culture who wrote for the bourgeois press. Moreover, he soon came to include the salon cubists among those he condemned: 'I was utterly distressed', he later recalled, 'to see, one after the other, my friends get themselves stuck in this blind alley: Albert Gleizes, Juan Gris, Marcoussis, Pierre Dumont and the exquisite Marie Laurencin, and the reliable Delaunay, demolisher of Eiffel Towers.'[6]

We may question whether Dorgelès should be seen as belonging to the Parisian avant-garde of 1910; the *humoristes* were hardly in the van of contemporary artistic experimentation and had no close connection with those who were, and even in Montmartre where they were based they had little contact with the Bateau-Lavoir circle around Picasso. Yet La Butte was separated from right-bank Paris by more than its steep slopes; in the first decade of the century its village character and bohemian traditions provided both attraction and refuge for those on the social and cultural margins of bourgeois life, and consequently there was by all accounts more common ground between the milieux that inhabited it than between any of them and the city centre below. The *humoriste* tradition was moreover as much one of irreverence and antipathy towards the bourgeoisie as of hostility to experimentation; if it was anti-modernist it was also anti-academic, occupying a territory between the two.[7]

This very fact gives the lie to the second assumption common to most writing on the avant-garde: that it was sharply demarcated from the social and cultural main-stream.[8] The borders of the avant-garde's territory were in fact poorly marked, and there was considerable traffic in both directions across them. Montmartre, as the journalist and critic André Warnod saw it in the decade before 1914, was composed not only of villains, prostitutes and bohemians but also of young men of the middle class – artists and poets as well as critics and collectors – in temporary flight from bourgeois morality.[9] Elsewhere in the city the traffic was in the other direction: as the essayist André Billy observed, from around 1910 it became conventional for young writers to make their name in the *petites revues* ('little reviews') of the avant-garde on the left bank before crossing the symbolic Pont des Saints-Pères to the establishment journals of the right bank.[10] Indeed, some appeared to have their feet on both banks at once: cubism had barely shocked its first salon audience before Albert Gleizes, writing in a *petite revue*, claimed for it the distinctly un-avant-garde quality of respectability.[11] The initial reception apparently given to the fictitious Boronali's canvas in 1910 is itself indicative of uncertainties over boundaries; while it was a source of hilarity for many, there were some who saw it as an insult to the other works on exhibition, and others who pretended to discern in it qualities that only an elite could appreciate.[12] For these salon visitors it was by no means certain who was laughing at whom, or even if they were laughing at all; this avant-garde text, if such it were, was difficult to decode.

Part of their problem was that, as the episode also illustrates, the avant-garde was not monolithic but composite – contrary to a third common assumption that has bedevilled understanding of it.[13] By 1910 it was composed of many groupings centred on a bewildering variety of aesthetic practices and positions, one index of which is the nearly two hundred *petites revues* that were founded in Paris between 1900 and 1914 (most of them after 1910, for reasons to which I shall return), each articulating a distinct shade of literary or artistic opinion.[14] They drew for their contributors and their audiences, minuscule though each of the latter were for the most part, upon what had become the largest and most diversified avant-garde community in Europe, a mecca to which flocked young aspirant artists from many other countries. While a proportion of these were attracted by the prestige of France's official art insitutions, hundreds were drawn to the cultural milieux and institutions which were developing in relative independence from them. These milieux, even (or perhaps especially) those groupings which gained particular notoriety and a large following, encompassed a sometimes debilitating plurality of positions and allegiances – such as the cubist movement, divided between salon and gallery, nationalist and internationalist affili-ations, order and iconoclasm.

Many of these aspirant artists were women, and in increasing numbers, as across Europe and north America at the turn of the century women laid claim to new opportunities placed within reach by liberal capitalist societies – social mobility, democratic citizenship, educational and professional advancement. Yet the received understanding of the character of the avant-garde has taken no account of the role of sexual difference in its construction. Only recently has feminist scholarship demon-strated the ways in which the social and cultural aspirations of women engendered in those societies a crisis of masculinity, of which one of the prime sites was that avant-garde. As Carol Duncan observed in a pioneering essay, 'The vanguard protested [against] modern bourgeois male–female relationships; but that protest . . . must be recognised as culturally regressive and historically reactionary. The point needs to be emphasised only because we are told so often that vanguard tradition embodies our most progressive, liberal ideals.'[15] If the affair of Dorgelès's donkey calls into question the assumptions about this formation, it has also functioned to obscure its gendered character by universalising Dorgelès's schoolboy humour as a common feature of avant-garde behaviour. The celebrity of the anecdote has reinforced a stereotype of the avant-garde artist for which Picasso in the cubist years has been paradigmatic, and in which there is no place for women artists.

The existence of a cultural matrix of the size, complexity and uncertain outline of that in pre-1914 Paris should, then, guard against conventional assumptions that the avant-garde was, *tout court*, those artists who made works that are today seen as belonging to the modernist canon, and who defined themselves as avant-garde in so doing. For such assumptions rest upon a confusion between the canon that has been selected in teleological fashion by modernist art historians, and those disparate milieux that represented unorthodox, unofficial or experimental art for the cultural producers, commentators and consumers of the period; a confusion, in other words, between our early twentieth-century avant-garde, and theirs. For artists and their

publics of that period there was not one avant-garde but many, and they did not together amount to a clearly distinguishable and coherent grouping, but rather a diverse and dispersed population, as yet uncertainly defined, fragmented into a multiplicity of milieux and structured by the asymmetrical pressures of sexual differ-ence. It is this complex and – from the turn of the century – rapidly expanding cultural matrix whose distinctive composition, structure and dynamics must be comprehended, if the meanings of cubism in pre-war Paris, and the role of these in shaping twentieth-century modernism, are to be understood, for it provided the immediate discursive and institutional context for both.

In the wider context, the emergent avant-garde must be seen as itself determined as well as determining: integral to the political economy of the radical Republic, not autonomous of it, a product both of its modernising forces and discourses and of the social and cultural resistances to them. As Michael Orwicz, Marie-Claude Genet-Delacroix and others have argued, successive French governments in the 1880s and 1890s made use of the prestige and co-optive potential of art to buttress the troubled Third Republic in both economic and ideological terms.[16] The salon was removed from state control – in modern terms, privatised – in 1881, with consequences for the diversification of the art market that I shall explore, in order to produce 'a multiplicity of pictorial styles for an increasingly varied and expanding middle-class clientèle'[17] and to foster that individualism and differentiation in art production which characterised un- or anti-academic work, in the interests of continued French hegemony in the international luxury goods market. This was also the ostensible policy of the Radical governments up to 1914, as the debate in the Chambre des Députés in December 1912 over the scandal of the cubists at the Salon d'Automne reveals: the Fine Arts minister Léon Bérard declined to accede to the demand that he in future refuse the Société du Salon d'Automne access to the Grand Palais for its exhibition, declaring himself 'a partisan of minimum political intervention in art, even of no intervention at all',[18] and reminding deputies that such liberalism had enabled many original and vigorous talents to emerge from this salon.

Such nationalistic cultural policies had other components, however. Alongside the privatisation of art production and distribution went a programme of state appro-priation – effectively, nationalisation – of the cultural heritage of France, through measures such as the law of 1887 which established a Commission des Monuments historiques and gave unprecedented administrative powers to a Ministère des Beaux-Arts,[19] and through the development, under the aegis of the latter, of an army of academic art historians, archaeologists (the first university chairs in these subjects were created in 1893) and museum curators.[20] All of these were instrumental in the elaboration of a history of French art which, as Genet-Delacroix argues,

consecrated the immortality of the race, the people and the French nation, the 'genius of France', sublimating and transcending all divisions, conflicts, accidents of history, classes and parties in a unified system of aesthetic and historical values that incarnated, represented and revitalised national sentiment, in a French society thereby convinced of its strength and its cultural and artistic superiority.[21]

In the years before 1914, this conviction was shaken by two related perceptions. The first was a growing awareness of the advances made by other countries in the decorative arts industries; the government responded to calls for reform of these with initiatives that somewhat compromised its laissez-faire liberalism. 'Working practices as rooted in individualism [as are those of the decorative arts] are unfavourable to directive action by the state', cautioned Bérard in the 1912 Salon d'Automne debate, but he announced plans to reform the Sèvres and Gobelins manufactures and measures to 'impose on industry the collaboration of art' that he argued were necessary if the French international lead in luxury goods was to be maintained.[22] The second perception was that the influx of foreign artists to Paris was threatening to swamp its art market with non-French products. It was this argument that provided Deputy Breton with a convenient scapegoat for his complaint about the cubists in the Grand Palais in 1912; he noted 300 foreign exhibitors among the total of 700, and a majority of foreigners on the salon jury.[23] His xenophobia was shared both by the majority of press commentators on the affair and, it appears, by the government; even as he declared his laissez-faire principles, Bérard was privately applying pressure to the president of the Salon d'Automne, Frantz Jourdain, to revise its rules to prevent both future excesses such as the cubists', and the domination of the salon by foreigners, as a condition of its continued access to the Grand Palais.[24]

In thus moving to allay nationalist anxieties and underpin the cultural supremacy of France, Bérard expressed in his arts policies a commitment to a notion of the national community which, from Waldeck-Rousseau's government of republican defence with which the century opened, to Viviani's ministry which rode into war on the *union sacrée*, secured the Radicals' hold on power and provided a period of relative governmental stability. But it was a surface stability only. Beyond parliament, French society in those fifteen years was anything but a harmonious national community: it was riven by structural contradictions at once economic and cultural, and by long-running social conflicts that developed into political crises.

The High Tide of the Bourgeoisie

For a few it was indeed the Belle Epoque. After twenty years of depression the French economy, like most others in the Western capitalist world, enjoyed from the mid-1890s nearly another twenty of growth. Industrial output accelerated, outstripping in the boom years of 1901 to 1913 even that of Germany and Britain.[25] As the economy grew its structure altered; industrial concentration intensified, production became more mechanised, the new high-technology industries of the twentieth century emerged: automobiles, aluminium, electricity, aviation. French men and women became wealthier, on average, than ever before: with no inflation or income tax, a stable franc, high rates of saving and investment, *per capita* income in 1909–13 surpassed that of every other European country save Britain.[26]

The new prosperity was increasingly visible, moreover, as the variety of ways in which that income could be disposed of grew enormously. Improvements in transport

brought cheaper food from across the world, and peasants to the cities; this and the exploitation of new technologies brought about a rapid expansion in the market for consumer goods.[27] The department stores in which these commodities were sumptuously displayed were a familiar part of the Paris spectacle by the end of the nineteenth century: the opening of new premises for the pioneering *grand magasin* Au Bon Marché in 1869 had been quickly followed by new emporia for the Magasins du Louvre in 1877 and Printemps in 1881. By 1914 this large-scale retailing had developed into a mass-market system defined not only by the number of customers but also by the range of goods on offer. This was 'a new commercial concept, designed to accommodate (and induce) a society that, more and more, would seek its identity in the variety of goods it consumed.'[28] Further big stores opened (La Samaritaine in 1903) and existing ones both expanded (the Bon Marché's annexe opened in 1912) and greatly widened their range of merchandise after 1900.[29] In this period, too, the reputation of Paris as the entertainment capital of Europe reached its apogee, and show business attracted its share of the new disposable income: receipts of Paris theatres and *spectacles*, which nearly doubled between the 1870s and the 1890s, had doubled again by 1911, and increased yet more rapidly in the next two years. The new medium of cinema contributed powerfully to this growth: from five cinemas in Paris in 1900, the number had risen to 260 in 1914.[30]

For those with the leisure as well as the money to spend on the new commodities, times were good; and the securing of as much leisure time as possible (preferably before the age of fifty) and living as *rentiers* was a primary ambition of most bourgeois men. In this ambition the moment was propitious: the value of inherited wealth increased by six times between the mid-nineteenth century and 1914, and that of rented property in Paris more than doubled. With these windfalls, half a million French men were able to live a life of leisure; for this one-eightieth of the population and their families it was the Belle Epoque.[31]

It was not so for everybody, however. In France of that period, 'the great majority of citizens dreamed almost exclusively of the means of assuring their existence'; since mid-century, 'pauperism had declined but social differences had become sharply accentuated'.[32] The production of the commodities now desired by the mass market required modern methods of industrial organisation: mechanisation, subdivision of craft activities, cost-cutting and 'scientific management'. The pressure of competition led many entrepreneurs to lower wages, and the real value of wages actually fell in the boom years between 1899 and 1913.[33] Thus the comfort of the bourgeoisie was conditional upon it not being shared by those who created it for them; indeed, its corollary was not prosperity but increasing impoverishment in many sectors of the urban and suburban working class, in absolute as well as relative terms:[34] a survey of living standards among the workers of the thirteenth arrondissement in Paris found that over half lacked the 1 franc per day minimum required to subsist without want or assistance.[35]

The conditions under which most people in France then worked were also such as to mock the idea of a Belle Epoque. The majority of peasants worked as long hours for as little return as had their grandparents, and the situation of many urban workers

was deteriorating. While legislation covering hours of work remained much as it had been in 1848 (with the exception of a 1906 law establishing a weekly rest day), the methods of assembly-line production first brought to France in the 1890s, the spread of mechanisation and the demands of the now powerful department stores worsened the working experience of many, especially in the luxury goods trades or *métiers d'art* concentrated in Paris, where mass-marketing brought sweatshop conditions to an ever increasing number of semi-artisans.

The furniture industry, for example, was conventionally divided, like most trades in Paris, into a luxury sector – the preserve of skilled artisans, inheritors of all the traditions of the craft and producers of made-to-order items – and a 'current' sector – which produced cheaper goods for the mass market. From the mid-nineteenth century, with the development of the railway and of department stores, the current sector expanded, and dramatically so from the 1870s. The agents of growth were the wholesale purchasing contractors, from the big stores and from 'furniture palaces' such as Klein's on the rue de Flandre, which after 1900 claimed to stock more than 2,000 varieties of dining and bedroom suites.[36] In a strong position to dictate sharper terms and establish close control over the details of construction, the contractors not only forced piece-rates down but also enforced managerial practices in the workshops that destroyed valued customs of worker autonomy and lack of hierarchy. In the current sector, specialised workers increasingly found that they could only maintain what standard of living they had by working at a frenzied pace for long hours. In the luxury sector, the pressures of competition from abroad (furniture imports tripled between 1892 and 1908[37]) and from the current sector, coming on top of the damage done to its markets by the deep recession of the 1880s, led to a sense of crisis and a fear of marginalisation. Skilled artisans found their workshop freedoms and craft culture under attack. As Lenard Berlanstein concluded,

> The distinctive feature of the prewar era for these humble people was the partial breakdown of the accommodations that had carried them through the earlier periods of economic transformation. The result was intensified frustration at work and deepening conflicts over authority.[38]

Although they mounted to a 'crescendo of hostility' in the *métiers d'art* that peaked in 1910,[39] such conflicts did not remain localised. As the social relations of production in these and other industries changed, craft bonds loosened and artisans were reminded of the fate they shared with other workers. Both a new class consciousness and a crisis of industrial discipline developed as support grew for working-class political organisations from the end of the nineteenth century. French socialist parties were established in the 1880s and unions given minimal legal recognition in 1884. But the former were dominated by bourgeois intellectuals whose inclination was for reform rather than revolution; their parliamentary alliance with the anti-clerical republican governments of Waldeck-Rousseau and Combes from 1899 forced them into compromises which steadily alienated their working-class support. In its place grew support for syndicalism and the principle of autonomous extra-parliamentary action by the working class. With that came severe social tensions, as the

complacency of the bourgeoisie in its prosperity was undermined by a wave of strikes after 1904.

Intersecting with these social tensions based on class was another set based on gender. The late nineteenth century had seen some moves towards the social and economic, if not political, emancipation of French women, especially those of the middle class. The education reforms of the Third Republic, beginning with the 1880 law that established a system of secular public secondary education for girls, opened new horizons to women. Even though their initial aim was 'to make them less susceptible to "superstition" and more capable of taking an intelligent interest in the intellectual preoccupations of their husbands', by 1914 small numbers of women each year were obtaining the *baccalauréat* – the passport to higher education – and even the formerly exclusively male professions of medicine and law had been opened to them.[40] With the general expansion of industry and commerce, more women were also entering the work force. While this development was a matter of economic necessity for many and represented, for some middle-class women, their 'relative proletarianisation',[41] together with the educational and professional advancement it gave a degree of independence and at the same time raised expectations of more, and both were articulated and given political focus through a rapidly growing feminist movement. Such advances should not be exaggerated – 'in the family, factory, schools, hospitals, and on the street, men were still the masters'[42] – but they still posed a threat to the patriarchal order and placed what was termed 'the woman question' on the political agenda from the 1890s. The response, by men of all classes and political persuasions, was primarily to reiterate not only a family-centred vision of gender relations in which women's subordinate role was biologically determined, but also an insistence on the domestic character of women's work for which *la femme au foyer* became the ubiquitous slogan.[43] In the same period, growing anxieties over the decline of the French birth rate, which was more marked than those of other countries (the population of France rose by 8% in the forty years from 1871, while that of Germany rose by 42% and that of England and Wales by 59%)[44] underpinned this response and led both to proposals for fiscal reform to reward motherhood and sharper condemnation of the *femme nouvelle* who sought other kinds of fulfilment. As the perceived threat of female emancipation grew, the feminist movement diversified, at once complementing, challenging and contradicting the reformist and revolutionary efforts of the organised male working class, and engendering a crisis of masculinity whose ramifications in the avant-garde as well as French society at large I shall explore.

Entrepreneurship: Caution and Competition

While the sluggish rate of growth of the French population led commentators to treat it as a scapegoat for the nation's economic ills, there were several structural reasons why France was not equipped to compete with the other major industrialised nations in all markets.[45] Despite the boom conditions and technological advances of the turn

of the century, a larger proportion of its active population remained on the land than in Britain, Germany or the United States, much of it in conditions of inefficiency, isolation and impoverishment. French industry was unlike its major competitors in importing as much as a third of its coal requirements, thus increasing manufacturing costs, and in lacking domestic supplies of other strategic raw materials. Perhaps most widely noted, industrial concentration lagged behind that of its rivals and the average size of firms remained small, with over 90% employing fewer than five people in 1900.[46]

The last of these characteristics reflected, among other things, two distinct and in some ways contradictory attitudes on the part of French entrepreneurs and politicians towards the conduct of business on both a macro- and a micro-economic level. The first was an attachment to France's multiplicity of small businesses as an expression, and guarantor, of economic individualism; concentrations of property and financial or industrial power were seen to threaten individual freedom. The expression of this individualism on the level of economic doctrine was liberalism, which held that nothing should curb the free activity of the market or the initiative of individual agents within it, and that the role of the state was merely to hold the ring. 'Civilisation rests on freedom and individual initiative', declared the leading liberal economist Paul Leroy-Beaulieu; 'anything that diminishes this cause of progress can only reduce general prosperity and the security and well-being of everyone.'[47] Such was the credo of the dominant sections of the French bourgeoisie in the 1890s: 'from the rostrum of the Palais Bourbon . . . and the offices of ministries and private firms to the salons of the most prominent families liberalism was *de rigueur*.'[48]

Commitment to this ideal was tempered by pragmatism, however. In several sectors of French industry the establishment of producers' associations or cartels, whose purpose was precisely to avoid the hazards of the free market, was well advanced by 1914.[49] Moreover, the vulnerability of some sectors of the French economy to competition from cheap imports, particularly farming and the manufacture of consumer goods for the domestic market, was keenly felt by those concerned. In order to prevent such producers from being driven to the wall by the bracing freedoms of the international market politicians adopted protectionism and supported the ascent of Jules Méline, its chief architect, to the premiership in 1896. For Méline the multitude of small workshops which characterised the French economy was not a drawback to industrial modernisation but a safeguard against its calamitous social consequences – crises of overproduction and unemployment, the destruction of farming and with it the social basis of rural life, which he saw as both a valuable social ballast in a changing world and the repository of traditional values. French taste, he wrote in his best-selling polemic of 1905, *Le Retour à la terre*,[50] was not for mass production but for the making of varied and individual goods, and this entailed the retention of small firms. His 1892 tariff legislation erected a comprehensive system of protection against cheap imports that was designed to ensure this. The Méline Law was, in the opinion of modern historians, a turning point in the history of the Third Republic: 'it tended to conserve the existing social structure as far as it was effective as a protectionist instrument. Its appeal was directly nationalist and

conservative, and it rallied the support of those who had most to fear from change.'[51]
The legislation was consolidated in 1910 and, with Méline's book, had political and
ideological implications for the pre-war decade that I shall examine later.

In economic terms it put a brake on the pace of industrial development, and
perpetuated habits of conservatism and caution in French entrepreneurship that were
of consequence both for the economy as a whole and for that sector of cultural
production within it that is our concern here. The post-revolutionary settlement of
the early nineteenth century had given the bourgeoisie a base in landed property and
established its economic and professional links with government; banking policies
had reinforced these, channelling funds into government bonds and public utility
shares as against those of private industry. In consequence, businesses were short of
both social esteem and funds for expansion or modernisation, compelled to behave
cautiously out of a concern to maintain respectability and in order to furnish the
required funds from internal sources. Shaped by these constraints, which were tight-
ened by the depression of the 1880s, French business consisted mainly of family firms,
for whom the honour and reputation of the family took priority over the profit
margin of the firm.[52]

By 1900 two features of family firms had become paradigmatic for much of French
entrepreneurial behaviour – their paternalism and their conservatism towards
growth. Institutionalised paternalism was a means of reproducing the relations of the
family in the firm, and of integrating its employees as it expanded. It took many forms
including pension funds, profit-sharing, workers' housing and adult education. Some
of these features had existed for decades, but their scope was greatly extended at the
end of the century; the Boucicauts' Au Bon Marché department store in Paris
provided its male and female employees by 1900 with everything from a provident
fund to lessons in music and fencing. As has been observed, 'what gave this new
paternalism particular force was that in design it effectively eliminated the boundary
between work and other aspects of social life'; and of the Boucicauts it has been noted
that the spectre of control lurked just beneath the surface of their programmes.[53]

The entrepreneurs' conservatism towards innovation led French industry to adapt
to circumstances and to rely on tried and tested methods, rather than seek to change
either of these. Protected by the Méline Law, supported by the prestige of Paris as the
cultural capital of Europe and aided by the rise in disposable income, French firms
saw as their special preserve the manufacture of quality goods, among them the
products of the *métiers d'art*: luxury furniture, jewellery and ceramics. In this sector,
however, they were losing ground to foreign competitors in the years around 1900.
While across Europe a growing acceptance of ready-made products, their improving
quality and a degree of democratisation of wealth were turning the interest of major
industrialists to questions of modern design (as in Germany where the Deutscher
Werkbund was founded in 1907), the response of French industrialists to these
changes was to fall back on the styles and models that had made their reputations,
much to the chagrin of decorative artists.[54] In this retreat they were supported,
however, by domestic demand; when it came to tastes in furniture, for example, as
Theodore Zeldin has suggested,

it was natural that the taste of an age of increasing prosperity, obsessed by social climbing . . . should have favoured in particular furniture that was solid, impressive, and that gave evidence of the hard work and money that had gone into it. Since furniture was above all property, people wanted theirs to look as much like the furniture of the rich as possible . . . they favoured the old and the fake-old because it had the essential quality of property, permanence and investment value.

This value was confirmed, as he noted, by the doubling of the price of antique furniture in France between 1865 and 1913.[55]

In the spate of international exhibitions that followed the Paris 'Exposition universelle' of 1900 – Turin 1902, Liège 1905, London 1908 – the showing of the decorative arts industries from other countries brought home to some French craft workers, politicians, critics and artists how far behind their own *métiers d'art* had fallen. An awareness dawned, to the accompaniment of alarm, in some quarters that French craftspeople were producing little other than pastiches of past styles and were rapidly losing markets in consequence. Although the causes of this predicament lay in the structural economic changes already identified, the debate that it engendered in the pre-war decade brought together a wider set of discourses: those of nationalism, tradition, progress and democracy, as well as issues of taste and design. It is thus a touchstone for attitudes to art in this period; we shall examine it in detail in Chapter 3.

The caution of French investors towards industry and of many industrialists towards innovation, and the brake upon the pace of modernisation which these helped to impose in the years before 1914 are the more ironic in that the period was in many respects very favourable to entrepreneurial initiative. For those for whom shortage of capital was not a problem, the upswing of the business cycle from the mid-1890s and the associated conditions, outlined earlier, of no income tax or inflation and a stable currency provided an auspicious climate for business activity, especially on a small scale. Thus the French automobile and aircraft industries, until 1914 still led by small firms with highly skilled work forces, were among the most innovative and successful in the field.[56] The Paris art market also offered good scope for enterprise, and here the caution of the majority of participants was an advantage rather than a constraint for those on both the supply and the demand side who were prepared to take risks.

The establishment of the supremacy of French art during the nineteenth century and of Paris as the art capital of Europe was naturally accompanied by the growth of its art market. By 1861 there were more than a hundred art dealers in Paris;[57] almost all of these, however, handled only *objets d'art* and the art of the past, leaving the distribution of work by living artists to be achieved principally through the salon. The efficiency of this institution as a sales outlet was diminishing towards the end of the century under pressure of numbers, both of works exhibited and of participating artists. In 1881 the government divested itself of the responsibility for this monopoly in the interests of a free market, introducing a series of measures that enabled a wider variety of art works to be produced for an increasingly diversified and expanding

bourgeois clientele.[58] In partial consequence, the numbers of artists in Paris roughly doubled in the forty years from 1870;[59] not only did foreign artists flock to the city, but also more sons and daughters of the bourgeoisie entered what had become a respectable profession with a carefully gradated career.

In this situation there was pressure to develop a more manageable system of distribution than that of the salons, and from the turn of the century to the First World War each year more private galleries were established to cater for a range of tastes and pockets. The French art public was as cautious in its approach to new art as it was to furniture, and for many of the same reasons: it showed a marked preference for painting and sculpture that remained within established conventions rather than any that departed from them. This attitude was matched by that of most art dealers, both in their choice of which artists to show and, equally important, in their business practice. Unlike the decorative arts industries, though, this did not lead to a loss of their markets to foreign competitors, since no other country could match the prestige which the Paris market wielded. Instead, it provided opportunities for those in a position to take them. Interest in new and unconventional art was mounting, stimulated by the attention of foreign (chiefly American and Russian) collectors; in around 1910 the works of Degas and Renoir, reviled thirty years before, were fetching over 50,000 francs, and in 1915 Degas's painting *Danseuses à la barre* of 1879 sold for no less than 435,000 francs.[60] For dealers, and no less for collectors, with enterprise, imagination and, preferably, initial capital of their own there were clear opportunities for gain.

Defending the Republic: The Bloc des Gauches and Cultural Politics

If the economic life of France as the new century opened comprised tensions and contradictions whose consequences, both for society at large and for cultural production, were not immediately apparent, its political life was clearly structured – or so it appeared – by the battle lines of the Dreyfus Affair. Like a drop of acid in a retort, as the essayist and politician Adrien Mithouard put it in 1901,[61] the Affair separated the political currents of the turn of the century into two opposed coalitions: on the right, catholic revivalists, monarchists and anti-semites, increasingly under the spell of Maurras's Action Française; on the left, anti-clericals, republicans and socialists, grouped under the banner of the Bloc des Gauches.

The Bloc had its most concrete existence and symbolic importance on a parliamentary level, as the basis of support for the Radical administrations of Waldeck-Rousseau (1899–1902) and Combes (1902–05). The 'government of republican defence' of the former had two overriding policies: anti-clericalism, or a commitment to the separation of church and state, which in private meant a weakening of the political power and social authority of the church and the dissolution of those religious orders that had been most openly anti-dreyfusard; and republicanism, which entailed the persecution (or at least removal from positions of influence in the army

and elsewhere) of those supporters of the political right who had sought to undermine the republic by means of the Affair. For Combes, who succeeded Waldeck as premier in June 1902, anti-clericalism was almost the sole motivation. When this policy achieved its consummation in the Act of Separation of church and state in late 1905, the Bloc lost its momentum; it fell apart in the eighteen months that followed, and was dead before the end of 1907.

This disintegration was not the product of the Act alone, however. The Bloc des Gauches is incomprehensible without an awareness of both its existence outside parliament and, more generally, the growth of extra-parliamentary political forces in the period. For the Affair precipitated the entry into public life of new social strata and groupings, expressing themselves by new means – not only the syndicalist movement and the political organisations such as Action Française but also co-operatives, professional societies and interest groups, setting up offices, publishing magazines, advertising with posters and leaflets. On the Dreyfusard side, for example, 'the Affair, which had united workers and intellectuals in their aims and even in action, convinced the latter that the consolidation of democracy required their active participation in social life'.[62] Examined in this broader context, the political chemistry of the Affair period seems less stable than Mithouard's metaphor suggests, and the character of the Bloc more ambiguous; not all the elements in the Bloc, moreover, had their origin in the Affair. For business managers and politicians alike, the tensions accompanying the economic developments threw the relations between labour and capital into as sharp a relief as those between the republicans and monarchists. In the assessment of one modern historian, 'battalions of businessmen, reformers and politicians' mobilised throughout the 1890s to forestall an eruption of working-class unrest, and 'a remarkably high degree of consensus on the 'social question' united disparate and otherwise antagonistic fractions of the French bourgeoisie' at the turn of the century. Indeed,

> As the clouds of disorder gathered, 'republican defence' – a venerable and empty slogan – took on precise ideological and political content as class divisions came to define the contours of French society. Industrial labour, as never before, had become a major presence on the social landscape . . . Thus republican defence came to mean social defence. The new conditions rendered meaningless such labels as 'opportunist', 'radical', 'liberal', 'Progressiste', 'clerical' and 'anticlerical'. However useful they may be for keeping track of shifting ministerial lineups, they tell us little about what happened on the level of social politics.[63]

This may underestimate the extent to which the Affair, and the use made of it by the right-wing coalition, was perceived by the parties of the Bloc to pose a threat to the existence of the republic, but it points to the economic and social context in which this threat should be set. Waldeck himself in 1902 expressed an interest in building a unified ruling-class alliance that would stand above political factions,[64] and appointed to his cabinet Alexandre Millerand who, although elected as a Socialist, shared his concern for the primacy of the national community (represented for Millerand by the state) over class interests.[65]

Thus, while on the surface of political life the oppositions generated by the Affair gave the Bloc des Gauches a progressive colouration, on a more fundamental level it was less so. Ultimately, it was the conflicts provoked by this ambivalence from 1904 to 1907, rather than the passing of the Act of Separation in itself, that brought the Bloc to its end. In its heyday, the extra-parliamentary groups and societies attached to it, through which intellectuals effected their participation in social life, reflected this ambivalence: they were both an extension of Dreyfusard comradeship into other arenas and, at the same time, instruments of corporate paternalism, a 'generalised political strategy aimed at fixing the pattern of labour–capital relations'.[66] This paternalism was a development from that of the family firm; where that sought to reproduce family relations and loyalties as the firm expanded beyond it, this addressed workers as a class, and its aim was their co-option and acculturation as a class. Its instruments were various: profit-sharing and worker shareholding schemes, company unions, workers' housing co-operatives, the garden city movement, adult education projects. In the late 1890s parapolitical organisations for their promotion mushroomed: the Société française des habitations à bon marché, the Musée social, the Société d'éducation sociale, the *universités populaires*, to name only a few, all began in this decade.

The last of these was among the most significant in several respects; first, because it achieved fairly spectacular, if brief, success in attracting support not only in Paris but in many towns and cities across France, in the years around 1900; second, because it won the participation of many intellectuals (including several in the literary and artistic milieux from which cubism emerged); third, because it reproduced in an acute form the contradictions of the Bloc. On the face of it, the *universités populaires* were a product of the Dreyfusard alliance, and were perceived as such; an attempt on the part of young liberal bourgeois intellectuals to create a link between themselves and militant workers by the formation of adult education institutes at which they gave evening courses on anything within their competence to any workers sufficiently motivated to attend.[67] For the contemporary social commentator Dick May it was 'impossible not to attribute the immediate cause of the movement to the Dreyfus Affair',[68] and the expressed aims of leading participants confirmed this: for Georges Deherme, founder of the first in 1896, 'the old fanaticisms that the Dreyfus Affair exacerbated, the intellectual misery that was discovered, brought home to some people how urgent was the need to undertake the work of education and mental discipline',[69] while others described their *université populaire* as 'an *école pratique* of liberty, of tolerance, of social solidarity'[70] that would reconcile the classes in a love of liberty and help to defend the Republic from those on the right who sought to destroy it. As has been observed,

> This institutional network of lectures, talks and educational festivals was almost always based on the idea that 'the people', the vast foundation of the Republic, were liable to be led astray and that it was the duty of the intellectuals, by proper instruction, to save them from the snares of clericalism and militarism.[71]

But also, it has to be added, from that of socialism. For while Jaurès and other parliamentary Socialists supported them, the paternalistic agenda of the *universités*

populaires could not be hidden from many on the extra-parliamentary left. As a recent historian of the movement notes,

> 'Aller au peuple' was then the response of an entire political class concerned for the security of the Republic, of an entire 'intelligentsia' alarmed by the rising tide of social conflict. The people became an obsession, the stake for which ideologies contested. The *université populaire* desired by Deherme and supported by the liberal bourgeoisie formed part of the arsenal built up to challenge socialism for the monopoly of the working class . . . [72]

The movement was dismissed by syndicalists and by other socialists as 'a mask chosen by property owners and the authorities, [who have] connived to hide their self-interest and to turn the masses away from new ideas'.[73] The paternalism is evident, indeed, in every aspect of the *universités populaires* – their character, their programme and their participants. For all the rhetoric of fraternity, it was clear who were there to teach and who to learn; as Deherme stated with disarming frankness, their aim was 'to gather workers together . . . in their own neighbourhood, and thinkers, writers, teachers, artists will visit them, to talk to them as comrades about whatever they know and whatever they wish'.[74] They brought with them, of course, not only their education but also the ideology in which this was grounded. Although the movement's leaders made a virtue of its ostensible political disengagement, a survey of lectures offered during 1900 betrays the influence of established anti-clerical ideas,[75] and their principal organisers were recognisable as Radical politicians and ideologues. Among them were Ferdinand Buisson, whose declaration of belief in a process of social osmosis that would dissolve class antagonisms and create a nation of worker-proprietors became a manifesto for young Radicals; Charles Gide, leading economist, godfather of the French consumers' co-operative movement and vehement critic of socialism; and Gabriel Séailles, Sorbonne professor, president of the Société des Universités Populaires founded in 1899 and equally ardent anti-socialist.

But the political allegiance was not only on the level of personnel. The purposes for which, in the words of their founders, the *universités*'s programmes of lectures and social events were established – to reconcile the classes, to develop a spirit of solidarity between them, and to encourage social peace[76] – also had, for all their apparent innocuousness, specific political connotations in this period. They were recognisably part of the anti-socialist consensus, indeed central to the programme of solidarism that, with the collapse of the Bloc, became the leading doctrine of republicanism. First presented as a coherent political position in Léon Bourgeois's book *De la solidarité* of 1896, solidarism, as we have seen, was an attempt to steer a middle road between capital and labour, to moderate capitalism's social consequences in the recognition that these, if unchecked, would produce increased social strife and eventually socialism. The latter was thus the main enemy; to defeat it, members of the working class had to be brought into the Republic as full citizens by encouraging not only their ownership of property and their access to its social and cultural benefits, but also their recognition of its responsibilities. The governing metaphor of solidarism was that of nature and the organic realm, whose cyclical renewal and unity in diversity were qualities that solidarists wished to encourage in the social order.

Their texts contain innumerable references to the 'social organism'. It was, nevertheless, a purely political doctrine; for all the biological rhetoric, the underlying conception was of 'social production as an integrated mechanism, in other words, smoothly functioning social machinery'. The integration, and the acculturation, had to be engineered.[77]

Alongside the *universités populaires* movement grew a more diffuse educational initiative: that of *art social*. The ideological function of art in bourgeois society, as well as its revolutionary potential, had been demonstrated by anarchists in the 1890s, and it was within this milieu that the *art social* movement had its beginnings.[78] In the first five years of the twentieth century, however, the movement came to counter the influence of socialism, by bringing the working class to an appreciation of the joys of art and the cultural heritage of France. Among the groups established for this purpose, and which organised lectures, museum visits and field trips to cultural monuments, were L'Art à l'ecole, L'Art et la vie, Art et travail, Art et science; perhaps the foremost of them was the Société de l'Art pour tous.[79] Founded in 1901, this group quickly gained the adherence of leading members of the political and cultural establishment, including the respected critic and high functionary in beaux-arts administration, Roger Marx; his ideas illustrate well the paternalism of the initiative. For Marx, the inspiration for the aims of L'Art pour tous lay in the writings of William Morris, which had been disseminated in France since the early 1890s – but it was a Morris whose political sting had been drawn in the process of translation and whose emphases were manipulated, in Marx's own writings, to suit another political agenda.[80] The concept of social and political revolution appeared nowhere in the critic's representation of Morris's ideas, and the whole of his impassioned condemnation of the prevailing social and economic system was excised; of his championing of art for all and by all, only the first part survived. As a modern commentator has noted, for Roger Marx, 'art is *popular* only because it is meant for the people . . . he makes no mention of the role of the people themselves in its production.'[81]

Such a misreading was even more blatant in the writing of another promoter of *art social*, Jean Lahor (alias Henri Cazalis), author of an enthusiastic book on Morris and – remarkably, given this fact – of a treatise entitled *L'Art pour le peuple à défaut de l'art par le peuple*; Lahor's ideas similarly illustrate this movement. A poet and friend of Mallarmé in the early 1870s, he turned his attention to social questions, presenting his social philosophy in *La Gloire du néant* of 1872, central to which was the project of individual and national rejuvenation through the creation of a superior race. The means to such ends included the enrichment of the life of *le peuple* through improvements in social hygiene and housing, and the introduction of some beauty and its appreciation into the lives of the working class; all of which would also help to wean them from socialism. Thus Lahor was active not only in the *art social* movement, but also – again with Roger Marx and others from its milieu – in related initiatives such as societies whose aims were to build low-cost housing, to provide cheap and nourishing food, to protect the countryside.[82]

While the example of Lahor demonstrates the potential uses to which the movement could be put, few of those active in *l'art social* shared his right-wing politics.

Many were active in their local *université populaire* and saw themselves as on the left of the parliamentary spectrum, supporters of the Bloc. Nevertheless, they shared a firm belief in the values of class collaboration, or 'social peace' as it was then termed, and their cultural activism reflected an awareness that

> neither good works delivered from above nor the coercion built into the productive process sufficed to consolidate bourgeois hegemony or to promote social peace. They paid off only if accompanied by instruments of cultural and ideological integration.[83]

During the years of the Bloc, this awareness coexisted with inter-class comradeship, born of the Dreyfus Affair, in defence of the Republic against the monarchist right; when the coalition collapsed, for reasons we shall now explore, such ambivalence was no longer possible. It was necessary to choose, and the choice made by most of these cultural activists showed where their deepest allegiance lay.

After the Bloc: Social Peace, the 'Debasement of Political Life' and the Rise of Nationalism 1906–1911

Not everyone in the Radical party was happy with the parliamentary coalition with the Socialists; on and beyond the party's right wing the Alliance démocratique, reluctant partner in the Bloc, was from early 1904 manoeuvring to exclude them, to delegitimise their participation in French politics. It was not until events of 1905 and 1906 turned the ambivalences of the coalition into contradictions, however, that their aims were achieved: it was a change of such fundamental importance for the cultural as well as the political life of France that it has been described as a historical watershed.[84] One of these events, as we have seen, was the Act of Separation of church and state, passed in late 1905; but if this removed the most visible reason for the existence of the Bloc, it was in many ways the least important. More fundamental were developments in domestic and international politics, particularly the disenchantment of the socialist and syndicalist movements with the performance of Parliament on issues of social reform, and the rise in diplomatic tensions occasioned by the first Moroccan Crisis.

The French socialist movement had been organised since the 1880s. After an early history of debilitating splits and quarrels, by 1900 it revolved around two groups, the predominantly Marxist Parti Socialiste de France and the reformist Parti Socialiste Français. Between these two the major issue, brought to a head in 1900 by Millerand's acceptance of a position in Waldeck-Rousseau's cabinet, was that of participation by Socialists in bourgeois governments. The issue was resolved at the Amsterdam congress of the (Second) Socialist International at the end of 1904, when the international movement, dismayed at Millerand's betrayals of socialism while in office and suspicious of the motives for his inclusion in government, voted in principle against participation, and for the unification of the French parties as the Section Française de l'Internationale Ouvrier (SFIO). This vote was of immediate and double

significance: first, it gave the parliamentary Socialists led by Jaurès less room for manoeuvre in their support of Radical policies, thus placing strains on the coalition in the Chamber and, second, it reinforced a move on the part of the working class towards reliance on its own extra-parliamentary resources, represented by the growth of syndicalist activity.

The syndicalist movement had emerged in France at the same time as the socialist, and grew steadily in the years around 1900; but its development was a separate one, influenced by a Proudhonist preference for economic rather than political action, and reinforced by a rejection of French socialism as doctrinaire, ineffectual and dominated by bourgeois intellectuals. The 1895 congress which established the Confédération générale du travail (CGT) declared the general strike to be its principal weapon and insisted on non-alignment with political parties, a 'neutrality' that was reaffirmed in the 1906 Charter of Amiens, at a crucial moment in the re-alignment of political forces. Between 1902 and 1906 the numbers both of CGT members and of strikes trebled; at the same time, the syndicalist movement made a significant break with anarchism. Although the latter had played a major role in its development, and syndicalist doctrine owed much to Bakunin, at the 1907 anarchist congress in Amsterdam the young syndicalist Pierre Monatte called for strategic rejection by revolutionaries of both the 'purely verbal revolutionism' of the Marxist Guesde and that of those anarchists who were 'superbly isolated in their ivory tower of philosophical speculation', in favour of an organisation that 'can and should be neither anarchist, nor guesdist, nor allemanist, nor blanquist, but simply an organisation of workers'.[85] While Monatte was not likely to have had them in mind, certain painters from the Parisian avant-garde could be included among such ivory-tower anarchists – such as Paul Signac, the respected president of the Salon des Indépendants, whose renowned artistic anarchism was indistinguishable, in its individualism and its insistence on the autonomy of art, from an attitude of *l'art pour l'art*.[86] This rejection, indeed, had its effect on members of the cultural avant-garde, as we shall see.

Monatte's belief in the potential of autonomous working-class action to achieve political change was justifiable in 1907; the three preceding years had seen a sharp annual rise in the number both of strikes and of participants in them. The rise was especially sharp in Paris and its suburbs, where a quarter of all strikes occurred in 1906, and on 1 May that year the skilled artisans of many of the city's *métiers d'art* joined unskilled workers from the suburban factories to lead a nationwide campaign for an eight-hour working day. The consequence was not only the enactment less than three months later of a law that made obligatory a weekly rest day – one of the few pieces of social legislation of the pre-1914 decade – but, more generally, alarm on the part of the bourgeoisie at the possibility of social conflict.[87] Anxiety about destabilisation of the Republic from the right turned to fear of revolution from the left. In such circumstances the Bloc could clearly no longer serve a purpose; three weeks later, in mid-May, parliamentary elections gave the Radicals and Alliance démocratique a majority between them, and the Bloc became effectively superfluous. Six months later, Clemenceau as premier initiated a policy of suppressing strikes, using troops with a brutality that shocked even his supporters. The rupture between the Radical government and the working class was then almost complete.

It was not only strike action and moves toward autonomy that placed the socialist and syndicalist left beyond the pale of the liberal Republic: international developments and domestic responses to them were equally significant. In March 1905 the German Kaiser, alarmed at the strengthening *entente* between France and Britain and the plans for French annexation of Morocco which depended on it, attempted to obstruct both by visiting Tangier and pledging his support for Moroccan independence. The move backfired and ended not only in a strengthened alliance but also in alerting the French public to the real prospect of war with Germany. The incident fuelled the resentment that was still lively in some quarters at the 1871 loss of Alsace and Lorraine, and gave a boost to the sentiment of nationalism. In particular, the fall from office of the foreign minister Delcassé, architect of the *entente*, was seen as a gesture of appeasement towards Germany and a national humiliation.[88] The Crisis gave special impetus to those anti-dreyfusard groupings for whom nationalism had become a standard to be raised against the Republic; encouraged by the succession to the papacy in 1903 of the ecumenically conservative Pius X, and reacting in proportion to the zeal of Combes's anti-clerical campaign, these groupings had been gaining adherents, despite the electoral success of the Bloc des Gauches. After 1900 a steady stream of intellectuals and students in Paris converted to Catholicism, expressing, as Henri Massis observed, a search not so much for ultimate truth as for order and discipline after the anarchy of the Affair years.[89] Such aspirations were also characteristic of Action Française which, soon after its foundation in 1899, became the standard-bearer of nationalism, gathering recruits partly as a result of the coherence and intellectual force with which its leader Charles Maurras argued its case in the fortnightly *Revue de l'Action française*.

From 1905 the activities of Action Française became more visible and more militant. From vigils in front of the statue of Strasbourg in the Place de la Concorde it moved to agitation among students, founding the Camelots du Roi, a militia of young thugs who persecuted Jews and internationalists on the smallest pretext. In 1908 they rioted when a Sorbonne professor proposed a visit with his students to Germany, when another gave a lecture critical of Joan of Arc, and when the ashes of Zola, author of the Dreyfusard *J'accuse*, were transferred to the Panthéon. By the summer of that year, Action Française dominated the Latin Quarter. Its magazine became a daily newspaper in March 1908 and was joined by a new monthly, the *Revue critique des idées et des livres*, in April.

For all its visibility in Paris, however, the group was only a few hundred strong, barely represented outside the metropolis and thus a minority – if not marginal – political force. It would probably have remained so had not other responses to the Moroccan Crisis broadened the appeal of nationalism. These also had their roots in the previous decade: alongside the *nationalisme de vocation continentale* of the right – for which the army, the forfeited provinces of Alsace and Lorraine and resentment of Germany were points of reference – there developed a *nationalisme d'expansion extra européenne* centred on a desire for France to acquire colonial possessions and imperial authority to match those of other nations.[90] From initial hostility to the risks of overseas adventurism, public opinion had turned to support by 1900, largely as a result of successful military campaigns in Dahomey, west Africa, in 1892–94. While

the nationalists of the right continued to condemn initiatives which they saw as only sapping the resources needed for the defence of France itself, the majority expressed an enthusiasm for the establishment of 'la plus grande France' that was barely dented by the 1905 scandal over French and Belgian atrocities in the Congo.[91] In Parliament support for colonialism was centred in the Radical party; many of the leaders of the colonial lobby, including business leaders and colonial administrators, were members or supporters or had other close links with it. The Moroccan Crisis brought about the rapprochement of these two strands of nationalism, for the colonialist rival opposed by supporters of extra-European initiatives were at the same time in this instance the focus if not the source of the intra-European nationalism of the right. Fear and resentment of German aggression brought together most of the public and most political parties in a mood of national unity that the Third Republic had not previously witnessed.

Not all the nation rallied behind this nationalism, however. Outside parliament, the socialist and syndicalist movement consistently and energetically, by means of publications and public demonstrations, opposed both the efforts of the right and the colonial programme of the Radicals, on the grounds of their exploitative and anti-democratic character and of the danger that they raised of war with Germany. At the end of 1906 Gustave Hervé launched the incendiary weekly *La Guerre sociale* which combined these arguments in a fierce and outspoken anti-patriotist and anti-militarist polemic: for the workers, he argued repeatedly, the only *patrie* was their class, and their response to the threat of war should be a general strike. The parliamentary Socialists led by Jaurès were more equivocal towards colonial initiatives until the Moroccan Crisis, accepting the 'civilising mission' of France overseas while condemning the uncivilised manner in which this was often conducted. The Crisis, in bringing Europe to the brink of war, convinced them that the costs and dangers of the establishment of *la plus grande France* outweighed the benefits. At the 1907 Socialist congresses in Nancy and Stuttgart Jaurès voiced a strong condemnation of 'the policy of conquest and pillage' that characterised colonialism, and espoused Hervé's anti-militarism, warning that the destabilising effects of expansionist policies, and the flames of nationalism that they fanned, would set Europe alight.[92]

Such statements were the last straw for liberal Republicans. The events of 1905–06 had clarified the contradictions of their coalition with the working class, and Jaurès's alliance with Hervé made plain that a gulf had opened between the socialists and the Radicals. For the latter, nationalism and anti-socialism became elements of a new ideological cement to replace that, now defunct, of anti-clericalism. It was in these circumstances that the politics of solidarism began to gain wider currency; faced with the real possibility of violent class conflict, many republicans rallied to a programme of social reform and cultural paternalism that no longer entailed any accommodation with socialist or syndicalist collectivism. Solidarist doctrine affirmed that society was nothing other than a chain of individuals, associated with each other on loosely contractual terms in the pursuit of common goals. Embracing this in a keynote manifesto of 1907, the Radical party set itself the goal of social peace, to be achieved by rejecting competing class interests, enshrining private property as the very condition of individual freedom and dignity, and giving the proletariat a sense of both its

rights and its duties; as the Radical deputy Ferdinand Buisson declared, Radicals were 'a class of owners who work and of workers who own'.[93]

The achievement of social peace on the basis of such a programme was the aim of the premierships of Aristide Briand; in addition, acting in – or prudently harnessing – the national spirit of the moment, Briand gave solidarism an extra inflection by defining a hierarchy of allegiances to which the individual was subject, at the top of which was the nation. He thus appeared as the agent of conciliation between antagonistic social and political forces, and became from 1909 to 1914 the key player in the many governments of those years (and premier in no less than four of them). Briand's political power base was indistinct – a corollary of his avoidance of partisanship – but he did have an unofficial secretariat. The Comité de la démocratie sociale, a group formed in late 1905 by young Radicals anxious to promote solidarist social reform, saw Briand as its figurehead, and undertook to promote his ideas outside parliament.

The Comité de la démocratie sociale is of particular interest for us, for two reasons: first, because its efforts can be seen as the political expression of the current cultural paternalism. The 'crucible of radical–socialist doctrine' of those years, as it has been described, it played a leading role in defining the social and cultural aims of Radicalism, from 1909 to 1912 through its weekly paper *La Démocratie sociale*.[94] It thus underwrote, and gave a doctrinal basis to, the incorporative efforts of both the *universités populaires* and the *art social* movements. Some of its founder members, such as Buisson, were active in these; another deputy, Joseph Paul-Boncour, a rising star of the Radical party, also promoted the efforts of *art social*, particularly its emphasis on the social benefits of a revival of French decorative art.[95] Reciprocally, leading figures in this revival such as Roger Marx articulated the solidarist doctrine of *démocratie sociale* in their writings on *art social*.[96]

The second reason for the group's interest here is that its participants, supporters and fellow travellers were not restricted to politicians, but included several members of the intellectual and artistic avant-gardes of Paris. The young writer Henri-Martin Barzun, friend of Albert Gleizes and other future cubists, was Paul-Boncour's secretary in 1906, and contributors to *La Démocratie sociale* during its three-year existence included the poets Paul Adam, Henri Hertz and Guillaume Apollinaire.[97] Moreover, the spirit of solidarist social activism which *Démocratie sociale* underwrote touched the cubist milieu. Poets sympathetic to cubism (in some or all of its variants) such as Charles Vildrac, Georges Duhamel, Olivier Hourcade and Apollinaire gave lectures at the Université populaire du Faubourg St-Antoine.[98] Meanwhile Gleizes and Alexandre Mercereau in 1905 had helped establish the Association Ernest Renan, an anti-clerical youth group with aims similar to those of the *universités populaires*.[99] Then in 1911 they joined Fernand Léger, the poets Roger Allard and Paul Fort and the publisher Eugène Figuière, among others, to found the Jardin de Jenny l'Ouvrière, whose mission was to brighten up the windowsills of workers' houses with potted flowers – decidedly utopian, but no less solidarist for that.[100]

While Briand was supported energetically by the solidarist idealists of *Démocratie sociale*, nevertheless it was during his years of stewardship that parliamentary government and politics came to be regarded with increasing disenchantment by the French

electorate. For another corollary of his avoidance of party politics was government instability and the increasing presence of vested interests – business, finance, the colonial lobby – in the corridors of political power. As eleven ministries came and went between July 1909 and August 1914, public perception of the debasement of political life grew. Etienne Antonelli noted in 1911 that the French people were uninterested in public affairs, scornful both of politicians whom they saw as self-satisfied and mediocre and of the political life that they had degraded; a view corroborated by Etienne Rey, checking the moral pulse of the nation a year later: 'People have tended to see in politics nothing but cynicism, haggling, lies and exploitation; they have become used to having a low opinion of parliamentarism, used to regarding deputies as either worthless or for sale.'[101]

One consequence of such disaffection was a rise in support for extra-parliamentary movements. On the right, Action Française reaped the benefits of this, in terms not so much of recruitment – its membership remained in the low thousands across France and a few hundred in Paris – as of sympathy, particularly among intellectuals. On the left, syndicalism and anti-militarism felt the same effect.

Sharing their disaffection with the status quo – but not, for the most part, with the liberal Republic itself – were the activists of the feminist movement. Emerging in the late 1880s and 1890s, this was by the first decade of the century a diverse and burgeoning formation; with a six-figure membership, more than twenty periodicals, regular congresses and the sympathy of nearly half the deputies in the exclusively male Chamber of the 1906–19 legislature, it had both a sizeable following and a solid organisational base.[102] It was, however, divided along both class and party lines, with different feminist groups seeking separate goals. The largest and most influential were those who articulated a 'familial' feminism, which 'aimed not to overthrow the economic basis of patriarchy but to reorganise the existing society to the greater advantage of women', and whose understanding of the social relation between the sexes was one of 'equality in difference'.[103] Their preferred political allies were the Radicals, whose solidarist morality insisted on the mutual obligations of men and women and on the family as a fundamental unit of social organisation. Just as their involvement in the *universités populaires* was for solidarists a means to confront the threat of socialism and syndicalism with inter-class collaboration, so their support for familial feminism helped to reconcile that movement with the prevailing sexual division of labour. As in the case of the *art social* movement, moreover, decorative arts practices and traditions were among the instruments of co-option: through the 1890s the Union centrale des arts décoratifs sought to link a French modern style based on organicism and the luxury crafts to women as craft producers and home-makers. They thus resurrected the aristocratic tradition of women's central role in the decorative arts and attempted to forge an alliance between the women tastemakers of the haute bourgeoisie and female artisans in the *métiers d'art*: 'in each case, the collaboration of the women and politicians was predicated on maintaining the "separate spheres" while expanding women's activities within the designated domestic realm.'[104]

Given such congruence between the aims of solidarists and 'familial' feminists, there was little support from the Radicals for those currents within feminism that

opposed such sexual divisions and sought political as well as property rights, and equality of opportunity for women. Nor was there much support from the organised male working class or its parliamentary representatives, who viewed such currents as at best an impediment to their own campaigns for reform or revolution, at worst a threat to wage levels and job security. The 'integral' feminist groups were small and split by factional disputes that won them few adherents among working-class women.[105] Demands for women's suffrage did gather significant and growing support after 1905, with *Le Journal* waging a campaign in its favour that gained over half a million adherents in 1914. Yet the support was in principle only: in practice, other priorities and deeper fears obstructed progress to legislation, and the outbreak of war halted its momentum.[106]

For many members of the intellectual and artistic avant-gardes, disaffection with the republican regime led not to any explicitly political challenge, but to a withdrawal from political engagement of any sort. The emergence of the cultural avant-gardes as self-conscious formations at the end of the nineteenth century was in part a function both of the promise of increased social esteem that the democratic institutions and higher education reforms of the Third Republic had held out for writers and artists, and of frustration at the failure of these to deliver that esteem in practice. As their channels of advancement became choked by the influx of new aspirants, and obstructed by the realities of a class society, the more marginalised members of these professions reached for the collective identities of 'intellectual' and 'avant-garde' as a form of security against social uncertainty and a compensation for their marginalisation.[107] Their participation in the Dreyfus Affair, whether as dreyfusard or anti, provided a sense of engagement in the mainstream life of the Republic, but after the watershed years of 1905–06 many transferred their energies from political and social causes to an exclusively aesthetic militancy. The consequence was the consolidation of the artistic avant-garde as a formation, and the emergence within it of self-conscious avant-gardism as both a social attitude and a promotional strategy.

Aestheticist withdrawal was not for everyone in the avant-gardes. Other intellectuals and artists who had supported or participated in the spirit of the Bloc, like the idiosyncratic, anti-establishment writer Charles Péguy, turned in 1905 and immediately after to the nationalism then strongly in the ascendant. A Dreyfusard and ardent socialist before 1905, Péguy proselytised for both in the review *Cahiers de la quinzaine* which he founded in 1900. The sharp rise in international and inter-class tensions of 1905–06 led him to reassess this allegiance, though, and to substitute for it an equally ardent nationalism. As Péguy himself described, in 'Notre patrie' of October 1905, his response to the Moroccan Crisis, and specifically to the resignation of Delcassé on 6 June 1905, his change of mind amounted to a quasi-religious conversion:

> Like everyone I had returned to Paris at nine in the morning; like everyone, that is, like about eight or nine hundred others, I knew at eleven thirty that in the space of those two hours a new period in my own life, in the history of this country, and certainly in the history of the world, had begun . . . Everyone, thus defined, knew at the same time that there now existed the threat of a German invasion, that it was present, an imminent reality.[108]

The ideological character of this conversion is succinctly illustrated in Péguy's changing notion of the 'people', a social category dear to his heart and to whose members, principally, he addressed his *Cahiers*. As has been noted,

> with 'Notre patrie' and the works which followed in 1905 and 1906, it was no longer the proletariat of a future revolution whom Péguy called the people . . . from then on the term represented for him an already mythic, or at least anachronistic, figure . . .
>
> To chart his passage from socialism to nationalism is to observe his near abandonment of the term 'people' in favour of that of 'race', as if the people, in some way absorbed by the writer, continued to lose its social reality, to be reconfigured in the formula 'un écrivain de race', where 'race' signifies conformity to a tradition, the ancestral voice of 'the French genius'.[109]

Péguy's nationalism as revealed here belonged to that profoundly traditionalist and predominantly right-wing ideology which was best and most famously articulated by Maurice Barrès, and which I shall examine in Chapter 3. If such qualities had remained the property of the right, however, they would not have achieved the wide resonance that they did in pre-1914 France. The Moroccan Crisis had created the conditions for the reconciliation of this intra-European nationalism with that extra-European current which had powered French colonial expansion. For this reconciliation to form the basis of a mood of national unity, it required the active participation of the politically dominant party, the Radicals. At its congress of 1907 the party had seized on the anti-patriotism of the Socialists as a pretext to wrap itself in the *tricolore*;[110] the policy of Briand's ministries from 1909 was to rally most of the electorate behind this banner, indeed to raise it above party politics. The means to this end was the extension of the solidarist idea of mutual rights and duties into a sense of patriotic altruism: 'Above the individual stands the group; but there is and must also be, the only guarantor of the individual and the group themselves, the association of all the citizens in the nation', Briand declared in a speech of March 1909, and he tied this patriotism neatly to progressive values: 'the beautiful country of the future will be that which is most human, which will have faced its problems calmly and have resolved them in a spirit of liberty and social justice.'[111] He developed the theme six months later: 'We must establish communication between republicans worthy of the name, not just in local constituencies or even within a *département* but from one *département* to another, and it must be the very heart of France herself that beats in all of these.'[112] By means of arguments such as this, Briand promoted an organic conception of the Republic, a solidarism founded in a mystique of the nation. And the policy succeeded; Briand himself was almost permanently in office until the War, and steadily from 1909 'nationalism became an atmosphere.'[113]

The Hegemony of Patriotism 1911–1914

It has been suggested that the nationalism of the right-wing leagues could not reach out to the general public because the very term *nationalisme* was not in common

French vocabulary in the first years of the century, and that its promoters were compelled to resort to other, more familiar terms such as *patrie* and *patriotisme* in order to be understood – but that these terms were common property, active in the lexicon of the left as well as of the right. Thus the spread of their message was necessarily at the expense of its ideological distinctiveness.[114] While it was around the themes and terms set by the nationalists – the threat posed to France by German military strength, industrial expansion and culture – that French patriotism developed, it was the growing fear of imminent conflict rather than commitment to the idea of the nation as primary in the social life of individuals that motivated the increasing expression of patriotic sentiment after 1905. Events in 1911 were instrumental in this broadening of nationalism into patriotism.

Morocco again provided the catalyst. Co-operation between French and German mining interests in the exploitation of the country that had been formalised in 1909 was functioning badly enough by April 1911 for the French government to decide to occupy Fez, in flagrant violation of the 1906 Algeciras Agreement. Germany responded by sending a symbolic warship to the port of Agadir in July. Tensions ran so high that the threat of war was very real, and while the incident was resolved on the diplomatic level in November 1911, the fear of imminent conflict remained, and raised the public mood of patriotism to fever pitch. The Paris correspondent of the London *Daily Telegraph*, describing in March 1912 the spring review of the Paris garrison reservists, an annual affair usually ignored by the city's inhabitants, reported that

> the most remarkable demonstration of patriotism I ever remember having seen here was made today. For a couple of hours this evening I have been hearing at frequent intervals the tramp of boots, the crashing and rolling of regimental bands, and roars of cheers along the boulevards beneath my windows . . . I repeat that I have never seen such a demonstration of military patriotism in Paris before. The change in the French national temper is one of the most remarkable events in Europe today.[115]

This testimony was corroborated a month later in almost identical terms by Pierre Monatte's syndicalist, anti-militarist newspaper *La Vie ouvrière*; these military demonstrations, it concluded glumly, were more than mere spring fever, for they signalled a vast reawakening of patriotism. And while the bourgeoisie had refound its love for *la patrie* and the army some years ago, 'for the great mass of the public, composed largely of the proletariat, to succumb to the sentiments of the bourgeoisie is a truly dangerous development.'[116]

Other witnesses saw this development differently. For Etienne Rey, writing at the same time, it represented an expression of a 'popular instinct' that could be relied upon to know what was best for its own interests and those of France, and was thus to be celebrated. But Rey saw the patriotic revival, and the spirit of national unity and French pride that it engendered, as principally the achievement of a new generation; 'youth has imposed its patriotic faith on the entire nation', he argued.[117] The most notorious contemporary expression of youthful opinion agreed emphatically. Agathon's 'Les Jeunes Gens d'aujourd'hui', serialised in the conservative weekly

L'Opinion in the spring of 1912, was the result of an inquiry into the social attitude of the students in the *lycées* and *grandes écoles* of Paris – a small but strategically opinion-forming elite. It revealed a clear consensus: no longer were there any anti-militarists or anti-patriots in the *écoles*. Not only that, Agathon reported that national sentiment was extremely strong and that the common ideal of the students was 'nothing less than a new kind of Frenchman, and a new France'.[118] This new Frenchman was to be a man of action, for 'action is the criterion of morality'; a Nietzschean *übermensch*, one could say, were it not that in their chauvinism Agathon's youth rejected him in favour of Stendhal, 'that Nietzsche of our own race, formed by the lucid analysis of the men of the 18th century, untainted by German metaphysics'.[119] The cult of action led them to exalt strenuous activity and physical courage; this too was seen in terms of patriotism. Sport, especially team sport, was valuable in its fostering of solidarity, endurance and aggression – indeed war itself was the ultimate team sport: 'These young men invest [the notion of] it with all the beauty by which they are so moved and which daily life denies them.'[120] Agathon also bore witness to the contemporary mania for aviation, and gave this a patriotic inflection, arguing that 'the exploits of our aviators are for the popular imagination a symbol of the courage and vitality of our race'; in the eyes of the people, they argued, 'the aeroplane is above all an engine of war.'[121]

Agathon's enquiry was influential as well as revealing, for it promoted as well as discovered the consensus among this young elite, giving it a clear identity and a public profile. As such it was not only welcomed by nationalists such as Barrès and the militants of Action Française (although the latter were not comfortable with the anti-rationalism expressed by Agathon's respondents),[122] but also met with acknowledgement from other political groupings. Radicals, Socialists and anti-militarists were obliged to accept its patriotic terms, even while they distanced themselves from its specific enthusiasms and allegiances.[123] It appeared, moreover, to echo, and find echoes in, a wide range of public statements and gestures. The Catholic daily *L'Eclair* expressed a common enthusiasm for sports as patriotic war games in an article of September 1911, a view which was endorsed the following year by Henri Bergson, who saw in such activities evidence of a moral rebirth of the French nation.[124] Both shared also Agathon's view of aviation; as did, it seems, the public at large; a national subscription launched by the press early in 1912 to raise money for a military aviation squadron reached half a million francs in two months and nearly three million by mid-April, with the aid (much publicised and acclaimed) of Sarah Bernhardt, who took collections during the intervals of her Paris performances. In March an aviator came close to winning a parliamentary seat in a by-election on the sole grounds of having the ability to fly in defence of his country; that same month Millerand, now Minister for war, introduced into the Chamber of Deputies a bill to establish a 'regiment of aviators'.[125]

Other debates in the Chamber, on topics less evidently related to the threat of war, also reflected the galloping progress of patriotic considerations; as we have seen, even the arcane activities of the cubists offended some of the people's representatives. While Deputy Breton's accusation indicates the hysterical level to which patriotism

had risen, the avant-garde itself was no more immune to the condition than other sectors of French society. In the milieux of the cubist painters themselves, nationalist sentiment was by 1913 strongly expressed by many. The magazine *Montjoie!*, founded in January of that year (ironically, by the Italian Ricciotto Canudo), rapidly became the mouthpiece of the leading grouping within the cubist avant-garde: it was strident in its combination of cultural elitism and bellicose nationalism; the title itself was a battle cry of the kings of medieval and renaissance France quoted from the *Chanson de Roland*. The majority of its articles represented this position in various ways, including in the first issue a contribution from Gleizes, 'Le Cubisme et la Tradition', in which the latter term was justified in terms of a narrow and nationalistic understanding of the former.[126]

The hegemony of patriotic sentiment in the social life of France was thus from 1912 almost complete. Only on the political left, among the organised working class and its sympathisers, was there resistance to its imperatives; for the socialists and syndicalists, engaged in the attempt to develop an alternative rule of international working-class solidarity, opposition to the threat of war with Germany was of paramount concern. Thus when the ardently nationalistic Lorrainer Raymond Poincaré, newly elected President in February 1913, pressed the Chamber to legislate for the period of military call-up to be increased from two years to three, the left campaigned energetically against it. They failed to prevent the measure becoming law in August 1913, but continued to voice strong opposition, and the considerable gains made by the SFIO Socialists in the April 1914 parliamentary elections indicates the depth of anti-militarist feeling in the working class, only four months before the outbreak of war.

Yet even in this quarter the patriotic imperatives proved ultimately irresistible; by the time France entered the war on 4 August, the anti-militarism of the left had given way to acceptance of the need to fight in defence of the nation. The way in which this change occurred reveals much about the ideological reach and potency of French patriotism. Two events of 1912 marked the turning-point; the first was the remarkable *volte-face* of Gustave Hervé, who emerged from 26 months of imprisonment for his anti-militarist publishing activities to declare himself a patriot, and to argue that his anti-patriotism of old had been only a hatred of bourgeois society and a campaign against those who exploited patriotism for other ends.[127] Fundamental for him now was a revolutionary patriotism whose roots are traceable back through Michelet to the 1790s. Just as Michelet was convinced that in defending France, whose vocation it was to promote the benefits of the Revolution of 1789 and to bring liberty to birth in every nation, he was defending not his country, but the principles of goodness and truth, so Hervé saw the defence of France as the means of safeguarding the goals of revolutionary socialism.[128] As one of the major figures of the left, such a shift of position was of huge consequence among his supporters, and caused alarm among other leaders of the working class.[129]

The second turning-point in 1912 constituted another setback to anti-militarism. The Agadir Crisis had led the syndicalist movement to discuss specific proposals to prevent the outbreak of war, and in November 1912 an extraordinary congress of the

CGT called a one-day general strike for 16 December as a warning to the government. It was a failure, and the government responded with the seizure of documents and a round-up of militants; from this moment onwards, confidence in anti-militarism as a policy began to ebb. Not that the organised working class did not remain profoundly opposed to war, in contrast to the rest of France: a demonstration against the seemingly imminent outbreak of hostilities called on 27 July 1914 at only four hours' notice by the CGT paper *La Bataille syndicaliste* brought a hundred thousand people on to the streets of Paris.[130] Rather they were, like Hervé – and Jaurès shortly before his assassination on 31 July – won over to the possibility of the reconquest of patriotism from the bourgeoisie, instead of its outright rejection. In practice, this entailed an acquiescence in the prevailing hegemony. 'What died in 1914', a modern commentator has observed, 'was the desperate effort of the CGT to keep open the social and ideological gulf which separated the French working class from the rest of the nation.'[131] That gulf closed in a resounding manner. On the outbreak of war the leaders of all parties and political organisations, including the Syndicalists, collaborated in the establishment of the *union sacrée*. Guesde, the Marxist and erstwhile revolutionary socialist, joined the cabinet in August and remained until 1916; Hervé moved even further, leaving the SFIO in 1916 and in the same year founding a pro-Clemenceau paper, *La Victoire*. The rout of anti-militarism, the hegemony of patriotism, was then complete.

Chapter 2

A Bold Aesthetic Band

For all the ubiquity of its appearance in art writing, 'avant-garde' is a slippery concept, the imprecision of whose use has bedevilled attempts to understand even its relation to modernism, let alone the specifics of its emergence and initial currency. Before exploring the latter, therefore, some preliminary clarifications need to be made. The first is to distinguish between the terms 'avant-garde' and 'avant-gardism': in much writing on the subject the two are elided, via a slippage (from 'avant-garde' as a noun to 'avant-garde' as an adjective) whose effect is to conflate the formation itself first with some of its assumed qualities and, following this, with the ideological concept associated with it. In consequence, we lose sight not only of the specific character of social and cultural alienation before avant-gardism, and its role in the construction of an identifiable subcultural artistic community, but also of the emergence of the avant-garde from that community into a counter-cultural formation – and with it the development of avant-gardism as both an articulation of a collective consciousness, and a strategy which was paradoxically one of defence against new art market conditions as well as of support for them.[1]

A second distinction needs to be made between art as itself avant-garde with regard to society, and an avant-garde within art.[2] The former appears to have had its origin in French Saint-Simonian thought of the 1820s, according to which the figures of the artist, the scientist and the industrialist were to play the key roles in the society of the future; of these, the artist would be the vanguard.[3] Such a concept in no way included the idea of an artistic avant-garde distinct from other artistic tendencies of its time. The use of the military metaphor in this sense, although appropriated for political discourse on both the right and the left for a brief period during the Second Republic, did not appear in writing on art until after a second wave of political usage of the term (again across the political spectrum) around 1900, and borrowed its force from the prevalence of that usage.[4] The failure to distinguish these two very different concepts has hampered attempts to trace the history of the avant-garde,[5] and led to the assumption that it had a material existence as a formation, and a primary determining role as such, in the development of modernism as early as the mid-nineteenth century in France. For that formation to emerge, however, two sets of conditions were required.

* * *

The Avant-Garde Formation: Emergence and Consolidation

The first of these, the material foundations for its cultural practices and circuits of commercial exchange, evolved over the second half of the nineteenth century. As successive generations of artists took action to circumvent the constraining tastes of the salon juries and the academic establishment by exhibiting their work independently, they were supported by a network, or more accurately a hierarchy, of private dealers in contemporary art that first complemented, then rivalled and ultimately replaced the salons as the primary focus of the art market. This development has been reconstructed in many studies since the pioneering work of White and White in 1965.[6] From Courbet's pavilion at the 1855 Exposition, through the impressionist exhibitions of the 1870s and 1880s and the activities of dealers such as Durand-Ruel, via the idiosyncracies of Vollard to Kahnweiler's role in the creation of cubism, it is now a familiar history. But there are problems with it. It has conventionally been harnessed to a larger narrative – that of the gradual disengagement of modernism from the cultural apparatus of the bourgeois state and its corresponding emergence into cultural and social autonomy – which, as has been more recently shown, misrepresents the relation between artists and the state in late nineteenth-century France and underestimates the congruence that existed between modernist disengagement with the academy and the cultural policies of the Third Republic.[7] It is, moreover, incomplete; first, because the establishment of the dealer system is inseparable from broader commercial developments, in which the flourishing department stores, the growth of merchandising and advertising, and structural changes in the decorative arts industries were primary factors – indeed, in the decade before 1914 the art market was integral, as I shall argue, to the political economy of the Radical Republic. Secondly, because it takes no account of the masculinist character of the avant-garde and of the role played by that market in constructing it as such: recent work by a growing number of feminist scholars and others has shown how the art educational, exhibition and career framework that shaped the emerging avant-garde consistently privileged male over female artists and helped to define avant-garde artistic practice in terms that marginalised the work of women.[8] These are the wider narratives of which the emergence of the avant-garde was a part.

But that emergence required a further set of conditions, namely its own circuits of intellectual exchange and the consciousness on the part of its members of its existence as a distinctive cultural community. That such consciousness and such a discursive framework were not yet fully developed at the end of the nineteenth century is indicated by the history of the Incohérents in the 1880s. As Daniel Grojnowski has argued in recovering the record of their exploits, this group can be seen to have invented dada *avant la lettre*, in their use of visual and verbal puns and their assault on bourgeois taste, but failed to meet the hostile response that dada incurred – or, indeed, to seek it, as did the latter: instead, they interiorised the cultural norms of their audience and accepted its designation of them as humourists.[9] The group was founded by Jules Lévy early in the 1880s, within a milieu of disaffected young bourgeois – including Hydropaths, Hirsutes, Jemenfoutistes – gathered by their

chroniclers under the banner of *fumisme*, whose social focus was the Chat Noir cabaret (opened 1881) in Montmartre and whose defining commitment was to upset the bourgeoisie with gestures of derision towards its most cherished beliefs, especially those about art.[10] From 1882 to 1886 the Incohérents mounted a series of ephemeral exhibitions in which they hilariously called into question the very status of art with parodies of museum painting and sculpture (Bridet's *Porc trait par Van Dyck* of 1884 was a drawing of a man in seventeenth-century costume milking (?) a pig; Alphred Ko-S'Inn-Hus's drawing *Le Mari de la Vénus de Milo* of 1886 replaced that sculpture's head with that of a bald-headed bearded man), and puns and poems in a similar vein.[11] The group won sufficient popularity for a café to be opened bearing its name, yet when faced with the criticism of sections of the press, and the thundering of the academician Gérôme, they denied their strategy of cultural subversion, and claimed that they were only joking. As Grojnowski argues, it was in the absence of a public that would have offered them sufficient resistance to have obliged them to focus and develop their projects that, alarmed at their own boldness, they failed to recognise the subversive significance of their gestures. Such a failure marks also, I would add, the absence of an avant-garde consciousness on their part, and of a developed alternative and critical artistic discourse that could have provided a frame of reference for these gestures, and underwritten their subversions.

This is not to argue that there was no subculture sustaining the Incohérents, or that the *fumiste* milieu from which they emerged did not stand in opposition to bourgeois society. The bohemia mapped by cultural chroniclers of nineteenth-century Paris from Murger to Goudeau had a long and rich history of providing both a refuge from that society and a subculture in whose arenas and protocols was encoded both resistance to it and consolation for its thwarting of cultural ambitions.[12] Between this bohemia and the avant-garde there were overlaps; Montmartre, for example, was a home for both, and its way of life and cultural practices a contrast, even a provocation, to those of the city centre at its feet. But bohemia was not an avant-garde; first, because it did not amount to a formation – its structures were too provisional, its markers too few and often ephemeral, its way of life (particularly in the shadow of defeat by Prussia) too uncertain.[13] Secondly, since its cultural ambitions were themselves invariably bourgeois, the consolations of bohemia were equally invariably temporary: its transitory members, predominantly young men from the middle class, soon exchanged its culture of *fumisme* and *blague* for the rewards of respectability. Indeed, as the boundaries of its territory began to overlap with those of commodified leisure in the 1880s, in locales such as the Chat Noir, bohemia 'was literally turned into theatre, acting out its estrangement from ordinary life but also masking it, channeling its energy to appeal to the bourgeoisie as patrons and consumers of literary and artistic work.'[14] What bohemia had to offer was a way of life, defined in opposition to that of the bourgeoisie and grounded in the marginalised locales of cafés in unfashionable or inexpensive quartiers. When commercialised entertainment appropriated these spaces, the only alternative to acquiescence was invisibility. In contrast, the avant-garde, founded on the firmer ground of a new art market, defined around an opposition not so much to bourgeois life as to its artistic practices and

institutions, was able to develop an identity which, for all the two-way traffic across its border with the mainstream that I noted earlier, was more resistant to those commercial forces and encompassed implicit criticism of them.

At what point, then, were both sets of conditions for its emergence – the material and the discursive – in place, if they were not yet so in the 1880s? In his study of the emergence of intellectuals as a distinctive social grouping within the field of literary production at the end of the nineteenth century in France, Christophe Charle offers the means to an answer.[15] Charle identifies a contradiction between the democratic and meritocratic values promulgated by the new Republic and the laws of social reproduction in a class society such as France still was:

> The advent of political democracy and the undoubted progress of meritocracy since the time of the 'notables' should have entailed that entry to the elites was open to anyone, whatever their social level or inheritance. If the people is sovereign and if it is merit that commands social success, every citizen can aim for the highest positions. Now the sociology of these elites has demonstrated these changes, but it has also shown their limits; the cards were indeed re-dealt, but within the restricted circle of the dominant class, that is, the bourgeoisie'.[16]

This contradiction was exacerbated by two developments: there was a rapid rise in the number of aspirant artists and writers in France – specifically, in Paris – in the thirty years after 1870, which overwhelmed the cultural apparatus of the Republic, choking its channels of professional and social advancement, and heightened the frustration felt by such aspirants at its failure to deliver its promised access to the elites. At the same time, the removal of the state's monopoly of control (and thus guaranteed support) of the annual salon from 1881 led increasing numbers of artists to find themselves dependent on the new dealer-based market; similarly, new writers found fewer opportunities in established publishing and journalism, and were reliant upon the uncertain support of smaller publishers and ephemeral magazines.

The consequences of this, Charle argues, were three. The first was the widening of the gap between the dominant groupings of the dominant class (those closest to political and economic power) and the dominated (those, such as academics and cultural producers, furthest from them). With the growth in confidence of the economic and political elites as the Republic stabilised, and with the state's relinquishing its patronage of the artistic elites to the free market, the isolation of the dominated groupings increased. The second consequence was their fragmentation:

> the expansion of the intellectual field, the growth of relations of economic dependence in cultural production . . . reinforced not only the importance of the intellectual, as against the liberal, professions, but also their internal differences. This contradictory process accentuated the autonomy or heteronomy of each sector of the intellectual field, preventing the formation of a common professional group.[17]

The third consequence (with respect to writers, with whom Charle is specifically concerned) was the emergence of an avant-garde as 'an increasingly autonomous sector of the literary field, with its own hierarchy, its specific organs of diffusion [of

ideas] and acrobatic means of survival (such as odd skills, part-time jobs and other expedients).'[18] The neologism 'intellectuals' which emerged from within this sector was testimony to 'a double mutation, with respect to anterior terms: from the singular to the plural, thus from the individual to the collective, and from recognition by others to autoproclamation.' Whereas the great writer, artist or philosopher is recognised as such only as an individual, argues Charle, and 'philosophers and artists taken collectively lose a part of their symbolic aura, because of the mediocrity and obscurity of the majority',

> It is the reverse for 'intellectuals'. They acquire their importance only as a group . . . In the notion of 'intellectual', number becomes strength and not privation. Moreover this is why they have no need, ultimately, for the recognition of others for the establishment of their symbolic power . . . their own social judgement can dispense with the external social judgement of other groups and even run counter to it.[19]

Charle's method of analysis thus takes account of both institutional and discursive factors in the emergence of the intellectuals. As such it is applicable to the study of the parallel emergence of an artistic avant-garde which shared the consequences of those same contradictions. The marked rise in numbers of artists, for instance, was a significant feature of the Paris art world of the late nineteenth and early twentieth century; as figures compiled by Charle from census returns show, the number of French men and women describing themselves as artists rose from around 22,500 to around 35,500 between 1872 and 1906. It was an uneven growth, however, reflecting the upward and downward swings of the French economy in this period: rapid growth in the 1870s (to over 40,000 in 1881) turned to decline in the depression that followed (to around 31,500 in 1896), and this was in turn followed by growth through the boom years until 1914.[20] It was accompanied by an increase in the number of works exhibited; a mid-century average of 3,000 salon exhibits a year had increased by 1914 to 5,500, and the Salon des Artistes Français had been joined by three others: the Indépendants in 1884, the Société Nationale in 1890 and the Automne in 1903. Pierre Tournier, the art critic for the review *Pan*, bemoaned in 1910 that 'Paris is becoming more and more like one vast market for pictures and statues . . . between the Cours-la-Reine and the Champs-Elysées and the surrounding boulevards we saw, this spring, nearly 15,000 works of art! And before six months are past, another crop is already ripe!'[21]

The first consequence for artists of the influx of aspirants and the state's relinquishing direct support of the salon was thus a loss of some of the prestige that the latter had given, as it faced a free market in art, and competition between salons.[22] The foundation in 1890 of the Société Nationale des Beaux-Arts by disaffected members of the Artistes Français, with a salon of its own that was in aesthetic terms almost indistinguishable from its rival, divided the artistic establishment and weakened its authority. Moreover, insofar as neither salon would meet either the aspirations or the aesthetic interests of the horde of newcomers, they allowed a place in the market for another salon, the Automne. Founded in 1903 and quickly establishing a

distinct profile through its retrospective exhibitions and espousal of decorative arts on an equal footing with fine art, the Salon d'Automne discovered an immediate constituency among the more adventurous artists and publics, and further eroded the prestige of academic art.

Yet if Tournier's spring harvest was of works of art gathered from the 'official' salons, as they were termed, of the dominant culture, un- or anti-academic artists or those simply unable to gain entry to them were producing in similar abundance. By 1911 the Salon des Indépendants and the Salon d'Automne, now cardinal points of reference for this growing cohort, were between them exhibiting nearly nine thousand works of art each year; between 1896 and 1910 the number of exhibitors at the Indépendants rose from around a hundred and fifty to more than a thousand.[23] As the critic Louis Vauxcelles observed in 1911, with art production on this scale (his estimate was 17,000 salon exhibits a year), the market was saturated; only a tiny proportion of works were bought by *amateurs*, and not many more by the state:

> And the rest? . . . What happens to all this painting? . . . The melancholy artist takes his canvas from its frame and stretcher, rolls it up and puts it, as a penitence, in a dusty corner. And one morning he picks it up, restretches it, places it on his easel and paints over it.[24]

It was not artists alone who suffered from such a surfeit, as Léon Werth confirmed, reviewing the Indépendants in 1910; noting that there had been 5,669 entries that year, he asked his readers, 'What would you say if someone played you 5,669 different pieces of music at the same time? And don't pretend that these 5,669 visual sensations are successive ones. I assure you that by the 5,669th, they are simultaneous.'[25]

The growth in the number of salons, itself in part a response to the problem, had thus served to exacerbate it. In the process they contributed to the second of those cultural contradictions identified by Charle, the fragmentation of the dominated section of the bourgeoisie – in this case, the art world. The diversification of exhibition venues outside the salons had been a feature of the early Third Republic, in keeping with successive governments' embrace of free market principles. Chief among these had been the socially exclusive private *cercles*, French equivalents of the English gentleman's club, which increasingly mounted exhibitions of art by their members; for example, the exhibitions of the Cercle artistique et littéraire and the Union artistique, known familiarly as Le Volney and L'Epatant respectively, which counted bankers as well as distinguished academic artists among their members, were considered major events in the social calendar of *le tout-Paris*.[26] By the turn of the century these had been joined by small exhibitions that preceded the salons and functioned as their curtain-raisers. In the next decade the number of such satellite exhibitions, for which Vauxcelles coined the term *salonnets*, had mushroomed: the critic estimated that a further 10,000 works were shown each year at these events.[27] The *salonnets* answered commercial and social, rather than aesthetic, imperatives, and there was little stylistic affinity between the members of many of them. Although groupings from the academic end of the spectrum predominated, they were often composed of

established, older artists, wanting to distinguish themselves from the many younger participants in the salons of the Artistes Français and the Société Nationale des Beaux-Arts. Some *salonnets* were founded by younger or less academic artists, however, whose main points of reference were the salons of the Automne and the Indépendants. Vauxcelles's observation of one of these, the Société Moderne, founded in 1909, is valid for most of them: it was 'a new, singularly eclectic group of artists . . . there's another one announced every day.' But they had no aesthetic significance, he argued; instead, their organisers tried to please a varied public. And he asked, 'When shall we see the blossoming of a group that is truly representative of modern trends, that would unite, for example, all those who are today learning from the lessons of impressionism?'[28]

In seeking such a categorical grouping Vauxcelles was, in fact, looking beyond the purposes for which most *salonnets* had been founded. While the unified artistic formation that would challenge the eclecticism of the salons – the cubist group – was, in early 1909, just over the horizon, the strategy which the *salonnets* represented was more cautious: one not so much of challenging that eclecticism as of reproducing it on a more accessible scale, and of complementing the annual salons rather than subverting them. As such it was unable to break the logjam of works choking the system; to do this, artists needed recourse to different kinds of exhibition space; in effect, to an alternative art market. By 1910 the network of private dealers in contemporary art was sufficiently large and diversified to provide this.[29]

Dealing in contemporary art had come relatively late to a Paris private gallery system that had been in existence for many decades, and that numbered over a hundred galleries in 1860.[30] From 1900, however, following the earlier initiatives of Bernheim, Durand-Ruel, Vollard, Goupil and others, increasing numbers of dealers, some of whom, like Georges Petit, had made their reputation or established their gallery stock in old masters, diversified into the contemporary field. Those who had come first into this field had been able to establish their capital resources and develop their pictorial reserves without fear of competition. By virtue of these assets as well as of their experience and reputation, firms such as Durand-Ruel, Bernheim-Jeune and Petit had an oligopolistic control over the gallery sector of the Paris market by around 1910, and had so organised that sector as to be the ultimate beneficiaries of a large and growing number of smaller galleries which operated on a more modest level. These included, in the rue de Seine area, the galleries of Rivaud, active by 1905, Prath et Magnier by the same year, Vildrac from 1910, Marseille from 1912; on the right bank, those of Barthélemy by 1906, Artistes Modernes by 1908, Barbazanges and Devambez, both by 1911; most famous of all these little galleries, that of Berthe Weill, in Montmartre as early as December 1901. Such modest dealers showed the work of novices and unknowns, edging up their prices and then, lacking the funds to build up stock, handing them on to the leading dealers. The last in turn cultivated such galleries by lending them works around which to build an exhibition (and thereby attract new clients to their own artists). In such conditions the major dealers were able to divide the most lucrative of the gallery sector's dealings in contemporary art among themselves and to safeguard their position from erstwhile competition.

They thus kept the top end of the market closed, but the corollary of their pre-eminence was a cautious and conservative business policy.

Precisely because of their reputation the major dealers were unwilling to take the risks which might have accompanied support for unknown artists, competition for clients, unorthodox sales techniques or too close an identification with a particular new artistic style. It is true that Durand-Ruel had taken great risks early in his career; in 1866 he had bought seventy paintings from Théodore Rousseau in a single transaction costing him 130,000 francs, the biggest purchase of its kind to that date. But he had paid for such boldness, coming close to bankruptcy in the 1880s. While he was extremely successful by about 1900, he no longer took risks, and his earlier difficulties served only to reinforce the caution of his colleagues. Established dealers in the 1900s saw little advantage in behaving recklessly when the clientele for modern art was steadily growing.

For the growth of the dealer system was not only a response to pressures on the supply side of the art market, but also a function of developments on the demand side. While private galleries needed artists willing to place their work with them as well as (increasingly, instead of) in the salons, they also needed patrons willing to buy this work. From the mid-1890s buyers began to appear in sufficient numbers to make speculative dealing in, and collection of, contemporary art feasible. At first, however, this concerned only the work of established artists. The rise in the price of impressionist paintings in the 1890s, consequent in part on the entrance into the market of American collectors such as Morgan, Rockefeller and Whitney, has been well documented in recent years.[31] This led eventually to increased interest in post-impressionist work, in particular that of Cézanne, whose prices rose spectacularly from the turn of the century. In the mid-1890s Vollard was pricing his Cézannes at around 500 francs, and in 1898 Gauguin sold for 600 francs a Cézanne *Compotier et fruits* which he owned; in 1907 that voracious collector the Prince de Wagram paid 19,000 francs for this same work, and in the same year Bernheim-Jeune sold a large Cézanne *Baigneuses* for 50,000 francs.[32] The prices of paintings by other post-impressionists also rose in this period, if less dramatically. Auctioning works from his own collection in 1900, the amateur dealer Eugène Blot was unable to obtain his reserve prices for paintings by van Gogh and Toulouse-Lautrec; six years later, he found that these works were now more sought after than his impressionist paint-ings.[33] The rise in the prices of the major post-impressionists in its turn gave market legitimacy to the work of those artists who were regarded as their heirs: at his 1906 sale, Blot found his paintings by neo-impressionists and nabis to be 'highly prized'; a year later, Bernheim-Jeune sold a work by Henri-Edmond Cross for 5,000 francs, and one by Maurice Denis for 4,750.[34]

Such prices placed the work of these artists out of the range of many collectors[35] and yet, given the buoyancy of the economy and the steadiness of the franc, they also encouraged a speculative interest at the lower end of the contemporary market, in the work of young, unorthodox or unknown – but invariably male – artists.[36] In 1904 an art-collecting syndicate was founded whose aim, as its choice of name made explicit, was precisely to profit from these modest but evident investment opportuni-

ties: the Société de la Peau de l'Ours was a group of fourteen young *amateurs*, led by the young collector André Level, who agreed to pool an annual sum of money with which to amass, over a ten-year period, 'a collection of pictures, principally important works by young painters or those just establishing some notoriety', and to sell it at auction at the end of that period.[37] The group titled itself after one of La Fontaine's fables in which two hunters sell the skin of a bear to a furrier before attempting (and eventually failing) to catch it – acknowledging thereby the risks of such art-market speculation at the very outset of their own adventure.

Not that these risks were all that great, for the moment was propitious for such backing of novices: the reputation of Paris as the artistic capital of Europe was at its height, and the unorthodoxies of impressionism, suitably bowdlerised, had become a stylistic convention, widely adopted. At the same time the rise in Cézanne's prices suggested a return to classical values and, as Level and his co-speculators reckoned, promised new artistic developments. The group's hunch proved correct; such was the momentum of the market for young and unorthodox artists in the decade following its foundation that by 1912 the funds of the syndicate were sufficient to enable it to buy only the work of less highly rated artists. Even so, the auction in March 1914 reaped a handsome profit for its *sociétaires*.[38]

Such speculation in the work of newcomers to the market as the Peau de l'Ours exemplifies was by definition selective, and the selection was both a determinant of the character of the avant-garde formation, and a function of an aspect of that character itself – its diversity and topography. Those collectors who risked investment in the work of unknown and unorthodox artists, and were less interested in following the taste established by the leading galleries than in making independent discoveries in small, out-of-the-way *boutiques*, were as a group a new phenomenon in the market, a fact which the critic Tournier registered with distaste in 1910:

> Merchants readily organise little exhibitions in which even the most disconcerting of novices can always find a place, for while the number of intelligent *amateurs* has barely increased, the speculators and the snobs have abandoned the pretention of admiring only after they have understood.[39]

Such *dénicheurs*, or winklers-out of bargains (the term was coined by Level) had a variety of motives for their activity, amongst which were the challenge presented by a relative lack of funds, the assertion of individuality and cultural confidence implied by their going beyond the pale of accepted taste and in trusting their own judgement, and the pleasure of 'déniching' a bargain, which was often equal to that of aesthetic contemplation of the prize.[40] Yet these activities were of consequence for the structure and dynamics of the avant-garde, for they effectively determined, in three ways, the selection of a particular kind of new art from the range of what was being made in Paris at that time. First, because of that predilection noted earlier for focussing their attention on small private galleries and the studios of the artists themselves, rather than on the salons or the leading dealers; thus André Level, Wilhelm Uhde and Leo Stein, three of the most active and influential of the *dénicheurs*, all preferred, once they had established themselves as collectors, to make discoveries on their own by

browsing through the artistic *quartiers* than to rely on what they found at the Indépendants or the Automne.[41] The corollary of such a mode of collecting was the neglect of those artists for whom exhibition at the salons was their chief means of exposure, who had no connections with private dealers and did not live in the artistic *quartiers* frequented by *amateurs* – a large number, which included the nucleus of the future cubist movement: Gleizes, Léger, Delaunay, Le Fauconnier and Duchamp. By contrast, the attention paid to Picasso by the *dénicheurs* was by 1905 sufficient for him to avoid the necessity of hawking his work around the dealers, showing in the salons, or indeed joining such movements.[42]

Allied to this influence was a second, that of their aesthetic preferences. Adventurous as they were, most of the *dénicheurs* shared a taste for art – chiefly painting – that combined individualism and experimentation with a firm commitment to traditional pictorial values. This tended to lead them to reject the impressionistic and decorative conventions which then dominated the taste of more conventional collectors in favour of work which, as Level described his purchases for the Peau de l'Ours, marked 'a return to solidity, composition, to tradition loftily understood'.[43] Before 1906, such work took as its frame of reference the painting of the post-impressionists (those of Gauguin and Cézanne in particular, both of whom were given major retrospectives by the Salon d'Automne in its first few years) and developed in conscious response to its precedents.[44] Again, the corollary of their preferences was that the *dénicheur* collectors paid no attention, until shortly before 1914, to art that did not share this frame of reference, for example the work of immigrant artists from Germany and Eastern Europe whose guiding tradition was expressionist.

A third factor, which in part followed from the first two, was their lack of interest in the work of women artists. Among the fifty-four artists represented in the Peau de l'Ours sale in 1914 was only one woman, Marie Laurencin, whose work entered the collection only in its final years, moreover, when that of many male artists was already beyond Level's price range and he was compelled to seek less established names.[45] The relative lack of gallery exposure of women artists was one reason, but another was the construction of a critical category, in reponse to the growing number of women studying and practising art around 1900, of *femmes peintres* characterised by what were perceived to be 'feminine' aesthetic sensibilities and interests. The hostility to these new products of the Ecole des Beaux-Arts (opened to women only in 1897) and the private academies was explicit: 'they threaten to become a veritable plague, a fearful confusion, and a terrifying stream of mediocrity', wrote one critic in 1910.[46] Relegation of women artists to a subordinate category was made possible by – indeed was the corollary of – a dominant discursive construction of artistic identity in terms of masculinity: 'The freewheeling individualism, the belief in the autonomy of genius, the freedom to possess the city and its urban spaces, both symbolically and physically, were exclusively male prerogatives'[47] and '[c]ollectively, early vanguard art defines a new artist type: the earthy but poetic male, whose life is organised around his instinctual needs.'[48] All these qualities were amplified in the avant-garde milieux frequented by the *dénicheurs*, and their purchase of works by members of such milieux not only supported them even more but also enabled each collector to acquire a share in this identity.

While habits and preferences like these acted to create distinctions and spaces within the emergent avant-garde, they were also in part a function of such spaces. The small galleries and bric-à-brac shops frequented by the *dénicheurs* were for the most part located in and around the artistic *quartier* of Montmartre, and orientated towards the young and unorthodox (male) artists who gravitated to La Butte. Montmartre was not the only, nor perhaps even in the 1900s the biggest, artistic *quartier* in Paris. Across the city Montparnasse (although not until just before the First World War the social and cultural attraction that later made it celebrated) became after 1900 a substantial community of artists, not to speak of the writers whom the Tuesday evenings of the literary review *Vers et prose* drew to the Closérie des Lilas from 1905.[49] But the two features of Montparnasse that brought so many artists to the area were not particularly attractive to the patrons of new art. The first was the growing number of academies which had initially supplemented and pre- pared students for the Ecole des Beaux-Arts but which by 1900 had in many respects superseded that overcrowded and, for many, moribund institution: the Colarossi, the Julian, the Grande Chaumière, from 1908 the Ranson, were the most renowned; others included the Palette and the Moderne. They were clustered in the 6th arrondissement, north of boulevard Montparnasse, a comfortable bourgeois area inhabited by journalists, politicians, established writers and artists of the Ecole. The second feature was the *cités d'artistes*, ramshackle buildings full of low-rent rooms and studios, which housed scores of penniless immigrant artists, many from Russia and Eastern Europe: the Cité du Maine, Cité Boulard, Cité Falguière and, subse- quently most celebrated, La Ruche; these were located south of the boulevard in the 14th arrondissement, an area that was altogether different: less affluent, still with traces of its rural past, the edge of the city.[50]

A corresponding social (and, to some extent, gender) division existed between these two kinds of institution, the academies and the *cités d'artistes*. The former were taught, in the years around 1910, by established artists of the Société Nationale and nabi circles, such as Bonnard, Sérusier and Denis at the Ranson, J. E. Blanche and Desvallières at the Palette, Guérin at the Moderne; their fees, although not excessive (the Grande Chaumière charged FF1.50 an hour[51]), were beyond the reach of many artists, and their students were predominantly young French or foreign artists from middle-class backgrounds. Many of these were women. Until the Ecole des Beaux- Arts opened its classes to women in May 1897 (and its *ateliers* only in January 1900) these private academies were the only avenue to a professional fine art career available to women, providing access to study from the nude model (though at twice the fee that male students paid) and sometimes to mixed classes. After the turn of the century, as the Ecole's authority waned, the private academies were buoyant – and correspondingly expensive – and full of middle-class young men and women from across Europe, among them Alice Halicka at the Ranson, Sonia Terk (later Delaunay) at the Palette, Marevna at the Julian.[52] The almost exclusively male inhabitants of the *cités*, by contrast, lived close to destitution in humble studios: La Ruche had rents of between 50 and 150 francs a year,[53] and André Warnod described the rabbit warren that was the Cité Boulard as 'a curious building made of panels and other materials saved from the 1889 Exposition'.[54]

The artistic population of Montparnasse thus comprised both the socially respect-able, sub-nabi decorative aesthetic of the academies, and the glamourless poverty and bleak expressionism of the studios in the *cités d'artistes*; neither appealed to the tastes of the *dénicheurs*. Montmartre was a world away from both. Although like the 14th arrondissement still rural in character, it was both inside the city and yet separated from it by its steep slopes; neither remotely bourgeois nor mouldering in melancholy, it was populated by a varied social mix: smallholders and market gardeners, workers from the factories of the northern suburbs, shopworkers from the nearby Magasins Dufayel department store, artists, anarchists and criminals.[55] The last three groups, and the commerce between them, provided the material for a myth of Montmartre as the capital of bohemia that had reached substantial proportions by the turn of the century, and that brought about its suffocation under the weight of tourism as early as 1910. In the brief period between, it harboured a society in which, as Warnod later recalled, 'pickpockets, forgers, thieves and worse' mixed with 'fallen women and debauched young men in flight from their respectable families', *humoriste* artists such as Forain, Willette and Steinlen and the young painters of the Bateau-Lavoir studios, and in which the Lapin Agile *bistro* served as 'a sort of *maison de culture* of bohemia'.[56] It was this mix, and the piquancy of what Warnod termed 'the snobbery of the gutter',[57] that attracted the *dénicheurs*, as well as young poets such as Salmon, Jacob, Raynal, Carco and Apollinaire. But for all the currency of the myth, this counter-cultural community was small and fragmented: it numbered perhaps fifty artists, most of whom belonged either to the *humoriste* or the Bateau-Lavoir milieux (and all of whom were men), between which there was little social contact and a clear difference in aesthetic allegiance, art market orientation, even dress.[58] They were clearly differentiated by language, too: the Exposition of 1900 brought a large influx of foreign artists, of whom many Spaniards, including Picasso, found their way to Montmartre and stayed there to form the nucleus from which grew the Bateau-Lavoir milieu. The development was significant enough to draw contemporary comment, and for Weill to show their work as a group in 1902.[59]

The *dénicheurs* thus stood in both a determining and determined relationship to the emergent avant-garde – dependent on its already fragmented, already disharmonious milieux in their collecting habits, yet furthering, through these, such fragmentation and disharmony. They also contributed indirectly to the avant-garde's development by making possible the activities of a new kind of dealer, epitomised by Daniel-Henry Kahnweiler, who opened his gallery in 1907. The circumstances of Kahnweiler's entry into the market were unusual, and the moment propitious.[60] Given by his family a year and the fairly substantial sum of 25,000 francs (equivalent to eight times the annual wage of a Parisian artisan) to prove himself as a dealer in Paris, he was able to leapfrog the crowd of undercapitalised little galleries – by comparison, Weill started her gallery in 1900 with 4,000 francs[61] – and establish his own niche in the market; he was anyway obliged to do so, since he was in no position to compete with the likes of Bernheim-Jeune for the leading contemporaries.

The year 1907 was also a good time to start: the rise in Cézanne's prices and the expectations this raised, the activities of the *dénicheurs* and the caution of the whole

gallery hierarchy towards promising young artists – indeed its conservative habits in general – were opening up opportunities for innovative entrepreneurs who were prepared to take risks. Kahnweiler took the risks that he had to and innovated: by restricting the range of his acquisitions (after his first, exploratory year) to the work of a shrewdly selected handful of young artists, by obtaining exclusive access to this work, and by a policy which combined minimum exposure of it in Paris with maximum participation in exhibitions all over Europe, he both ensured his own commercial success and transformed the Paris art market.[62] In the process, he also helped to structure the emergent avant-garde, first by raising the profile of experimental work both in Paris and, perhaps even more significantly, in the international arena; and secondly, by sharpening distinctions, indeed rivalries, between groupings and provoking the adoption by artists of strategies of competitive avant-gardism, which ranged from careful self-positioning within the salons to the publication of magazines and the proclamation of manifestos.

Avant-gardism was, however, more than simply a strategy of defence against, or a support for, new market conditions, although these played a significant part in its elaboration, as I shall argue. On its profoundest level it articulated that sense of alienation from bourgeois society first registered in its modern form by Manet,[63] but now in a collective consciousness: a recognition on the part of unorthodox, anti-academic or otherwise culturally marginalised and predominantly male artists, as their numbers rapidly rose, of their common identity as such, and a response to this. Its emergence marked, in Charle's words, that mutation, with respect to anterior terms, from the singular to the plural, from the individual to the collective, and from recognition by others to auto-proclamation – and put in place that second set of conditions necessary for the consolidation of the avant-garde as a formation.

Avant-Gardism as Ideology and Strategy

While the Incohérents were unable to draw upon the discourse of avant-gardism in the mid-1880s, they themselves perhaps contributed to its establishment. From the evidence of the titles of periodicals, it would appear that the term 'avant-garde' began to gain currency in that decade. From no more than one or two periodicals, at most, styling themselves avant-garde before the mid-1880s, the number rose to 15 by the end of the decade and 41 by the end of the century, peaking in 1904 at 45, and declining to 18 by 1914.[64] As in mid-century, however, the context and thus the connotations of the term were political: almost all these periodicals declared allegiance to one or another political party. If this widespread currency drew the attention of self-consciously radical or unorthodox artists, such a political inflection also prevented them from appropriating it openly.[65] It would seem therefore that 'the notion of an *artistic avant-garde* became current in the critical vocabulary only *after* this wave of the *political* usage of the term', that is, after 1905.[66]

This conclusion is borne out by the fact that most art critics who made use of the term in the decade after 1905 did so self-consciously, and in ways that signalled its

novelty, enclosing it in inverted commas (Mauclair in 1905), holding it at arms' length (in 1909 Vauxcelles wrote of 'these self-styled avant-garde colourists'), or openly criticising it (in 1911 Roger Allard, the poet and art critic, wrote of 'contemporary painters who are called "avant-garde", in a childishly bellicose metaphor').[67] Indeed, in 1912 Allard, a friend of the salon cubists, confronted the neologism squarely:

> To begin with, what is an 'avant-garde' art? Such expressions have no correspondence with reality. Art is art, quite simply. As regards artists one may if one insists term 'avant-garde' painters whom one could more simply call young or new. Youth and novelty are realities.[68]

Perhaps most tellingly, Allard wrote three articles in the winter of 1913–14 whose specific subject was avant-gardism, a phenomenon that he clearly saw as both recent and an art-market strategy: 'With the help of articles in the press, artfully organised exhibitions, contradictory lectures, polemics, manifestos, proclamations, prospectuses and other futurist publicity, a new painter or group of painters is launched.'[69] He condemned it unequivocally:

> Avant-gardism is not merely ridiculous; it is a plague. In the sphere of painting where rivalries of self-esteem multiply out of a twopenny quarrel, avant-gardism ends in organising, to the profit of the most resourceful, a sort of terror in which the sincere inquirer is no longer safe, where the independent talent is forced to stick to his own territory . . . too bad for those who have no stomach for fairground shows and quacks' displays![70]

That Allard could itemise so specifically the promotional devices of this market-driven avant-gardism indicates that by 1914 both it and the critical response to it that he articulated were well established. His reference to 'futurist publicity', moreover, suggests where he and other critics were inclined to lay the blame for the phenomenon. Marinetti's bold move in publishing his founding manifesto of futurism in February 1909 on the front page of *Le Figaro*, one of Paris's leading conservative newspapers, had attracted widespread critical attention, as much for the promotional coup that it represented as for what it had to say. It offers an obvious point of origin for avant-gardism as a strategy.[71] Its importance as such should not be exaggerated, though: most critics 'simply recognised Marinetti as the noisiest version of a larger domestic practice',[72] one analysed with distaste by Mauclair as a 'prejudice of novelty' in an article published after, but probably written before, futurism's Parisian debut.[73] Also, Marinetti's self-promotional gesture was itself a response to the emerging market conditions. In the free-for-all of a deregulated art market whose centre of gravity was shifting decisively towards the gallery sector, and where Kahnweiler's innovative business methods were raising the stakes of competition, artists without dealers – and writers without publishers – were compelled to elbow their own way to the front of the race for a reputation.

The consequence was a proliferation of self-promotional tactics by artists, of which there were three principal kinds. The first to be developed was the attempt to obtain

a distinctive profile within the salon itself, or in exhibitions that coincided with or preceded these: examples of the former are the *cage aux fauves*, prime position at the 1905 Salon d'Automne, secured by Matisse and his friends with the help of Salon *placeur* Desvallières, and the *putsch* which secured for the launch of cubism Room 41 at the 1911 Salon des Indépendants; of the latter, the miriad *salonnets* and the 1912 Salon de la Section d'Or, the cubist exhibition which ran concurrently with the Salon d'Automne of that year. The second kind of tactic was directed at securing a distinct aesthetic position in the critical debate; hence the proliferation of 'isms' which, as Gleizes later recalled in his account of the 1911 Indépendants, 'would soon multiply according to the will of artists seeking more to attract attention to themselves than to produce serious works';[74] hence too the many artists' statements, position-papers and, at their most ambitious, manifestos – the 'futurist publicity' which Allard deplored. The third kind of tactic was closely related to the second. Between 1900 and 1914 Paris saw a rapid growth in the number of *petites revues*, the often slim, usually ephemeral magazines that served as mouthpieces for those distinct aesthetic positions. More than 185 of these circulated in this period, of which the majority were founded after 1910.[75] Although principally orientated towards literary production and debate – and thus a function of the surfeit of numbers in the writing market – they often carried exhibition reviews and articles on art, offering valuable exposure and support for un- or anti-academic work. Recognising the potential of such publications, artists and writers of the cubist milieux made efforts in 1911 to found their own magazines, eventually producing three between 1912 and 1914 – *Les Soirées de Paris*, *Poème et drame* and *Montjoie!* – which were of primary importance for the dissemination of modernism.[76]

If such avant-gardist strategies were a response to developments in the art market, they – and these – were also functions of wider changes, both commercial and cultural. The years before 1914 saw the first flourishing of the culture of mass consumption and merchandising which had grown exponentially since the late Second Empire. In this forty-year development the distinctive contribution of the new century was in the field of advertising; it was 'the sheer emphasis on merchandising' that marked out the Exposition Universelle of 1900 from its predecessors, the 'new and decisive conjunction between imaginative desires and material ones, between dreams and commerce'.[77] France's first advertising trade magazine, *La Publicité*, was founded three years later.[78] A principal vehicle for advertising's development was the Parisian daily newspaper press, whose rapid expansion in this period, from around two million copies a day in 1880 to four and a half million by 1914, has been well documented.[79] It was chiefly to offer space for more advertising that the Parisian penny papers expanded from four pages to six, and in the case of *Le Journal* to eight and more, between 1895 and 1914.[80] On the eve of the War these newspapers made significant innovations in advertising layout, with the introduction of illustrations, the mixing of advertisements with news and features, and full-page advertisements.[81] At the same time, large-scale billboards, or *panneaux-réclame*, became a common sight in public places; indeed, their omnipresence both in Paris and, following the new motoring public, in the surrounding countryside became the object of a campaign of vilification that led in 1912 to a punitive tax on 'les barre-la-vue'.[82]

The significance of this coincidence of developments in merchandising and in avant-gardist promotionalism was not lost on contemporaries, as Jeffrey Weiss demonstrates. He cites numerous cultural commentaries that both made an explicit connection between them and usually drew negative conclusions from this: 'The critical conflation of advertising and the avant-garde reflects general suspicion of exaggerated claims to originality. Indeed, the very concept of new or original art bore an uncomfortable resemblance to appeals for consumer approval'.[83] Such negative responses did little, however, to check the momentum of avant-gardism; as Charle argues, artists within its compass could dispense with the social judgements of other groups, and rely on self-recognition for their sense of symbolic power. They were the more able to do so in that their avant-gardist consciousness was itself part of a wide and deep response on the part of political and cultural elites across Europe to the establishment and consequences of universal male suffrage in the late nineteenth and early twentieth centuries. On the political level in France it found expression in the growth of anti-parliamentarism on both the right – in the shape of the monarchist Action Française and the anti-Dreyfusard leagues – and on the left in the autonomism of the anarchist and syndicalist movements. Ideologically opposed as these formations were, they shared a rejection of bourgeois society and republican liberal democracy. The current of left autonomism gained momentum after the collapse of the Bloc des Gauches in 1905–06, when many in the politically organised working class embraced syndicalism as they rejected parliamentarism. It was paralleled by a growth in cultural militancy, when many anti-academic artists and intellectuals, correspondingly disillusioned by the failure of solidarist efforts at class collaboration, transferred their vanguardist energies to the field of cultural production.

A good illustration of such transference comes from within the milieu of the future salon cubists and their literary friends, in the activities of Henri-Martin Barzun, Albert Gleizes and others. In 1906 Barzun was, as noted in Chapter 1, secretary to Paul-Boncour and thus closely involved in the establishment of the Comité de la Démocratie Sociale. From this strategic position, he planned to launch a literary magazine, the *Revue rouge*, which would promote 'the literature of the young generation' and 'support a [solidarist] politics of reform'.[84] By the end of the year, however, he had abandoned both his post and his proposed publication and joined the painter Gleizes and four young poets in the foundation of an artistic commune, the Abbaye de Créteil, in the south-eastern suburbs of Paris. Here they hoped to escape from both politics and the city into an aesthetic arcadia. It lasted fifteen months, during which time it was hailed by many in the literary avant-garde as a model, a means of replacing a notion of the collective located in society by one of an anti-social aesthetic elite.[85] When it ran out of steam Barzun moved on, in 1912 giving this aesthetic collective both a more accessible position and a wider horizon by founding a magazine, *Poème et drame*, whose purpose was to 'federate intellectually the young creative elites of the whole world'.[86] In its editorials his rejection of political engagement was stated unequivocally: condemning those 'revolutionary' poets who had become 'unfortunately misled into making social statements [and] who confuse aesthetic research with class struggle', Barzun declared that 'the creative drive

forward can only come from the poetic instinct'.[87] The magazine reserved its highest praise for writers and artists who, eschewing the democratisation of art, addressed the aesthetic elite – a putative collective whose members, he claimed, had become as brothers 'through the anguish, the privations, the dangers of their adventure, through the hostility of the fat cities that exile them, through the hard-won victories that will one day be the inheritance of everyone.'[88]

Such was the bold aesthetic band that had replaced, for Barzun, the alliance of the Bloc des Gauches. The compensatory nature of such a notion is clear: as Raymond Williams observes;

> In and through the intense subjectivities a metaphysical or psychological 'community' is assumed, and characteristically, if only in abstract structures, it is universal; the middle terms of actual societies are excluded as ephemeral, superficial, or at best contingent and secondary. Thus a loss of social recognition and consciousness is in a way made into a virtue: as a condition of understanding and insight.[89]

The milieux of the nascent Parisian avant-garde bore little resemblance to Barzun's ideal fraternity. Yet his elitism was characteristic of them, and his activities contributed to their consolidation. His magazine, and the series of lectures, meetings and banquets that it sponsored in 1912–14 formed important elements of their developing circuits of intellectual exchange, as I hope to show.[90]

For all the autonomism of such artistic elitism, however, and the corresponding disregard of mainstream opinion, neither the avant-garde formation nor its governing ideology stood outside liberal republican society. Not only were its borders ill-defined and porous and its membership heterogeneous, as the affair of Dorgelès's donkey reveals, but its very existence was an expression of the free-market liberalism of that society, indeed – as I have argued – it was in fundamental respects a function of the governmental policies of the Radical Republic. If that liberal individualism sat uneasily with the solidarist nationalism of those governments, the tensions between these elements of Radical ideology were felt also within the avant-garde in the pre-war decade. The presence of foreign artists, dealers and critics in leading positions within its most influential milieux was a salient feature of it, and one which distinguished this formation from other formations and institutions of Parisian cultural production. As the tide of French nationalism rose through the decade it came into conflict with the internationalism and unfettered individualism that this foreign presence brought to its milieux. At the same time as those institutional and discursive factors that I have explored were acting to consolidate the avant-garde, this conflict opened up fissures and fractures within it. It was no accident that Dorgelès gave his donkey an Italian name.[91] To understand both the significance of his gesture for his contemporaries, and its resonance within the avant-garde, we need to map these fissures and fractures, by examining the ideological discourses that structured them.

Chapter 3

Discourses and Debates

Nationalism: Ideologues and Intellectuals

'Nationalism means resolving every question with reference to France. But how to do so, if we have neither a definition nor a common idea of France?' wrote Maurice Barrès as the new century began.[1] At this moment, at the climax of the Dreyfus Affair, the question of national identity was indeed an uncertain one, as supporters and opponents of the luckless officer (and, more importantly, of what he was seen to represent) each fought to establish their own definition as hegemonic. For most of the previous century, nationalism had been an ideological standard of the left. From the Jacobin patriotism of the revolutionary years, through the Commune, to the brief heyday of Gambetta, its universalising mystique had underpinned the unity of France and promoted its civilising role in the world. After the disasters of 1870–71 and the establishment of the Third Republic, however, this revolutionary nationalism was steadily replaced by a nationalism of forces on the right, as first the Boulanger crisis and then the Dreyfus Affair engendered a discourse of revolt against the consequences of republican democracy and liberal capitalism, that took the church, the army and the monarchy as its key points of reference. With the founding of the *Bulletin* (soon *Revue*) *de l'Action française* in 1899 this discourse gained both in coherence and – in the opinion-forming milieux of Parisian intellectuals and students, at least – in resonance, with the result that 'at that moment, *écrivain nationaliste* became more or less a generic term designating intellectuals of the right.'[2] This development was very largely due to the emergence of Charles Maurras as Action Française's leading ideologue.

Maurras came to the nascent grouping with a reputation as essayist and critic. A Provençal, he was a supporter of the regionalism of the poet Mistral and the Félibrige movement; a friend of Jean Moréas and a participant in the promotion of the classical values of his poetic *école romane*, he had written in condemnation of the individualism and 'barbarism' of romanticism and celebrated the rationality, order and rigour of the classical tradition. The translation of these values into explicitly political discourse soon followed: in 1898 Maurras wrote a pamphlet in defence of Colonel Henry, the forger of Dreyfus's treason note, who had just committed suicide, and in 1900 published an *Enquête sur la monarchie* in which he presented his political

philosophy. An amalgam of Comteian positivism, the social organicism of Le Play, literary neo-classicism and regionalist politics, this was new not so much in any of its parts as in the sum of these, in the way Maurras drew together the main strands of nationalist ideology and underpinned them with an argument for a monarchy. 'The desire to preserve our nation of France once postulated, everything follows, can be deduced ineluctably', he wrote. 'If you have resolved to be a patriot, you are obliged to be a royalist . . . Reason requires it.'[3]

If the nationalist movement owed much of its political presence after Dreyfus to the doctrine and programme articulated by Maurras, it was correspondingly indebted for its ethical force to the writings of Maurice Barrès. Between them the two men represented the twin poles of attraction of the nationalism of the right. Where Maurras was its theorist, Barrès has been characterised as its poet;[4] his nationalism evolved not from a carefully thought intellectual system but from the encounter between an aesthetic narcissism formed in the symbolist years of the late 1880s and early 1890s and the anti-republican *boulangisme* of the same period. He elaborated his ideas not, like Maurras, in philosophical essays but principally in a sequence of novels: from his first trilogy *Le Culte du moi* of 1888–91, through the *Roman de l'énergie nationale* of 1897–1902, to *Les Bastions de l'Est* of 1905–09 can be traced his evolution from symbolist dandy to fervent nationalist. Both positions were motivated by opposition to the bourgeois materialism of a liberal capitalist régime that not only crushed the spirit of artistic creativity, but also installed in power 'the aristocracy of the Bourse in place of landed authority', that swept away old collective disciplines and traditions in the name of money, progress and democracy. But in this evolution, Barrès's early celebration of individualism was replaced by a profound collectivism, as he became aware of the extent to which the individual was formed and defined by society and by history. A member of a generation traumatised by the Franco-Prussian War, born and raised in the eastern provinces, Barrès understood both of these terms in specific ways: 'society' was the French nation, its shared customs, territory and communities; 'history' was the succession of its generations through the centuries. Nationalism was thus 'the acceptance of a determinism', that of *la terre et les morts*: 'There is not even liberty of thought', he declared in 1899. 'I may not live but as my dead determine. They and my land command a certain activity in me.'[5]

Between Barrès and Maurras there was much mutual esteem, but also fundamental disagreement, in the first place as to what 'the nation' comprehended. For Barrès, brought up under the shadow of a resurgent Germany and in a region dominated by the sentiment of *revanche* (revenge), it was founded upon the integrity of the *héxagone* that was modern France. 'The nation' included the Revolution and its inheritance, since 'if one is a traditionalist, and submits to the law of continuity, one must take things as one finds them'.[6] It therefore included the Third Republic as well, for all that he railed against its inadequacies: in 1906 he was elected deputy for Paris-Les Halles as a *républicain patriote-libéral*. For Maurras, traditionalism was not so all-encompassing; what was important was to choose the good tradition and reject the bad. The former was founded on reason, and the latter on anarchy. Reason required any nationalist to recognise that the logical embodiment of the concept of the nation

was a monarchy: 'Hereditary monarchy in France is the natural, the rational, the only possible constitution of central power.'[7] The Revolution and its consequence, democracy, were the enemies of order, and the revolutionary tradition was to be rejected.

Secondly, Barrès and Maurras disagreed on the intellectual inheritance of nationalism, and on the significance for it of a doctrine grounded in systematic thought. 'The procedures of regular argumentation give the illusion of scientific method', wrote Barrès in his notebook in 1900, 'but they lead nowhere. Establishing the foundations of the idea of France on logic does not satisfy me; I want them to be founded on feeling.' And he added, referring to Maurras and his circle, 'My friends . . . are more fond of their systems than of France.'[8] There was also a strong element of populism in this anti-rationalism; Barrès criticised intellectuals in general, 'all these aristocrats of thought', for being 'in revolt against their own unconscious', out of touch with the real world of feelings. Against them he counterposed the 'sure instinct' of the 'humble people', of the masses.[9] For Barrès, as historian Zeev Sternhell notes, 'popular judgement was based upon an unreflective spontaneity originating in the unconscious, uncorrupted by long meditations on obscure abstractions'; the *petit peuple* thus stood for him as the authentic guarantor of the identity of France.[10] For their part Maurras and his circle, though they admired Barrès greatly and regarded the novelist's fictional characters as role models for the generation of 1900, saw him nevertheless as too imbued with the spirit of romanticism to be of help in their political work. Maurras's priority was to provide the nation with the institutions it required to survive; Barrès's preoccupation with questions of morality irritated him.[11]

Barrésian nationalism was indeed part of a broad ideological current that owed much to romanticism and the challenge it mounted to nineteenth-century bourgeois society; but there were more elements in this current than romanticism alone. Sternhell has argued that modern France produced two political traditions: one universalistic and individualistic, rooted in the Revolution; the other 'particularistic and organistic . . . often dominated by a local variant of cultural, and sometimes biological and racial nationalism, very close to the *völkisch* tradition in Germany.' This other tradition, he argues, 'launched a general attack on the dominant political culture at the turn of the century, its philosophical foundation, its principles and their organisation'.[12] It was made up of different strands: one, from Michelet via social Darwinism through Renan and Taine, established the racial distinctiveness of national identities; another, nourished by late nineteenth-century developments in psychoanalysis, challenged the mechanistic and rationalist doctrines of positivism and stressed the role of instinct, the unconscious and the irrational in human behaviour. Outside France, the ideas of Freud underwrote the advance of an anti-intellectualist, anti-rationalist and determinist politics; in France, the reactionary and racist doctrines of Gustave Le Bon, author of the bestselling *Psychologie des foules* (1895), drew heavily on this discourse.[13] It was the author of another theoretical bestseller, though, who represented the anti-rationalist current of ideas most famously. Bergson's *L'Evolution créatrice*, published in 1907, brought its author celebrity that was unprecedented for an academic, and gave wide currency to its key concept of *élan vital*.

Born in the same year, 1859, that Darwin's *Origin of Species* was published, Bergson was profoundly affected by the implications of this work. He accepted the historical reality of evolution, but rejected attempts to explain it in mechanistic or materialistic terms. To obtain a true understanding of the evolutionary process, he argued, biology must be supplemented by metaphysics, by a consideration of our own nature as human beings and as typical constituents of the universe. The key to this understanding for Bergson was intuition, which he defined as a 'kind of intellectual sympathy by which one places oneself within an object in order to coincide with what is unique in it and consequently inexpressible'.[14] In the case of ourselves, intuition is an immersion in the indivisible flow of consciousness and of becoming, thus of real duration (*la durée réelle*), 'the continuous progress of the past which gnaws into the future and . . . swells as it advances',[15] and which Bergson counterposed to the conventional, mathematical idea of time. Intuition also makes us aware of a vital impetus (*élan vital*) in ourselves, of our own evolution in time; it thus leads us to the idea of an original impetus (*élan original*) of life that pervades the whole evolutionary process – a process that is consequently creative, not mechanistic.

Bergson's philosophical thought ranged widely; he wrote on free will and determinism, on memory, mathematics and religion, as well as biology. His anti-rationalism, first articulated in his *Essai sur les données immédiates de la conscience* of 1889, had much in common with the symbolist aesthetics of that decade, but it was after his appointment as professor of philosophy at the Collège de France in 1900 that his work gained public acclaim, not only in intellectual milieux but also among the fashionable public of *le tout-Paris*. The term 'five o'clock Bergsonians' was coined in reference to the crowds who packed the philosopher's weekly public lectures. This extraordinary fame has been widely documented.[16] Its general source lay in the current of anti-rationalist thought that was steadily gaining momentum and to which, in turn, it made a fundamental contribution: Bergson's theory of mind, expounded in *Matière et mémoire* (1896), fuelled from the turn of the century both the Catholic revival and the burgeoning interest in the occult, providing as it did a theoretical argument for immortality.[17] A more specific motivation for the popular embrace of Bergsonism was the deeply rooted character of the alternative, organicist political tradition in France identified by Sternhell, for which Barrès was, increasingly after the Dreyfus Affair, the primary spokesperson: Bergson's concepts of intuition, duration and *élan vital* added significant depth and resonance to the central tenets of Barrésian nationalism, in which rejection of the aridity of positivist scientism combined with a revolt against liberal democracy and a nostalgic longing for a mythic community which traditionalism promised to restore.[18] Bergson's critique of rationalism was by its very nature an attack on liberalism's theory of mind and, although there is clear evidence of his own sincere republicanism, 'there is some substance to Bertrand Russell's claim that the main impact of Bergson's philosophy is a conservative one, and that it "harmonised easily with the movement which culminated in Vichy".'[19]

Bergsonism's particular stimulus in the conjuncture of pre-1914 Paris, however, was the upsurge in nationalistic sentiment across a broad political spectrum from the right to the centre-left. As the tide of nationalistic sentiment rose through the pre-war

decade, so did Bergson's stock, along with that of Barrès; the ideas of both men received their most explicit homage in Agathon's *Les Jeunes Gens d'aujourd'hui*, first serialised in the conservative weekly *L'Opinion* in the spring of 1912 and reprinted as a pamphlet in 1913. Not only was this manifesto of strategic sectors of the young generation an influential statement of French patriotism, as noted earlier; more specifically, in its espousal of the cult of action, its moralism and its romanticism it nailed the colours of Barrès and Bergson firmly to its mast.[20]

In so doing Agathon (alias Henri Massis and Alfred de Tarde) took issue with the ideas of Action Française and provoked divisions within its ranks. While they praised Maurras in particular for his intellectual discipline and political leadership, they criticised his nationalism for its royalist exclusivity and its arid abstraction.[21] The Maurrasians thus found themselves in a dichotomous position. As the sentiment of nationalism broadened after 1905 from being the property of the anti-republican right into a patriotism that was claimed by all except the far left, it was the ethical and aesthetic nationalism of Barrès that became hegemonic, rather than the doctrinaire monarchism of Action Française.[22] Yet,

> the theses of Charles Maurras, far from being marginalised, constituted a set of ideas at the very heart of ideological debates, a rallying-point for some and an object of refutation for others; as such, a constant theoretical point of reference. Moreover, in certain literary or student milieux Maurrasism effectively exercised, at the moment of its apogee in the years before and after 1914–18, a dominant influence.[23]

Student milieux in Paris were mushrooming before 1914; between 1875 and 1908 student numbers quadrupled, from just under ten thousand to nearly forty thousand,[24] and as anti-republican sentiment – from boulangisme to the anti-Dreyfusards – increased, so did student unrest. Action Française marshalled this discontent effectively, forming the Camelots du Roi in 1908 to translate its authoritarian ideas into physical intimidation in the streets of the Latin Quarter; by the summer of that year, they appeared to dominate student Paris.[25] 'Faced with a régime that had withstood the crises of the fin-de-siècle and was now secure, the 'nationalists' decided to attack it on another flank, and the student milieux proved in this respect a good terrain for their manoeuvres.'[26]

So too did the literary milieux, and with far greater consequence for those of the avant-garde. Both Barrès and Maurras had begun as men of letters, and literary work remained a primary activity for each. The relation between this and their politics was for each self-evident; Maurras wrote in 1910 of his early development that he

> had seen the ruins in the realm of thought and taste before noticing the social, military and economic damage that generally results from democracy . . . by analysing the literary errors of romanticism we were led, indeed dragged, to study the moral and political errors of a state involved in revolution,[27]

while in *Scènes et doctrines du nationalisme* Barrès made plain his understanding of nationalism as both ethic and aesthetic:

Nationalism is more than merely politics: it is a discipline, a reasoned method to bind us to all that is truly eternal, all that must develop in continued fashion in our country. Nationalism is a form of classicism; it is in every field the incarnation of French continuity.[28]

It is no surprise, then, that literary criticism should have 'represented one of the activities privileged by the men [sic] of Action Française'.[29] In the same year as the Camelots du Roi were formed, and as the *Revue de l'Action française* became a daily newspaper, a group of young Maurrasian writers established the monthly *Revue critique des idées et des livres*. Offering reviews of new books, plays and other literary periodicals, conducting regular *enquêtes* on politics, literature and the relation between them, it became a pivot for the movement; for the next six years it led a neo-classicist, nationalist assault on the literary status quo. Its combative, often vituperative tone galvanised other writers into reply, and ushered in a period of lively polemics and numberless *enquêtes*.

The *Revue critique* was itself a function of the emergence of an avant-garde formation and of avant-gardism, a product – alongside the other two hundred or so *petites revues* of the period – of the surfeit of numbers in the writing market and the marginalisation of the dominated fraction of the dominant class. Both because avenues to literary advancement through the established press, that of the 'right bank', were increasingly constricted, and because the contemporary rage for merchandising and promotion gave them incentive, young writers (and following them, young artists) made their early-career moves in the milieu of the 'left bank' *petites revues*, devoting as much ink to literary polemic, gossip and aesthetic positioning as to the production of original work.[30] The consequence was both an aesthetic debate whose extraordinary complexity and range is reflected in the multiplicity of 'isms' which it threw up, and (fortunately for the historian) the recording of it for posterity.

This debate can tell us much about the preoccupations and ideologies of the communities of avant-gardist artists in Paris – with the caveat that literary and artistic discourse as represented in the pages of the *petites revues* should not be assumed to be identical in character or significance, since specificities of practice, education and milieu differentiated them. The literary and artistic communities were, however, closely connected. Not only did most of the reviews have regular accounts of art exhibitions in Paris and articles on contempoary painting and sculpture, but there was close association between artists and writers, aesthetic ideas and products. This is especially true of the circles within which cubism evolved, both that around Picasso which was based initially in Montmartre and included the poets Apollinaire, Jacob and Salmon, and that of the salon cubists Gleizes, Metzinger, Léger, Le Fauconnier and Delaunay who were close to Mercereau, Romains and Allard in the literary community of Montparnasse. Some of the leading figures of the previous generation of anti-academic artists, moreover, had established influential critical positions for themselves: Maurice Denis wrote regularly for the review *L'Occident* and published a widely quoted, rapidly reprinted collection of essays on art in 1912,[31] while Emile Bernard edited his own review and wrote for several others. Their example may have

contributed to the decision of the salon cubists to launch their own magazine in 1911.[32] Not all reviews were equally significant, of course; the authority and reach that any one of them acquired depended on the stature of its contributors and the breadth of support for its aesthetic position – and that authority in turn gives an indication of the forces shaping this discursive field.

The Debate over Classicism

'A national literature, a renaissance of classicism, from 1908 to 1911 these notions were passionately debated everywhere', wrote Michel Décaudin in his still indispensable survey of pre-1914 literary coteries; he added, 'but they were often mixed with political options that modified at once their meaning and their resonance.'[33] The debate had in fact begun earlier, remarked at the start of 1905 by Camille Mauclair, and evident later that year in the replies of artists and critics to Charles Morice's *enquête* on 'contemporary trends in the visual arts'.[34] Offered a choice between the work of Gauguin, Fantin-Latour and Cézanne as points of reference for contemporary painting, most of the respondents to Morice chose Cézanne, and in terms that were summarised in the reply of the former nabi Paul Sérusier: 'If a tradition is to be born in our time, it is from Cézanne that it will come', he declared, 'not a new art, but a resurrection of purity, solidity, *classicism*, in all the arts.'[35] The next phase of the debate brought the last of these terms into sharper focus. In 1907 a series of articles in the *Revue de l'Action française* by Pierre Lasserre developed the critique of romanticism presented earlier by Maurras, and elaborated in opposition to it a theory of literary neo-classicism that quickly became dominant in the movement. Published separately later that year, *Le Romantisme français* gave, in Décaudin's words, a new basis to literary nationalism; it became the 'bible' for a whole new generation of young critics.[36] It provoked the launch in 1908 of the *Revue critique* and *Les Guêpes*, whose editor Jean-Marc Bernard joined Action Française that year and promoted its monarchism, xenophobia and anti-semitism in its pages.

With Henri Clouard, editorial secretary of the *Revue critique*, Bernard was the driving force of Maurrasian neo-classicism. The former nabi Emile Bernard, also prominent in their circle, wrote a regular column for both magazines: for the *Revue critique* a series of notes on art and for *Les Guêpes* brief aphorisms that encapsulated his position: 'the maintenance of an aristocracy is the moral life of the nation: without aristocracy, all becomes useless: art, piety, virtue, learning; only brute force and money remain.'[37] At the same time he waged in his own magazine *La Rénovation esthétique* 'a battle for classicism and a return to tradition'.[38]

These two terms above all had precise meaning for the Maurrasians, and their efforts were directed at promoting an understanding of them that differed sharply from that of Barrès. Clouard argued that, unlike the latter, 'we are precisely not traditionalists', because 'everything that we detest can be found, and has existed for over a century, in our own tradition'; indeed, 'the classical tradition has no friends more dangerous than the traditionalists'.[39] Barrès's acceptance of the heritage of the

Revolution and of romanticism as constitutive elements of the national past alarmed these neo-classicists, for it attempted an unnatural coalition. The true tradition for them was that which eliminated negative elements of the past and accentuated the positive; most positive was the culture of the seventeenth century, the *grand siècle* of Louis Quatorze, inheritor of the classicism of Greece, Rome and the Renaissance. It was the qualities of order, clarity and rationality that characterised this acme of Latin culture, and that made it the model for contemporary cultural practice.

Barrès's classicism, like his nationalism, was both less reductive and less retrospective. Nationalism *was* classicism: 'it is in every field the incarnation of French continuity', a continuity of tradition and *terroir* that formed the bridge between the living and the dead of France. 'As long as I live', he declared,

> neither my ancestors nor my benefactors will have turned to dust. And I am confident that I will be watched over, when I can no longer protect myself, by some of those whom I awaken . . . Thus I have my fixed points, my markers in the past and in posterity. If I connect them, I obtain one of the principal lineages of French classicism. How can I not be ready to make any sacrifice to protect this classicism that forms my very backbone?[40]

Such a sense of tradition was more open to contemporary initiatives in cultural practice than was that of Maurras, and less sectarian; it accepted into its pantheon the symbolists as well as the parnassians, the impressionists as well as Ingres. Underwritten by the philosophy of Bergson, vulgarised by Agathon and given momentum by the spread of patriotic sentiment, its ascendancy in the literary milieu of the *petites revues* by 1913 was such that it split the editorial group of the *Revue critique*.[41] Moreover, it received an imaginative and impassioned elaboration in the first decade of the century, in the writings of Adrien Mithouard, whose varied activities as poet, essayist, publisher and politician gave him a strategic and influential position in the literary milieux of Paris. Mithouard published his early volumes of poetry in the 1890s, and became involved in municipal politics from the end of that decade, elected to the Paris City Council in 1898; from 1914 until his death in 1919 he was President of it. At the same time he continued his literary activity, founding the review *L'Occident* in 1901 and writing four books between then and 1910 that his friend Morice felt were among the most important of the decade, and that he saw as amounting to 'a summation of nationalism'.[42]

Mithouard followed Barrès in emphasising through all his writing the value of traditions that have stood the test of time, in understanding nationalism as constituted by 'la terre et les morts', and in defining classicism within its terms. 'Continuity imposes itself upon us; we experience time [*la durée*] as a connecting link between works that are successive and interdependent.'[43] Traditions were valuable for this reason, and also 'because the observation of long-established traditions gives greater security to our undertakings and greater force to our actions.'[44] Western civilisation owed its existence to the strength of its traditions, for it was by means of them that it was able to withstand outside pressures, and to absorb outside influences without loss of integrity. France was the centre of this civilisation by virtue of its Celtism ('the

modern world has become Breton, and is proud of it', he declared in 1904),[45] its chivalry which had given Europe its sense of honour and, perhaps most important of all, its cathedrals which had given Christianity the definitive form of its church. It was the cathedrals of the Ile-de-France that embodied most clearly for Mithouard the Western classicism that he celebrated, a classicism that was ordered temporally rather than spatially, and was governed by realistic principles of utility and economy rather than abstract concepts such as reason and harmony. The cathedrals had lasted because they had been built according to time-tested constructional principles, there was no wasted strength in them; mindful of the need for a cathedral to withstand the hostile climate of this land, the medieval architect 'was concerned less to perfect the silhouette of the work than to calculate its structure correctly'.[46] And in general, 'our works are full of Time [*du Temps*], since our tradition has always been to conquer it without force and to embrace it without weakness'.[47] It was traditions such as those of realism and mastery of materials that were the patrimony of the French artisan and had enabled French culture both to resist the more pernicious aspects of the Italian Renaissance and to adapt other aspects of it to its own requirements. Poussin, whose mastery of architectural equilibrium also epitomised French classicism, 'demanded no more from the Eternal City than one thing: serenity, and that method which he needed to direct with sureness a lively genius'.[48] In the work of Ingres, the harmony of the art of Raphael was wedded to a solid sense of realism: 'truth above all was loved and sought . . . as a base for relentlessly reasoned compositions, as a reliable and stable ground on which to build works that were visibly composed, ardently systematic, raised in defence against Time.'[49]

The specific characteristic of French classicism for Mithouard, then, was that it combined two fundamental qualities: a sense of realism, which accepted the action of time upon things and 'which passionately holds works up to the world', and a sense of harmony and stability, 'which contains them within the outline of its forms'.[50] The great achievements of Western (for which read French) civilisation were the product of an equilibrium between these qualities; an equilibrium that, when attained, integrated a work and its creator into the order of the universe, but which was elusive and impermanent. For Mithouard, as Morice wrote of him in 1914, it was

> this innate sense of order that gave our ancestors their great collective works, such as those secular undertakings the cathedrals, which employed an entire populace of clerks and artisans; for it kept each skill in its place, imposed on all elements an awareness of the whole, and subjected the work of every hand to the commandments of the spirit.[51]

Such a community, unified by its sense of order, no longer existed, argued Mithouard; in the post-Dreyfus, post-Bloc des Gauches decade the equilibrium of French classicism had been replaced by polarity; like a drop of acid in a retort, the Dreyfus Affair had separated France into what he termed an 'irreconcilable dimorphism'.[52] It was now imperative, he insisted, to put back 'order into our spirit, unity into our labours', it was vital 'not to allow our traditional understanding of materials, nor our sense of grace and rigour, to be lost or weakened.'[53]

Mithouard's elaboration of Barrésian nationalism into a broad and inclusive definition of classicism gave it a reach that went beyond the circle of self-conscious literary nationalists of the right. André Gide and friends, launching in 1908 the magazine *La Nouvelle Revue Française* (*NRF*), which quickly gained a leading position in the French literary world, chose *L'Occident* as their model. Despite their declared intention of avoiding the political and religious colouration of the latter and adopting a policy of political impartiality, their editorial position repeated much of its emphasis.[54] Criticising the neo-classicists in three articles of 1909, Gide questioned their narrowness in clearly Barrésian terms, arguing that it led to the stifling of any vitality; against this, he proposed an attitude of openness towards new work (to which the magazine's record of publication in its early years was to be a testament), balanced by an insistence on disciplined and finished compositions: a 'modern classicism' that maintained an equilibrium between order and vitality.[55] Echoing Mithouard's equilibrium between realism and reason, this position accounted in large part for the authority that the *NRF* soon acquired; it allowed for differences of emphasis between editorial group members and support for work that was as far apart as that of academic painting from cubism.[56] In general, however, the range of attitudes and aesthetic efforts supported within the *NRF* group was narrower than this: if academic art was rarely given approval, its artistic centre of gravity was equally far from cubist experimentation. The magnetic attraction of the twin poles of literary nationalism, and in particular the noisy polemicising of the *Revue critique* and other Maurrasian reviews, from the beginning drew Gide and associates towards the political right. The first two years of the *NRF* revealed a consensus around Catholic, nationalist and even anti-semitic attitudes: indeed, 'the *NRF* began to show such patriotic ardour' writes its historian, 'that one wonders if it was being mischievous about it.'[57]

An equivalent position in the field of art criticism to that of the *NRF* in literature was held by Maurice Denis, a close friend of both Mithouard and Gide and a contributor to the review. In the decade before 1914 Denis was an influential figure in the Parisian art world: as an artist, he was a former nabi and much sought-after painter of decorative murals; as a teacher, he joined the staff of the Académie Ranson soon after its foundation in 1908; most particularly, as a theorist and critic, his reputation was established at the age of twenty in 1890 with his 'Définition du Néo-Traditionnisme', and by the time of the publication of his collected essays in 1912, he had few rivals in the field. His espousal both of a classicist aesthetic and, from 1904, of the cause of Action Française was thus of significance.[58] Denis's classicism was consistent with his politics in its apparent Maurrasian character. Provoked by visits to Tuscany and Rome in the 1890s, he declared his commitment to an aesthetic embodying the order and rationality of the Latin tradition, praised contemporary neo-classicism for its 'truly French qualities of precision and clarity',[59] and wrote favourably of Maurrasian integral nationalism in his keynote article of 1909, 'De Gauguin et de Van Gogh au classicisme'. He also noted in the article the current vogue for these values, and quoted from Apollinaire's review of the Braque show at Kahnweiler's gallery in November 1908 the poet's endorsement of 'an art that is more noble, more measured, better ordered, more cultivated'.[60]

There was order and order for Denis, however, as for the *NRF* circle. He criticised the painting of Matisse for its excess of rationality; 'the desire to rebuild art anew with reason alone must be renounced', he argued *à propos* Matisse's notorious contribution to the 1905 Salon d'Automne: 'We must put more trust in sensibility, in instinct, and accept without too many scruples much that past experience can offer. A recourse to tradition is our best safeguard against the dizziness of reason, against an excess of theory.'[61] Such distinctly Barrésian sentiments were in keeping with other emphases made by Denis that echoed closely those of Mithouard, on the unjustly overlooked qualities of some fifteenth-century frescoes in a Breton church, on the need for art to return to that alliance between traditionalism and realism which these displayed, and for artists to show vitality above all. 'What makes a renaissance', he declared, 'is less the perfection of the models chosen than the strength and unity of ideal of a generation full of vigour.'[62]

Denis's example, like that of Mithouard in the field of literature, showed how responsive Barrésian nationalism could be to contemporary aesthetic initiatives, and it was soon followed. While Apollinaire's endorsement of classical qualities in Braque's early cubism remained unspecific, in three articles of 1910–11 Roger Allard constructed on nationalist foundations an argument in support of emergent salon cubism that brought classicism and Bergsonism explicitly together. The classicism was not entirely Barrésian, it must be said. The traditional values that Allard sought to encourage in contemporary painting were those that stood firmly opposed to the aesthetics of impressionism. Like the literary neo-classicists, he looked to the *grand siècle* of Poussin and Lorrain whose example Cézanne had followed and from whom in turn the painters whom he supported had learned: 'There is thus being born, at the antipodes of impressionism, an art which . . . offers to the intelligence of the spectator the essential elements, in all their pictorial plenitude, of a synthesis situated in time.'[63] As this reference to time (*la durée*) indicates, there was more to Allard's classicism than Maurrasian doctrine. Elaborating his ideas over the course of the three articles – and presenting as he did so the first philosophical justification for the experimentation of salon cubist painting – the critic developed an increasingly Bergsonian understanding of cubist devices such as the fragmentation of forms and the use of multiple perspective, and applied this to the masterpieces of the classical tradition. It was, for example, the balance that Poussin achieved between the dynamism of his figures and the stasis of his compositions that gave his paintings a living beauty, one that was beyond the reach of the formulae of neo-classicism and must be intuited rather than analysed. 'Thus to love the living work for the vital forces that are in it', Allard argued, 'is to understand and possess nature, since by an act of genius a human thought has known how to contain it whole.'[64]

In this way Allard sought to reconcile the burgeoning interest of the cubists in the dynamic possibilities of both Bergsonian philosophy and modern life with the imperatives of the classical tradition. In so doing he provided a bridge between the modernism of the salon cubists and the conservatism of Barrésian nationalism, extending the hegemony of the latter into a milieu that until then had been indifferent to explicitly political argument, and offering the former the means to relate their avant-

gardist painterly preoccupations to their awakening response, as French men and women, to the nationalist call to order. That some were ready to is clear from the spate of articles in which Gleizes sought to explain cubism to the public in late 1912 and early 1913. Echoing the main themes of Mithouard and Barrès almost to the letter, Gleizes laid claim to a 'pure' French cultural tradition that ran from the gothic, through Clouet, de Champagne, Ingres and Delacroix to the modernists, in an argument that excluded the Renaissance as a foreign import and celebrated 'our ancient Celtic origins' with a nationalistic enthusiasm that became more strident with each pronouncement.[65]

From the right-wing literary activists of Action Française to the most experimental painters, therefore, there was among certain milieux of writers and artists within the avant-garde formation of the pre-war decade a common adherence to nationalism and the classical tradition, however varied the meanings ascribed to these terms. It is, moreover, evident that the Barrèsian and Mithouardian vision which many of these shared – of an organic society cemented by artisanal and rural traditions and skills, in which each element had (and by implication kept to) its place, to the greater glory of the nation – coincided with that described, and deployed to his considerable political advantage, by Aristide Briand in 1909. For the mood of pessimism and sense of loss of community were felt by many French men and women in the first decade of the century, and Briand's articulation of a mystique of social solidarity rooted in national identity drew heavily on those anxieties about the destabilising effects of economic modernisation that haunted the work of both Barrès and Mithouard. But what distinguished this nationalism of the right, crucially, from solidarism was the centrality of tradition understood as a constitutive order, and as counterposed to the idea of progress. Briand's faith, declared in a keynote speech of 1909, in the existence of that 'beautiful country of the future' to which solidarism pointed the way, had been mockingly anticipated five years earlier by Mithouard: 'Do they not look ridiculous, all those emphatic advocates of progress, marching drunkenly to who knows where, sparing not a thought for the beauty of the times that they leave behind?'[66]

Such an adherence to the constituting power of tradition and the concomitant (if less generally explicit) hostility to the cultural consequences of modernity functioned as the dominant discourse in that avant-garde; we can call it that of traditionalist nationalism. The double emphasis within this discourse around which the debate over classicism turned, upon Graeco-Roman and Gallic tradition, is indicative both of those aspects of the contemporary cultural and social order that each participant in the debate sought to defend, and of what each saw as the principal danger to this. For all the differences between Barrésian and Maurrasian positions, there was implicit agreement that the present situation posed a threat of some kind to a social hierarchy whose preservation was imperative, and that such preservation entailed a firm commitment to traditional values. As a discourse, traditionalist nationalism provided a sense of identity for certain groups within the avant-garde, by which to distinguish themselves from others. As nationalist sentiment broadened after the 1905 Moroccan Crisis, however, its authority was challenged, both explicitly and implicitly, by a

discourse in which the notions of tradition and progress were in alliance rather than conflict.

The explicit challenge was presented in an article in January 1905 by the critic Camille Mauclair, 'La Réaction nationaliste en art'. He tellingly criticised the contemporary vogue for classicism that he saw in all the arts for its snobbery, cultural conservatism and aversion to democracy ('a love of M. Ingres, of Rameau, of the *Schola [Cantorum]*, of regular verse, of pastiches of Greece or the 17th century, goes together unfailingly with reactionary opinions. It is all a matter of "good behaviour"'[67]). Mauclair condemned in particular the 'wretched interference of political nationalism in questions of art', and argued that 'it is the absurd question of race and the search for origins, over which politicians and artists are equally pretentious, that is the cause of all the evil'.[68] 'Everywhere', he complained, 'the reactionary impulse betrays itself: the need to "trace things back to their origins", the anxiety to be "French", as if to be French were to deal in pastiche and to retreat.'[69] Against this retrograde obsession with the past Mauclair offered an alternative that, ironically, repeated some of its emphases, a 'licit and necessary nationalism' that had strong Barrésian accents. 'Our classical culture', he declared,

> is French tradition, and French tradition is contempt for classical pastiche, it is the defence against the Greeks and the Romans, it is the springing of the native sap, of clear-sighted and sensitive realism overturning pedantry and academic dogma.[70]

Yet he at once distanced himself from traditionalism by outlining an aesthetic that embraced the modern world:

> I remain convinced that there is a wholly new beauty to discover, quite distinct from that which satisfied us yesterday, that to recoil from it would be wrong; that the true French tradition is to go ever forward, to love the future . . . if science and social transformation offer us a new ideal, let us regard them with love, and leave the past to become silently a part of history. If an artist admits even for a moment that he is not, before anything else, working to build a new world, he is consenting to moral suicide – and it is this suicide that nationalism is offering.[71]

The aesthetic that Mauclair sketched here was one of the first statements in this period of a nationalism that balanced an attachment to tradition with an acknowledgement of the economic and political forces of the modern world in which France as a nation state had to exist and compete.

In this it was in close accord with the doctrine of solidarism that was fundamental to the politics of the radical Republic, indeed its 'official philosophy', as a 1905 commentator observed.[72] It was noted earlier that the programme of solidarism and its Radical ministries was dictated by a concern to accommodate French social and entrepreneurial customs to the expansionary demands of capitalist modernisation, to moderate but not negate the latter in the interests of social peace. I argued that a shared commitment to solidarist ideology also underpinned the efforts of the liberal bourgeois intellectuals who participated in the spirit of the Bloc des Gauches through the educational initiatives of the *universités populaires* and the *art social* movement.

With the collapse of the Bloc in 1905–06 many of these initiatives foundered as their working-class members withdrew inside the stockade of syndicalism and, as union militancy and strike action mushroomed in the five years that followed, those efforts that could still be promoted without such members were left to continue the work of republican defence. For these reasons a debate developed after 1905, both within and outside the uncertain boundaries of the avant-garde, on a question that, like classicism for traditionalists (and in implicit challenge to it), focussed on a single issue, and brought together a wide-ranging set of discourses: of tradition and progress, patriotism and democracy. For solidarists and their fellow travellers, the question was that of the decorative arts.

Nationalism and the Decorative Arts

Interest in the decorative function of art had been growing in France since the 1890s (and is once again the focus of scholarly attention[73]); Maurice Denis saw the fin-de-siècle as a period when the word 'decorative' became 'the *tarte à la crème*' of discussions among artists and even among their fashionable followers.[74] The interest had two main components – the notion of painting as decoration, and a concern for the status, social role and condition of the decorative arts in France. Engendered by the art education reforms and mural painting commissions of republican governments of the 1880s,[75] nourished by the rococo revival of the 1880s, synthetist aesthetics and the revival of the tradition of the *paysage décoratif*, decorative painting was widespread enough by 1910 for the painter Jacques-Emile Blanche to describe the students at the academies where he taught as obsessed with the idea of decoration, and for the critic Arsène Alexandre to complain that contemporary art was 'almost exclusively decorative'.[76] Art historian Debora Silverman has shown how in the 1890s the Union Centrale des Arts Décoratifs campaigned for a return to the tradition of the *ancien régime* in which aristocratic women had a leading role in the decorative arts. The Union sought to establish an alliance between bourgeois luxury craft makers and artisanal craftswomen, as part of an effort to confront the phenomenon of the *femme nouvelle* by co-opting those aspects of French feminism that could be reconciled with prevailing republican patriarchical relations by emphasising women's role as homemakers.[77] This campaign reinforced a gender division that already existed in art education, whereby young women with artistic aspirations had access only to the Ecole Nationale de Dessin pour les Jeunes Filles, where they were taught to be decorators or craftswomen, since the Ecole des Beaux-Arts, the main route to a fine art career, was closed to women until 1897.[78]

In this context, the theorisations of the decorative in that decade by writers such as Aurier and Denis represented an attempt 'to salvage it from [these] derogatory connotations'[79] for the purposes of synthetist painting. The attempt was successful: Matisse developed its reworking in his *Notes d'un peintre* of 1908, giving it a cardinal role in his aesthetics; and, as critics noted, decorative panels featured prominently in the salons of the period: many had been commissioned by leading collectors or

members of fashionable society (such as Misia Godebski, wife of the *Revue blanche*
publisher Thadée Natanson and arbiter of élite taste), whose association gave such
painting added prestige.[80] The arrival and immediate social success of the Ballets
Russes in 1909 provided the ultimate accolade. Observers noted that Diaghilev's
company brought productions whose set designs, overwhelming in their richness of
colour and materials, shared the anti-naturalist aesthetic of those made by the nabi
artists for Lugné-Poë's Théâtre de l'Oeuvre, and that painters such as Denis greeted
them with enthusiasm, while attendance at a Ballets première soon acquired a social
cachet of the highest order for *le tout-Paris*.[81] When Misia Godebski established
herself as the 'queen' of the Ballets Russes, thereby linking the artistic achievements
of one circle with the social renown of the other, the decorative aesthetic had clearly
arrived.

Fundamental to both the programme of the Ballets Russes and its decorative
schemes was orientalism, a site of fantasy for much nineteenth-century European
culture, a 'field of free play for shamelessly paranoid constructions, dreamlike
elaborations of a succession of western traumas'.[82] In productions such as *Cléopâtre*
of 1909 and *Schéhérazade* of 1910, the premise of the otherness of the orient was the
vehicle for the Ballets' decorative excesses. In the context of the imperialist scramble
for Africa, orientalism, like primitivism, underpinned the *nationalisme d'expansion
extra européenne* that fuelled French excursions into Dahomey and the Congo, as
well as the European perceptions of African social custom that legitimised such
ventures.

After the first Moroccan Crisis, similar paranoid projections of otherness, in this
case focused on Germany, were fundamental to the second component of the deco-
rative discourse – concern over the international competitiveness of France's decora-
tive arts industries. The recognition of French decline had been dawning in the
aftermath of the 1900 Paris Exposition, as a spate of international exhibitions during
the next decade (in Turin, Liège, London, St Louis, Milan and elsewhere) revealed the
progress made in other countries.[83] The perception was sharpened by the exposure of
representatives of French craft industries to the work of their Bavarian counterparts
at the 1908 Munich Ausstellung: this, they found to their surprise, was well designed,
modern and skilfully executed. One report concluded with dismay, in a phrase that
would be echoed by many, that France was about to lose the war with Prussia all over
again, but this time on the economic front: 'the Sedan of commerce with which we
have been threatened for so many years is no longer to be feared', reported the
furniture maker Rupert Carabin to the Paris City Council, 'it is a *fait accompli* and
we must play our part.'[84] The professionals' surprise grew into widespread critical
alarm when this work was exhibited at the 1910 Salon d'Automne in Paris. The
largely negative, and in many cases profoundly chauvinistic, responses launched a
press campaign against consumer products made in Germany whose level of vitriol
rose each year with the tide of patriotism, reaching its flood after the second
Moroccan Crisis in 1911.[85]

A significant difference between this harnessing of the decorative arts industries to
a political agenda and that of the 1890s was the lack of explicit gendering of

decorative arts practices: in contrast to the Union Centrale's campaign, reference to their 'feminine' character was conspicuous by its complete absence from the later debate. This is not to suggest that its connotations were free of gender, but that decoration and its associated industries were now a male province – not only, as a synonym for 'abstraction' or 'expression', a central concern of technically radical, avant-garde painterly practice, but in economic and occupational terms, a field of activity that men could not afford to leave to women. The threats posed to male employment and wage rates by the entrance of women into traditionally male trades, and to the national economy by the German example required the re-masculinisation of the decorative arts.[86] As recognition of the latter threat dawned, support grew for positive initiatives: from 1907 politicians began to call for an exhibition of decorative art in Paris, to showcase but also to stimulate domestic production and innovation.[87] When in January 1909 the well-connected arts bureaucrat and respected critic Roger Marx published a keynote article adding his weight to it,[88] this campaign gathered momentum with a speed that indicates the breadth of concern over the issue. By early 1911 three of the leading decorative arts associations – the Union Centrale des Arts Décoratifs, the Société d'Encouragement à l'Art et à l'Industrie and the Société des Artistes Décorateurs – had joined in formally adopting the project, making broad suggestions as to the shape it should take and establishing a *commission d'étude* to develop detailed proposals.[89] Two months later the *commission* presented its report, written by the president of the Société des Artistes Décorateurs, René Guilleré, this time in the name not only of these three associations but also of other leading arts bodies, including the Société des Artistes Français, the Société National des Beaux-Arts, the Salon d'Automne and the Union Provinciale des Arts Décoratifs, as well as more than fifty individuals from the decorative arts establishment.[90] It thus represented a broad consensus of opinion, and carried enough weight to be taken seriously by politicians of all parties; its arguments were repeated in Chamber debates over the following year, and received formal all-party support in a vote of July 1912.[91]

There was broad consensus also on the reasons for the malaise of France's decorative arts industries. Its causes, as noted earlier, were largely structural, in particular the mechanisation of production, the growth of department stores and the consequent change in relations of production. But these factors were overlooked in favour of such as were more susceptible to remedial action by government or other agents. Primary among identified causes was the conservatism of French custom, in both commercial practice and matters of taste. Following up his broadside against cultural conservatives of 1905, Mauclair published the following year a harsh critique of their entrepreneurial counterparts in the decorative arts industries, charging the commercial interests who dominated the Union Centrale with snobbery and hostility towards modern products, venality and timidity in their business practices. It was easier, more socially acceptable and more profitable, he suggested, to order copies of styles from the *ancien régime*, pastiches of former glories, than to commission new work; but it led the artisan to abandon creative initiative, and the public to assume that there was no modern French style.[92] The argument found echoes elsewhere: 'we no longer invent, we inventory', declared Roger Marx in January 1909, marking in a neat

phrase the difference between solidarist and traditionalist nationalism; obsessed with the past, he argued, French decorators risked disqualifying themselves from international competition.[93] Replying to an enquiry into the crisis in the decorative arts – itself symptomatic of the widespread anxiety – Marx insisted that their renewal 'is an economic as much as an aesthetic imperative . . . the French genius knows no other alternatives than, in the words of Michelet, "to invent or to perish".'[94] Others, including Louis Vauxcelles[95] and Joseph Paul-Boncour[96] took up the refrain, and it found its most authoritative expression in the 1911 report of the *commission d'étude*, where it occupied a central place: the *leitmotif* of Guilleré's assessment of the industry was that manufacturers were largely to blame – for bypassing skilled French artisans in favour of machine-made furniture components purchased abroad, and for endlessly copying past styles.[97]

Most of these calls for a renewal of modern decorative arts were accompanied, however, by criticism of art nouveau, for an excess of modernity – what G.-Roger Sandoz of the Société d'Encouragement à l'Art et à l'Industrie in 1913 called its 'macaronic exaggerations'[98] – that was also implicitly understood as gendered. In 1909 Mauclair returned to the fray, criticising the rage for renewal of decorative art for having resulted in a 'hysterical, comical, lamentable, useless style . . . pretentious and fantastic trash whose obsolete models the Faubourg St Antoine now revels in'; like several others, he condemned art nouveau as a false start.[99] More moderately, in his report to Parliament in July 1912 on the exhibition project, the Socialist deputy Roblin noted art nouveau's efforts to escape the past but criticised its excessive search for originality, which was not in the French tradition.[100] This was the key: true renewal, the establishment of an authentic modern style, meant not abandonment of, but reattachment to, traditional aesthetic values. The question was, which ones?

The answers varied; some, such as Denis (responding to Roger Marx's proposal for an exhibition), and the young critic and friend of the cubists André Véra, echoed the Maurrasian argument of the classicism debate in their call for a return to the example of France's *grand siècle* and their corresponding contempt for democracy.[101] The majority, however, understood tradition in populist rather than elitist terms; thus Mauclair (again early into the field), argued in September 1905 that the source of the greatness of French art lay in 'the people . . . [since] everything came from it: gothic figures and choir stalls in the fourteenth century, tapestries, brasses, Louis XV and Louis XVI furniture. It was that admirable people of the guilds who kept alive the gift of French perfection in the times of foreign invasion.'[102] Frantz Jourdain in 1909 criticised decorators for having been 'hypnotised by luxury objects and having completely forgotten the French people'; 'there will inevitably come a day', he stated,

> when we will shake off the lethargy from which we are suffering and will regain the noble and logical tradition of the French race, the tradition of good sense and truthfulness that, in every age and each time with a new vision, has given birth to masterpieces.[103]

The same year the critic Paul Gsell declared that the decorative arts were 'the emanation of the collective sentiment of the French race', reflecting more faithfully

than did the fine arts 'the soul of the nation from which they issue'.[104] In his Salon d'Automne catalogue preface in 1910 the critic Léon Werth appealed to the sense of harmony, simplicity and rationalism of the native tradition, while in his 1912 report to the Chamber on the state of the decorative arts, Deputy Roblin spoke up for artisanal virtues, for the characteristics of the 'healthy French tradition' of fitness for purpose, order, measured grace and charm.[105] Once again, though, it was Roger Marx who in his article of 1909 voiced this populist understanding in terms that were most widely quoted:

> When an art is intimately joined to a society's collective life, only the designation *art social* is appropriate for it. The prerogative of its inventions cannot be limited to a single class, for it belongs to all without distinction of rank or fortune; it is the art of the hearth and the garden city, of the castle and the school, of the precious jewel and of peasant embroidery; it is also the art of the soil, the race and the nation.[106]

This statement is significant for more than its resonant rhetoric. In its final phrase it pointed clearly to Barrésian nationalism; implicit in the populism voiced by others, this was a discourse whose accents and emphases shaped much of the decorative arts debate. But within this, Barrès's anti-intellectualist populism was given a new twist: it was argued by many that the decline of the French decorative tradition began when the Italian Renaissance was imported and the arts were divided into high and low, continued with the establishment of the Académie in the seventeenth century and was completed by the suppression of the guilds in 1791. In this narrative the principal villains were the monarchy, the aristocracy and the academic apparatus, and the heroes were the artisans and the common people.[107] While such characterisation was consistent with Barrésian doctrine, its politics were more explicitly republican, indeed self-consciously solidarist, as is confirmed by the customary use of this argument to condemn the contemporary hierarchical distinction between fine and decorative art, and to call for its abolition.[108] The policy of fostering the 'unity' of the arts was upheld by Gambetta's short-lived government in the early 1880s, in an attempt to dismantle the Academy and its anti-republican influence.[109] Although the reforms had been abandoned with Gambetta's fall, the perception that these cultural hierarchies were obsolete had been given momentum by the decision of the Société Nationale des Beaux-Arts to allow the exhibition of decorative art in its salons from 1890, and sharpened by that of the young Salon d'Automne to end the distinction between types of art in its catalogue from 1906. By 1911 it had been reaffirmed as government policy.[110]

Marx's association of a range of art practices under the umbrella term of *art social* itself indicated his commitment to such a policy,[111] but his allegiance to solidarist cultural politics was signalled more clearly in other ways. One of these was his emphasis on the values of rural craft traditions. This reflected the Radical party's turn to the countryside; through the mediation of Radicalism the message of *art social* thus reached as far as the peasantry, and some significance has been seen in the coincidence between Marx's espousal of rural traditions and Briand's politics of rapprochement

between peasants and urban workers.[112] Yet this emphasis was balanced by Marx's insistence on the need to seize the opportunities offered by technological development to modernise the decorative arts industries. Against those traditionalists who argued for the retention of craft skills and opposed mechanisation, he energetically advocated both the adoption of machine production alongside handicraft and the division of labour that it permitted, as promoting at once the fullest development of workers' faculties and their harmonious orchestration in a common task.[113] It is significant, too, that in his definition of decorative art as *art social* his chosen examples of its practices encompassed not only all classes but also, if less explicitly, both sexes. If the idea of an art 'intimately joined to a society's collective life' was to be a means to moderate both inter-class conflict and the crisis in these industries, it could no longer be seen as exclusively feminine, domestic and traditional in character, but as part of the modern, masculine world of mechanised production as well. The balance between the traditional and the modernising was crucial, as Marx demonstrated with another example: against the claim that progress was destroying the particularity of each region of France, he insisted that the reverse was the case: improvements in transport, by giving easier access to all regions, had fostered a familiarity with their characteristics that in turn had only strengthened appreciation of rural and popular industries.[114]

Such judicious modernisation was in turn a means to the fundamental solidarist goal of social peace that, as I have suggested earlier, motivated many of the *art social* initiatives. Marx's use of the term signified his commitment to the cultural paternalism that the movement represented. In his case the commitment was longstanding; from the mid-1890s he had argued for initiatives such as *musées du soir*, museums for the workers that, by showing them the art of Daumier, Millet, Steinlen and other recorders of their labours, would teach them a language other than that of the strike. The call was repeated, generalised to include the gamut of *art social* initiatives, in his last essay. Marx regretted that as yet (in late 1912),

> apart from a few perceptive minds, no one has calculated the prudence and utility of ensuring that it is noble pretexts that capture the enthusiasm of the masses, that they be encouraged to honour genius, to glory in their labour and find peace of mind in their common tasks.[115]

It was an attitude of wariness towards the working class that this argument reflected, a wish to see it take up – and keep to – its proper place in an ordered republic (or as solidarists preferred, an organic society). The purpose of the democratisation of art was, by 1912, plainly not to defend the Republic against the elitism of the right so much as to safeguard those social privileges that it consecrated from the threat posed by socialism and syndicalism. Others voiced the wariness too, rarely as eloquently as Marx but perhaps more revealingly as a result; thus Vauxcelles, arguing in 1910 that the restoration of pride in craft skills that could revive the decorative arts was in the hands of the *syndicats*, but complaining that these cared only for the rights of the worker and nothing for his or her duties.[116] This was how the enthusiasm for class collaboration that had fuelled the Bloc des Gauches turned to disenchantment on the

part of many of those liberal bourgeois who had welcomed it – a disenchantment that was to be reciprocal.

The debate over the decorative arts was thus complex and wide-ranging, and one that articulated the interrelated responses of cultural producers, critics, politicians and entrepreneurs to anxieties stemming from the international and inter-class tensions of the moment. The significance for us of these responses lies chiefly in their interrelationship – the particular combination of a deep attachment to tradition with a recognition, of a certain kind, of the economic imperatives that modern capitalism imposed; of demands for social justice and a democratic society with concern for the preservation of the existing social order. What united these apparently contradictory attitudes, drew them together as components of a single discourse, was their common anchorage in the solidarist doctrine of organic nationalism. It was this also that made it a dominant discourse, complementing but also contesting the authority of traditionalism in and outside the avant-garde formation; framing and shaping avant-garde practices as it did the policies of the Radical government.

The avant-garde was also, however, one of the primary sites of resistance to burgeoning pre-war nationalism. There were two reasons for this, as noted before: first, because of the many foreigners in its milieux, particularly after the influx of visitors to the 1900 Exposition. From the little coteries of Montmartre, and the Montparnasse colonies of East European exiles, to the cosmopolitan network of dealers and collectors – Kahnweiler and Uhde, Shchukin and Morozov, Kramar, the Steins, to name a few – and the international clientèle of the academies (including that of Matisse), there was little incentive to endorse French nationalism. Second, because the collapse of the Bloc des Gauches and all it entailed left many of those French artists and writers who had participated in it with little appetite, for social or political intervention of any kind, as I argued, and heightened their sense of alienation from the concerns of the bourgeois republic. For émigré members of avant-garde milieux, self-referentiality and isolation encouraged the notion of the artist as necessarily estranged.[117] For those whose attempts at class collaboration ended in disillusionment around 1905, the idealism that had driven those attempts was transferred, as I noted earlier, to the field of aesthetic practice, and the comradeship of such collaboration was replaced by that of artistic avant-gardism. For both, resistance was grounded in the values of art in and for itself, as the product of a necessary estrangement, or as uniquely free from commodification and mediocrity. This was the resistance of aestheticism, and it took the form of a counter-discourse, through which the force of the dominant discourse of nationalism was refracted, transcended or simply negated.

Aestheticism

In the last weeks of 1906 a group of young men of the middle class, each of whom had begun to fashion a career for himself in that border country between the artistic avant-garde and the liberal professions, and all of whom had participated to a greater

or lesser degree in the extra-parliamentary adventure of the Bloc des Gauches, set up a commune in a country house and park on the banks of the Marne at Créteil, a few miles south-east of Paris. Henri-Martin Barzun, as we know, was an apprentice politician; Albert Gleizes, a painter; Alexandre Mercereau, René Arcos, Charles Vildrac and Georges Duhamel, all writers.[118] Since it was founded at the end of a decade which saw the establishment of so many anarchist communes in France, it is understandable that the Abbaye de Créteil should have been taken by historians to be another such; it was, however, something altogether different – a flight from politics and the urban world, motivated by a desire to escape not the ills of capitalism but the constraints of market forces.[119] Its prospective members wished to be free to work full-time at their arts instead of squeezing them into the hours not taken up by earning a living. Their decision to instal a printing press and to work on it for a proportion of each day derived not, as in the anarchist communes, from a belief in the moral worth of manual labour, but from the need to secure their subsistence; to this end they asked a printer, Lucien Linard, to join them. Although the Abbaye, like those communes, was a refuge 'from the world of utility and of economic struggles',[120] it was a refuge for an elite only; the group dreamed, as their appeal for support testifies, of 'an abode too high and vertiginous for the impure, where we shall be free from shallow society'.[121] Little in the ideas of the group had any relation to anarchism, and despite the subsequent recollections of Gleizes and Mercereau which portrayed it in political terms,[122] the Abbaye was not a *milieu libre* nor, as Barzun pointed out in an article written at the time, were the others even aware of its predecessors. It seems, indeed, that they held him in low esteem for being politically active.[123]

During the fifteen months of its precarious, impecunious existence the Abbaye was widely fêted in the milieux of the Parisian literary avant-garde, and frequently visited by their adherents. As a withdrawal from the quotidian world of the cash nexus into one of artistic freedom (albeit one that carried the conditions and attitudes of bourgeois society into its communal existence), it was taken as a significant declaration of aestheticist principle.[124] If it had its heroic aspects, it was nevertheless an isolated gesture; a more broadly based commitment to aestheticism was evident elsewhere, in the gathering momentum of the neo-symbolist movement. The emergence of this has been well charted, from Marcel Raymond in the 1930s who saw a symbolist-inspired *fantaisisme* as one of the main currents of the poetry of that period, through Leroy Breunig's identification of a 'vigorous neosymbolist movement' in Paris in 1905–08, to Michel Décaudin's exhaustive cataloguing of the revival of the symbolist aesthetic in the *petites revues*.[125] As Décaudin also noted, the poetry of Mallarmé was at this time once more a touchstone of literary debate. From the distance of a decade after his death an assessment of the poet's achievement seemed possible – indeed to some it appeared as a matter of more than literary urgency that it be called into question; for writers sympathetic to Action Française the symbolist-inspired aestheticism for which Mallarmé stood was a challenge to their classicism and an impediment to the establishment of its pre-eminence that they saw as a political imperative. Accordingly, Jean-Marc Bernard launched a critique of Mallarmé in 1908, arguing that his poetry was elitist and sterile – elitist, because the

search for the Absolute which engendered the hermeticism and abstractness of his style made his work inaccessible to most people; sterile, because those qualities also required the reader to do the work of ordering and composing – hence of producing meaning – which was properly the job of the poet. To this critique André Gide replied in the founding issue of his *Nouvelle Revue Française* in February 1909, defending both Mallarmé's poetry and the principle of aesthetic disinterest. No theory however interesting, he argued, had ever served to make a work of art any more than to destroy one, and poems needed no other defence than their own beauty, a beauty that in Mallarmé's case was so telling that Bernard remembered them despite himself.[126]

Despite the magnitude of his reputation, until the publication in 1912 of Thibaudet's study of his poetry, more was known about Mallarmé the man than about his work; the Gide–Bernard quarrel and the different aesthetic positions which it articulated provided *mallarmisme* with both a currency and its signifying terms in the post-Bloc period. These terms were, however, severely reductive and filtered Mallarmé's ideas through the needs of the moment. As Julia Kristeva has argued, far from being politically disinterested, the poet's aestheticism was closely aligned with the revolutionary ambitions of 1890s anarchism: 'Certain tendencies in anarchism', she has observed, 'far from stopping at contestation of state and social structures, demanded a profound transformation of the concept of the speaking subject itself', while reciprocally, 'writers engaged in an interrogation of the subject in language met the preoccupations of anarchists in combat with social structures.'[127] Insofar as it was the institutions of the bourgeois state that determined relations between subjectivity, language and sexuality, the political affiliation of symbolist writers was with any movement, from the liberal right to anarchism, that demanded the reshaping of, or rupture with, those institutions.

Yet the complicity was on the level of practice only. As Richard Terdiman has observed, symbolist writers insisted on the independence of the aesthetic realm from any contamination by the social or political, and reciprocally refused to acknowledge that literature might have any role to play in arguments beyond that realm. Kristeva noted Mallarmé's lack of interest towards 'les questions du jour', and stressed that while it 'aligned itself with movements of state, national and even social subversion such as anarchism', his aestheticism 'autonomised itself . . . in a rigorous engagement with the workings of language'.[128] Terdiman argued that Mallarmé's writings consti-tuted a counter-discursive celebration of individual aesthetic creativity in the face of a bourgeois state (be it Second Empire or Third Republic) that regulated all social possibilities and cultural behaviours with an apparently irresistible set of collective apparatuses. 'Crise de vers' (published in fragments between 1886 and 1896) mapped, he suggests, a complex relation of exclusion and refusal with the concrete social world, and Mallarmé's prose poems in particular constituted 'a strategy for counter-discourse' which, 'by turning the language of dominant discourse *against itself* . . . could begin to situate the oppressive character of the dominant'.[129] For by the late nineteenth century the bi-polar pairing of prose and verse was firmly social-ised, even politicised: prose stood for the liberal democratic ideals of the Republic, and the prose poem thus located the means to a critique of it within the realm of the

dominant itself. The project carried the risk, though, that by situating itself at the furthest border of the dominant discourse, but not crossing this, it condemned itself to both inaccessibility and political impotence. Aestheticism celebrated this marginality and difficulty, however, as in Mallarmé's 'Le mystère dans les lettres' (1896), while 'Crise de vers', Terdiman notes, 'evokes the revolutionary, but only to differentiate its own mode of opposition [to the dominant social apparatus] from it'.[130]

Mallarmé's writing offered a paradigm for *fin-de-siècle* aestheticism's resistance to the prosaic discourse of the dominant social order, a counter-discourse that opposed itself especially, as his essay on 'Le Livre' indicates, to the instrumental and commercial language of newspapers, epitomised in the irredeemable banalities of their *petites annonces*.[131] After 1905, however, aestheticism's co-ordinates were radically different; with the collapse of the Bloc and the disengagement of its participants – the organised working class withdrawing behind the stockade of autonomous action, the liberal intelligentsia embracing solidarism or aesthetic avant-gardism – the affiliation between aestheticist and political counter-discourses atrophied. Anarchism was no longer in a position to broker relations between them; for its part, syndicalism had broken with anarchism in 1907, disillusioned – as Monatte made plain – with the aloofness from political activism of many of its intellectual adherents, while the distinctly un-anarchist character of the Abbaye de Créteil epitomised a reciprocal aestheticist disillusion with politics.

The character and the reach, within the literary avant-garde, of neo-symbolism also indicates these changes. The movement had a firm material foundation in two reviews launched at this time. *Vers et prose* first appeared in the spring of 1905 and quickly gained a strategic influence surpassed only by that of the *Nouvelle Revue Française* after 1909. It attracted a large number (in avant-garde terms) of readers and a wide range of contributors; its Tuesday evenings at the Closerie des Lilas in Montparnasse were famous, even before the period of that *quartier*'s notoriety. Despite such breadth of appeal *Vers et prose* had a definite orientation, towards both the heroes of the generation of 1885 (and Mallarmé in particular) and those younger poets who were seen as inheritors of their mantle. *La Phalange*, launched in the summer of 1906, was even more narrowly orientated towards symbolism, its editor Jean Royère an ardent *mallarmiste*; Décaudin describes it as the neo-symbolist review *par excellence*.

Yet neo-symbolism lacked the counter-discursive ambitions that characterised Mallarmé's aestheticism. The editorial secretary of *Vers et prose* was André Salmon, member of a Montmartre-based group of *fantaisistes* that, as the literary chronicler André Billy recalled, 'opposed the serious, social, humanitarian concerns' then current in French poetry.[132] Billy added that the unofficial leader of this group was Guillaume Apollinaire; it was on his initiative that the *fantaisiste* review *Le Festin d'Esope* was founded in 1903 and survived for nine months. Apollinaire, too, was close to *Vers et prose* and *La Phalange*, both of which first published poems that appeared in his 1913 volume *Alcools*, and his poetry of 1908 reveals the growing importance for him of symbolism, in particular its preoccupation with interior vision and individual creativity. 'Le Brasier' and 'Les Fiancailles' are two poems of this time that meditate in the distinctly personal manner of Apollinaire's most affective works

upon a theme central to Mallarmé: the experience and significance of creative inspiration, the *noble feu*, and that resonate with exotic, metaphysical and symbolist imagery. Yet the oppositional implications of this experience explored by Mallarmé are here missing. As scholars of his work have noted, Apollinaire's insistence on the all-absorbing nature of creative experience went together with a profound attraction to the constitutive order of tradition that led, in his art criticism of the same year, to an embrace of classical values.[133]

The avant-gardist elitism of the Abbaye de Créteil represented one aspect of post-1905 aestheticism, and Apollinaire's preoccupation with creative inspiration another; both were combined in the work of another inhabitant of the neo-symbolist milieu, Mécislas Golberg. A strange and shadowy figure in the intellectual life of Paris at this period, Golberg died in 1907 before the aestheticist withdrawal from social engagement had gained momentum but, in a way that parallels Mithouard's relation to traditionalist nationalism, he was its paradigmatic figure and a major influence on many of its later representatives. Born in Poland of a wealthy Jewish family, he came to Paris in 1891 after receiving an education centred on medicine but including wide reading in philosophy and literature; for several years he was active in the anarchist movement, writing for a number of periodicals. In 1898 he threw himself into the Dreyfusard cause, was arrested, and freed on condition that his political activities cease. They did so abruptly and with remarkable completeness, and from then until his death he concerned himself solely with aesthetics, writing several essays and one book, *La Morale des Lignes*, published posthumously in 1908.[134]

Golberg's ideas epitomised key elements of the aestheticist ideology and the course of its evolution. His initial orientation was towards *art social*; in 1895 he founded and published several issues of *Sur le Trimard*, 'mouthpiece of the unemployed', in which he juxtaposed biting attacks on capitalism, its values and its ruling class with declarations that art was 'the essential driving force of all movements of social renovation', and the power that 'will guide the long march of the unemployed towards the rich regions of great and sublime emotions'.[135] His direction was already evident in this privileging of the aesthetic. After 1898 the pairing of such an emphasis with a concern for the proletariat was discarded and Golberg's ideas, presented in the writings for which he was subsequently celebrated, became clearly elitist and avant-gardist, displaying a highly personal yet paradigmatic fusion of Nietzschean individualism, Hegelian idealism and neo-platonic mysticism. Thus he argued repeatedly that the present age was a time of mediocrity, the age of the glory of everyman with his small ambitions and smaller wisdoms. There was a need for heroes, who would be creators, but, reversing the cautiously populist emphasis of *Sur le Trimard*, he insisted that those creators who attempted to work from within the crowd would be lost in it. The creators should work 'far from the masses', to become 'themselves *signs* for the masses, abstract, active, luminous signs', lighting the true path into the future.[136] The life of the masses was full of contradictory energies and impulses; the aim of the creator should be to unite hostile forces, to co-ordinate discordant 'lines' or energies, to search in and beyond these for that point of equilibrium where they were resolved. Such a point was 'the moment of the aesthetic of order, born from the peace

established between the creator and life',[137] a point of unity that existed beyond all 'divergences', and that 'reveals itself in the co-ordination of forces . . . replacing the godliness of Mind or Matter with the principle of Beauty'.[138]

Thus Golberg established aesthetics at the centre of his metaphysics. Beauty was 'the most perfect expression of existence, the expression in which all contradictions disappear, giving way to an absolute form'.[139] It was the role of the spirit, or mind, to find it in things, to detach and express it, but this was not easy, for it was not always apparent. One must be ready to 'seize it the instant it takes visible shape'.[140] The principal means to this, of course, was art, and the artist was chief among creators, able to reduce the real to its essential lines and colours. 'Art is that which finds the law and the essence of the truths that pass us by', Golberg wrote in one of many similar definitions.[141]

Golberg's last and most celebrated essay, *La Morale des lignes*, was the culmination of his philosophical enquiries, an attempt to construct an aesthetic around an analysis of a book of drawings, *Carcasses divines*, by the caricaturist André Rouveyre. Its thrust was made plain in his introduction: 'I shall attempt to reconstruct the intellect of line, to seek the verbal soul of these graphic marks, and to formulate some laws concerning the mysteries of the human soul'.[142] Throughout the essay Golberg repeated, in the context of analyses of Rouveyre's caricatures of public figures, the cardinal points of his philosophy, defining art as 'the respectful notation of the geometric proportions of an object and of their relation to Harmony or Emotion . . . to create a work of art is to register the balancing act of universal forces',[143] and arguing that its procedure was to reduce the real to the essential: 'Material things are expressed by more precise surfaces and volumes, conceptual ones by signs that are increasingly simple, the more closely they approach the abstract.'[144]

La Morale des lignes was the most interesting of Golberg's writings to young and unorthodox painters. Rouveyre, indeed, later claimed that Matisse's *Notes d'un peintre* had been largely written by Golberg, and although modern scholarship has discounted this it has been acknowledged that he was perhaps the first to formulate the general laws of an aesthetic to which Matisse subscribed, and that

> most of the theories that Apollinaire disseminated and that have gained renown amid such clamour and wild excitement, notably those concerning the basis for the expressive effect of the distortion and conceptualisation of lines and planes, are in Golberg's writings.[145]

It is clear, however, that his influence was more profound even than this, that each of the principal features of his philosophy was of major significance for post-1905 aestheticism. This ideological relationship is underscored both by the close acquaintance that leading participants in aestheticist discourse had with Golberg and his writings, and by the debt to him that much of their work reveals. As early as 1904 the group of *fantaisiste* poets around Apollinaire was aware of these writings, as an enthusiastic article in *Le Festin d'Esope* indicates.[146] In 1908 the depth of Apollinaire's own attachment to Golberg was made plain in a moving obituary:

Mécislas Golberg had few friends and many enemies because he was poor and because his life, so full of suffering, was entirely consecrated to the ideal, misunderstood and mocked by imbeciles, of beauty. I was a friend of Mécislas Golberg and I should not wish to be the last to render a sad homage, to say a mournful adieu to a man to whom we owe some of the most exalted and moving books of our time.[147]

At the same time Golberg was influencing the ideas of those artists and writers gouped around the Abbaye venture and its aftermath. The relation here was, if anything, even closer, as the Abbaye press published a volume of Golberg's *cahiers mensuels*,[148] and several of the post-Abbaye circle showed in their work a clear debt to his writings. Mercereau, writing as Paris correspondent for the Moscow art magazine *Le Toison d'or*, prefaced his critique of the 1908 Salon d'Automne with a thoroughly Golbergian declaration of aestheticist avant-gardism, and followed it with a description of the ideas current among young artists in Paris that was in part borrowed directly from *La Morale des lignes*.[149] Barzun's debt, less explicitly acknowledged, was even greater: his poetic *magnum opus* of the Abbaye years, *La Terrestre Tragédie*, echoes Golberg's writing to the very phrase, and his own move from political engagement to aestheticism followed in the latter's footsteps. The work of future cubist members of this circle, too, was shaped by Golberg's ideas: Le Fauconnier's activities of 1909–10 both as a painter and as a theoretician show a familiarity with *La Morale des lignes*; so too does Gleizes' and Metzinger's preoccupation with geometry and number.[150]

Yet important as these relationships and influences were for the circulation of ideas within the cubist movement, what is of primary significance in the context of this chapter is the ideological character of Golberg's thinking. That it contributed to the reconfiguration of the discourse of aestheticist avant-gardism seems clear; what is equally important to note is the overlap effected through Golberg's writings between this discourse and that of traditionalism. Events of 1912–14 were to demonstrate that the two were not fundamentally opposed – that, indeed, the idealism of the aestheticist withdrawal from social engagement was rooted, for some of its principal agents, in a conservative impulse. What makes Mécislas Golberg of particular interest is that his writings indicate the nature of this relationship, and anticipate the broad ideological realignments that occurred ten years later under the pressure of political events.

Aesthetics was the key element, I have argued, in Golberg's philosophy. The 'rule of beauty' was where order emerged from disorder and contradiction was replaced by conformity.[151] If on one level such an emphasis led towards the aesthetic of *La Morale des lignes* – as well as to classicism – on another it represented a quietist justification of the social status quo, the complete abandonment of commitment to the cause of the proletariat: 'All is in order if our eyes understand how to look . . . things that exist according to their laws cannot but be useful.'[152] In this argument the most glaring social ills could be viewed with complacency: 'Thanks to the emotion of order . . . it is enough to wish for them, to find its benefits everywhere, even in suffering, even in

death. Then the divine, fatal and inaccessible, becomes human. It passes from mystery into beauty.'[153] This substitution of aesthetics for ethics was underpinned by a Hegelian sense of a determining tradition. Each of the great creators had fixed the stages of the evolution of humanity and determined the direction of this; they were 'sublime signs of the life of mankind', to which we who had been instructed by centuries were compelled to conform. The present moment required a commitment to order: 'The epoch of Darwin and Pasteur is over . . . After the search for laws comes their application. After analysis comes ordinance . . . our objective is to submit life to law.'[154]

It is in emphases such as these that we can see how, for Golberg, aestheticism could be rooted in conservatism. Aesthetics was the realm of true creativity, and of freedom from the contradictions of the base world, but its freedoms did not extend to the material, to effecting social change; in the final analysis, it had the freedom only to reveal the necessity of the existing order.

Left-Wing Alternatives

Aestheticism was not the only counter-discourse circulating within and shaping the milieux of the artistic and literary avant-gardes. After the collapse of the Bloc, not all avant-gardists withdrew from social or political engagement. Even while the foundation of the Abbaye de Créteil was a notable gesture of such withdrawal, the venture also represented an embrace on both an ethical and an aesthetic level (in the life its participants lived there, and the poems they wrote) of the traditional 'good and simple' virtues of rural subsistence and community. As such it was congruent with the ideology of solidarism, and after its demise the extra-aesthetic energies of some of its participants continued to find expression in the social activism noted earlier: giving lectures on art to manual workers, or distributing potted flowers for their windowsills.[155]

Such activities, however, were peripheral to their aesthetic interests and avant-gardism. For other avant-garde participants in the Bloc's extra-parliamentary activities, whose motivation was not cultural paternalism but a socialist or syndicalist politics, aestheticist withdrawal was out of the question. In the post-Bloc decade, just as the organised working class managed to resist the mounting pressures of reaction and chauvinism down to 1914, so their sympathisers in the avant-garde articulated an alternative aesthetic, founded on visions of a socialist or syndicalist society. These left-wing intellectuals agonised over the role that they might play in the new proletarian culture – the self-styled revolutionaries of *Les Feuilles de mai* acknowledging in an editorial of 1913 that 'the first cells around which the new social order will crystallise will be the cells of syndicalism', and confessing their anxiety that they had no such cell to join: 'We are artists, as are many of our friends. The militants have baptised us: we are intellectuals. We are anguished to feel already barred from the ranks of those to whom we feel closest.'[156]

On the other hand they scorned not only solidarist efforts to *aller au peuple* armed with bourgeois cultural models, but also the argument that avant-garde aestheticism

amounted to revolutionary practice. Thus in 1912 the socialist Jean-Richard Bloch dismissed the idea of art for art's sake as comparable to that of charcuterie for charcuterie's sake: art's importance, he argued, was determined by its utility. And the anarchist Léon Werth ridiculed the populism of leading writers in the Bloc era:

> 'To the people' they cried. But it was a mystic chant . . . The people to whom they wished to go were a people of theatre extras, of shy and peaceful monsters. They saw them as destined to the job of suffering, so that in their turn delicate artists could do their job of pitying them.
>
> One day . . . the aesthetes of the bourgeoisie noticed without any joy that the people were coming to them. Or at least they were coming to their fathers, the factory managers. The aesthetes . . . telegraphed the government to send them soldiers. And instead of going to the people that wouldn't let them love them, they decided to go to church and salute the flag.[157]

Recognition of the social value of art had been widespread in the nascent syndicalist movement of the 1890s. Before the solidarist cultural initiatives of the Bloc years and after, attempts had been made to unite anti-bourgeois artists and workers. The Groupe de l'Art Social was one such attempt; founded in 1891, it faltered in mid-decade and, in a new start of 1896, declared its intention to 'bring to an end the misunderstanding that exists between manual and intellectual workers, and thus to unite them', to delineate 'an art that could be of relevance to the people'.[158] Not, however – unlike its namesake movement of the following decade – in the cause of social peace; on the contrary, art was a weapon to be used in the class struggle. Just how it could be used was spelled out by syndicalist leader Fernand Pelloutier in a lecture of 1897 sponsored by the group. Art, said Pelloutier, could reveal to workers the truth of their condition and the ideological instruments of their oppression; it could 'unmask all the social lies, show how why religions were created, the cult of patriotism conceived, the family constructed on the model of government', and just as

> bourgeois art does more to maintain the capitalist régime than all the other social forces put together – government, army, police, judiciary – so social and revolutionary art will do more to bring about free communism than all the acts of revolt that men are inspired to by their surfeit of suffering.

Pelloutier therefore called upon artists to come to the aid of revolution, to depict the evils of present society: 'All you workers and scholars who have a hatred of evil and a desire for a better life, a passion for intellectual and material emancipation, fight with us, for the source of our miseries is common.'[159] Pelloutier's appeal for an alliance between artists and workers was echoed by others on the left at the time, Jaurès among them.[160]

In sharp contrast to this optimism and spirit of collaboration was the attitude expressed by workers' representatives and left-leaning artists after the collapse of the Bloc and the growth of syndicalist autonomism. The illustrator Grandjouan, one of the leading contributors to the weekly *L'Assiette au beurre* and creator of some of the sharpest satirical images of Third Republican politics, in 1908 made a withering

riposte, in a series of articles in Hervé's anti-patriotist weekly *La Guerre sociale*, to Roger Marx's suggestion of *musées du soir* for the people. 'Under our beautiful Republic, Art is nothing but a mockery', he wrote, 'And the museums are a perpetual insult to the misery of the people.' Art was not only at the service of the bourgeois order, it was itself bourgeois: 'Today, art revolves around the Bourgeoisie. Women revelling in *its* luxuries, vibrant pages of *its* history, depictions of *its* leisure-time; there is no Beauty that is not in the service of the comfortable class.' This was because the dominant class had purloined art for itself:

> When I consider that I shall never be the bourgeois's equal, even in front of art, and that along with that solace for the body which is well-being, you have stolen that solace for the spirit which art is, I am seized with anger and I feel like joining the starving band that one fine evening will set fire to the four corners of the Louvre.[161]

Art for the people 'is no more than a fig-leaf for its misery', declared Grandjouan; 'art cannot be separated from comfort. The one is the necessary consequence of the other. Seize them together!'[162]

Grandjouan thus extended to art *La Guerre sociale*'s argument with respect to patriotism: that as an ideological weapon of the bourgeoisie it could not, in the absence of social revolution, serve the proletariat. Unlike Hervé's incendiary message, his assertions were passed over in the mainstream press without comment, but they were taken up in one quarter. In 1910 Jean-Richard Bloch founded in provincial Poitiers a review entitled *L'Effort*, around which gathered a small circle of left-leaning writers and in whose pages was elaborated the thesis of an autonomous proletarian art. Bloch generalised from Grandjouan's assertions in terms that suggest his acquaintance with Marxist ideas: 'Art is always an efflorescence of a country's dominant class, and is worth as much as that class', he wrote;[163] denouncing the initiatives of *art social* as a 'famous lie', he rejected also the proposal that artists could be brought into the revolutionary fold:

> Bourgeois prejudice is nowhere more deeply rooted than among artists, all of whom come from the lower class. I know not one of them who 'loves the poor', that is, who works on the same horizontal level as they, with them and for them . . . we must excuse them. They imagine that only the rich can understand [art], because only the rich can afford a thousand francs for a painted canvas![164]

Instead of expecting progressive art from this quarter it must come from the people; 'Art by all (and not art *for* all) . . . is what we are working for.'[165] Over the next year this became the explicit programme of the review: '*L'Effort* aims to become the voice of all those who seek a revolutionary art', Bloch stated, adding that 'the art of tomorrow will be an art of *social renewal* or it will be nothing.' By 1913 he had developed his ideas into a more or less resolved theory of revolutionary art which acknowledged its dependence on the syndicalist movement:

> Instead of regarding the moral and intellectual culture of the proletariat as sufficiently established by the simple fact of its organisation into trade unions, *let us see this organisation of the proletariat as the possible point of departure for a new – revolutionary – civilisation.*

Since the new society had its roots in the bourgeois order, this should not be rejected in all its respects – some could be learned from. Moreover, the new proletarian culture could only be built by artists and workers together – each alone would not achieve it – yet it would be an alliance of comradeship and equality: it would no longer be, as in 1900, a patronising 'descent to the people': 'The goal of *L'Effort* can thus be specified anew: to bring together these two forces, to overcome the rancour and suspicion of the worker for the artist, and to dissipate the aristocratic and scholarly prejudices of the latter.[166]

Bloch's periodical was until 1912 virtually alone among the *petites revues* of the literary avant-garde in declaring and elaborating such an explicit allegiance to revolutionary syndicalism. The art critics Léon Rosenthal (for *L'Humanité*, the organ of the parliamentary Socialists) and Henri Guilbeaux (who wrote for the radical socialist *Hommes du jour* and edited the satirical magazine *L'Assiette au beurre* in 1912, its final year) carried their socialist sympathies into their salon reviews, but unsystematically, and made no attempt to theorise their aesthetics. In late 1912 and early 1913, though, *L'Effort* was joined by a number of other magazines, chief among them *Les Cahiers d'aujourd'hui*, *Les Feuilles de mai*, *L'Action d'art* and *Les Horizons*, a development that registered the rapid emergence of a revolutionary consciousness in some literary milieux.[167] Attempts were made to co-ordinate these 'counter-reactionary' projects, to fashion a collaborative, oppositional grouping of intellectuals that would help to bring artists and workers together. The sophistication of Bloch's theorising was rarely matched, however, in a discourse whose anti-bourgeois rhetoric does little to mask the considerable common ground it shared with the solidarist populism of *art social*. The support of these cultural revolutionaries for decorative art and for efforts to stimulate its revival differed from the latter only in the higher profile it gave to the role of craft workers, and in its dismissal of the work of contemporary decorative artists as sterile and elitist. Thus in late 1912 and early 1913 Charles Le Cour and Jean Lurçat presented, in the opening issues of *Les Feuilles de mai*, a severe if veiled critique of the *Maison cubiste* project, exhibited at that year's Salon d'Automne as typical of the product of such artists, and countered such empty modishness, as they saw it, with an appeal to artisanal skills and workshop traditions. But the values they promoted were consonant with the ideas of Roger Marx – whose book, moreover, was warmly reviewed in these pro-syndicalist magazines.[168] Similarly their allegiances among fine artists, like those of the Radical critic Vauxcelles, were with the innovators of the 1890s – in particular the politically committed neo-impressionists such as Signac and Luce – and their immediate heirs, bastions of the Salon des Indépendants.[169] From this left-wing perspective the formal researches of aesthetically radical artistic avant-garde groups such as the cubists were doubly suspect: first because, accompanied as they increasingly were by the apparatus of publicity, oriented increasingly towards private galleries and clients and away from the public forum of the salon, they smacked of commercialism and hype; second because, as Madeleine Rebérioux has suggested, for a generation of young bourgeois who all had the same cult of the humanities and the same rhetorical training, such linguistic obscurities nourished obscurantism of thought and opened the door to irrationalism, mysticism – thus even to nationalism itself.[170]

For it was anti-nationalism above all that separated these intellectuals from the mainstream and lay behind their political alignment with revolutionary syndicalism. From issue to issue in 1913 and 1914, as the patriotic and militaristic temper of the majority rose, their magazines repeated their rejection of an ideology that they saw as harnessed principally to the interests of capital. Werth put it plainly: 'There is the country [*patrie*] of the rich and the country of the poor', he declared:

> We say that the poor have no country or that its country is the revolution – it's the same thing. The revolutionary country is not a territory, but a morality, as religion used to be, only it is founded on work and the spirit of revolt . . . If the country is a fact it depends, like all facts, on our interpretation. In France there are two interpretations of the fact 'country': the interpretation of the rich and that of the poor, the interpretation according to the tradition of authority and that according to revolutionary tradition.[171]

They contested too the hegemony of nationalism among the youth of France, countering Agathon's 'more or less gilded youth' of the *écoles* who, they argued, were turning back to the past, with those of the faubourgs who were seizing the future.[172] And they distinguished themselves from aestheticism, Werth claiming that 'for the patriotism of business, which is nationalist patriotism, some aesthetes and even some artists substitute a sort of aesthetic patriotism'. Quoting some lines by André Salmon in praise of uniforms and military discipline, Werth criticised him for succumbing to just such a sentiment.[173]

Such distinctions and such resistance to the co-optive force of nationalist discourse turned out for some on the left to be as durable as they were deeply felt. In a trajectory that, as we shall see, was the exact reverse of that of the cubist avant-garde, their syndicalist sympathies led a small number of writers and artists via an internationalism that grew with the threat of war to a position of pacifism when war eventually broke out, and thence to exile.[174] For the majority, however, the nationalist appeal was ultimately irresistible. While bitterly opposing the 'patriotism of business', they juxtaposed to it another patriotism, that of the jacobin tradition – as did Hervé on his release from prison, and Jaurès on the eve of war. 'We believe', declared Werth, 'that the spirit of France is the spirit of revolution';[175] it was an argument that signalled the capitulation of this counter-discourse and led the left into the *union sacrée*.

Part Two

Constructions of Cubism

Chapter 4

Cubist Painting and the Discourse of Nationalism

Le Fauconnier, Tradition and Avant-Gardism

In the three years before the outbreak of war in August 1914 cubism's notoriety spread rapidly between the cities of Europe. As the nascent avant-gardes of those cities networked across the continent, at once accommodating and exploiting the new technologies and economies of communication, an unprecedented number of exhibitions and publications gave the cubist painters of Paris wide exposure, and established the work of some of them as paradigmatic for modernism. Although the outlines of this development are now familiar, and certain events – the Armory Show in New York, Roger Fry's second post-impressionist exhibition in London, the Deutscher Herbstsalon in Berlin, the Knave of Diamonds exhibitions in Moscow – have become legendary, many of the details of this hectic traffic in avant-garde art and artists have been overlooked. It therefore comes as a surprise to discover that the leading cubist player on this European stage appears to have been a painter who is now regarded as among the least significant of them.

Henri Le Fauconnier has long been relegated to a footnote in the history of modernism, and his paintings to the basements of its leading collections, if they made it into them at all. Yet his 1911 painting *L'Abondance* (Fig. 1), now in the basement of the Gemeentemuseum in The Hague, was perhaps the best-known cubist picture in Europe before 1914, and almost certainly the most travelled. In cities from Amsterdam to Moscow, from Budapest to Berlin, this picture and studies for it were shown in most of the key exhibitions of those years, reproduced in influential publications (the *Blaue Reiter Almanac* among others) and brought their author a renown that was sealed by a 1913 retrospective of his work, organised by the Folkwang Museum of Hagen and circulated across central Europe.[1] For a brief moment Le Fauconnier was widely regarded as one of the most audacious artists in all Europe, and as the originator of a new movement in painting.[2] The disparity between that reputation and his present one should give pause for thought. To understand it requires that at last we historicise the cubist conjuncture, that we move beyond the still-dominant twin assumptions that the range of work within the cubist movement can be adequately represented in terms of a simplistic, even manichean,

opposition between (good) modernist experimentation and (bad) academic conven-
tionality, and that cubism's aesthetic transformations were punctual and final, fully
significant to its creators from the first.[3] Conceiving how *L'Abondance*, of all paint-
ings, could have come to stand for cubism before 1914 entails attendance to the
mechanisms by which, and the terms in which, it did so, to the specificities of the
production and reception of this and other cubist pictures, as well as to the character
of the pre-war conjuncture, the material and discursive factors that shaped it, and
that determined what meanings were and were not available for cubism in that
moment. It entails, finally, acknowledgement both of the plurality of interests within
the cubist movement and of its heteronomy – its relation to that broader discursive
field.

As Raoul Girardet observed, the Dreyfus Affair, culminating moment of the
nationalist agitation of the 1890s, ended in the complete failure of this on the level of
politics; from that moment nationalist energies were transferred principally to the
cultural level, in that effort of elaboration and dissemination of, for some, a coherent
doctrine, for others an ethic and aesthetic, that was traced in the previous chapter.[4]
The literary and artistic avant-gardes, increasingly overlapping as the dealer–critic
market grew and evolved, were among the primary sites of this elaboration. This
dynamic was complicated, however, by events of the watershed years 1905–06: the
crisis over Morocco and the collapse of the Bloc des Gauches led both to the spread
and concomitant diversification of nationalism to encompass most of the political
spectrum, and to the emergence of aesthetic avant-gardism as a replacement
and compensation for the abandonment of social activism. The artistic avant-garde
in Paris was caught up in this complex dynamic, and added its own particular
twist, for it was itself fractured, or at least in tension, between nationalism and
internationalism.

For cubism this tension was expressed in part on the level of the market – the
organisation of which of course had its own specific effects. The cubist movement was
the first avant-garde grouping to encompass, and to divide between, two distinct and
almost mutually exclusive market orientations, salon and gallery. The consequences
of this division were not only differences in the mode of pictorial production and of
avant-gardist 'address' of each subgroup (to which I shall return), but also in
responses to the nationalist appeal. The gallery cubists were grouped together largely
on Kahnweiler's initiative in a market sector necessarily international in outlook, and
represented in microcosm the cosmopolitan character of the Parisian avant-garde at
large. In contrast, the salon cubist grouping was the result of mutual recognition
among artists who were all French, orientated to a market sector that was a source
of national self-esteem.[5] Among the salon cubists the case of Le Fauconnier is
significant because, as I hope to show, his cubist paintings and the brief but bright
course of his avant-garde career throw into relief the ways in which nationalism and
the discourses that it subsumed in the pre-war period came into conflict with avant-
gardism, and with what consequences.

What factors, then, gave *L'Abondance* its instant renown? The most immediate
was the development of that avant-gardism discussed in Chapter 2. Le Fauconnier

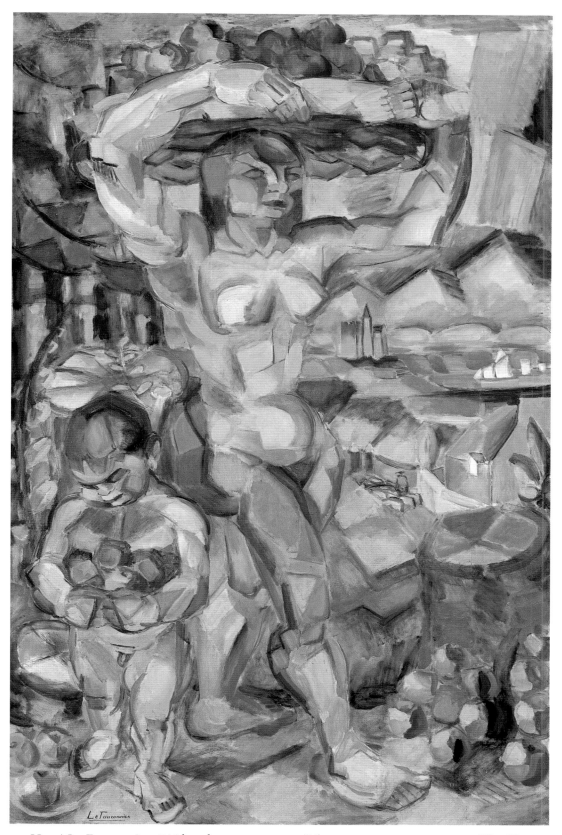

1 Henri Le Fauconnier. *L'Abondance*. 1910–11. Oil on canvas, 191 × 123 cm. The Hague: Haags Gemeentemuseum.

was among the first artists to pursue a strategy of competitive self-promotion that took advantage of his circumstances in the newly consolidated Parisian avant-garde, and earned his paintings a short-term prominence that few other cubist works could match. Not that he was alone in such self-promotion: by all accounts it was a collective initiative[6] that won him the office of President of the *commission de placement* at the 1911 Salon des Indépendants and enabled him to group his paintings (including *L'Abondance*) with those of like-minded artists such as Gleizes, Léger, Metzinger and Robert Delaunay in a prominent position – the infamous Room 41. But Le Fauconnier's ambition had already acquired him a leading role within this milieu; on the strength of his membership of the Neue Kunstlervereinigung (NKV) in Munich by 1910, and of his authorship of a theoretical statement on contemporary art for the catalogue to its second exhibition that September,[7] *L'Abondance* was anticipated keenly by his friends as a keynote picture, and the process of its painting was followed closely by them through the winter of 1910–11.[8] His tireless promotion of the work around Europe after its Parisian début indicates his estimate of its significance, as well as his recognition – one that Kahnweiler, but few others, also shared – of the benefits of such exposure. Kahnweiler, however, combined energetic pan-European promotion of his stable of artists with an insistence on their abstention from the Paris salons[9] and understood that, in an increasingly dealer-centred market, picture sales were ultimately more significant than publicity for the establishment of an artist's reputation: in contrast, Le Fauconnier's primary orientation was to the salons and their associated public and critical discourse. It was, in consequence, the need to gain attention in the increasingly overcrowded conditions of the Indépendants and the Automne that in part determined the qualities of *L'Abondance* – its large scale, its time-honoured allegorical subject and its academic patina. Equally important, it was the elevated mode of pictorial address which a publicity-driven avant-gardism necessarily entailed that shaped Le Fauconnier's artistic efforts before 1914 and that – when such avant-gardism was answered in 1911–12 by the Italian futurists – ultimately (I shall argue) shackled them.

A second, if less immediate, factor determining the painting's reputation was the congruence it established (which the art historian Daniel Robbins was the first to note) between the aesthetic programme of the painters of Room 41 and that of a significant grouping of Parisian writers.[10] Le Fauconnier worked, and *L'Abondance* was painted, within a milieu that was more literary than artistic, and the aesthetic of some of its literary members found visual representation in this picture. The milieu was that of the former members of the Abbaye de Créteil: Albert Gleizes, René Arcos, Georges Duhamel, Alexandre Mercereau, Charles Vildrac; Jules Romains was associated with it, also Roger Allard, Paul Castiaux and Pierre-Jean Jouve; all but Gleizes were writers. Their aesthetic interests met in a post-symbolist celebration of everyday life and human community, within which there were significant differences of emphasis ranging from Romains's unanimist hymns to the collective consciousness of modern Paris, to Vildrac's Rousseauesque vision of a simple and harmonious, implicitly rural community.[11] Common also to much of their writing was the adoption of an epic verse or prose style that brought the example of Walt Whitman's *Leaves of Grass* to bear on contemporary innovations in *vers libre*.[12]

Underpinning this aesthetic was a commitment, the depth and character of which has been well explored, to the philosophy of Bergsonism. The writers and artists of the post-Abbaye milieu appropriated the major elements of Bergson's philosophy: his privileging of intuition over analysis as the vehicle for insight into the nature of reality, the foundation of which was duration, his emphasis – argued eloquently in his 1907 bestseller *L'Evolution créatrice* – on the regenerative *élan* of nature.[13] Romains, in *La Vie unanime* (1908) and *Un Etre en marche* (1910), and Arcos in *Ce qui naît* (1910) explored the implications of Bergsonian intuition and memory as the subjective condition of existence; Mercereau's *Paroles devant la vie* (1912) was an exaltation of *élan vital*, especially in its first section, 'Paroles devant la femme enceinte', since organic regeneration and, especially, motherhood were key instances of creative evolution.[14] Their work was complemented and supported by that of a few critics, in particular Tancrède de Visan who presented a Bergsonian interpretation of the symbolist aesthetic, arguing that symbolism made use of images successively, or accumulated, to exteriorise a 'lyric intuition'.[15] De Visan thus claimed for symbolism a poetic aim which coincided with that of the post-Abbaye writers. Although they rejected the imagery and language of symbolism, these poets recognised in its technical innovations the means by which their own 'lyric intuition' could be communicated. In a treatise of 1910 Duhamel and Vildrac explained the advantages of one of those innovations, that of *vers libre*, the liberating effects of which were based, they suggested, on its substitution of a flexible 'rhythmic constant' for the inflexible six syllables of the conventional alexandrine poetic form.[16]

Le Fauconnier's *L'Abondance* was in part a product of this discourse and was integrally related to the concerns of these writers on several levels. The painting asserts, if awkwardly to modern eyes, the epic character of ordinary life. Its allegorical female nude surrounded by emblems of nature's fecundity, with her male child canonised by a tree-trunk halo, both parallels Mercereau's hymn to motherhood (and possibly contributed to its imagery, for the prose piece was probably written at the time of the completion and exhibition of the picture[17]) and shares its Bergsonian celebration of organic regeneration. In his articulation of forms the painter uses repeated contrasts of curves and angles (as in the picture's upper right quadrant) which suggest the 'rhythmic constant' deployed by Duhamel and Vildrac,[18] and its heavily painted, facetted volumes convey an idea of abundance by means consistent with de Visan's ideas. Most important in the context of the broader literary community, however, was the contribution that Le Fauconnier offered in *L'Abondance* to the debate over classicism. Like Maurice Denis but without Denis's explicit political and religious allegiances, his response to the classicist revival combined aspects of both the exclusive latinist and rationalist classicism promulgated by Maurras and the literary neo-classicists, and the inclusive, intuitionist alternative offered by Barrès. Unlike Denis, and with the assistance of Allard's philosophical and critical writing, Le Fauconnier evolved a style of painting that could address the growing interest he shared with the poets of his circle in the dynamic possibilities of both Bergsonian philosophy and modern life.

The artist's engagement with classicism began in the eighteen months before *L'Abondance*, as Gleizes' testimony and his own paintings of that time reveal; his

points of reference were on the one hand those painters, from the Renaissance through Poussin to David and Ingres whose works presented 'simplified structures derived from the application of laws',[19] and a Cézanne whose achievements were then seen in unequivocally classicist terms.[20] In a reply to an enquiry in early 1911 he lauded 'Cézanne whose great merit was . . . to return to the integral principles of pictorial tradition, adapting these to his own means of expression', adding:

> On the day when lovers of art rediscover Poussin's *Enlèvement des Sabines*, Ingres' *Apothéose d'Homère* and the admirable *Sacre* of David, perhaps they will realise that in their own time there are painters who, far from all exoticism, symbolism or neo-classicism are working in complete serenity in the most profound French tradition.[21]

While claiming the inheritance of classicism, Le Fauconnier thus sought to distance himself from the pedantry of Denis's painting. He found the means to this through an apprenticeship to the work of Cézanne that took from it more than the conventional lesson in classical values. A painting of 1910 of *L'Ile Bréhat* (Fig. 2), off the north Brittany coast, is indicative of this apprenticeship, derivative of Cézanne's painting

2 Henri Le Fauconnier. *L'Ile Bréhat*. 1910. Oil on canvas, 90 × 71 cm. Whereabouts unknown, formerly collection F. J. Sandbergen, Amsterdam.

not only in its classicising geometry but also in the awkward insistence of this, in its abrupt spatial transitions and a tentative use of Cézanne's signature device of *passage*.

Hesitant and uncertain as such painting was, it caught the eye of a critic who in 1910 was also looking for a way beyond both the aesthetic of impressionism and the sterility of the neo-classical reaction to this represented by Denis, Girieud or Friesz. The young poet Roger Allard, a member of the post-Abbaye circle, made a forthright critical début with a review of that year's Salon d'Automne for a Lyon periodical. 'A beautiful picture is nothing other than a true equilibrium, an equivalence of weights and a harmony of numbers', he declared; dismissing the 'arid formulae' of neo-classicism, he called for 'an expansion of tradition towards the classicism of the future'.[22] Le Fauconnier's entries, together with those of Gleizes and Metzinger, displayed 'the noble desire to contribute to the restoration of a canon for the plastic arts',[23] and he concluded that they offered 'to the intelligence of the spectator the essential elements, in all their pictorial plenitude, of a synthesis situated in time'.[24] The implicit Bergsonism of this interpretation of nascent salon cubism I noted in Chapter 3 in the context of Barrésian nationalism. In his discussion of the work of these artists, it sits a little uneasily with Allard's invocation of classical values: he seems to be overreading the paintings, straining to fit them to a philosophical template.[25]

Perhaps recognising this, in his next two articles he separated the classicist emphasis from the Bergsonian. 'Sur Quelques Peintres', a review of the 1911 Indépendants, dwelt on the former, applauding the 'common determination' of the salon cubists (grouped together in Room 41) to avoid the fashionable obsession with 'the insidious anecdote . . . the bric-à-brac of false literature and pseudo-classicism' and instead 'to paint *pictures* . . . understanding by this, works that are composed, constructed, ordered – in place of notations and sketches, where the tricks of a false spontaneity mask an essential emptiness'.[26]

The Bergsonian interpretation of classicism he elaborated at one remove from contemporary practice, in an assessment of the painting of Poussin whose pretext was the recent acquisition by the Louvre of his *Apollon guidant un jeune poète*. But he also drew on his earlier account of the art of Metzinger, Le Fauconnier and Gleizes to propose that not only they but Poussin himself offered 'the essential elements of a synthesis situated in duration':

> Thus with the *Bergers d'Arcadie*: to arrive at the definitive arrangement, some of the movements have described innumerable complicated orbits; others, halted in their trajectories it would seem by a superior necessity, have in that instant undergone a miraculous transposition. Everything that was incomplete in space is now complete in time, and the object that was limited in dimension becomes infinite in duration. But the forces which first gave birth to those movements that are now interrupted continue to act – and the *living* beauty of the work is born of the resistance with which they are opposed by the balance of volumes.[27]

With this argument Allard sought to appropriate the values of France's *grand siècle* itself, so beloved of the neo-classicists of Action Française, both to the more inclusive, intuitive classicism of Barrès and to the Bergsonian lyricism of the post-Abbaye

circle's celebration of modern life. His championing of Le Fauconnier's painting in particular from the 1911 Indépendants offered to his readership an instance of such appropriation in pictorial terms.[28] The painter's attachment to *grand siècle* classicism was as evident, both from his pictures of 1910 and from his occasional statements, as Allard's;[29] the allegorical subject matter and the structural armature of *L'Abondance* confirmed this explicitly. But read in the terms that the critic proposed, the insistent repetition of curvilinear elements and the accumulation of volumes, as well as the centring of the composition on the abdomen of Abundance could be seen to furnish the formal means to reconcile this with the painting's Bergsonian message. Allard's summary of his response to the *Bergers d'Arcadie* – 'Thus to love the living work for the vital forces which are in it is to understand and possess nature, since by an act of genius a human thought has known how to contain it whole'[30] – could refer also, if hyperbolically to modern eyes, to Le Fauconnier's painting.

Bergson himself, as well as his academic supporters, thought of his philosophy as standing within classical tradition. The pamphleteers Massis and de Tarde (alias Agathon) polemicised in 1911 against the *esprit de géométrie* whose Cartesianism, positivism and scientific method dominated teaching at the Sorbonne. They found among its students a lively *esprit de finesse* whose attachment to intuition, spontaneity and metaphysics embodied all that was best in classical culture, and championed Bergson as its leading academic representative. In the same year the Ligue de la Culture Française was founded to campaign for the restoration of the old classical curriculum at the Sorbonne among other things; its predominantly conservative membership included thirty-six out of forty Academicians, as well as Barrès and Bergson.[31] This common affiliation of the writer and the philosopher is significant, for it is a token both of the relationship between Bergsonian anti-rationalism and Barrésian classicism that I noted earlier, and of how the nationalist discourse of the latter extended its hegemony to encompass the concerns of artists and writers whose avant-gardism was directed more explicitly to the aesthetic than the political arena. The adventure of the Abbaye de Créteil had been not only a founding gesture of the abandonment of solidarist cultural paternalism by some of its former promoters; it had also been an escape from the contaminations of modern city living and an attempt to re-establish a mythic pastoral community. Thus, for all their declaration of aestheticist autonomy, members of the post-Abbaye circle were not immune to the attractions of a traditionalism rooted in a rural myth of national identity. While the polemics of the *Revue critique* met with little sympathy in this milieu, the Bergsonian metaphysic was a powerful ideological cement that bound them into traditionalist discourse.

Bergson's *L'Evolution créatrice* was published at the moment when the aftermath of the first Moroccan Crisis of 1905 was stoking the fires of nationalism. Its argument for the fundamental importance of duration as 'the foundation of our being', 'the very basis of our conscious existence . . . the prolongation of the past into the present . . . acting and irreversible', 'the continuous progress of the past which gnaws into the future and which swells as it advances'[32] gave a philosophical foundation to Barrésian traditionalism; it was Bergson's lucid, poetic and passionate exposition of

vitalism, however, that resonated most widely. Armed with its understanding, he declared,

> we feel ourselves no longer isolated in humanity, humanity no longer seems isolated in the nature that it dominates . . . All the living hold together, and all yield to the same tremendous push. The animal takes its stand on the plant, man bestrides animality, and the whole of humanity, in space and in time, is one immense army galloping beside and before and behind each of us in an overwhelming charge able to beat down every resistance and clear the most formidable obstacles, perhaps even death.[33]

Passages such as this (*L'Evolution créatrice* is full of them) not only satisfied the vague spiritual longings of a newly godless generation but also met, in ways explored in the previous chapter, the needs of those with specific objections to the scientific rationalism of the liberal republic, including the supporters of a mystique of nationalism.[34]

Apologists for the continued subordination of women also found support for their argument in Bergson's book. Scientists, sociologists and writers were engaged in the pre-war years in forging modern theories to support prevailing sexual inequalities – more severe in France than in most other European countries – and to combat the small but rapidly burgeoning feminist movement.[35] Arguments that women were less intelligent because their brains made up on average a lower proportion of their body weight than those of men (except, coincidentally, men of 'inferior races') and that woman's intellect was governed by her uterus accompanied the belief that the 'two essential functions' of women were childbearing and motherhood.[36] At a moment when France's declining birth rate was causing alarm among politicians of all colours from the nationalists of the right to the socialists and the competition of women in the job market was causing resentment among syndicalist men,[37] ideas like these met with widespread sympathy. They were given further nationalist resonance by writers such as Zola, whose novel *Fécondité* of 1899 proposed a new moral order for France founded on farming and childbearing and which is overladen with organicist analogies between the two.[38] Bergson's vitalist celebration of human regeneration gave intellectual legitimacy to such ideas and their elaboration in poems such as Mercereau's 'Paroles devant la femme enceinte'.

L'Abondance stood at the intersection of this complex, mutually reinforcing and reactionary set of discourses, structured and articulated by them in both its style and its iconography, and contributing in turn to their articulation by virtue of its paradigmatic status. At a time of unprecedented urban growth and economic dynamism, of inter-class conflict that engendered fears and hopes for the future of France and the prospects of progress, Le Fauconnier reached back for an expression of his ideal of a harmonious society to a pre-industrial and rural mode of living. It was represented not as a working community in which men and women produced their livelihood, but as a projection of a mythical and idealised relationship between humankind and nature, a world of pastoral plenty – Eden before the Fall, secure in its spiritual values (underwritten by the background church) and in the benevolence of nature – a nature

at whose centre was woman doing what she could be relied upon to do best, as the prime bearer of the vital flame. At a time when the syndicalist and feminist movements were gaining momentum, threatening both the stability and the patriarchal complacency of republican society, the vitalism of *L'Abondance* carried the implications that change was the result not of such decisive collective action but of instinctual biological imperatives, that the rural past was a better model for the present than an industrial future, and that women's social role was the bearing of children.

Behind the optimism and regenerative *élan* of Le Fauconnier's painting could thus be read, in 1911, a message of social quietism and nostalgia. This not only registered the distance between the Abbaye group's aesthetic and the social reformism that many of its members had earlier embraced, but also represented an accommodation to the ideology of traditionalist nationalism that was made possible after 1910 by the gradual divergence of their ideas. With the mounting interest in the phenomena of modern city life on the part of avant-garde writers and artists, the differences of emphasis between urban and rural models of community that the work of the group had encompassed were difficult to contain. In the face of the challenge presented by Italian futurism from 1909 – and especially from 1911, with the visit of the futurist painters to Paris – the differences became contradictions. Insofar as the rural model became anachronistic it took on the colouring of a traditionalist projection, and such, in part, was what *L'Abondance* was.

Le Fauconnier was predisposed to respond to the attractions of traditionalism before 1911. A doctor's son from the Pas-de-Calais, educated at an exclusive Jesuit college near Boulogne and originally destined for the law, he studied art at the Académie Julian in Paris from around 1900, until an inheritance in 1907 at the age of 26 gave him a *rentier*'s income and the financial independence to move back to the country.[39] He chose Brittany, for the same reasons as two generations of artists and other tourists had done already: a work of 1908, *Le Village dans les rochers* (Fig. 3) is typical of his early paintings in its Gauguinesque, primitivist representation of the granite landscape around Ploumanach, a village on the north coast. Nothing in his painting of these years took him beyond this paradigm, well-worn by 1906 – indeed vulgarised by mass tourism, for Ploumanach was by then celebrated for its huge red granite rocks. As Charles Morice observed in a 1911 newspaper article that is as notable for its reiteration of the primitivist clichés as for its testimony to the spread of tourism in the locality: 'However the Breton is stubbornly determined to live. He resembles his rocks, he is sad like them and, like them, threatened . . . one trembles as one passes these giant, nude stones'. But clearly there was safety in numbers:

This empire of horror has tempted the tourists. They are intrepid characters. Thanks to their courage, there are no more 'lost corners': they have all, alas, been found again! . . . At Ploumanach there are more tourists than rocks; with their toiletries and their autos, with their town talk, their factitious needs and real laziness, they have transformed this region – which, for its part, has readily sacrificed all to please and retain these passers-by.[40]

3 Henri Le Fauconnier. *Le Village dans les rochers*. 1908. Oil on canvas, 73 × 2 cm. The Hague: Haags Gemeentemuseum.

Le Fauconnier would have seen the big Gauguin retrospective at the 1906 Salon d'Automne shortly before he left Paris for Ploumanach, where he reproduced the mythic image of rural France in a series of landscapes of just such erstwhile 'lost corners' of Brittany. Alongside these he painted a number of nude studies of his companion, the Russian painter Maroussia Rabannikoff. *Femme à l'éventail* of 1909 (Fig. 4), exhibited in the Salon d'Automne of 1910, was the most ambitious of these, in formal terms as well as those of scale, its *grisaille* colouring and heavily modelled, sharply chiaroscuroed volumes marking a departure from the flat *cloisonné* forms of earlier canvases. These qualities together suggest that the painter was attempting something thematically grander: the prominence and equivalence given to the figure's abdomen and brow imply a symbolic level of meaning whose terms, if they are tacitly Bergsonian, are also entirely consonant with the explicit anti-feminism noted above. Maroussia's status as a painter was apparently less significant for her companion than her potential as a mother.

In his predilection for Gauguinesque primitivism, rural utopias and fecund female nudes, Le Fauconnier can be seen, thus far, as epitomising the assertive and regressive masculinism that has recently been identified as characteristic of early twentieth-century avant-garde culture. Yet in stylistic terms *L'Abondance* was also self-

4 (right) Henri Le
Fauconnier. *La Femme à
l'éventail*. 1909. Oil on
canvas, 146 × 96 cm. The
Hague: Haags
Gemeentemuseum.

5 (below) Fernand
Léger. *Nus dans une
forêt*. 1909–11. Oil on
canvas, 120 × 170 cm.
Otterlo: Kröller-Müller
Museum.

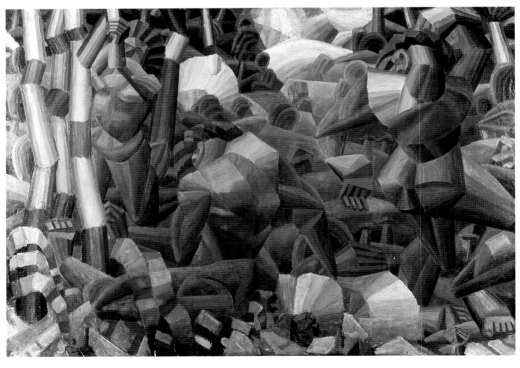

consciously innovative. Its accumulation of volumes through a rhythmic repetition of planar fragmentations across the pictorial field was not only a means to the expression of a reactionary biologism but also, in its emphasis on the unity of the picture's surface, an assertion fundamental to modernism. At the same time it co-ordinated formal relationships, of contrast and contiguity, whose expressive potential was noted and utilised by other salon cubists – above all Léger, whose *Nus dans une forêt* of 1911 (Fig. 5), exhibited with *L'Abondance* in Room 41, was an immediate product of the evenings spent following the elaboration of the latter in Le Fauconnier's studio, and which developed its somewhat cautious innovations into a painting of startling, though awkward, dynamic intensity.[41]

Le Fauconnier's painting thus inscribed a tension between an emerging pictorial syntax whose modernist innovations were engendered in large part by avant-gardism and the reactionary ideology in whose service it was deployed. In his subsequent work this tension was raised to the level of contradiction, as the pressures of both avant-gardism and traditionalism increased in the second half of 1911. Following the exhibition of *L'Abondance* Le Fauconnier set out to deepen his acquaintance with latinist classicism, transcribing Poussin in the Louvre before travelling to Italy for the summer to study the work of Raphael.[42] The result, *Allégorie pour la chasse* (Fig. 6), appears to display a clearer commitment both to the principles of such classicism and

6 Henri Le Fauconnier. *Allégorie pour la chasse*. 1911. Oil on canvas, 149 × 100 cm. Whereabouts unknown.

their contemporary ideological resonance.[43] Lacking any of the symbolic attributes that in his previous picture suggested a concern with the modernist ideas shared by the Abbaye poets, it seems to indicate on this level a move on the artist's part to a thoroughly traditionalist emphasis. At this moment, however, the gathering momentum of Le Fauconnier's classicism was interrupted by developments that pricked his avant-gardist sensibilities: through the mediation of, respectively, Apollinaire and Allard the salon cubist group gained over the summer a sharper awareness of the rival cubism of Picasso and Braque and the challenge posed by the futurist painters,[44] and in October the Italians themselves visited Paris, with plans for a November showing at Bernheim-Jeune.[45] If the hermetic paintings in Kahnweiler's gallery would have made little sense to him, Le Fauconnier would have found the self-promotion of the Italian painters familiar. Perhaps in response, he appears to have shelved plans to enter the *Allégorie* in the Salon d'Automne[46] and turned instead to a project that marked a radical departure, a work entitled *Le Chasseur*.

Eventually exhibited in the 1912 Indépendants (which opened that year in late March), *Le Chasseur* (Fig. 9) was the culmination of six months' work. Two oil studies exist – a small sketch of the proposed configurations of the picture and a large final study (Figs 7 and 8). Although the latter, in the collection of the Museum of Modern Art in New York, has had more exposure (reproduced for example in John

7 (left) Henri Le Fauconnier. Sketch for *Le Chasseur*. 1911. Oil on canvas, 55 × 46 cm. The Hague: Haags Gemeentemuseum.

8 (right) Henri Le Fauconnier. *Le Chasseur*. 1911–12. Oil on canvas, 158.1 × 117.8 cm. The Museum of Modern Art, New York. Gift of Mr. and Mrs. Leo Lionni.

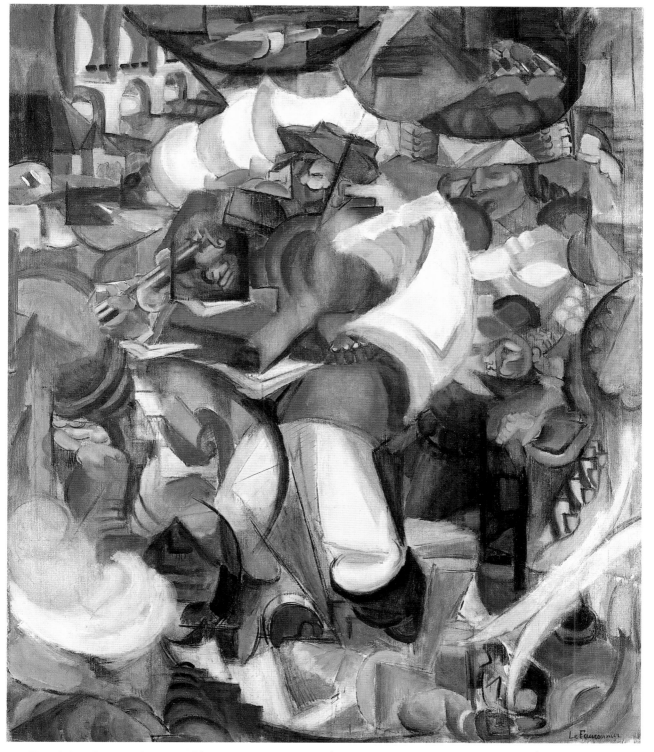

9 Henri Le Fauconnier. *Le Chasseur*. 1911–12. Oil on canvas, 203 × 166.5 cm. The Hague: Haags Gemeentemuseum.

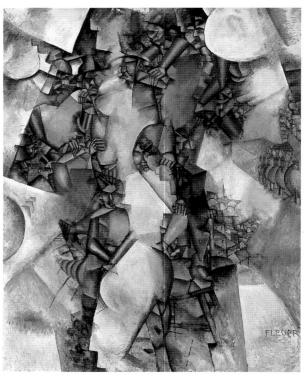

10 (above) Umberto Boccioni. *Stati d'animo: Quelli che vanno* (second version). 1911. Oil on canvas, 70.8 × 95.9 cm. New York: The Museum of Modern Art. Gift of Nelson A. Rockefeller.

11 (right) Fernand Léger. *La Noce*. 1911–12. Oil on canvas, 257 × 206 cm. Paris: Musée National d'Art Moderne.

Golding's *Cubism: A History and an Analysis*), it is the former which is more striking and which, despite its small size, is closer to the final painting in composition and style. The sketch is remarkable in that, in the context of Le Fauconnier's work to that date, it marks a clear and accomplished articulation of a vocabulary of dynamic contrasts of line and form that was only adumbrated in the *Allégorie*. It also presents, unmistakably and as a key device, a juxtaposition of the central figure of the hunter with isolated, perspectively inconsistent pockets of space. In these ways the work resembles, and probably predates, the most aesthetically radical of the futurists' paintings of the winter of 1911–12, such as Boccioni's reworked *Stati d'animo* triptych, that were first seen in their Bernheim-Jeune debut in February 1912, as well as Léger's *Noce* (Figs 10 and 11).[47] Such formal boldness was consistent with Le Fauconnier's avant-gardist ambitions: it is possible that Boccioni told him of his ideas on pictorial representations of simultaneity, and that Delaunay's parallel explorations in this area gave him food for thought. As cubism's self-appointed *théoricien* he was obliged to keep abreast of such innovations.

His ambitions were easier to adumbrate in sketch form than to achieve in a fully resolved painting, however. Gleizes remarked with surprising candour in an article of that same autumn that 'Le Fauconnier thinks better than he paints';[48] *Le Chasseur* illustrates his point well. The final picture is a complex, crowded work, many of whose images are unclear despite their evident iconographic significance. At its centre stands the hunter, firing a shotgun at mallard ducks, some of which are scattering above and below him. It seems from studies that Le Fauconnier intended this figure to stand, at least on one level, for himself (or as 'the artist'): several pencil studies for

12 (facing page) Detail of plate 9.

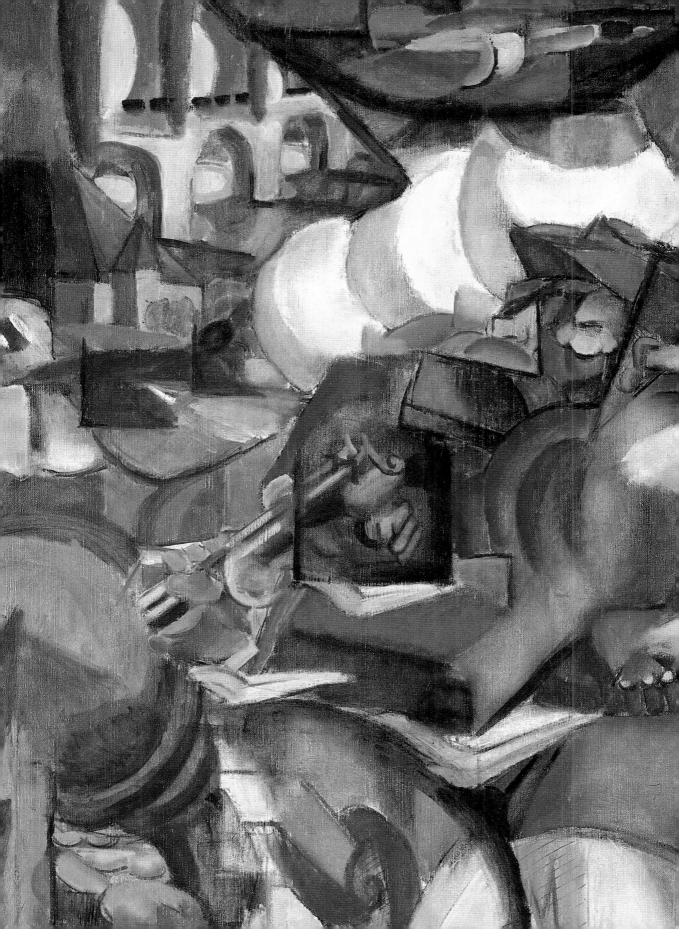

13 (above) Henri Le Fauconnier. Drawing for *Le Chasseur*. 1911. Pencil on paper, 18.8 × 28.5 cm. The Hague: Haags Gemeentemuseum.

14 (right) Henri Le Fauconnier. *c.*1911. Photo courtesy M. Didier Sevin, Carpentras.

the head are also self-portraits, the hat worn by the hunter was his own, and the association between the figure and his own name would surely not have escaped him (Figs 13 and 14). The hunter is formally and thematically the origin of the dynamism of the picture – explosive, destructive and disharmonious, accompanied not only by gunsmoke and dead ducks but also by the figures of *l'Abondance* and her son, the representatives of a more mutually enriching relationship between humanity and nature.

We can therefore infer an equation between the hunter and the modern world of violence and metal, in which the world is mediated by the artist who discovers the visual language appropriate for its expression. Such an inference is supported by the juxtaposition of the railway bridge over the river with the church (emblems of the modern and the traditional); the emphasis, by isolation, of the firing mechanism of the gun; the dislocation of the countryside into scattered fragments of a landscape (Fig. 12).[49] If this inference is correct, and if these grandiose ideas were indeed Le Fauconnier's, they indicate a deepening of the painter's attachment to traditionalism, a pessimism in the face of modernisation that ran counter to the simultanist enthusiasm for urban dynamism which his fellow and rival artists shared, and which found expression in these same pictorial devices of spatial and formal contrast; a sharpening, in sum, of the conflict between his painterly avant-gardism and the ideological purpose it served.

On one level the pessimism was perhaps justified in late 1911 and early 1912, for the prospect of war with Germany had been brought closer than ever by the second

Moroccan Crisis of July 1911 and its repercussions. While to suggest that the *Chasseur* was in any sense a direct response to diplomatic tensions would be absurd, collapsing into a crude binary relation of political 'cause' and cultural 'effect' the complex discursive field within which Le Fauconnier's artistic practice was consti-tuted, the Crisis, in both heightening alarm at the prospect of war and giving further motivation to the projects of national self-definition surveyed earlier, could only have exacerbated the tensions between traditionalism and modernism, nationalism and avant-gardism that *L'Abondance* inscribed. The ideological repercussions of the Crisis were refracted, however, through developments more specific to Le Fauconnier's milieu. Out of the growing and increasingly diverse circle of artists and writers that had gathered round the cubist painters after their showing at the 1911 Indépendants and again at that year's Salon d'Automne, a nucleus formed whose members met weekly at the home of the Duchamp brothers in Puteaux.[50] It appears to have excluded Le Fauconnier who, despite – or perhaps because of – his efforts at self-promotion, became steadily more independent of the other cubists, an independ-ence that was sealed with his non-participation in the keynote Salon de la Section d'Or at the Galerie de la Boétie in October, in favour of a personal retrospective exhibition in Amsterdam.[51] Public success in Paris remained paramount, however; given both his own independence and the many new entrants to the field in the wake of the cubists and the futurists, the stakes of such success were, if anything, higher than before. Le Fauconnier therefore sent to the 1912 Salon d'Automne which opened on 1 October, ten days before the Section d'Or, a single vast painting, at 2.5 by 3.5 metres his largest to date, *Les Montagnards attaqués par des ours* (Fig. 15). He appears to have been rewarded with a public response commensurate with its size, which even included protests in the Chambre des Députés and footage in a Gaumont newsreel.[52]

As with the *Chasseur*, only more so, the scale both of the picture and the painter's ambition were matched by the illegibility of the image. *Les Montagnards attaqués par des ours* was listed in the catalogue as having been painted between 1910 and 1912 at Annecy and Paris; while the earlier date is probably an instance of retrospective back-dating,[53] the painting was in effect a résumé of his concerns from *L'Abondance* onward. Again the subject appears to be the relationship of humanity with nature; again it featured a rollcall of recent *dramatis personae*: the main figure from *Le Chasseur* (right of centre, firing a shotgun), the figure of *L'Abondance* with her basket (upper right) and her son (lower left of centre). Again, much else remains indecipher-able, buried both by the weight of anecdotal detail and avant-gardist pictorial dislocation and by the uninflected heaviness of Le Fauconnier's brushwork. Enough pieces of the jigsaw can be fitted together, however, for a picture to emerge of an alfresco meal interrupted by bears, whose attack is resisted by hunters. The principal figures other than those identified are, on the left, a hunter swinging his shotgun club-fashion at a bear which is mauling a comrade; in the centre, another bear lifting a hunter off his feet with the strength of its hug; a dog cowering under a table, lower left, and other frightened figures, lower right. The pictorial space is dislocated by devices repeated from *Le Chasseur*: on one hand the isolated vignettes of referential

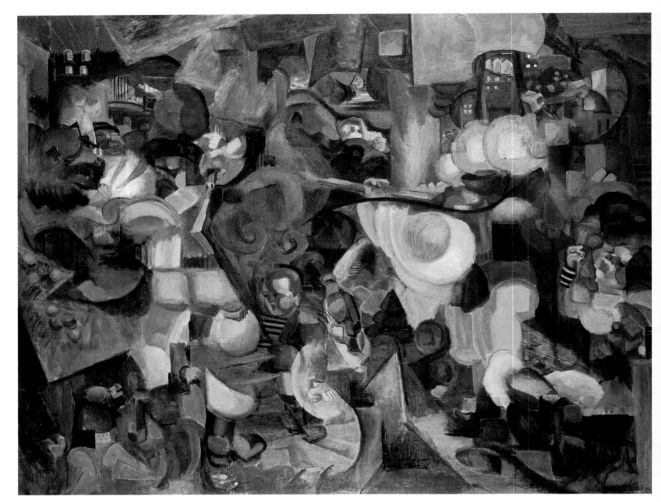

15 Henri Le Fauconnier. *Les Montagnards attaqués par des ours*. 1912. Oil on canvas, 241 × 307 cm. Rhode Island: Museum of Art, Rhode Island School of Design.

scenes including, upper left, a bridge with a village and telegraph poles with conductors and, upper right, elements of a villagescape; on the other hand, the semi-representational, swirling smokelike forms also used by Léger in *La Noce*.

On one level of meaning the painting appears to refer specifically to the Annecy landscape and possibly to a specific anecdote associated with it: the alpine bears of the region had spawned a considerable local literature, and the last of them to be hunted, in the parish of St Ours in 1893, crawling away to die in a cave such as that depicted right of centre in the *Montagnards*, was celebrated in tall tales told to tourists (such as Le Fauconnier in the summer of 1911).[54] But the primary meaning, we can infer, is more general. It has been suggested that the bears represented for Le Fauconnier both brute instinct and the victims of humankind's bestiality.[55] Given the repetition from *Le Chasseur* of juxtapositions of modern technology and traditional rural

16 (facing page) Detail of plate 15.

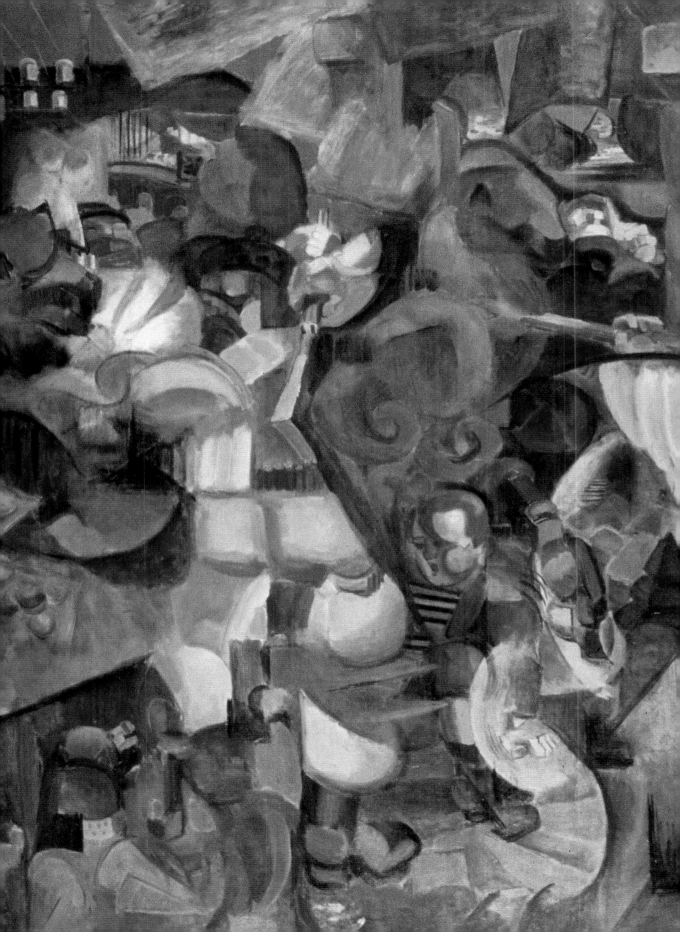

community, I would be more specific: our modern civilisation, Le Fauconnier seems
to be implying, with its dynamic dislocation of a way of life grounded in centuries of
tradition, must surely provoke a reaction from brute nature of such force that it will
be overcome by it. In late 1912 such a message would have been powerfully amplified
by the organicist discourse of Barrésian anti-rationalism. It is possible that Le
Fauconnier meant, further, to implicate the pictorial dynamism and dislocations of
salon cubism and futurism in this provocation, since this was to be the last of his
paintings to make use of their innovations; the bestiality may also refer to the war
which, in the second half of 1912, the French public believed to be imminent. But this
is speculation. What is relatively clear is that in *Les Montagnards* Le Fauconnier was
developing the ideas of *Le Chasseur*, and attempting the restatement of a profoundly
pessimistic and conservative response to the contemporary social and cultural cli-
mate. His singular and fascinating failure to articulate pictorially that response
marked the end of his attempt to do so and the abandonment of his struggle to
harness the avant-gardist stylistics of his salon cubism to his deepening hostility to the
urban experience, and social implications, of modernity.

Gleizes: Between Classicism and Simultaneity

Le Fauconnier's conservative modernism and the discursive forces that shaped it are
thrown into relief by a comparison with the aesthetic trajectory of his friend and
co-debutant of Room 41, Albert Gleizes, in the pre-war period. Le Fauconnier's
closest associate among the proto-cubists,[56] Gleizes later recalled how in the two
years from their meeting in 1909 to salon cubism's debut at the 1911 Indépendants
they explored together the constructional principles of classicism in the art of the
Renaissance, of David and of Ingres: 'lines and volumes, densities and weights,
symmetries and equilibria between parts [of a painting], such were our interests and
aspirations', he wrote, acknowledging also the uncertainties to which these gave rise
in his own mind, over the relative importance of formal and thematic concerns.[57] All
found expression in *Femme aux phlox* (Fig. 17), the most substantial of the paintings
he exhibited alongside *L'Abondance* at the 1911 Indépendants: a domestic interior
shows a seated female figure and a framed painting of a river landscape in the
background. The uncertainties over thematic issues are evident. Gleizes' apparent
interest is with formal considerations, with developing the pictorial vocabulary
adumbrated in his earlier work and that of others, and exploring the potential of
weight and volume. As with *L'Abondance*, the palette is restricted to sober greys and
greens with touches of sienna, and the figure is integrated with its surroundings by the
fragmentation of all forms into equivalent and weighty elements. Unlike
L'Abondance, however, the striking pictorial density of the work is without self-
evident relation to the painting's subject; like the complexities of Léger's *Nus dans
une forêt* (see Fig. 5), its neighbour in Room 41, its formal innovations appear to
represent a technical audacity with little thematic purpose. It is also possible to
interpret the subject as symbolic of a harmonious relationship between humanity (the

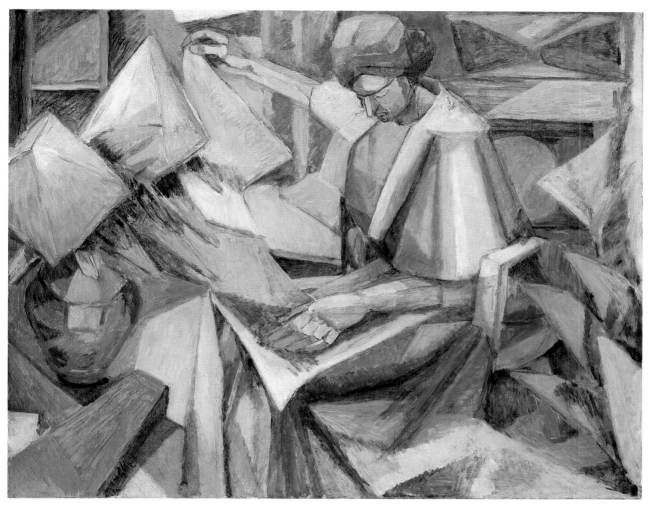

17 Albert Gleizes. *La Femme aux phlox*. 1911. Oil on canvas, 81 × 100 cm. Houston: The Museum of Fine Arts. Gift of the Esther Whinery Goodrich Foundation.

woman and her domestic occupation) and nature (the flowers, the river landscape) that would be in keeping both with the organicism of the post-Abbaye circle and, contemporary (as well as congruent) with it, the anxious stress on the domestic role of women; while there is no direct evidence that such a meaning was intended, it was available within these overlapping discourses.[58]

In the paintings he made following the Indépendants, however, Gleizes took the example set by Le Fauconnier to heart. *A la Cuisine* and *La Chasse* (Figs 18 and 19), both larger than *Femme aux phlox*, each gave a higher priority to thematic concerns at the expense of formal innovation, and addressed issues that *L'Abondance* had encompassed. The subject of *A la Cuisine* is a kitchen interior with a woman seated,

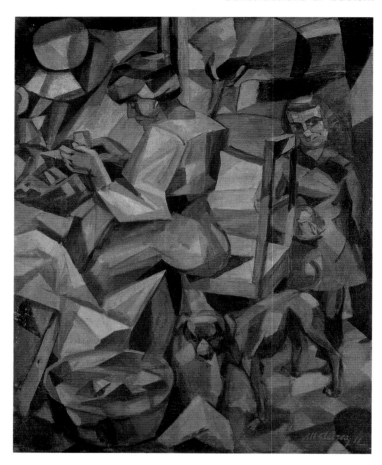

18 Albert Gleizes. *A
la Cuisine*. 1911. Oil
on canvas, 123 ×
98 cm. Courtesy of
Faggionato Fine Arts,
London.

working at a counter; beside her a child stands holding fruit or vegetables gathered
from the garden that is visible through the door in the background. Clarifying both
the interior–exterior juxtaposition of his previous painting and its depiction of
domestic work, it presented in the summer of 1911 an image of rural harmony that
by transposing the elevated allegory of *L'Abondance* into the minor key of genre
echoed both its vitalism – including its representation of the nurturing and domestic
role of women – and its expressive means.

 The implicit message of *La Chasse* was even clearer. That Le Fauconnier was
painting *Allégorie pour la Chasse* at this time was no coincidence but, in substituting
the specificity of a contemporary genre subject for the generalisation of allegory,
Gleizes' picture went beyond mere acknowledgement of his associate's example
almost to the point of social commentary. Not only was its subject emblematic of
rural tradition and hierarchy, but its composition underscored this. The work is
dominated by a foreground group of riders in hunting pink with hounds, behind
which a rolling landscape holds a shepherd and flock, a mother and child and, closing

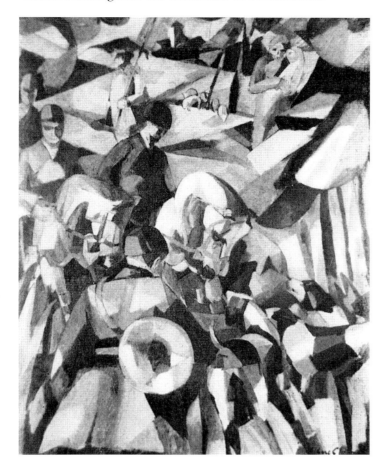

19 Albert Gleizes. *La Chasse*. 1911. Oil on canvas, 123 × 98 cm. Paris: private collection.

the scene on the horizon, a village nestled beneath its church. Like Le Fauconnier's *Allégorie*, however, *La Chasse* appeared to sacrifice modernist complexity – even more than *A la Cuisine* – in the interests of iconographic clarity. In cubist terms both works were a step backwards from the engagement, in *Femme aux phlox*, with questions of spatial ambiguity and formal density.

At this moment Gleizes took a significant step away from Le Fauconnier. With the latter away in Italy and Savoie during the summer, he spent these months in close companionship with Metzinger; for several weeks the two were in almost daily contact and developed an intimate understanding of each other's art practice and ideas.[59] On one level this shift in allegiance represented an acknowledgement of the ascendancy of the aesthetic ideology and stylistic characteristics of gallery cubism within the cubist movement, which I shall discuss more fully in another chapter. As the salon cubists' acquaintance with the paintings of Picasso, Braque and Gris improved (with Apollinaire's encouragement) after the 1911 Indépendants, the position of Metzinger became central, within the Room 41 group, for he alone of them

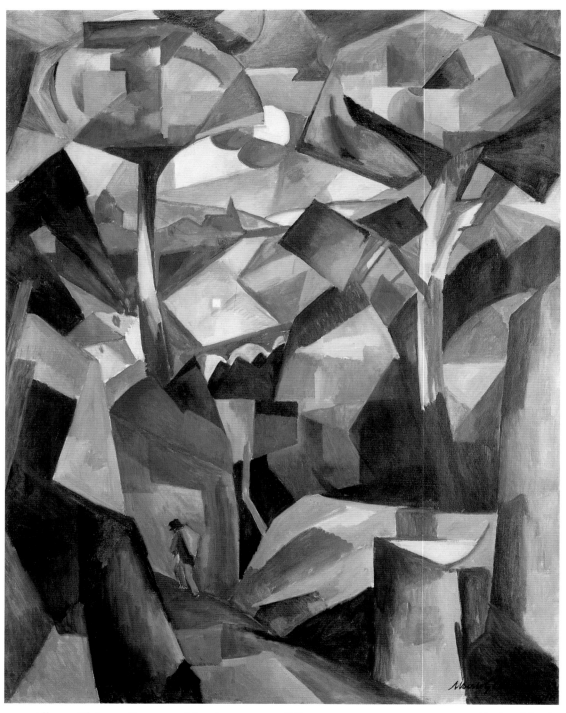

20 Albert Gleizes. *Paysage, Meudon*. 1911. Oil on canvas, 147 × 115 cm. Paris: Musée National d'Art Moderne.

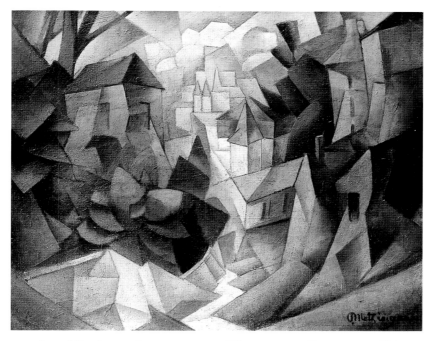

21 Jean Metzinger. *Paysage*. 1911. Oil on canvas, 81 × 97 cm. Private collection. Courtesy Sidney Janis Gallery, New York.

had been familiar with the work in the Bateau-Lavoir studios for some years. This development was registered both by André Salmon in his studio-gossip column and by Gleizes in an article devoted to his new associate – his first venture into print.[60]

On another level, perhaps Gleizes recognised the limitations of Le Fauconnier's example, for his painting over the summer absorbed from Metzinger such key elements of gallery cubist style as Metzinger had himself adopted. These included the use of multiple perspective and the deployment of volumes and planes within pictorial space in a way that was more consistent than his earlier work with the principles of classicism to which they both adhered. The immediate result, in *Paysage*, *Meudon* (Fig. 20), his largest painting to date and the principal product of this *rodage* (as Gleizes later termed it) with Metzinger, was a self-conscious and mannered modernism that was quite new for him, if characteristic of the latter's painting (Fig. 21). The classical armature and Claudian image of Gleizes' picture are both overlaid with a pattern of planes and facets that fragments forms, combines perspectives and complicates the relation between spaces and volumes, but does little to disrupt the conventional spatial recession. Such devices in the work of other cubists conveyed a sense of the simultaneity of modern perception, but were here used, it appears, for primarily decorative effect.

Gleizes remained attached to thematic concerns, however, and unwilling to follow Metzinger far in diminishing the importance of the specific subject, as he later recalled.[61] The painting's title indicates a precise location, the south-western suburbs

22 (above) The south western suburbs of Paris in 1892. View from Bas-Meudon towards Billancourt.

23 (right) The same suburbs in the early 1920s.

of Paris; the bend of the Seine suggests that the viewer is looking down river, away from the city, west towards the setting sun. This district marked one of the interfaces between city and country in the years before 1914, as contemporary photographs show (Figs 22 and 23). The two views illustrated frame the area temporally between 1892 and 1925, roughly thirty years in which Billancourt on the right bank changed drastically from country village to industrial suburb dominated by the Renault factories.[62] Walking through this landscape almost daily on his way to and from Metzinger's house in Meudon, Gleizes would have been familiar with the emblems of this rapid urbanisation, then at its height. Yet he omitted even such few signs of modernisation as already existed twenty years before his picture, and represented this mushrooming suburb in clearly pastoral terms, directing attention to those elements that were either pre-modern or timeless. In 1911, such a representation of an identifiable location and the evident classicism of its composition amounted to a clear declaration of the values of traditionalism, of the country against the city, the past against modernity.

If thus far Gleizes was, like Le Fauconnier, sailing before the wind of traditionalism, however, the experience of the summer set him on a different tack, for it gave him the pictorial means, once he had mastered them, to elaborate a more complex

and more ambivalent response to the experience of modernity. Moreover, where Le Fauconnier's individualism led him into isolation from, and resistance to, continued cubist experimentation, from that summer Gleizes moved in the opposite direction. He was less constrained than the former by overweening avant-gardist ambition, and more of a painter: his openness to the expressive potential of Metzinger's decorative pictorial rhetoric was accompanied, it seems, by a readiness to address the enthusiasm of his salon cubist and (from autumn 1911) Puteaux circle friends for the dynamic quality of modern urban life. In his paintings of the next two years he returned time and again to this theme, not – unlike Léger and Delaunay – to celebrate it, but to accommodate it, to integrate it into a vision that remained anchored in tradition. The *Baigneuses* (Fig. 24) exhibited in the Indépendants of 1912 shows the transition. The painting depicts a harmonious and balanced landscape in which industrial and urban elements are imbricated with the surrounding countryside; Poussinesque in its organising geometry and Claudian in its specificity of place, this is the landscape not of Arcadia but of France as Gleizes wished it to be. The formal innovations of cubism that he had learned from Metzinger Gleizes used expressively to unify the gestures of the foreground figures and the swirls of background chimney-smoke into a timeless

24 Albert Gleizes. *Les Baigneuses.* 1912. Oil on canvas, 105 × 170cm. Paris: Musée d'Art Moderne de la Ville de Paris.

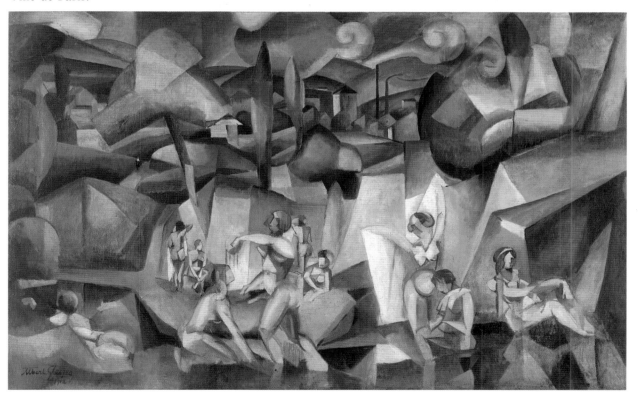

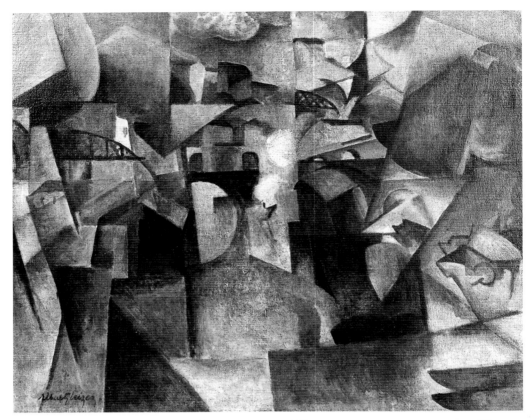

25 Albert Gleizes. *Les Ponts de Paris*. 1912. Oil on canvas, 58.3 × 72.7 cm. Vienna: Museum moderner Kunst Stiftung Ludwig.

and purportedly natural order. While the subject was explicit in its reference to latinist classicism – and implicit in its rejection of the avant-gardist challenge of the futurists to avoid the pictorial representation of the nude as inescapably *passé* – the presence of emblems of industrialisation, not juxtaposed but integrated with the rhythms of the landscape, marked a definite, if tentative, departure from the concerns he had shared with Le Fauconnier.

In this development, Gleizes' sensitivity both to the aesthetic implications and to the sheer painterly appeal of the modernist conceits of gallery cubism as retailed initially by Metzinger was perhaps a paramount factor (although the consistence of the ideology inscribed by the *Baigneuses* with his earlier participation in solidarist cultural initiatives should be noted; I shall return to it). In his paintings of the next few months he adopted these wholeheartedly, making use of the fragmentation of forms or perspective views, and their reconfiguration through a linear and planar scaffolding, that was common currency in the Puteaux group, yet deploying these in a radical, personal and coherent manner. In *Les Ponts de Paris* (Fig. 25), first shown

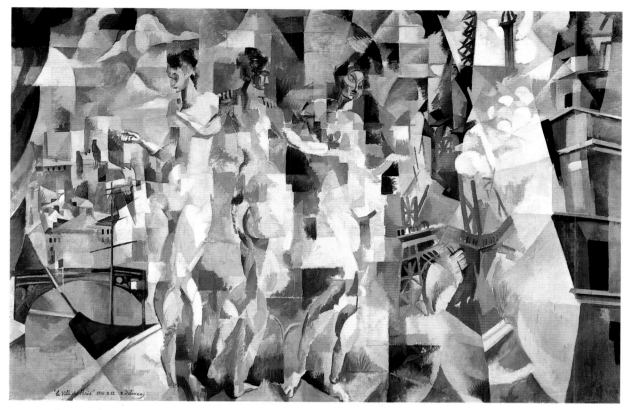

26 Robert Delaunay. *La Ville de Paris*. 1912. Oil on canvas, 267 × 406 cm. Paris: Musée National d'Art Moderne.

at the Société Normande exhibition in June 1912 and probably painted in the months before this, the abrupt discontinuities of forms and vistas resemble those of contemporary paintings by Robert Delaunay and Léger, whose *Ville de Paris* (Fig. 26) and *Noce* (*see* Fig. 11) respectively date from early 1912 (as well as, more distantly, the 1910–11 Cadaqués and Céret landscapes of Picasso and Braque). But their reassemblage is suggestive of the collaged fragments of a cut-up postcard, the shadows between them functioning as both signified and signifying elements in a way that anticipates Gris's Céret landscapes of 1913 (Fig. 27). The organising perspective of the painting, for all the resulting cut-and-paste effect, remains that of a conventional landscape, however, and the sobriety of its colour and composition are clearly classical in reference, qualities that are matched by the predominance of images of pre-modern Paris: only the swing bridges, peripheral to the composition as they were to the city centre, refer to modernity. This was the representation of a diachronic, rather than synchronic, simultaneity; a reassertion of temporal continuity, of Bergsonian *durée*, of the identity of France, the images of past and present Paris threaded on to the Seine like beads on a rosary.

27 (right) Juan Gris. *Landscape at Céret*. 1913. Oil on canvas, 92 × 60 cm. Stockholm: Moderna Museet.

28 (below) Albert Gleizes. *Le Dépiquage des moissons*. 1912. Oil on canvas, 269 × 353 cm. Paris: private collection.

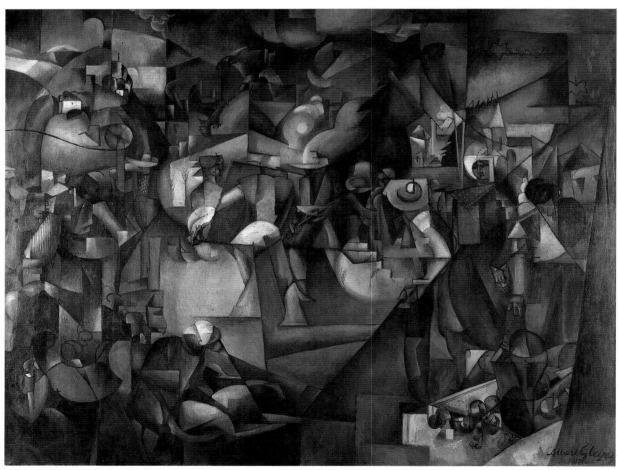

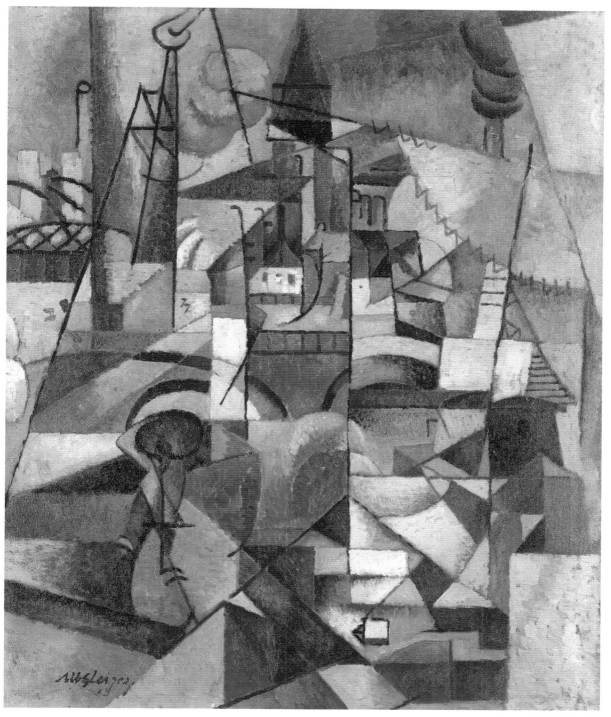

29 Albert Gleizes. *La Ville et le fleuve*. 1913. Oil on canvas, 79 × 63 cm. Ursula and R. Stanley Johnson Family Collection.

If *Les Ponts de Paris* thus held the old and the new, together with formal conven-
tion and innovation, in a balance of sorts, in Gleizes' two largest – and thus, one
could infer, his most ambitious – paintings of the two years before August 1914 the
components of the present were each treated individually, while stylistic innovation
became an end in itself. *Le Dépiquage des moissons* (Fig. 28), shown for the first time
in the Salon de la Section d'Or of October 1912, was a huge work, at over 2.5 by over
3.5 metres the equal in scale of Le Fauconnier's *Montagnards* and, as an epic handling
of a time-honoured rural activity, its equivalent for Gleizes, it has been suggested, in
thematic terms as well.[63] Like the latter painting, it is difficult to decipher; although
Gleizes was a more adept painter, and the details of this work are handled with a
delicacy and clarity not evident in Le Fauconnier's art, the *Dépiquage* is overladen
with cubist conceits and compositional geometries that make the work more compli-
cated but not more complex – as Allard remarked of the work of Metzinger, whose
decorative mannerisms they resemble.[64] Yet one effect of these is to depersonalise the
figures of the harvesters and their companions, scaffolding the sweeping rhythms of
their gestures and dispositions within a trapezoidal schema, and thus to tie them and
their activity into an order that was traditional in both pictorial and social terms. For
all the self-conscious modernism of its stylistics, and despite the inclusion of farm
machinery (what appears to be a tractor is discernible left of centre) as metonym for
modernity, the result was a hymn to the timeless, ritual character of the harvest, as
constitutive of community at the level both of the *pays* and, by implication – in the
context of 1912 – of the nation as well.

A year later, in *La Ville et le fleuve* (Fig. 29), Gleizes' substitution of an inventory-
style combination of views and details, then also characteristic of the work of other
Puteaux familiars such as Gris, for the recondite geometries of the *Dépiquage* was
accompanied by an equivalent thematic change to an up-beat, dynamic representa-
tion of the modern industrial city. The largest of three works shown at the 1913 Salon
d'Automne, though not on the scale of the earlier picture, the painting developed the
implications of the cut-and-paste configuration introduced in *Les Ponts de Paris* into
a composite image whose radically flattened spaces and juxtaposition of emblems of
modernity anticipate the cinematic devices of Léger's *Ville* of 1919.[65] Yet, as in the
Ponts and – crucially – unlike the Léger, its disparate elements fall into place in a
conventional perspective whose coherent spatial recession, punctuated midway by the
bridge pillar, is closed by the church and its spire. And it is these pre-industrial
features that, with the river, command the scene into which those emblems – iron
bridge, factory chimneys, stevedore – are set. Once again, the simultaneity is dia-
chronic, the old and the new bound together in dynamic – vital – harmony but, again,
one for which tradition provides the anchor. The orthodox perspectival recession
represents the essence, as it were, of the phenomena of cubist stylistics, running deep
beneath their surface play, as the *longue durée* of true France did beneath the dynamic
spectacle of metropolitan life. While, unlike Léger in 1919, Gleizes in 1913 was
unwilling to abandon either the pictorial convention or its ideological referent, he was
yet able, unlike Le Fauconnier, to integrate both modernity and modernism into his
aesthetic ideology.

Discourse and Practice

As this chapter has sought to demonstrate, cubism was a product of the prevailing discourses of the pre-war decade; these determined in crucial respects what innovations were or were not thinkable and paintable, what meanings were available for the works produced. The work of Le Fauconnier and Gleizes was produced, as I have argued, at the intersection of two discourses in particular, those of avant-gardism and traditionalist nationalism. The reactionary modernism of the former inscribed the conflict between an ideology of traditionalism to which Le Fauconnier was drawn by social background, cultural predisposition and professional allegiance, and an orientation to a sector of the art market in which (and at a moment when) a strategy of avant-gardist self-promotion was put at a premium. That Le Fauconnier's traditionalism was not explicitly nationalist is perhaps a mark of his avant-gardism, in that his sustained attempt to keep pace with contemporary innovations (both pictorial and promotional) outside France as well as in Paris fostered the internationalist aspects of this at the expense of chauvinism. Gleizes' painting, by contrast, while representing an accommodation between the traditional and the modern that Le Fauconnier was not able, or prepared, to make, did so in terms that were (implicitly and sometimes explicitly) nationalist, displaying an ambivalence towards modernisation that was fundamental to the ideology of solidarism and to Radical republican government policy.[66]

What must also be acknowledged in this analysis, however, is the complexity of the relations between such discursive factors and their product, the need to take account of the specificity *both* of political and ideological discourses and of artistic practices, in the pre-war decade. If Gleizes and Le Fauconnier are to be understood as painters, rather than politicians or ideologues, their artistic practice, the role of painting as *métier* must be acknowledged as central in the formation of their identity. Not only because their practice of painting was an active part of the process of the construction of ideology rather than a passive reflection of this, but also because it was painting, as well as ideology, that distinguished between them. Gleizes was the better painter: more dexterous, more visually adept, more formally accomplished. These accomplishments were a factor in his accommodation of tradition and modernity, for that accommodation was in part driven by the painterly exploration of cubist stylistics on which he embarked during his summer with Metzinger. As I have suggested, the readiness with which he adopted such stylistics and the thoughtful use he made of them indicates their sheer technical appeal for him, and the process of their appropriation drew him away from the classicist paradigm of Le Fauconnier's paintings, into an engagement with that experience of modernity that had prompted the elaboration of such stylistics in the work of others.

It was, then, as painters that these members of the post-Abbaye circle encountered the debates over Bergson and classicism, nationalism and regionalism that were circulating in the avant-garde; such enthusiasms were neither as systematic as philosophy nor as militant as political activism. This fact must be acknowledged, if we are to avoid collapsing the particularity of lived experience into flat abstractions.

After 1905, moreover, their attention to their practice was underwritten by an avant-gardism which they experienced and adopted partly as compensation for a lack of purchase on political discourse. Yet it was not entirely as painters that they expressed their avant-gardism; first Le Fauconnier and then Gleizes, among others in the salon cubist circle, found their voice as writers and expounded on cubism and contemporary aesthetics in magazine articles, catalogue statements and manifestos. This activity accompanied that of their painting and helped, as we shall see in Chapter 6, to fashion conceptions of cubism whose relation to that painting was by no means straightforward.

Chapter 5

Collage and Counter-Discourse: Aestheticism and the 'Popular'

My dear friend Braque, I'm using your latest papery and powdery procedures. I'm in the process of imagining a guitar and I'm using a bit of earth on our horrible canvas.

Picasso, Pasted Paper and the Balkan War

Only days before this announcement by Picasso, in early October 1912, of his work on the first of that interrelated series of constructions and *papiers-collés* that are now seen as among the most important products of his cubist years, the artist had returned to Paris from the south of France and moved into a new studio on the boulevard Raspail, exchanging the villagey bohemia of Montmartre for the cosmopolitan cafe-terrace culture of Montparnasse; only days later, war began in the Balkans. Within a month, Picasso had embarked on a series of *papiers-collés* in which newspaper reports of the progress of the war were a central feature.[1]

The conjuncture of these few weeks was an extraordinary one, a defining moment not only in the relation between European nations – in that it first brought into play the cat's cradle of diplomatic alliances that was to lead in two years to the mobilisation of their peoples for total war – but also in the relation between modernism, for which the cubist adventure was paradigmatic, and the common culture of those peoples – the commercialised popular culture of modern capitalism. As Robert Rosenblum first suggested in 1965, the pasted papers of Picasso and Braque represent 'the first full scale absorption into high art of the typographical environment of our century'.[2] In the decades since Rosenblum directed attention to the confrontations in these works between verbal and visual signifiers, between the esoteric ideograms of gallery cubism and the ephemeral images of advertising, the post-modernist fascination with commercial culture of which his paper was an early manifestation has ensured that this encounter between the 'high' cultural discourse of cubism and the 'low' discourses of publicity, the newspaper and commodified leisure has been the subject of increasing scholarly attention. In the same period, out of the structuralist and post-structuralist engagement with the linguistic model there has developed a semiotic interpretation of Picasso's cubism, within which his *papiers-collés* occupy a privileged position as inscribing a radical shift, in Peircean terminology, from an iconic to a symbolic system of visual representation.[3] While together these approaches

have taken present understanding of Picasso's pasted papers beyond the conventions of a Greenbergian formalism for which their cultural status and engagement with 'debased' materials was a peripheral issue, neither takes account of the conjunctural character of the moment of their invention. With one significant exception, considerations of this phase of Picasso's cubism have ignored not only the Balkan subject matter of his first *papiers-collés* but even the concurrence of these two developments.[4] Yet it is only when these radically innovative works are read in that context that they can be understood historically. Such a reading of the 'Balkan' collages offers an insight into how Picasso used both the materials and the iconography of popular culture, and into how the complex interplay of discursive forces at work can be brought to bear on the analysis of specific 'texts'; how, in short, 'history' enters the art work.

Some recent contributions to the discussion of Picasso's *papiers-collés*, with respect to their appropriation of 'popular' materials and to their innovative textual play, have found a common reference in the aestheticism of Mallarmé. The key texts here are his writings of the late 1880s and 1890s, principally 'Crise de vers' and 'Le Livre, instrument spirituel', in which Mallarmé sharply contrasted the debased, commercially determined forms of journalistic writing, exemplified in the daily newspaper, with the profoundly spiritual potential of 'literature' (which for him meant poetry, including the prose poem) whose typical form was the book. Picasso's frequent choice of newspaper as a collage material has been interpreted by Christine Poggi as reflecting a 'self-conscious, ironic negation of symbolist values' such as these, and a critique of painting's fine art status.[5] Where Mallarmé saw his poetic ideal of the pure work of literature as implying 'the elocutionary disappearance of the poet, who cedes the initiative to words',[6] for Picasso the 'effacement of the self' implied in his manipulation of the already existing conventional signs of journalistic discourse, and his use of newspaper and other mass-produced materials, 'pointed towards the obsolescence of contemporary cultural hierarchies and theories of representation.'[7]

Demurring from this interpretation, Rosalind Krauss offers a reading of the newspaper collages as an attempt by Picasso to recover newsprint 'from a world of futurist abandon to which he himself was extremely hostile', but which was heralded by Apollinaire and others of his circle as the embodiment of *l'esprit nouveau*: manipulating fragments of newsprint and their interrelation, she suggests, he was able without abandoning their columnar monotony to 'transmute the grey drone of the marks on the page into the very sign or constellation for light', and while acknowledging their flatness, to deploy them as signifiers of the turning pages of a book. For Krauss, such a recovery 'means here not simply siding with Mallarmé's condemnation of the newspaper, but showing that the newspaper can, to the contrary, be made to yield – for the new art – the very qualities Mallarmé condemned it for lacking.' Thus this 'very first embrace' by Picasso of mass-cultural materials was at the same time 'so very tremendously qualified as almost to appear a kind of rejection', and an admonishment to Apollinaire.[8]

In a more recent restatement of her position, Poggi has acknowledged the force of this argument, modifying her claim for Picasso's assault on cultural hierarchies with

the observation that the formal and material properties of many of his collages and constructions seem 'designed specifically to elude the apparently inevitable process of commodification', and that while they 'seem to elide the distinction between fine and popular art', they do so 'from within the ranks of the avant-garde'. As such they neither address a popular audience nor change the relations of production. Such a change, she suggests, would entail bringing art into the realm of the political; something the futurists undertook, but not Picasso.[9]

Challenging the premise of Picasso's lack of political engagement – which, despite this gesture towards the historical conditions of the making and reception of the *papiers-collés*, Poggi shares with Krauss[10] – Patricia Leighten argues for the fundamental importance for his art practice of the anarchism in which Picasso had been steeped since his years in Barcelona. The first to explore the implications of the Balkan subject matter of his earliest collages, Leighten infers from these Picasso's intention to express through them his anti-war beliefs and his concern to introduce political questions 'into the dynamic interaction of the total work'.[11] The *Verre et bouteille de Suze* (Fig. 30), made at the end of 1912 or start of 1913, incorporates fragments from *Le Journal* of 18 November 1912, among which are reports about the Balkan War, a socialist and anarchist demonstration against this in Paris, and part of the daily serialised novel. In Picasso's deployment of them, she suggests, 'unlike the commodified newspaper, these scraps of 'discarded newsprint' bear an intertextual relation to one another and re-establish a matrix of meaning, indeed an anarchist analysis of power relations.'[12] Leighten argues that while Picasso subsequently moved away from the predominantly political concerns of his early collages, other works employing clippings from *Le Journal* – amounting to a quarter of those incorporating newsprint – 'exhibit a consistent and more than formalistic attitude to the world beyond the picture frame, an attitude that Picasso's profound if unsystematic attachment to Barcelona anarchism permits us to call "political".' The characteristic subject matter of these – accounts of murders, suicides, assassinations, vandalism, acts of absurd and often domestic violence – the artist treated with a 'black humour and comic posturing [that] recall similar strategies of social criticism and personal rebellion in Apollinaire and Jarry'.[13]

The resonances of such humour were not confined to avant-garde milieux. As Jeffrey Weiss demonstrates, Picasso's collages shared many qualities with one of the most popular forms of commercial entertainment in pre-1914 Paris: the music hall or, more specifically, that variant of it known as the *revue de fin d'année*. Music hall supplanted the *café-concert* in popularity after 1900; by 1912 it was still being described as a new genre, which fused the *café-concert* with the circus. The sub-genre of the revue, in vogue in Paris from around 1910, took the form of a series of fast, topical sketches and songs which demanded a well-informed audience and whose material dated quickly into incomprehensibility.[14] To practise the revue in any form, therefore, Weiss notes, was to cultivate an aesthetic of the newspaper; as 'a comic system according to which French society commentated itself' this popular entertainment thus 'comprises a set of larger cultural co-ordinates for collage'. More than this, indeed, as he suggests:

The revue furnishes virtually a complete agenda of the motifs and devices in cubist collage, especially in the oeuvre of Picasso. As a model, it comprises the entire jumble of pasted subjects in any given picture, rather than requiring us to acknowledge some and ignore others. The vocabulary of the revue is the vocabulary of collage, a period lexicon of technical language specific to both: the *actualité*; the pun, the allusion and the *à peu près*; the *sous-entendu* and *entente*; irony, satire and *grivoiserie*; newspaper, advertising and song.[15]

Besides such specific homologies, Weiss points to striking circumstantial evidence connecting the two: the fact, for example, that the 'high season' for the *revue de fin d'année* coincided, in the year when the craze for it reached its height, with the month in which Picasso began his first, newspaper-based, *papiers-collés*. Or that on 10 November 1912 *Le Journal* published, in the issue from which Picasso took the Balkan War headline for his first pasted newspaper, a 'mock programme for its own seasonal Balkan war *revue à grand spectacle* . . . an irrepressible sequence of wordplays, jokes and comic song titles at the expense of enemy and ally alike'.[16] In the light of such coincidences and resemblances, he suggests that the *papiers-collés* represent a transposition of revue strategy and aesthetics into the cubist milieu, a pictorial *revue de société* for Picasso's cafe and studio companions.[17]

Similar parallels are drawn by Natasha Staller in respect of early cinema. Charting the position of this new medium in the field of Parisian entertainment culture around 1900 and the rapid growth in its outlets and audiences, she stresses the popular character of cinema, notes the lack of serious attention paid to its visual innovations by cultural critics of the period, and contrasts with this attitude the enthusiasm for cinema of Picasso and his friends from as early as 1904. Like Weiss, however, Staller argues that there was more than mere entertainment for the artist in the nascent aesthetic of film: reviewing the characteristic illusionistic devices of the cinema of Georges Méliès in particular – dismemberment and rearrangement of bodies, multiple and conflicting perspectives, impossible juxtapositions of scale – she suggests that Picasso and Braque appropriated them for cubism, and 'translated these reviled prosaic objects into works that were intentionally and emphatically artful, hermetic, difficult and multivalent . . . They took a culture common to everyone, a visual vulgate, and transformed it into a culture available only to an artistic elite'.[18]

Where, then, has the debate left our understanding of these collages? How are we to decide between interpretations of Picasso's deployment of pasted papers and charcoal drawing as inscribing a neo-mallarmist resistance to the social forces that would reduce them to the shabby status of commodities, and those for whom these works articulate a profound engagement with the political and popular aspects of these forces? Rosalind Krauss suggests that to understand 'the specificity of Picasso's utterance' we need to do two things: 'to trust our eyes about how the newsprint actually looks in this first bout of Picasso's use of it, and to understand something about Picasso's attitude toward Apollinaire's embrace of the newspaper.'[19] The second of these suggestions appears to depart both from the formalist concerns implied by the first and from the structural linguistics that have provided the foundation for them in most of Krauss's writing, in acknowledging a dialogical dimension to

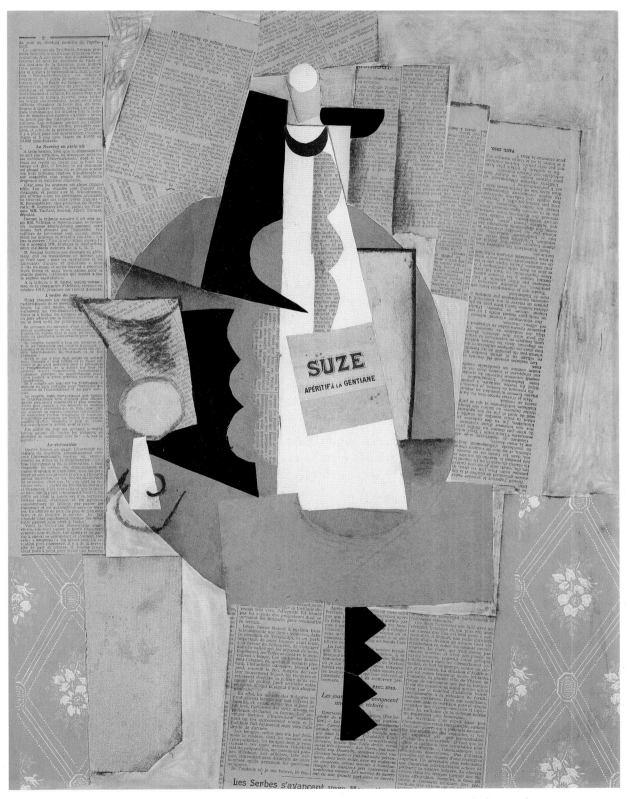

30 Pablo Picasso. *Verre et bouteille de Suze*. 1912. Pasted papers, gouache and charcoal, 64.5 × 50 cm.
St Louis: Washington University Gallery of Art. University purchase, Kende Sale Fund, 1946.

the construction of linguistic meaning and thus of Picasso's artistic 'utterances'. This is because of the role she ascribes to the sociological poetics of Bakhtin in reconciling the methodologies of semiology and social history: thus the *papiers-collés* were a response to the prior utterance of Apollinaire.[20] But such a suggestion at once distorts Bakhtin's concept of the 'dialogical' by bracketing off its social dimension, as Leighten has cogently argued,[21] and contrives to leave history out of the account – both that of the time when the *papiers-collés* were first envisaged, made and read (and Apollinaire's enthusiasm for newspapers fashioned) and that of the (post-modernist) present in which these scholarly exchanges have taken place.

Instead of Krauss's paired suggestions, then, I offer a different pair. First, that if a contemporary understanding of Picasso's pasted papers is to avoid reading the ambivalences of the present towards the modernist project back into visual texts that were produced at a moment when that project was viewed quite differently, attention should be paid to the conjuncture of late 1912, of which that project, and those texts, were a part (and the character of present interest in the latter acknowledged). Second, that – correcting Krauss's reductive interpretation of Bakhtin – the dialogical character of Picasso's visual utterances, and their available meanings for both the artist and his audiences, must be recognised as constructed within the discursive space inhabited by each, within that conjuncture.

What, therefore, were the co-ordinates of this, and how did they shape the discursive field within which Picasso's *papiers-collés* signified? The most salient of them was nationalism, whose spread in the years following the first Moroccan Crisis of 1905 was accelerated by the second, of 1911; originating among the right-wing leagues, this had by 1912 come to dominate the French political landscape, co-opting all shades of political opinion except that on the left. Classicism was one discourse through which these complexities were figured in the dominant culture both in and outside the avant-garde formation, engendering the contest between Maurrasian and Barrésian versions of a specifically French classicism, through which, as we have seen, the innovations of Cézanne and other artists and writers of the previous generation were refracted.[22]

Picasso's relation to this discourse was oblique and equivocal. Its specifically nationalist connotations meant little to him, as a Spanish artist surrounded by his compatriots and other émigrés, and sharing little of the rootless Apollinaire's need to adopt French culture and nationhood as his own. Yet, as his repeated bouts of engagement with it from 1905 on make plain, the classicist aesthetic and the classical canon held deep attraction for him. For the *dénicheurs* who made up gallery cubism's first clientele, classical values were central to the qualities that they saw in the paintings of Picasso and Braque, for all their émigré indifference to French chauvinism and the self-conscious iconoclasm of their pictorial tastes.[23] But it is evident from Uhde's reported reaction to Picasso's use of Ripolin enamel housepaint in works of spring 1912 that the painters themselves were not afraid to undermine such values, and offend those tastes in doing so.[24] The purpose, and the implications, of such undermining I shall examine later.

Only the organised working class resisted the hegemony of nationalism before 1914. The syndicalist movement, disillusioned by the experience of the Bloc des

Gauches, replaced this with self-reliance and autonomous action, and after Jaurès's 1907 espousal of anti-militarism had aligned socialists with syndicalists in opposition to an increasingly bellicose nationalism, there opened up an ideological gulf between the organised working class and the rest of the nation.[25] The high point of syndicalist agitation came at the end of 1912, with the decision of the CGT's congress in late November to call a general strike for 16 December in protest at the slide towards a pan-European war that seemed to be the imminent outcome of the Balkan conflict; its failure marked the turn of the tide of anti-militarism, though not the end of working-class opposition to war.[26]

Thus the last weeks of 1912, in which Picasso made his first experiments with pasted paper in his 'Balkan' series, were also the moment of the syndicalist movement's most acute pre-war isolation – an isolation not only from its former collaborators in the Bloc des Gauches, for the collapse of the Bloc had led also in 1907 to the break between anarchism and syndicalism. By 1913, moreover, if not before, the co-optive force of nationalism had polarised the ranks of the anarchists and anarchist sympathisers in the Parisian avant-garde coteries, with some articulating a *patriotisme esthétique*. One such was André Salmon, whose earlier links with anarchist milieux have been well documented, but who appears by 1913 to have been attracted by the modern beauty of military colours and military discipline. Others such as Léon Werth sought to escape the 'ivory tower' by voicing their outspoken opposition to the patriotic clamour and outlining, in that collective effort traced in Chapter three, an aesthetic which they sought to ground in working-class culture.[27] Between the positions taken by Werth and his small circle of associates who aligned themselves self-consciously with syndicalism and those of Salmon and others in the gallery cubist milieu, there existed a gulf which was the equivalent of that between syndicalism and the rest of the nation.

To assume, therefore, that Picasso's inclusion in his pasted papers of press cuttings about socialist and syndicalist anti-militarist demonstrations or the war in the Balkans indexes his support for the former and his opposition to the latter, and that such works thus articulated a counter-discourse that stood with those movements in political opposition to the dominant, is to ignore those features of the discursive terrain which separated his milieu from the movements of the French left in 1912. For all the artist's earlier anarchist allegiances, the means to any identification that he felt or wished to express with either anti-militarism or the working class was shaped, as for everyone else, by a field of social and cultural relations whose pressures were pushing individualistic aesthetic practice away from engagement with collective political action, intellectuals and artists from workers, French men and women from foreigners. Thus, the pasted newspapers in the *Bouteille de Suze* registered – could only register – not an affiliation but a dislocation between Picasso and the left, the stories of the Balkan War and the Pré-Saint-Gervais demonstration serving as the formal and figurative background of events to a private life symbolised both in the objects of the foreground and in the esoteric manner of their depiction; a dislocation that was also, more generally, between the artistic and political avant-gardes.

If such a rupture between the public and the private is veiled and muted by the visual richness of this particular *papier-collé*, its variety of materials and cryptic

complexity, it is clearly evident in those that immediately followed, a sub-set of works in which Picasso reduced his pictorial means to the bare minimum of a few fragments of newspaper and an armature of charcoal lines. In *Bouteille et verre sur une table* (Fig. 31), for example, a single cutting from *Le Journal* of 14 December 1912 contains within itself the juxtaposition of public and private, isolating and coupling a sub-heading about diplomatic efforts to end the first Balkan War ('La Négociation/ [les délégu]és sont à Londres') with another concerning a more private drama ('Un dra[me]/Parisien/M Walter de Mumm bles[sé]/'), suggesting a rich polarity of meanings with the synecdochical economy that is typical of the work as a whole. Two others from this sub-set, both entitled *Bouteille sur une table* and coupled by an

31 Pablo Picasso. *Bouteille et verre sur une table*. 1912. Charcoal, graphite and newsprint on paper, 48.2 × 63.1 cm. Houston: The Menil Collection.

32 (far left) Pablo Picasso. *Bouteille sur une table*. 1912. Pasted papers and charcoal on paper, 62 × 44 cm. Paris: Musée Picasso.

33 (left) Pablo Picasso. *Bouteille sur une table*. 1912. Pasted paper and charcoal on paper, 60 × 46 cm. Switzerland: private collection.

obvious formal reciprocity, achieve the same end with different means (Figs 32 and 33). In one, a newspaper covers the whole (paper) support except for a cut-out 'bottle' ideogram in the centre, and is both the background to the still-life and the ground on which Picasso has drawn it. It is the entire financial affairs page of *Le Journal* of 8 December 1912, much of which itemises the economic repercussions of the diplomatic initiatives. In the other, the newspaper piece that isolates and foregrounds the bottle in an identical shape (in reverse) is taken up with an item on 'the war against syphilis' from the same day's *Journal* – but not, as close inspection reveals, from the same sheet of paper; the formal and thematic reciprocity between the two was hence willed, and not accidental.[28] The particular relationship here proposed between the background of public events and the foreground of private concerns, turning wittily on contrasting arenas of war, could hardly be more clearly indicated.

Dislocation, however, did not mean immunity. The consolidation of the avant-garde as a formation in no way insulated its members against the political pressures, any more than it ensured their ideological unity. In contrast to the gulf that separated the working class from the bourgeoisie until the *union sacrée*, the borders of the avant-garde were, as we have seen, uncertain and open to traffic, within the dominant class, in both directions. As the example of Salmon indicates, it was not only in the exclusively French milieu of the salon cubists that nationalism made headway, but also in the more cosmopolitan circle of *la bande à Picasso*. As is further shown by that of Apollinaire – who enthusiastically and unnecessarily enlisted when war broke out ᵒ the colours but foreigners too.

ERRATUM

The publishers regret that plates 32 and 33 have been reproduced upside-down

Yet the communities of the artistic avant-garde were also among the primary sites of resistance to nationalism, because it was among other things the preponderance of émigrés among their ranks that simultaneously marked them off from the artistic mainstream and drew them together, as noted earlier. Their self-referentiality and relative isolation underwrote the idea that the condition of the artist was necessarily one of estrangement – both from the ideology of nationalism and from the principal institutions of the the mainstream cultural apparatus (Academy and salon, juries and medals) – and fostered an ideology of aestheticism.

It was towards this ideology that Picasso and Braque's immediate milieu from about 1908 was weighted – the close circle of dealers, collectors and *fantaisiste* poets whom they saw almost daily. For all of them, the experience of aesthetic creativity was of overriding importance. In the case of the collectors and dealers such as Uhde, Dutilleul and Kahnweiler the exercise of their independent aesthetic discernment in the discovery of contemporary *maîtres* was a source of the profoundest pleasure: Uhde once declared that the pleasure in the discovery of a bargain was often equal to contemplation of the prize, and his days appear to have been spent during those years in the pursuit of such bargains. For him and other *dénicheurs* – Level, Haviland, Leo (if not Gertrude) Stein – the discernment, the advanced taste necessary for such pursuit seems to have been a foundation for their sense of identity, a means of distinguishing themselves from their social peers. Secure in their class but not part of its dominant fractions, of independent means but richer in cultural capital than economic, for them patronage of cubism was among other things an assertion of individuality, a social manoeuvre, which Pierre Bourdieu has described:

> Liking the same things differently, liking different things, less obviously marked out for admiration – these are some of the strategies for outflanking, overtaking and displacing [the dominant fractions] which, by maintaining a permanent revolution in tastes, enable the dominated, less wealthy fractions, whose appropriations must, in the main, be exclusively symbolic, to secure exclusive possession at every moment.[29]

The art that they bought did not depart entirely from orthodoxy, however, as we have seen: its radical formal inventiveness and esoteric intertextuality were anchored to traditional pictorial genres and aesthetic values. For Level, Kahnweiler's great merit was that 'he was able to discover, among those artists who were ignored by the big Parisian dealers, the best champions of the young, independent yet traditional art of the first years of this century.'[30]

It was this acknowledgement of a tradition whose unspoken yet cardinal reference was classicism that also marked the difference between literary aestheticism in the years after 1905 and that of Mallarmé. In the context of the literary polemics of the post-Bloc moment it signalled a retreat from the counter-discursive ambitions and political allegiances of the latter. However symbolically these were articulated, they had given Mallarmé's efforts to renew and problematise poetic language a subversive potential that post-Bloc aestheticism lacked, as I noted in Chapter 3. Yet it is evident that Mallarmé's work remained paradigmatic for members of the Bateau-Lavoir

milieu as well as being a touchstone in contemporary aesthetic debate. In relation to cubism, indeed, *mallarmisme* had specific connotations: these were negative for Roger Allard, who saw in the 1910–11 paintings of Picasso and Braque a 'composite mallarmism' whose complex yet formulaic obscurities he juxtaposed to the constructional clarity of salon cubism. For Ardengo Soffici, writing in the same summer, they were nothing but positive: comparison with Mallarmé's 'elliptical syntax' and 'grammatical transpositions' offered a means of characterising paintings whose mystery and difficulty only increased the pleasure they gave him.[31]

Given such currency in the *bande à Picasso* it is likely that Picasso himself was keenly aware of Mallarmé's ideas, even if evidence of his personal acquaintance with the poet's writings is, to say the least, inconclusive.[32] Moreover, his artistic practice had in early 1909 altered in such a way as to encourage a development of his already evident interest in interrogating the conventions of pictorial realism, into an absorption with the 'incantatory power' of pictorial signs. As Terry Eagleton argued *à propos* literary production:

> If literary modes of production are historically extrinsic to particular texts, they are equally internal to them: the literary text bears the impress of its historical mode of production as surely as any product secretes in its form and materials the fashion of its making . . . One might add, too, that every literary text in some sense internalises its social relations of production – that every text intimates by its very conventions the way it is to be consumed, encodes within itself its own ideology of how, by whom and for whom it was produced.[33]

For Picasso the first months of 1909 were the pivotal moment when the patronage of the small group of collectors who had been drawn to his work was consolidated in several ways: new collectors, including Shchukin, Haviland and Dutilleul, joined the circle; Vollard, whose support for Picasso had faltered after *Les Demoiselles d'Avignon*, began buying again; crucially, Kahnweiler decided at this time, as his acquisition records show, to risk concentrating his attention on a small stable of artists, and from this point until the war effectively underwrote their pictorial production.[34] This group of patrons provided for the work of both Picasso and Braque an audience that was small, private, self-selected, made up of cognoscenti responsive to formal innovation and intertextual play.

It was at exactly this moment that Picasso's manner of working abruptly changed. After early 1909 he made no more big paintings, undertook no more major projects in the salon manner, until 1913. With the completion of the *Pains et compotier sur une table*, the culmination of an extraordinarily rich and complex series of such projects, Picasso adopted a very different way of working, in which each painting was part of an open series, a fresh point of departure for a sustained interrogation of the conventions of pictorial illusionism, whose own formal conventions posited just such an audience as he had acquired. As if in specific response to Mallarmé's demand, in 'Le Mystère dans les lettres', for an art that would 'dissuade the lazy',[35] these paintings were dense and difficult to read, elliptical in their inter-references, accessible only to initiates. It was, indeed, in the words of the poet that Kahnweiler later characterised works such as these:

To evoke purposely in a shadow the silent object, with words that are never direct
but allusive, subdued to an equal silence, requires an endeavour close to creation;
it becomes credible within the limits of the idea that is uniquely called into play by
the magic of letters until, of course, some visual illusion sparkles. Poetry, that
spellbinding ray![36]

Papier-collé and the 'Popular'

For Mallarmé and the symbolist writers and artists of his generation, aestheticism had
signified estrangement from the commodification of art to which the proliferation,
overcrowding and – for many – democratisation of cultural institutions had led. But
by 1912 the commercial landscape had altered as much as the political. As noted
earlier, the strategies of avant-gardism by which such estrangement was declared in
the decade after 1905 were themselves in part functions of wider cultural and
economic changes, such as the developments in consumerism, particularly the growth
of the department stores. Here the Exposition Universelle of 1900 marked 'a new and
decisive conjunction between dreams and commerce, between events of collective
consciousness and of economic fact'.[37] The most dynamic among the economic
sectors where dreams were commodified were those whose products were used and
enjoyed by Picasso, both in his art practice and outside it: these were advertising and
entertainment, both of which grew rapidly in the pre-war period. Advertising quickly
expanded both in the streets of Paris and in its daily papers: from about 1912 there
were innovations in the design and deployment of newspapers which now juxtaposed
advertisements with editorial copy across all pages and introduced photographic
illustration.[38] In the same period, the takings of the city's entertainment industry rose
dramatically, by 1911 doubling those of 1900 (and now including cinema receipts as
well as theatre, *café-concert* and music hall) and increasing more rapidly still in the
next two years.[39] The momentum came from the newest media: even by 1901 a
critical observer could report that the music hall had 'definitively' replaced the
cabaret, *café-concert* and theatre, all by then too conventional. The growth of cinema
was most spectacular: from five 'permanent' cinemas (as opposed to the temporary
screens erected in billiard halls and the like) in Paris in 1900 the number rose to 200
in 1913 and 260 in 1914.[40]

Both contemporary observers and modern historians of these developments are
agreed on the emphatically popular character of the new entertainment media;[41] the
social base of music hall and particularly cinema was overwhelmingly working class,
for several reasons, of which the primary was cost. After 1900 the price of the leading
café-concerts was more than five francs, equal to the daily wage of an unskilled
worker, while theatres cost double or three times this amount. Cinemas, by contrast,
charged two francs at most, and as little as 30 centimes – at this price an evening spent
at the cinema was for a poor family an evening's heating and lighting saved.[42] A
second reason was convenience: where the theatre required attendance for a complete
performance and close attention to its plot, not to mention to codes of audience dress

and conduct, cinema especially could be taken on each spectator's own terms, its darkened auditoria entered and left at any moment in their programmes, which consisted – like music hall – of numerous short, often unrelated items. A third was inheritance: both music hall and early cinema owed much to circus and fairground entertainment in their slapstick and variety character, and before 1914 temporary screens in sideshows were a regular feature of cinema.[43]

But it is important to stress that there was nothing in these particular media that made them inherently 'popular'. Within a few years the cinema was both an acceptable bourgeois entertainment and legitimised as art, and some of its common characteristics (movement, montage, encyclopedic reach) were quickly identified by numerous observers, from Doumic in 1913 onward, as emblematic of modernity itself, while slapstick and variety were long ago assimilated to dominant culture. As Stuart Hall has emphasised, 'the meaning of a cultural form and its place or position in the cultural field is *not* inscribed inside its form. Nor is its position fixed once and forever'; instead, that meaning is 'given in part by the social field into which it is incorporated, the practices with which it articulates and is made to resonate'.[44] What is essential to the definition of popular culture in particular, Hall argues, is not a fixed set or inventory of practices and artefacts, but 'the relations which define 'popular culture' in a continuing tension (relationship, influence and antagonism) to the dominant culture.' This is a conception of culture, he notes, 'which is polarised around this cultural dialectic. It treats the domain of cultural forms and activities as a constantly changing field . . . [and] looks at the relations which constantly structure this field into dominant and subordinate formations.'[45] Within the conflicted social field of the pre-war decade, and given the ideological gulf that then separated the working class from the dominant bourgeoisie (physically marked by the increasing displacement of unskilled workers to the periphery of post-Haussmann Paris[46]) the subordinate, 'popular' character of cinema and music hall was accentuated, their distinctiveness from dominant culture placed at a premium. For those spectators who had access to dominant culture, this distinctiveness was – could not help but be – a part of their reception of the performances and screenings.

As the numerous essays on the exponential growth of both music hall and cinema testify, it was obligatory for cultural commentators to register this distinctiveness. The ways in which they did so varied, from the condemnation of a conservative such as Talmeyr who was outraged at the music hall as 'an agent of perdition and of brutalisation of the people' and dismissive of the incoherence of its form; through the paternalistic detachment of Haugmard for whom the 'people' was 'still a big child that needed, to help forget its miseries, an album of images to leaf through'; and the equivocation of Doumic, who regarded the cinema as 'theatre for illiterates' and as formally incoherent but as such also 'eminently modern'; to the enthusiasm of Rémy de Gourmont for whom cinema's encyclopedic reach was as instructive as its naïveté was amusing.[47] Significant among the critics at this end of the spectrum was Maurice Raynal, a familiar of the Bateau-Lavoir from 1910 and a key contributor to the debate over cubism in 1912, who from December 1913 wrote a fairly regular column on cinema for Apollinaire's *Soirées de Paris*. Nothing of his cubist criticism is

remotely evident in these reviews; as Staller has observed, 'for Art, Raynal explicated abstract ideas in lofty, rather philosophical language; for film, he went slumming with gusto.'[48] His reviews convey an infectious enthusiasm for the fantasies of film, but one laced with a transgressive enjoyment of the marginal and licentious character of its auditoria and ironic appreciation of its unintended mistakes and banalities – such as a cinema's piano acompaniment to a screen figure playing a violin, or the bad acting of Mlle Mistinguett, or the obscenities that he claimed to have lip-read actors speaking in place of their 'proper' lines. Staller notes that 'Raynal viewed these banal works through the prism of a heretical, disjunctive sensibility.'[49]

The disjunction was not, however, only with the primary audience of this cinema or the aesthetic of the films themselves – neither of which shared Raynal's sense of irony – but was also (and perhaps more intentionally) with the cultural assumptions of the dominant fractions of that bourgeoisie, to a dominated fraction of which Raynal as an intellectual belonged. In this context, Bourdieu's analysis of the strategies of distinction pursued by intellectuals is as applicable to Raynal's taste for the popular as to that of the *dénicheurs* for gallery cubism:

> Intellectuals and artists have a special predilection for the most risky but also most profitable strategies of distinction, those which consist in asserting the power, which is peculiarly theirs, to constitute insignificant objects as works of art or, more subtly, to give aesthetic redefinition to objects already defined as art, but in another mode, by other classes or class fractions (e.g., kitsch). In this case, it is the manner of consuming which creates the object of consumption, and a second-degree delight which transforms the 'vulgar' artifacts abandoned to common consumption . . . into distinguished and distinctive works of culture.[50]

In these terms, Raynal's 'slumming' – his self-positioning with respect to the films and their primary audience, by means of ironic detachment and a facetious enthusiasm, or 'second-degree delight' – represented a gesture of avant-gardist distinction from dominant, bourgeois culture. As a strategy it was not confined to cinema: Raynal wrote in a similar vein, both in his cinema column and elsewhere in *Les Soirées de Paris*, about a variety of popular cultural forms, including boxing and crime thriller novels – the most celebrated example being *Fantômas*, for which the *bande à Picasso* shared an enthusiasm that has been widely documented, and whose extravagance of expression was another marker of their ironic detachment and thus distinction.[51]

Picasso's own enthusiasm for popular entertainment of all kinds is well known, and his visits in the cubist years to the Cirque Médrano and nearby cinemas even more widely documented. Together with anecdotes about the habit he and Braque had at that time of wearing *bleu mécano* overalls, and of calling Kahnweiler *patron*, this has often been taken as evidence of Picasso's preference for the unpretentious pleasures of 'low' culture over those of 'high', and of his identification with their working-class audiences, an identification that was declared both in their inclusion of popular motifs and artisanal techniques in paintings from 1912 and, above all, in the *papiers-collés*; and following from this, as evidence of Picasso's readiness to mock conventional cultural hierarchies.[52] Once again, though, such inferences ignore both the specific discursive forces through which cultural relations and social identities were

constructed, and their configuration in 1912. Like Raynal's response to the cinema, Picasso's engagement with popular motifs and materials registered the tensions and pressures of that moment, which not only sharply separated popular from dominant culture, 'low' from 'high', but also consolidated the distinct identity of the dominated fraction of the latter that was the avant-garde.

These movements of disjunction and distinction were inscribed in the *papiers-collés* in a number of ways. One was through Picasso's consistent selection (as it appears) of the cheapest, least culturally elevated examples of whatever medium he employed. Thus, for his fragments of newspaper Picasso looked to the downmarket 'penny press' rather than the more staid and expensive upmarket dailies, habitually choosing *Le Journal*, the most expansive of the former, and usually selecting from its range of advertisements not the most sophisticated, which drew on the newest technologies of photographic illustration, but the cheapest and crudest *petites annonces*.[53] Thus too for his fragments of wallpaper: recent developments in mechanisation had greatly expanded the availability of inexpensive wallpapers, and as both Poggi and Leighten note, Picasso invariably used the very cheapest of the range, papers most commonly found in working-class homes and cafés – such as the fragments used repeatedly in the *Bouteille de Suze* and other *papiers-collés* of late 1912.[54] Such a selection, underscoring the emphatically popular character of these materials, not only distinguished his aesthetic from the dominant discourse of traditionalism but also undermined its values, those of the 'great' (and essentially classical) 'tradition of the Louvre', which Uhde had recognised in the cubism of 1910. Hence Uhde's dislike of Ripolin housepaint.

Dominant culture was not monolithic, however, and its increasingly nationalist character was configured not only by traditionalism but also by that discourse of decoration which represented on an aesthetic level the ideology of solidarism. The contemporary renewal of interest in the decorative had two main components: one was the idea of art as decoration, fostered by the art educational and institutional reforms of the early Third Republic, and by the commodification of art to which these reforms and the proliferation of the art market had led; the other was the encouragement of the decorative arts industries and of *art social*, prompted by economic anxieties and fears for social peace, as we saw in Chapters 1 and 3. Both led to the blurring of the conventional distinction between fine and decorative art, and an increasingly desperate emphasis on craft skills and *métier* in the face of encroaching mechanisation and division of labour. Such emphases and such an identification of art with craft were antipathetic to aestheticism, since they denied the transcendent potential of aesthetic endeavour. For Picasso, art could not be reduced to artisanal dexterity, to the *patte* of the painter, any more than the 'magic of letters' was for Mallarmé a matter of mere facility with words. Against this decorative discourse, the *papiers-collés* declared in the manner of their making Picasso's rejection of its very definition of art; nothing could be easier to construct than these cut-and-paste pictograms.

Radical departure though they were, Picasso's adoption of popular materials and motifs and his abandonment of craft skills were themselves less significant, however, than the purposes to which he put them. It is in their seemingly effortless invention,

manipulation and juxtaposition of verbal and visual signifiers that both the appeal and the importance of Picasso's *papiers-collés* reside, that witty and often scabrous word- and image-play to which Rosenblum first gave scholarly consideration (as the repeated attention that these qualities have subsequently received testifies). In them especially the character of Picasso's relation to popular culture is evident. On the one hand, they show his real enjoyment of this culture and his appreciation of its characteristic devices; on the other hand, his distinction from that culture was marked by the hermeticism of these *papiers-collés* – the difficulties of reading that they must have presented for any contemporary audience, even that of his own milieu – and their multi-layered engagement with the rich potential of the interrelation between verbal and visual signifiers. For all the complexity and in-joke character of the *revue*, it needed (as Weiss acknowledges) a large audience to survive: if its oblique and ironic attitude to political events was a measure of its publics' alienation from these and their lack of power to affect them, its sketches yet depended for effect on the wide currency of its references in public discourse. For Picasso, by contrast, such irony registered his separateness not only from the discourse of public events but also from the publics that newspapers constructed for these events, as well as his *mallarmiste* absorption in the 'magic' of the aesthetic; their very difficulty counterposed his pasted papers to the accessibility of popular entertainment.

Such a counterposition entailed a dialogical construction of the meaning of pictorial utterances that was more inclusive than the relationship *à deux* of Picasso and Apollinaire that Krauss, misreading Bakhtin, posits as the basis for the signifying strategies of the *papiers-collés*. For Bakhtin and his circle, individual participants in an utterance are not separable from their social and ideological context; it is their social identity that gives a linguistic sign its specific accents. 'At any given moment of its evolution', Bakhtin declares,

> language is stratified not only into linguistic dialects in the strict sense of the word . . . but also . . . into languages that are socio-ideological: languages of social groups, 'professional' and 'generic' languages, languages of generations and so forth . . . And this stratification and heteroglossia, once realized, is not only a static invariant of linguistic life, but also what insures its dynamics . . . The authentic environment of an utterance, the environment in which it lives and takes shape, is dialogized heteroglossia, anonymous and social as language, but simultaneously concrete, filled with specific content and accentuated as an individual utterance.[55]

It was thus not only against Apollinaire's aesthetic of the newspaper that Picasso's was counterposed, but that of the newspapers themselves and of the popular culture of which they were a part. And the *papiers-collés* used the 'period lexicon', as Weiss terms it, of that aesthetic only to mark their difference from it. As the sociologist John Clarke observes of contemporary youth sub-cultures, the materials and motifs that are used to assemble a new sub-cultural style

> must not only already exist, but must also carry meanings organised into a system coherent enough for their relocation and transformation to be understood *as a transformation*. There's no point in it, if the new assemblage looks exactly like, carries the same message as, that previously existing.[56]

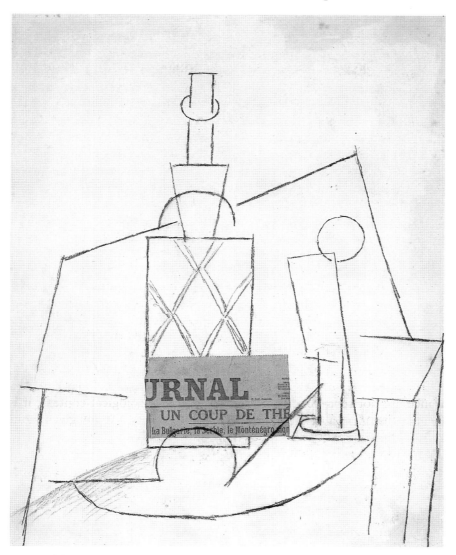

34 Pablo Picasso. *Bouteille, verre et journal sur une table*. 1912. Pasted paper and charcoal on paper, 62 × 48 cm. Paris: Musée National d'Art Moderne.

So too with Picasso's sub-cultural *détournement* of the communicative system of the newspaper: it was against its aesthetic, not in support of it, that his transformations of its materials were deployed, along that axis of dislocation between the public and the private that I have already identified.

Thus in the *papier-collé* of December 1912, *Bouteille, verre et journal sur une table* (Fig. 34), the inclusion in the precisely trimmed fragment of newspaper of an unambiguous reference to the Balkan War and its diplomatic resolution ('La Bulgarie, la

Serbie, le Monténégro sign[ent]') indicates clearly his acknowledgement of that public
discourse. Against the fixity of this pole of reference the other typographic elements
interact with graphic signs in a free play of meaning on several levels. The signified of
'UN COUP DE THÉ[ÂTRE]' is unclear; however unlikely the term 'a "hit" of tea' may be,
that is its literal meaning, and on an iconographic level this accompanies, on the café
table, the newspaper and the bottle for which the cutting also provides a surrogate
label. But 'UN COUP DE THÉ' has also been taken – reasonably, given the circumstan-
tial evidence – as a punning reference to Mallarmé's poem 'Un Coup de dés jamais
n'abolira le hasard', whose complex and allusive deployment of typography across a
series of double-page spreads was, among other things, the poet's profoundest riposte
to the newspaper, a literary text that takes on the graphic challenge of the latter and
magisterially marks its difference from it.[57] In this very uncertainty, this slippage of
the signifier, is registered Picasso's delight in the aesthetic process, foregrounded here
against the background monotone of political discourse.

This counterposition is even more marked in the very first *papier-collé* that the
artist made. *Guitare, partition, verre* of November 1912 (Figs 35 and 36) once again
includes an unambiguous, metonymic reference to the Balkan War, secured in a
newspaper fragment by the single word 'CONSTANTINOPLE'. As with the *Bouteille,
verre et journal*, the reference was clearly deliberate: had Picasso not intended it, he
could have cut it off, for that section of the clipping serves no other purpose. But it
is this anchoring of one pole of meaning in the public discourse that gives the other
textual elements their resonance; without it, the ambiguities of 'LE JOU' and 'LA
BATAILLE S'EST ENGAGÉ[É]' would lose much of their allure of private, sub-cultural
play.[58]

At the centre of that play, the key term in the transformations that these *papiers-
collés* effect, is wit; the juxtaposition of these slippages of the signifier from one
private allusion to another against the fixity of public events turns on, and throws
into relief, Picasso's own creative imagination. As Pierre Daix observes of these first
spare, succinct, charcoal-and-single-clipping Balkan War works,

> Never before did he present himself to the spectator, not only without the tricks of
> the trade, but using means that are within everyone's grasp. And never before had
> a painter asserted his power as a creator, as a poet in the strongest sense of the
> word.[59]

Daix's terms are precisely appropriate: it was against just those 'tricks of the trade',
those *métier*-based skills of the painter which the dominant cultural discourse privi-
leged, that Picasso profiled his creative power, against the banality of public discourse
and the ubiquity of its media that he counterposed his poetic inventiveness. The
parallel with Mallarmé is implicit; yet the differences between this aestheticism and
that are clear. Between the fin-de-siècle and 1912–13, the co-ordinates of aestheticism
had changed: where, for Mallarmé, popular culture, epitomised by the newspaper,
was part of the dominant culture of the secular republic – the banalities of the
collectivism of both threatening the individualism of the aesthetic – by 1912 domi-
nant and popular culture were more distinct, separated by the ramifications of mass
production and inter-class hostility – the popular challenging the hegemony of the

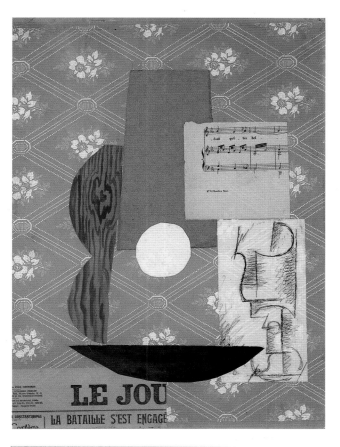

35 (left) Pablo Picasso. *Guitare, partition, verre.* 1912. Pasted papers and charcoal on paper, 48 × 36.5 cm. San Antonio: Collection of the McNay Art Museum, Bequest of Marion Koogler McNay.

36 (below) *Le Journal*, 18 November 1912, top part of front page.

dominant with its energy, ubiquity and novelty. In appropriating popular culture's materials and motifs, Picasso was distinguishing himself from the dominant fractions of bourgeois culture, but in the aestheticism of his use of these he also registered his distinction from the popular.

If this double movement of appropriation and disjunction distanced such an aestheticism from that of Mallarmé, so too did Picasso's foregrounding of his creative imagination. The poet had envisaged words themselves taking the initiative, 'mobilised by the collision of their inequalities, kindling reciprocal reflections like the flashes of fire between precious stones'.[60] But for the painter the art of turning commercial dross into aesthetic gold illuminated above all his own alchemical genius. That such display of his creative imagination was of fundamental importance for Picasso, a constant term in his otherwise astonishingly varied oeuvre, is now a commonplace of modernist art history. Attention to it in these terms, though, has obscured the extent to which it was discursively constructed. 'Genius' was the lynchpin of the concept of avant-gardism. As a consolation, since the beginnings of modern capitalist relations of cultural production, for the alienation of the artist, it gained added valency in the fin-de-siècle as this condition was exacerbated by commodification, marginalisation and technological obsolescence. Underwritten by Nietszche and others, it registered on an aesthetic plane an unfettered individualism, the assertion of which was both central to the ideology of liberalism and a bulwark against the collectivist imperatives of liberal democracies such as the Third Republic. In the post-1905 movement of artistic disengagement from political activism and of consolidation of the avant-garde formation it was this shared quality that, in the words of Henri-Martin Barzun quoted in Chapter 2, enabled the mutual recognition of 'the creative elites of the whole world', united 'as brothers, by the anguish, the privations, the dangers of their adventure.'

Crucially, as Barzun's phrase demonstrates, both this genius and the creative elites who possessed it were masculine. For Picasso in particular, this understanding of its character was overdetermined. Leo Steinberg was the first to argue, in his groundbreaking 1972 articles on the *Demoiselles d'Avignon*, that the relation between Picasso's sexual and artistic identities – indeed their conflation – was for the painter a burning issue from the time of that painting if not earlier. Since then a generation of scholarly work has deepened this understanding but, once again, the extent to which this gendered artistic identity was socially constructed has been less acknowledged, despite Carol Duncan's equally pathbreaking analysis in 1973 of the masculinist ideology of the early twentieth-century avant-garde milieux, and of the *Demoiselles* as a product of this.[61] Since Duncan's essay the history, and the character, of gender relations in pre-war France have been more clearly drawn, and the regressively sexist character of avant-gardist liberation from bourgeois convention that she succinctly outlined can be seen as part of the crisis of masculinity experienced by that generation.

Threatened in economic and social arenas in the years around 1900 by the broad-based yet limited advance of women's emancipation, known patronisingly as 'the woman question', disconcerted by the growing strength of the feminist movement

and alarmed at France's declining birth rate, French men of all classes gained a heightened awareness of their gender. This found expression in a variety of ways, as noted earlier, from anti-feminist treatises, novels and plays to the cult of action, the growth of sports and other customs of male sociability. The consolidation of the Parisian avant-garde formation was in part one such expression: Barzun's band of heroes, the little magazines and associated coteries, the competitive posturing of the manifesto culture were all emphatically male. Picasso was at the centre of this, his affectation of *bleu mécano* overalls a gendered as much as classed statement against the 'bohemian' sartorial style of his *humoriste* elders in Montmartre[62] – and his *papiers-collés* repeatedly indexed the masculine social environment of café drinking, card games and dirty jokes whose male exclusivity was heightened by its juxtaposition with, and subversion of, the discourse of public events.

Seen as a practice shaped by the discursive field of 1912, Picasso's engagement with the 'popular' in the materials and motifs of his pasted-paper works thus emerges as both more complex and more ambivalent in its cultural significance than recent interpretations have suggested – neither a purely *mallarmiste* refusal of the aesthetic of the newspaper and the social forces that this represented, nor a wholesale critique of the aesthetic hierarchies of dominant culture, its pretensions to counter discourse compromised to the degree of its complicity with these. For all the evident iconoclasm of his appropriation of the vernacular, due attention to the particularities and dynamics of that discursive field reveals the unwisdom of drawing inferences about Picasso's intended meaning from 'how the newsprint actually looks' alone – and beyond this, the inadequacy of any *a priori* equation between 'avant-garde' and 'oppositional'.

Newly emergent though this formation was in pre-1914 Paris, it was already fragmented by the social forces I have outlined, pulled into a plurality of positions vis-à-vis a dialectic of dominant and popular culture that the conjuncture of the end of the twentieth century has made more sharply visible, perhaps, than at any time since its beginning. The heightened clarity brings its attendant shadows, however, and throws its objects of analysis into a pattern of relief specific to the co-ordinates of the present. An understanding of the counter-discursive potential of cubist engagement with the popular in pre-1914 Paris requires an attention both to the co-ordinates of that conjuncture and to those features of its cultural dialectic which, once illuminated by these, are now obscured. Picasso's *papiers-collés* were not in a position to fulfil the subversive promise of Mallarmé's aestheticism; Paris in 1912–14 was not, unlike Moscow or Berlin in 1919–20, open to the possibility of either cultural or political revolution. Indeed, the tide was running strongly the other way, with consequences for cubism that I shall examine later.

Chapter 6

Between Theory and Practice:
The Meanings of Cubism

Of all the manifestos of modernism, a genre of writing notoriously productive of confusion, none has produced more than *Du Cubisme*. Written by Gleizes and Metzinger sometime in 1912 as a theoretical accompaniment to that autumn's showing of cubist painting at the Salon d'Automne and the Salon de la Section d'Or, there is even uncertainty as to when it was actually published.[1] Given both the paradigmatic status that cubism soon acquired for modernism and the public profile of its authors before 1914, the notoriety of this first substantial account of cubist aesthetics from within the movement was inevitable, its widespread influence hardly less so, and thus any confusion over its content was bound to resonate widely. In itself, by the standards of the genre the text is quite comprehensible; the confusion arose from attempts to read the manifesto in direct and unmediated relation to the canonical works of cubism. Understandable though such attempts have been, they rest upon two misconceptions: first, that *Du Cubisme*'s two salon cubist authors were in a position to speak for the gallery cubists (principally Braque and Picasso) whose paintings predominate in that canon; second, that the writing which Gleizes and Metzinger undertook to accompany their visual practice can be read unproblematically as an explanation of it, or indeed of that of any other cubist. For within the dynamic of the pre-war Parisian avant-garde milieux, both art criticism and art practice developed their protocols, pursued their own avant-gardist strategies and agendas. *Du Cubisme* was written and Gleizes' and Metzinger's pictures were painted within closely related but different discursive spaces; what and how each signified was a function of the way in which their authorial identity was constructed, and their verbal and visual statements positioned, by each discourse. What bearing *Du Cubisme* as an artists' text had on its authors' painting, or that of other cubists, was in turn a function of the specific relation that obtained between these discourses; a relation that was not, I shall argue, as direct or as one-way as has been assumed. As the notoriety of cubist painting increased through 1911 and 1912, a debate developed among critics over both its possible meanings and its significance, in which more was at stake than artists' reputations. With each critical intervention, the terms of the debate slipped steadily further from the exhibited visual work, and it articulated more concerns than aesthetic ones alone. *Du Cubisme* was first and foremost a contribution to this debate, a staking-out of a position in the contest over the meaning of a

cubism that was a critical and ultimately ideological construct, and only secondarily an explanation of cubist paintings.[2] It is this critical context, and contestation, that must be explored if the significance for its contemporaries of cubism's only manifesto – and, beyond this, the relation between critical and artistic practices in the construction of cubism – are to be understood.

Critical Adjustments

> The cubists play a role in art today analogous to that sustained so effectively in the political and social arena by the apostles of anti-militarism and organised sabotage; and just as it is evident that the preachings of Hervé[3] have contributed strongly to the renaissance of patriotic sentiment that we are now witnessing, so doubtless the excesses of the anarchists and saboteurs of French painting will contribute to reviving, in artists and amateurs worthy of the name, the taste for true art and true beauty.

Thus wrote the critic Gabriel Mourey in his review of the 1911 Salon d'Automne for the moderate conservative daily *Le Journal*, pithily encapsulating all the fears and hopes of an art establishment faced with the avant-gardist innovations – both in art and in the promotion of it – of the salon cubists at a moment of national crisis.[4] The second dispute with Germany over Morocco, begun in July, was as yet unresolved, and the rising temperature of patriotism and xenophobia made such elisions between aesthetic and political subversion easy: Mourey was not alone in condemning the cubists in social as well as aesthetic terms.[5] Such comments came chiefly from the professional, journalist critics who wrote regularly for the daily papers, and whose numbers were increasing; the space they commanded in those papers was expanding, as the art market grew in volume and the outlets for contemporary art proliferated.[6] Perhaps more than ever before a necessary element in that market – selecting on behalf of their publics from the many works on exhibition, guiding their viewing habits and tastes in a period of a bewildering variety of styles and art attitudes – the critics were committed as much to their readership as to the artists whose work they reviewed; none were close to the cubists, and they had as individuals no influence on their art. They did, however, collectively create a climate of reception for the movement that, growing stormier with each public appearance of cubist painting from the 1911 Indépendants on, contributed in its turn to the way the artists promoted, justified and even regarded their own work.[7] By late 1911, nationalism had become a central term in this reception.

It was not the only one. For a generation, the efforts of anti-academic or unorthodox artists had conventionally been regarded as legitimate targets for satirical wit or critical disdain, and these responses had developed a set of standard tropes and clichés that were repeated and elaborated with increasing frequency as avant-gardism became a strategy adopted profitably by artists and dealers alike. The publication within a few weeks of each other in early 1909 of Marinetti's founding manifesto of

futurism and Mauclair's condemnation of 'the prejudice of novelty in modern art' marked a significant moment in this elaboration, in which the congruence of avant-gardism with contemporary trends in commercial advertising was for the first time widely registered; from then on, the two were understood by journalist critics as sharing the same character of self-interested and dishonest hype. It was also the moment that the term 'cubism' first entered the critical lexicon, its jargonistic absurdity signifying just such qualities even while it as yet lacked any specific referent.[8] By the time of the eventual appearance of this referent in Room 41, the terms of its inevitably hostile reception had thus been predetermined. To take but three examples: Janneau, for *Gil Blas*, duly questioned the salon cubists' sincerity, Claude of *Le Petit Parisien* accused them of *arrivisme*, while Tardieu in the *Echo de Paris* condemned 'the snobbery of the gullible which applauds the most stupid nonsenses of the art of painting presented to idiots as the audacities of genius'.[9]

Such suspicion is unsurprising in critics who supported the aesthetic and social status quo; it is interesting, however, that already in 1911 it was shared by critics of cubism whose guiding commitment was to the political far left. Henri Guilbeaux, anarchist and sympathiser with revolutionary syndicalism, reviewed the 1911 Indépendants for the left-wing weekly *Les Hommes du jour* in terms close to Tardieu's, dismissing the work of Léger, Metzinger and others as 'grotesque, ridiculous, intended – it would appear – to bewilder the bourgeoisie', paintings 'whose cubes, cones and pyramids pile up, collapse and . . . make you laugh'.[10] While the underlying reasons for Guilbeaux's criticisms were quite contrary to those of Tardieu, and related to his interest in the development of a public, popular and accessible art – one towards which he thought his fellow-anarchist Signac, Luce and other neo-impressionists were striving – such suspicion of the sincerity of the cubists appeared to bridge the ideological divide between them. It also joined them to journalist critics who stood, aesthetically and politically, at all points in between. Louis Vauxcelles, one of the most active and conscientious of these, declared that a critic should be aware of 'all the artists of Paris, painters, sculptors, engravers, decorators, potters', and should be someone in whom they would 'have confidence not only for his clear-sightedness but for his integrity'.[11] A Radical, as noted earlier, in his political and aesthetic affiliations, Vauxcelles wrote regularly for the left-of-centre republican daily *Gil Blas*; he was sympathetic to the efforts of young and unorthodox artists, preferring the Salon d'Automne (of which he was a director) and the Indépendants to the 'official' salons, the 'gauche' of the artistic spectrum, as he put it in 1909, to the 'droite'.[12] None of which prevented him from indulging in witty and ribald mockery of what he saw as the pretentiousness of the cubists ('But in truth, what honour we do to these bipeds of the parallelepiped, to their lucubrations, cubes, succubi and incubi'[13]), pandering to the prejudices of his audience in a way that suggests greater familiarity with their tastes than with the ideas of the artists he was reviewing.

Vauxcelles's critique contained more than the scepticism of the ill-informed, however. His aesthetic allegiances were with ex-nabi artists such as Denis and Bonnard, who were among the leading patrons of the Salon d'Automne, and who were then turning the synthetist precepts of Gauguin to decorative purpose.

Vauxcelles's views also extended as far as the fauve painters of 1905; the concept of the 'decorative landscape', elaborated by artists and theorists of their milieu, fitted in well with the solidarist *art social* initiatives to which he gave enthusiastic support.[14] From 1907 he became uneasy at the direction being taken by Matisse, Derain and their followers, which he saw as perilous and dogmatic, 'an uncertain schematisation, proscribing relief and volumes in the name of I know not what principle of pictorial abstraction'.[15] Not only did it conflict with his commitment to *sensibilité* as the basis of the relation between art and visual reality, but the grouping itself appeared to signal an abdication from individualism, which he valued as highly. His concern sharpened on both counts in the next few years as the members of the salon cubist group began to find common ground; as early as 1909 he condemned 'the frigid extravagances of a number of mystificators', and demanded:

> Do they take us for dupes? Indeed are they fooled themselves? It's a puzzle hardly worth solving. Let M. Metzinger dance along behind Picasso, or Derain, or Bracke [sic] . . . let M. Herbin crudely defile a clean canvas – that's their mistake. We'll not join them . . .[16]

A year later he repeated the condemnation, attacking the *pasticheurs* of Matisse, Friesz or Picasso, in particular Metzinger and other 'ignorant geometers' who 'reduce the human body and the landscape to livid cubes'.[17] The terms of this criticism – rejection of an intellectual approach to painting and of the validity of a grouping based on adherence to a common style – were fundamental to Vauxcelles's subsequent critique of cubism. As the movement developed, so the terms became more explicit, two aspects of a single refusal to accept the avant-gardism that was beginning to characterise the art market. Intellectualising equalled mystification; mystification equalled *surenchérisme* or promotional hyperbole; the accusation, arrived at by a different route, is once again that of Tardieu, Guilbeaux and the rest.

Yet for another leading journalist critic it was the lack of intellect in current painting that was the problem: Arsène Alexandre, who wrote for the conservative *Le Figaro* and the arts-oriented *Comoedia*, lamented the ubiquity of the 'decorative' sensibility:

> There is concern for nothing else besides decoration, ornament, the colourful – or rather, coloured – atmosphere of everyday life; superficial, electric, materialistic, whirling, torrential life, vibrant with impatience, avid for shock, incapable of meditation, unfit for contemplation, hostile to thought, which is what we believe our life to be.[18]

Alexandre called for a more serious and intelligent art, rejecting at the same time the current propositions on offer: there was no faith to support religious or classical themes, and history painting was now ridiculous; could the solution be found in 'meditation on nature, in a science of beings and phenomena?' With heavy sarcasm he answered: 'Painters are ignorant of their own *métier*; surely you would not wish them to pretend as well to be naturalists like Pisanello or Poussin, mathematicians like Leonardo?'[19]

These concerns were, of course, those of the salon cubists at exactly this period; Le Fauconnier had been copying Poussin in the summer of 1911, and at the home of the Duchamp brothers in Puteaux from September, his co-exhibitors of Room 8 at the Salon d'Automne were beginning to read the works of Leonardo. Indeed, there were several points in his article where Alexandre's ideas coincided with their ideas and practices, such as his pleas that artists resist the temptation to turn to the financially rewarding production of hasty sketches, or of objects of decorative art, and instead paint works 'lengthily considered, slowly elaborated, testifying to a will to perfection comparable with that which fired the masters of the past',[20] a demand that Gleizes was also putting in writing at that very moment, as we shall shortly see. Alexandre, however, was unable to perceive such congruences. He reacted, as did Guilbeaux on the political left, Tardieu on the right and Vauxcelles in the centre, against the avant-garde aspects of their work and the promotional devices that accompanied its exposure; for him, as for these others, the cubists were mere jokers 'who bring us nothing but a piece of foolery without either serious principle or significance . . . for the amusement of idlers at the back of the class.'[21]

The Moroccan Crisis of July to November 1911 was to turn them into something more serious. For it opened the way for a condemnation of the international character of the anti-academic community in the name of national tradition and cultural order; not only was the liberalism of the Indépendants and the Salon d'Automne being exploited by increasing numbers of foreign artists (as critics noted in their salon reviews of 1912, and Deputy Breton in Parliament that November[22]), but – it was claimed – the anarchy and *surenchérisme* that resulted was on the increase, and the jury of the Salon d'Automne was influenced by a majority of foreign artists who had little knowledge of French art and even less care for its prestige and its future.[23] The arrival in Paris of Italian futurist painting and sculpture – threatened in November 1911, realised in February 1912 – was for some the last straw. Faced with the rapid succession of 'dogmas', Vauxcelles confessed himself bewildered: 'We have undergone the assault of barbaric cubism, the *vachalcade* of epileptic futurism. What tomorrow will bring, I know not . . . one is no longer certain of one's bearings.'[24] Unable simply to laugh them away, he felt compelled for the first time to present a reasoned rebuttal, presenting in his review of the 1912 Indépendants a lengthy defence of his own post-synthetist aesthetic against the cubists' disregard of nature and sensibility.[25]

That Vauxcelles should feel so compelled is an indication that the critical stakes in the debate over cubism had been raised; that he should be so disconcerted is, in part, a measure of how effective in raising them were the arguments put forward in support of cubism from another critical quarter. As its notoriety grew – thanks not only to the spate of exhibitions in Paris and abroad after the salon cubists' debut at the 1911 Indépendants,[26] but also to the almost universal hostility of journalist critics – the movement attracted the analytical attentions of increasing numbers of young writers concerned to establish their own aesthetic position or critical reputation in the small but seething milieux of the *petites revues*. Given this position in the cultural field, the inclination of most of them was to argue for the legitimacy of the cubists' innova-

tions, indeed the respectability of their aesthetic concerns; against the ridicule of the newspapers, to insist that these deserved serious attention. Several arguments were offered, not all of them consistent with each other. First into the arena were Allard and Apollinaire, the former staking out the ground that he felt the nascent salon cubist group should occupy in the sequence of articles from late 1910 through mid-1911 noted in an earlier chapter, the latter championing first Picasso but also – once he recognised both their avant-garde as well as their painterly potential – the salon cubists.[27] Each of these was a close associate of the artists he discussed, Allard in the post-Abbaye circle of Gleizes and Le Fauconnier, Apollinaire a member of the *bande à Picasso*. As such they were in a position to influence the development of cubist painting both directly and indirectly: directly, by suggestion, criticism and theoretical underpinning of pictorial innovations, indirectly by giving support to specific promotional initiatives and assisting in forming groups; both were active in support of the Room 41 initiative at the 1911 Indépendants.[28] Each was probably less influential than he appeared to suppose,[29] but together they contributed greatly to setting the terms of critical discourse within which cubist painting signified on and after that public debut, each writing a keynote statement in support of the salon cubists in the strategically important aftermath of the exhibition.

Allard's 'Sur Quelques Peintres' was the more ambitious and explicit, attempting as it did to appropriate salon cubism for a Bergsonian interpretation of a specifically French classicism. He juxtaposed it both against the commercially driven fashion for sub-impressionist spontaneity that he saw as depressingly ubiquitous, and against the growing influence of what he termed the 'composite mallarmism' of the paintings of Picasso and Braque.[30] In this, his first reference to gallery cubism, the description is revealing, for the aestheticism of Mallarmé's poetry was, as noted earlier, a touchstone in a current debate with ideological ramifications. From one side the Maurrasians of the *Revue critique* charged the poet with obscurity and sterility, while from the other, neo-symbolists championed its beauty and profundity. Indeed, Allard went further than the Maurrasians in this condemnation, warning in particular Metzinger against too close a familiarity with the work of Picasso whose 'violent personality . . . is resolutely exterior to the French tradition', and co-opting the other salon cubists for his position: 'and the painters with whom I am concerned here have instinctively sensed this'.[31]

Where Allard saw dangers to the French tradition in both Mallarmé's aestheticism and Picasso's personality, Apollinaire saw what he most valued, and from his earliest critical writing had extolled Picasso's painting in terms that related both to his own poetry and to the neo-symbolist defence of Mallarmé.[32] While he also stressed the importance of tradition, welcoming the classical qualities he found in Braque's L'Estaque paintings of 1908 – 'there is room now for an art that is more noble, more measured, better ordered, more cultivated' he declared – it was Picasso's audacity that he clearly preferred.[33] As the future members of the salon cubist group gained critical attention through 1910, not only did he take every opportunity to assert the fundamental nature, as he saw it, of Picasso's influence on them, but he was at times openly critical of the work of Metzinger in particular as derivative of that of his favourite.[34]

At the same time Apollinaire had a strong investment in his reputation as a leading player in avant-garde milieux, and as the group came together, shepherded by Allard, he recognised the prudence of supporting it. His review of Room 41 was notably more sympathetic and supportive than hitherto,[35] while for their exhibition at the Salon des Indépendants, Brussels (which opened in June 1911 as that in Paris closed) he wrote a catalogue preface in which, barely a year after condemning 'the modern malady which takes the expression of modern life as the sole aim of art', he celebrated, without a blush, the salon cubists' readiness to address exactly this subject on the grand scale.[36]

Apollinaire's avant-gardism was not solely a matter of opportunist self-promotion, however. The exalted conception of art and the role of the artist that motivated his eulogising of Picasso entailed also a more general commitment to unorthodox and experimental poetry and painting.[37] When the unanimist poetry of Romains, with its celebration of the dynamism of modern life, gained critical momentum in 1909, Apollinaire's own poetry too began to embrace everyday city experience, for reasons of aesthetic as well as self- interest. As has long been noted, the tension and implicit contradiction between the positions that he successively (even simultaneously) occupied was a source of the richness of his poetic imagery; it also contributed, as his friends understood, to the strategic role he played in the avant-garde.[38] Like Allard's, Apollinaire's criticism at times amounted to a campaign to legitimise cubism – both in terms of a national tradition, as in his appeal to classical values and, in his claims for salon cubism's epic qualities, as of contemporary relevance. Unlike Allard's, this effort was complemented, or rather compromised, by his frequent full-throated declarations of aestheticist avant-gardism: 'the painter must above all reveal to himself his own divinity' he wrote, in characteristic vein, in 1908, 'and the pictures that he offers for people's admiration will confer on them too the glory of exercising their divinity in their turn, if only momentarily'.[39]

Despite Apollinaire's own estimation of his position as broker to the cubists – 'I see myself as virtually alone among writers on art in defending these artists whom I know and whose works I admire', he wrote with breathtaking chutzpah *à propos* the salon cubists in autumn 1911, at a time when not only Allard but several other critics too were in visible support[40] – his criticism was not, unlike that of Allard, significant for its theoretical underpinning of the painters' insights or its articulation of their aesthetic interests. His support counted for much, however, and between them these two poets had by the end of 1911 made cubism a critical force to be reckoned with. Together with two events that raised the avant-gardist profile of the salon cubist group at that moment, an immediate consequence was to open a second phase of the critical response to cubism – to open the debate proper, since hitherto neither side had appeared to listen much to the arguments of the other. The first of these events was the exhibition of futurist paintings at Galerie Bernheim-Jeune; planned for November 1911 but at the last minute postponed until February 1912, this and its accompanying manifesto posed an avant-gardist challenge to the salon cubists and brought the nationalist sentiments aroused by the Moroccan Crisis to bear on their immediate professional interests. The second, intended perhaps as a preliminary reply to the

futurists, was the salon group's own gallery debut that November.[41] Prompted by these exhibitions, more young writers threw their hats into the ring, concerned less to defend or explain cubist paintings than to offer interpretations of a monolithically conceived 'cubism' in terms that represented their own response to the heightened mood of nationalism and the aesthetic positions that mediated it. Meanwhile, those already within the cubist circle – artists as well as writers – each became aware of the need to press his (for the participants were exclusively male) own understanding of cubism against alternatives.

Among the earliest new entrants were Olivier Hourcade and Jacques Rivière. In articles written in late 1911, at the moment of the upsurge of nationalist resentment over the Moroccan affair, but not published until the following spring, each presented an understanding of cubism that drew, directly and supportively in one case, indirectly and critically in the other, upon the discourse of traditionalist nationalism. Hourcade followed Allard in condemning impressionist anecdotalism and championing the salon cubists for rejecting it, but he differed from him in introducing, for what appears to be the first time, an explicitly philosophical justification for cubist painting, citing Schopenhauer and Kant for a distinction between essence and appearance that, he argued, underlay its characteristic departure from conventional perspective in the representation of objects.[42] That this argument rested on a misunderstanding of Kant's philosophy and explained nothing about actual cubist paintings,[43] mattered little; it sounded good, and it offered an intellectually substantial, idealist rationale for cubism that was consonant both with the claims for its classicism and with the symbolist aesthetic that still underlay much contemporary literary debate. It was thus a fruitful misapplication, widely adopted for a range of purposes, as we shall see, during 1912. Hourcade combined it, firstly, with aestheticist avant-gardism, quoting Schopenhauer again, who 'taught that the crowd was made to obey laws and not to dictate them', thus 'it is for each artist to dictate the laws of aesthetics through his works'; secondly, with traditionalism, arguing that, far from being the anarchists that critics had identified, the efforts of the cubists marked a return to 'sound traditions' and they were therefore reactionaries, not revolutionaries.[44] Even more explicitly political was his principal assertion, that the essences which the cubists presented, in their figure and landscape works, were racial in character. Published in the first issue of a magazine edited by him and committed to a politics of regionalism – the regeneration of France economically, politically and culturally through the encouragement of its regional identities – his article focused on the work of Gleizes, Lhote and Tobeen on the grounds that they were Gascons like himself, and suggested that their painting revealed 'the profound truths of a race [and] a locality'.[45]

Against Hourcade's uneven, shot-gun style of argument in support of cubism, Jacques Rivière, by then an essayist of reputation and editorial secretary of the right-leaning *Nouvelle Revue Française*, presented a critique that was as rapier-like as it was savage. While he too presented a traditionalist aesthetic, his purpose was to demonstrate how far cubist painting was from displaying this, to 'give the cubists a little more freedom and self-possession by furnishing them with profound reasons for what they are doing. It is true', he added, 'that this cannot be done without showing

how badly they have been doing it up to now.'[46] To this end he constructed an argument, echoing Hourcade with a closeness that reveals the discursive level of determination of the positions in this debate, that the true purpose of painting had always been to present the essence of objects, as distinguished from their transitory appearance – their solidity, stability and equilibrium. The innovations of the cubists, in rejecting consistent lighting and perspective on which presentation of the appearance of objects depended, were a means to this, potentially enabling an object to be seen in all its fullness and density, 'such as we see it when we see it well'. But the cubists had taken such means to the point of absurdity, rejecting the compositional hierarchies that their devices demanded and thus reducing their paintings to 'that mad cacophony that makes us all laugh'.[47] It was a cogent argument, that picked a careful path through questions of arbitrary lighting and multiple perspective, but his implicit classicising of cubism entailed a selection of certain qualities as against others – like Hourcade he made no reference to specific paintings – and an intellectual coherence for whose lack he castigated the cubists was won at the expense of the ambiguities and contradictions that made their work so fruitful. The result was a reductive interpretation that betrayed a certain disdain for painters and their *métier*, and whose ideological grounding is underscored by his championing of Lhote, the most traditionalist of cubist painters.[48]

In the summer of 1912 a substantial contribution to the debate came from a third newcomer: Maurice Raynal had come to cubism around 1910 via the Bateau-Lavoir milieu. The catalogue of the Société Normande exhibition in Rouen in June 1912 carried a brief preface by him which again drew on purportedly Kantian distinctions between essence and appearance – in his expression, 'conception' and 'vision' – but which gave this argument the additional twist of vague reference to mathematics and contemporary scientific discourse. If the argument was by now familiar, the presentation of the cubist exhibitors at Rouen as creators of an 'algebra of painting' provided it with further intellectual artillery. Perhaps to cover all angles in the debate, however, Raynal also added a Bergsonian gloss about the dynamic relations between objects, and this sat uneasily with his argument.[49] In a newspaper article in August he expanded both the distinction between conception and vision, and the artillery, bringing to his aid the idealist philosophies of Berkeley and Bossuet, the painting of Giotto and the mistakes both of futurist painters and wrong-headed aviators in an uncompromising argument for the cognitive function of an art based on conception. Once again, however, he added an awkward coda, quoting Kant on the purposelessness of beauty in support of a declaration of aestheticism that, this time, directly contradicted all that he had just written.[50]

Raynal's inconsistencies, like the unevenness of Hourcade's argument, betray the discursive tensions that ran through this debate. Whatever cubism had meant before late 1911 – curiosity, novelty or nonsense for most journalist critics, renewal of traditions or inspired innovation for its poet supporters – what was at stake in the post-Morocco conjuncture was the legitimacy not only of the cubist endeavour but of experimental art in general. Mourey's equation between cubism and anti-militarism was no mere journalistic witticism; it posed the question clearly: was such experimen-

tation a threat to the French cultural – and beyond that, social – order? For its supporters the answer was equally clearly no, but the philosophical and scientific precedents on which they drew in its defence indicate, among other motives, the obligation they felt to insist upon that legitimacy. For both Bergson and Kant had a discursive significance that was tacitly understood, references to each encoding – though in different ways – an appeal to classicist values, and thus to nationalism. Yet legitimation was not the only option: rejection of the very terms of the nationalist discourse and espousal of an aestheticist avant-gardism was another, and Apollinaire, Hourcade and Raynal were all torn in varying degrees between the two.

The complexity of Apollinaire's motives and role compelled him to face both ways at once as the debate widened, and as the challenge posed by futurism became a negative point of reference for the concerns of the salon cubists. In the first half of 1912 Apollinaire supported the group as it gathered promotional momentum and a widening circle of adherents; in April and May his essay 'La Peinture nouvelle' defended its apparent preoccupation with geometry, asserted both its audacity and its respectability and harnessed it to an explicitly French tradition that linked it to gothic art, of which it was no less than the rebirth.[51] But he also unequivocally reasserted his belief in Picasso's genius, comparing him in an exhibition review to Michelangelo and Rembrandt and presenting, in another essay of the same period, an understanding of cubist aesthetics that explicitly privileged his achievement; elsewhere he went so far as to group the salon cubists implicity with the futurists in distinction to this.[52] A letter of January 1912 to Soffici makes clear the tactical reasons for supporting the salon group,[53] but two other factors appear to have determined the restatement of his real aesthetic commitment. First, the challenge presented by the writing of newcomers, which was constructing cubism as an object of critical discourse and contention to a degree that neither he nor Allard could ignore (indeed, it was during this period that each chose to follow Raynal in the use of pseudo-mathematical language, Apollinaire temporarily adopting in an article of May 1912 a more analytical, less elevated mode of writing about cubism, Allard explaining cubist space in terms of quadratic equations, in an article written at the same time for the *Blaue Reiter Almanac*[54]). The second factor was the establishment of a little review as a mouthpiece for the views that he and others embraced. The foundation of *Les Soirées de Paris* in February 1912 by Apollinaire's friends, ostensibly a gesture to cheer him up at a low moment,[55] reflected an awareness both of the paucity of magazines prepared to devote substantial space to consideration of the new painting, and of the advantages that regular access to such a mouthpiece offered to participants in the debate. It was followed within a year by two other reviews orientated principally to cubism and its milieux: Henri-Martin Barzun's *Poème et drame* was launched in the autumn, and Ricciotto Canudo's *Montjoie!* in January 1913.

The emergence within a short space of time of three such magazines all substantially, if differently, aligned with the cubist movement indicates that it was by now established as the ascendant grouping within the artistic avant-garde, but also that the terms in which cubism signified, and their relation to the dominant and counter-discourses of the pre-war period, were still in contention. The magazines' immediate

effect was to sharpen positions within the debate and their differences, in ways we shall examine below. It was thus no coincidence that Apollinaire chose the first issue of his new magazine to publish his most substantial statement on painting for nearly four years, one which – as noted – explicitly interpreted cubism in terms of Picasso's work. The initiative contributed to a perceptible tilting of the balance of argument over cubism in favour of an aestheticist interpretation and the gallery cubist axis to which it corresponded, in the spring of 1912. The shift was registered by Allard, in his *Blaue Reiter* article: arguing once again, but now for an international readership, for the classical character of cubist paintings, he acknowledged the priority of Picasso, Braque and Derain in cubist experimentation. He distinguished their efforts from the more systematic approach of the salon cubists, however, and sought to define the style in terms of the latter, to which the formal innovations of the former were merely the useful preface. That he should feel obliged to do either indicates clearly which way the wind was by then blowing.[56]

Cubism between Painting and Writing

According to Gleizes, the salon cubists were taken aback by the public and critical response to Room 41:

> No one could have thought that this would be the object of scandal. And we were the last people who would have wished it. At that epoch one had more modesty, and the act of exhibiting paintings conceived in a spirit somewhat different from that of surrounding work in no way indicated, in itself, the intention of provoking the public. And we were greatly surprised when, at the vernissage, there was an outcry.[57]

Surprised or not, the response of Gleizes and Metzinger appears to have been to write in defence of their work, to argue in a series of articles in the second half of 1911 for its legitimacy, indeed its respectability. This was not the first time that salon cubists had appeared in print; a year earlier, first Le Fauconnier and then Metzinger had presented their ideas about the new painting. These statements, however, had pre-dated the group's debut and were primarily for consumption within the restricted milieu of their artistic and literary acquaintances – avant-gardist moves in a process of jockeying for position. Le Fauconnier's energetic self-promotion was noted earlier, and his catalogue statement 'L'Oeuvre d'art', for the September 1910 exhibition of the Neuekunstlervereinigung in Munich in which he participated, played its part. This was a dense and jargon-ridden text that purported to explain the laws of art in mathematical terms:

> A numerical work of art must represent numerical characters in its constructive and expressive arrangement. In its arrangement the number is simple or compound. Simple when a group of numerical quantities corresponds to the measurements of flat or figured distances between points . . . compound when a group of primordial surfaces forms the constructional base and a group of points of weight results from their directional effects . . .

Convoluted and almost incomprehensible though this statement was, it must have circulated among and impressed his friends in Paris, for both Allard and Metzinger closely echoed its terminology in reference to Le Fauconnier, in articles published that November.[58]

Metzinger's 'Note sur la peinture' was about the work of Picasso, Braque and Delaunay as well as Le Fauconnier; a tactical selection which threw into relief, besides these artists, the fact that only Metzinger himself was in a position to write about them all; uniquely, he had a close acquaintance by that time with both gallery cubism and the painting of the nascent salon group. He had arrived in Paris from Nantes in 1902; gravitating to Montmartre, he was soon exhibiting neo-impressionist paintings in Berthe Weill's gallery. He changed his manner of painting on an almost annual basis and had arrived by 1908 at a nabiesque *cloisonné* style and an accompanying post-synthetist decorative aesthetic, both of which were illustrated in Gelett Burgess's article 'The Wild Men of Paris' – an inclusion which probably reflected as much Metzinger's developed skills of self-promotion as it did his place in the Montmartre milieu.[59] In the meantime he had become friendly with Max Jacob, who introduced him in 1907 to Picasso and Apollinaire;[60] influenced by Jacob, it seems, he wrote poetry in a neo-symbolist vein on themes that were also common to the work of the latter, as well as Salmon: 'L'Alchimiste', 'Le Dément', 'La Féerie' were among those published.[61] Behind their obligatory exotic and obscure imagery these poems indicate two preoccupations that were to appear in his later work – a sense of artistic elitism, a belief in the cultural and moral superiority of artistic creativity that he expressed in several poems in an idealist language weakly reminiscent of Apollinaire's;[62] and a fascination with number and geometry that had begun in his schooldays. Both had their esoteric and traditionalist aspects, and owed much in each respect to the ideas of Mécislas Golberg, but as nationalism extended its hegemony after the watershed of 1905 it was traditionalism that began to predominate. 'Note sur la Peinture' opened with an assertion of elitism and individualism on the part of its selected artists ('Loftily inspired, they believe in the stability of no system') but it ended with a clear emphasis on tradition: 'If we abandon the antique world to archaeologists . . . it does not follow from that, I repeat, that we pretend to turn our back on Tradition. It is within us, gathered into our unconscious, beyond the need to consider it.'[63]

It was partly this common positive response to the contemporary call to order that drew Metzinger towards Gleizes and Le Fauconnier in 1910; but it was also the result of more instrumental reasoning on his part, that was of consequence for the emergence of the salon cubist group. In the spring of 1910 the future salon cubists were only loosely associated; while Gleizes and Le Fauconnier were painting shoulder to shoulder, Léger's milieu was that of La Ruche, peripheral in all respects; Robert Delaunay was unacquainted with these, and Metzinger himself was in the outer circle of the Bateau-Lavoir group. His entries to the 1910 Indépendants (Fig. 37), however, revealed little if any familiarity with paintings of the previous two years by either Picasso or Braque.[64] But between the Indépendants and the Automne he moved from the edge of Montmartre to its centre; a move that can be taken as symbolic of a turn towards the style of Picasso, for his next exhibited work, the *Nu* shown at the 1910

37 Jean Metzinger.
*Portrait de Guillaume
Apollinaire. c.*1909. Oil
on canvas, dimensions
and whereabouts
unknown.

Salon d'Automne, is plainly derivative of Picasso's *Portrait de Wilhelm Uhde* of that spring (Figs 38 and 39). At the same time Metzinger made acquaintance with the Gleizes–Le Fauconnier ex-Abbaye circle, with his friend Robert Delaunay; by the autumn he had written 'Note sur la Peinture'. The article helps to explain what would otherwise seem a paradoxical double movement on his part, towards both the cubism of Picasso and Braque and the proto-cubism of Gleizes and Le Fauconnier; for in discussing the very different ideas of each grouping in the same text, he suggested a common purpose in their work which he alone was in a position to perceive. Perhaps Metzinger, meeting the salon painters, saw at once the fruitlessness of working in the shadow of Picasso and the advantages for himself of presenting as his own in public the visual vocabulary which Picasso had been elaborating in private, and grasped the opportunity to place himself, armed with Picasso's audacities, at the head of this group. Such, at any rate, appears to have been the outcome.[65]

While statements by the salon cubists before Room 41 had been thus motivated solely by avant-gardism, their response to the outcry which Room 41 provoked came from a desire to legitimate their painting. If the terms of the former were set by their orientation to the art market, the terms of the latter were set by the critical discourse. As we have seen, this discourse was decisively shaped by its political conjuncture; for the cubists, given the tacit acknowledgement of the authority of public opinion that their salon participation entailed (and that Gleizes' remarks quoted above indicated), an appeal to nationalism in some form or another was pre-ordained. Within its constraints there was, however, some room for manoeuvre. Thus Metzinger – first into the fray in August, in explicit reply to press criticism – adroitly combined an argument for salon cubist innovations with a stress on the traditional qualities of these. Echoing Allard's 'Sur Quelques Peintres' of two months earlier, he explained the device of multiple perspective in terms of a Bergsonian classicism; these painters

> have allowed themselves to turn around an object to present, under the control of
> their intelligence, a concrete representation made up of several successive aspects.
> Where once a painting possessed space, so in this way it governs time as well.[66]

Similarly, he offset an assertion of avant-gardist elitism ('Who does not know that the essential mission of the artist is to imprint his ideas on the minds of others?') with an appeal to the example of the the old masters, whose glory

is precisely to have printed on our minds prototypes so perfect that we can say, after centuries, that what resembles them is beautiful and what does not is ugly. Those whom people call the cubists are trying to imitate the masters, to fashion new types . . .[67]

Following Metzinger, Gleizes made his literary debut with three statements in the autumn and winter: an article on the colleague with whom he had spent the summer working and a review of the Salon d'Automne, both for *petites revues*, and a newspaper interview.[68] Common to all three, once again, was a stress on the qualities which placed cubism firmly within a tradition that, while it included Giotto and Raphael, Gleizes repeatedly defined as specifically French ('whose pillars are grandeur, clarity, equilibrium and intelligence'; 'that shimmering of coloured greys that is essentially French'[69]) and in whose terms he condemned impressionism (including, in an avant-gardist gesture for a restricted readership, the 'impressionism of form' that the work of Picasso and Braque amounted to).[70] He echoed Metzinger's avant-gardism, asserting the artist's role in discovering visual signs that would enrich the perception of everyone, and – in an implicit about-face from his activities in the days of the Bloc des Gauches – dismissed the 'easy option' of *art social*; but he also argued

38 (left) Jean Metzinger. *Nu*. 1910. Oil on canvas, dimensions and whereabouts unknown.

39 (right) Pablo Picasso. *Portrait de Wilhelm Uhde*. 1910. Oil on canvas, 81 × 60 cm. Private collection.

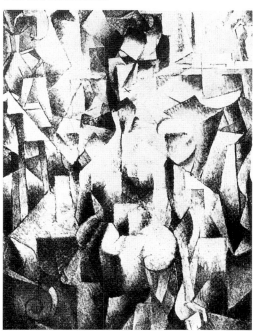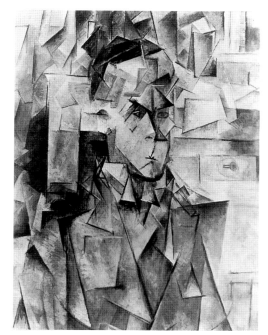

for the respectability of the cubist project, citing the careful attention to *métier* in an unwitting reply to Arsène Alexandre's demand, quoted earlier.[71]

Puteaux and the Ascendancy of Gallery Cubism

Legitimation and avant-gardism thus constituted in late 1911, both for the salon cubists (or these self-appointed spokespersons) and their critic supporters over the next few months, the two poles of their explanations of cubism. While a concern for legitimacy precipitated the spate of statements, it was avant-gardism – specifically, recognition of the promotional advantages of having a periodical of their own – that motivated their attempts to found such a review, recorded by Salmon in his gossip column in September and October 1911. Although this never materialised, staggering from one proposed title (Les Fauves[72]) to another (Les Lions) and a third (Le Cube) before collapsing,[73] the effort of consolidating a group identity perhaps contributed to another initiative, that of the regular weekly discussions, after the 1911 Salon d'Automne, at the home of the Duchamp brothers in Puteaux. It was at these meetings, as historians of cubism have noted, that most of those who joined in the debate I have outlined exchanged and explored their ideas. What also needs to be noted is that, reciprocally, Puteaux brought the field of discursive forces into the centre of cubist thinking: for the first time salon and gallery cubism, and their associated aesthetics, shared a milieu, and at a time when the debate over cubism was at its liveliest. Marcel Duchamp later recalled that 'the group that spent Sunday afternoons at Puteaux was far from homogeneous'; not surprisingly, another participant, Georges Ribemont-Dessaignes, remembered 'passionate discussions on which it seemed the future of the human spirit depended.'[74] The philosophy of Bergson, the question of dynamism, the notion of simultaneity and their relevance to painting, the social purpose and epistemological status of art, the symbolic, expressive and formal possibilities for painting of number and geometry – these were some of the topics discussed.

This was the immediate context of *Du Cubisme*. Eventually published at the end of 1912, the manifesto was written at some time during the first few months of the Puteaux gatherings. It was intended by its authors as a means of positioning themselves within that milieu and as an intervention in the wider critical discourse which Puteaux mediated, and its length (at about 6,000 words it was by far the most substantial account of cubist thinking to date) as well as the broad compass of its argument reflected the attempt to address both readerships. Of these, the wider one seems to have been primary; for what was at issue was the comprehensibility, and beyond this the legitimacy, of cubism. Thus the essay opened and closed with arguments whose terms were those established in the critical debate, and which were in little need of restating for a Puteaux readership. On the one hand, Gleizes and Metzinger sought from the outset to situate cubism within a pictorial tradition that, although explicitly modernist, was by then respectable – that of Courbet, Manet and Cézanne, the last compared to Rembrandt and presented as the progenitor of cubism – and that ran back through David and Ingres to Leonardo and Michelangelo.[75] On the other hand, they sought to justify the difficulties cubism presented to the viewer

by asserting the avant-garde status and role of the artist and the necessarily elitist character of his (*sic*) practice:

> The artist . . . endeavours to enclose the quality of [a] form in a symbol likely to affect others. When he succeeds he forces the crowd, confronted by his integrated plastic consciousness, to adopt the same relationship he established with nature . . .

> Let the artist deepen his mission more than he broadens it. Let the forms which he discerns and the symbols in which he incorporates their qualities be sufficiently remote from the imagination of the crowd to prevent the truth which they convey from assuming a general character . . .

> That the ultimate end of painting is to reach the masses, we have agreed; it is, however, not in the language of the masses that painting should address the masses, but in its own, in order to move, to dominate, to direct, and not in order to be understood . . .[76]

Assertions such as these, which lean heavily on the writings of Nietzsche,[77] punctuate the essay repeatedly; together with the appeal to tradition with which they are occasionally yoked (as in a reference to Leonardo to justify the difficulties which cubist painting presented to the viewer),[78] they form one of its main themes. Although addressed principally to the wider debate, this also engaged with the arguments of the critics in the Puteaux milieu who were extending its terms by referring to Kantian philosophy, geometry and science. In a thinly veiled rebuttal of the suggestions of Raynal and Hourcade in particular, Gleizes and Metzinger dismissed such explanations[79] and tacitly accused their authors of conventional thinking, in contrast to their own freedom from 'common standards'. At the same time they distanced themselves from the 'systematic obscurity' of some painters who, in discarding conventional pictorial signs completely, were only 'fabricat[ing] puzzles': 'Not to discern at first contact the individuality of the objects which motivate a painting has its great charm, true, but it is also dangerous. We reject not only synchronistic and primary images, but also fanciful occultism . . .'[80] The culprits here were implicitly Picasso and Braque and the criticism, similar to Allard's accusation of *mallarmisme* a year earlier, was a bold attempt to challenge the paradigmatic status that was being claimed for their work by Apollinaire in particular.

The challenge, if it was to have any meaning, needed to be accompanied by the articulation of an alternative understanding of cubism's pictorial innovations; thus the pamphlet was structured loosely around a series of doctrinal assertions about form, colour, the relation between them and the role of taste in determining this. Some of these assertions repeated the gestures towards a Bergsonian epistemology already made by Allard and themselves, such as their stress on cubist painting's engagement with the concept of duration ('moving around an object to seize from it several successive appearances, which, fused into a single image, reconstitute it in time'[81]) and with the dynamism with which this quality invests the relation between objects. As many other assertions, if not more, however, suggested a Nietzschean idealism, alongside the avant-gardism already noted, as the basis of cubist aesthetics. The idealism provided a means both to dismiss the pseudo-Kantian exegeses of cubism offered by Raynal, Rivière and others, and to distinguish the cubism of those

painters such as themselves 'who move freely in the highest planes' from that of its mediocre camp followers, by virtue of their possession of the faculty of taste and its subordination to their will.[82] Taste was a register of creativity: 'Any painter of healthy sensitivity and sufficient intelligence can provide us with well-painted pictures', they declared, 'but only he can awaken beauty who is designated by Taste.'[83] It was with its guidance that those cubists who had taste were able to achieve the 'plastic integration' they sought. Since it constituted the only law that painters need follow, it thus won for painting 'an indefinite liberty' from system and convention.[84] The latter they distinguished from method, however, for plastic integration – the 'eliminat[ion of] everything that does not exactly correspond to the conditions of the plastic material'[85] – entailed a pictorial method. Hence some of the doctrinal assertions were on technical questions – the role of the spectator in the construction of pictorial space, the need for diversity in the relation between straight and curved lines on which (they argued) the quality of a picture depends, the pictorial ramifications of colour science, the antithetical relation of painting and decoration. Laced with knowing references to, and appropriations of, recent mathematical and scientific concepts, these assertions served both to distinguish cubism from its avant-garde competitors, the 'synchronistic and primary images' of the futurists and the fauvist heirs of neo-impressionism, and from the gathering momentum of the contemporary decorative aesthetic – and to position their authors in the Puteaux discussions.

If *Du Cubisme* was thus a complex text whose multi-accented character inscribed what one participant at Puteaux described as an attempt at 'a kind of legislation of the cubist movement, in order to raise it to the rank of an honourable means of expression, to integrate it into the Eternal and Universal Unity of art',[86] it also represented a decisive shift in the balance of forces within the cubist movement, and a crucial stage in the ascendancy of gallery over salon cubism. The themes, the frame of reference and the language of the text all mark it as far more the work of Metzinger than of Gleizes. The elevated tone and symbolist imagery of its claims for avant-garde elite status resemble that of Metzinger's poetry, while the Nietzschean character of these reflects an acquaintance with his writings that can be found in the Bateau-Lavoir milieu of which Metzinger was a peripheral member – Nietzsche was the only philosopher quoted by Salmon and Apollinaire[87] – but that is nowhere evident in Gleizes' thinking of the time. The references to Leonardo and Michelangelo echo those made in Metzinger's '"Cubisme" et tradition' of a year earlier; the lengthy and detailed section on colour science and the mistakes of neo-impressionism drew on his early apprenticeship to its methods and theories, of which Gleizes had little direct knowledge; the knowing allusions to non-Euclidean geometry are in keeping with Metzinger's long-standing interest in the subject. By contrast, there is very little of Gleizes' particular concerns in *Du Cubisme*, and none that cannot be traced back to Metzinger.[88] Notably absent is any appeal either to nationalism or classicism. Despite the centrality of the former in the critical response to cubism and in Gleizes' own appeal to a specifically French tradition, the manifesto's implicit criticism of the futurists (for 'mistak[ing] the bustle of the street for plastic dynamism') carries not a hint of xenophobia; while in place of that insistence on classical values, in particular

compositional equilibrium, that was the primary emphasis of Gleizes' statements of late 1911, its claim that cubist paintings achieve a 'superior disequilibrium without which we cannot conceive lyricism' was little short of a rebuff.[89]

The principal themes of *Du Cubisme* were also very largely those of the critics who spoke for the gallery cubist painters. For all that Metzinger was the *chef de file* of salon cubism, his aesthetic position remained unchanged from his Bateau-Lavoir milieu days, as his text revealed. Indeed, he was in several respects directly indebted to Apollinaire in particular for the terms in which this was articulated. Thus, in distinguishing from the colour science of neo-impressionism a cubist understanding of light as creative revelation, *Du Cubisme* employed a metaphor that Apollinaire had made profoundly his own, both in his poetry and in his critical writing, the latter with particular reference to Picasso.[90] In suggesting that the ultimate goal of art was non-imitative 'pure effusion', it echoed the poet's essay on the subject in modern painting, which once again privileged that artist.[91] Throughout the manifesto, the assertions of avant-gardism were couched in the elevated symbolist-inspired language that characterised all Apollinaire's references to the painting he most admired. Despite the veiled critique of the hermetic paintings of Picasso and Braque, which served to distinguish their 'fanciful occultism' from Metzinger's own more legible images, Metzinger argued for an aestheticism that differed far more fundamentally from the engagement with the dynamic experience of modern life that characterised the work of the other salon cubists. To argue, with Apollinaire, that painting should dispense with the subject and 'present nakedly its *raison d'être*' – that its ultimate aim was 'pure effusion' – was certainly to misread Picasso's intentions, but it was to contradict flatly those of others in the Puteaux circle, Gleizes in particular.

The omission of all Gleizes' own arguments for cubism from a manifesto to which he put his name is so striking that we must wonder why he acquiesced in its publication. That he regarded his views as under-represented, at the very least, is indicated by the spate of explanations of cubism that he gave around the time of its publication, in which he not only reiterated points made in *Du Cubisme* but added to them the traditionalist argument which this had omitted, elaborating it at greater length with each opportunity. The first of these came even before the pamphlet was published: in an interview which, as printed, consisted largely of quotations from it, Gleizes argued once again that cubism stood 'in the purest tradition' of French painting that ran from the gothic through Poussin to Delacroix and the nineteenth-century modernists.[92] Two months later, in response to an enquiry into cubism, he developed this argument, giving it an explicitly nationalistic twist that clearly marked the distance between his own ideas and those expressed in *Du Cubisme* even as he quoted from it: repeating the modernist lineage claimed for cubism, he declared the latter to be

the natural issue of the work of these liberators that leads us back to the true path of French tradition and that is violently opposed to the detestable Italian influence, sad heritage of the sixteenth century Renaissance, that outrage against our national genius.

Ignoring the references to Leonardo and Michelangelo in his own newly published pamphlet, he counterposed to 'the Italian masters who are not of our patrimony and whose creative genius is inferior to ours' the 'primitive' paintings and cathedrals of France; it was through these 'masterpieces tempered by time' that an understanding of the meaning of cubism could be reached.[93]

There is a Mithouardian tenor to these assertions and appropriations – the appeals to race as the basis of tradition, to the temporal character of French classicism and to the cathedrals of the Ile-de-France as cultural paradigm are reminiscent of the *Traité de l'occident* and its elaboration of the aesthetic dimension of Barrésian nationalism – but there is also another note, of cultural rivalry, even xenophobia. In Gleizes' next explanation of cubism, this grew both deeper and more strident. 'Le Cubisme et la Tradition', published in the first two issues of *Montjoie!* in early 1913, offered a potted lesson in the history of French art whose narrative was driven by a succession of heroes and villains. The latter were the Italian artists of the 'disastrous' Renaissance who first grafted the already exhausted stock of latin on to the vigorous rose of French culture, and the aristocracy which encouraged the 'forced and unnatural mannerisms' of 'cosmopolitan court favourites' such as Rosso and Primaticcio. The heroes were 'the old image-makers' and their 'robust and honest descendants': from François and Jehan Clouet through the Le Nain brothers to Chardin, these 'incarnate a whole race full of vitality' whose origins lay in the Celtic past. The artifices of the courtly tradition led to that painting which made the 'grave error' of compromising with 'foreign elements' – literature or music, flywheels or pistons – while the realist audacities of the native tradition and its attention to the integral qualities of painting led directly to cubism's concern with the 'plastic dynamism' of the material world.[94] The article thus claimed for cubism a lineage that was both nationalist and populist. The latter emphasis was new in Gleizes' critical writing, and that it should emerge at this moment, in the wake of *Du Cubisme* from which it was completely absent, indicates a desire to keep this dimension of the signification of cubism in contention, and suggests profound uncertainty on Gleizes' part over the steady narrowing of the terms of cubist discourse.

It also indicates a degree of disjunction between his authorial identities as painter and writer. As a painter, I have argued, Gleizes was attracted by the technical appeal of the stylistics of gallery cubism, as retailed by Metzinger and others in the Puteaux circle, towards a pictorial accommodation with modernity. As a writer, he found in the increasingly hegemonic discourse of a broadly traditionalist nationalism the terms of reference for the articulation of a populism that, with its emphasis on time-honoured artisanal skills, contained echoes of Roger Marx and *art social*. Yet both pictures and essays shared an ambivalence towards the relation of modernity to tradition and this was also, as we have seen, fundamental to the solidarist politics of which he had earlier been an explicit supporter. In this Gleizes differed both from others in the Puteaux circle, such as the Delaunays[95] – whose work registered an increasingly positive engagement with a notion of 'the popular' understood as the common culture of modern urban life – and gallery cubists such as Picasso, to whose aestheticism the rising tide of a commercialised, mass-produced, enticing yet dis-

posable visual culture of the urban everyday was a challenge. We shall explore the ramifications, and implications, of these different constructions of the popular in the following chapter.

Puteaux produced another promotional initiative alongside that of *Du Cubisme*, and this too registered its shifting balance of forces. From the beginning of 1912 strategic thinking in the group developed around the idea of an exhibition that would be the most comprehensive assertion of the strength of the cubist movement yet made. The Salon de la Section d'Or, while it grew out of the earlier exhibitions organised by the Société Normande de Peinture Moderne, was intended as a manifestation of a different order from these. Initiated and funded by the independently wealthy Picabia, it represented a conscious and clear alternative to the exclusive, monopolistic commercial policy pursued by Kahnweiler in his rue Vignon gallery, and his patronage of a small stable of artists.[96] In terms of market strategy it was a curiously hybrid event, less a manifestation of a unified grouping (although originally intended as such[97]) than an avant-garde *salonnet*: thirty artists showed more than two hundred works, and although the Puteaux cubists were the core of these, there were many hangers-on. In relation to the contending positions within the Puteaux circle, however, its significance was clear: like *Du Cubisme*, it marked the ascendancy of the Metzinger–gallery cubist axis, and underscored the significance for aestheticist avant-gardism of a profound attachment to tradition.

It did so in several ways, not the least of which was the choice of its very title. An interest in number, mathematics and geometrical systems was one of the common interests of the Puteaux circle, one that brought together, more than any other topic, several currents of thought within it. The structuring of a painting according to a proportional system gave the work a unity and autonomy that were consistent with the anti-decorative intentions that *Du Cubisme* declared, as well as relating to a tradition of arcane and occult knowledge which, for different reasons, attracted several members of the group. This tradition had fascinated the symbolists; suggesting an ideal, non-material reality veiled in obscurity and accessible only to initiates, it satisfied both their idealist aesthetic and their elitism. Apollinaire was deeply interested and widely read in the history of the occult, as is well known and as his poetry reveals; so too were Mercereau (co-founder of the Société Internationale des Recherches Psychiques) and Kupka (a practising medium).[98] Metzinger's interest in the esoteric associations of geometry and number have been remarked on, as well as his awareness, revealed in *Du Cubisme*, of contemporary scientific discussion of non-Euclidean geometries and the concept of the fourth dimension. Indeed, in the Puteaux circle he appears to have been the authority on the subject, although compared to Duchamp's thoughtful and provocative engagement with these notions, Metzinger's use of them amounted to little more than avant-gardist name-dropping.[99] He also shared the interest of Gleizes and Le Fauconnier in the constructional principles that guided painters of the Renaissance and the French classical tradition; so too did Jacques Villon, at whose instigation some of the group read Leonardo's *Treatise on Painting*, published in a French translation by Péladan in 1910, and other texts that discussed proportional systems. Their attention focussed on the golden section, oldest

and most attractive of these, and Metzinger, Villon and Gris, among others, made use of it in their paintings. The choice of the term as their exhibition title was a declaration of all of these aestheticist and traditionalist affiliations, as Apollinaire tacitly confirmed in the promotional pamphlet which accompanied the opening of the Salon.[100]

Apollinaire's close involvement with the exhibition, and the character of the critical suport for it that he marshalled, also marked the ascendancy of the aestheticist axis. Besides writing the editorial for the promotional pamphlet, he played a key role in shaping the project – proposing (unsuccessfully, presumably because Kahnweiler vetoed it) the inclusion of Picasso and Braque, as well as that of Laurencin – and gave the first of a series of three lectures organised in conjunction with it,[101] while in two articles published as the exhibition opened he gave an account of cubism's development with pride of place for the gallery cubists, Picasso in particular, and from the salon cubists he singled out Metzinger for praise.[102] In both articles he presented cubism's aims in terms of a distinction between conceptual and visual reality that was borrowed from Raynal's writing of the summer – a significant gesture, for Raynal's star was on the rise.

Following his critical debut in the summer Raynal was as active as Apollinaire in support of the Salon de la Section d'Or, giving the second lecture in the series, securing the inclusion of Gris and Marcoussis and articulating, in the pamphlet's keynote article on the exhibition, a clearly partisan position with regard to cubism. Opening with a puff for Picasso, Braque and Metzinger as 'the sole initiators of the movement', he went on to eulogise cubist painting in the aestheticist terms of his August article and, developing Apollinaire's editorial emphasis, stressed its fundamental traditionalism:

> What finer idea than this conception of a *pure* painting, one that is in consequence neither descriptive, nor anecdotal, nor psychological, nor moral, nor sentimental, nor pedagogical, nor, finally, decorative? I do not say that these latter ways of understanding painting are neglible, but it is incontestable that they are irredeemably inferior. Painting, in fact, should be nothing other than an art derived from the disinterested study of forms, that is, free from any of the purposes I have mentioned . . . What can one say of this rich flowering of ideas, always based on the best and purest precepts of the ancients, this love of science that is a criterion of our modern, refined sensibility, this urge to weigh and measure everything . . . ?[103]

Turning to the exhibition, Raynal found a few words for most of its participants; once more it was Metzinger whom he favoured – comparing him, improbably, to Renoir as 'the man who perhaps knows best how to paint, in our epoch'[104] – while his discussion of the merits of other Puteaux artists was tempered in each case with reservations. Léger was inclined to be seduced by 'the slightly perverted charms of sensual vision', Duchamp's work was marred by 'incoherence' and lacked force, and Gleizes' major painting, *Le Dépiquage des moissons*, 'has even a 'museum' air about it'. The paintings of Picabia posed a problem: too numerous to avoid mentioning (as

one of the instigators of the exhibition and its major financier, Picabia had entered thirteen works, a number exceeded only by Gleizes' fifteen) – and, moreover, supported by Apollinaire, whose authority counted for much – they were yet not easily assimilable to an aestheticist interpretation; by discussing them only in the most general terms, acknowledging their difficulty and postponing further analysis to another occasion, Raynal got by without committing himself. In contrast Gris, 'certainly the most fiercely purist of the group', he lengthily and warmly commended for his intellectual approach to painting and collage.[105]

The ascendancy of gallery cubism that these critical initiatives of Apollinaire and Raynal helped to secure by late 1912 was acknowledged by the critics who cheered for salon cubism. Allard's review of the 1912 Salon d'Automne provided the occasion to stake his claim to priority in the articulation of a cubist aesthetic. 'In truth', he noted, 'this preciseness might have been omitted if certain efforts which I shall discuss below did not oblige each to recognise his responsibilities'.[106] In fact, he did not elaborate on it, but the remark can be taken as an oblique reference to the Section d'Or initiative, in which neither he nor his favoured cubist, Le Fauconnier, participated. Hourcade was more outspoken. 'I am well aware', he declared soon after the exhibition opened,

> that some . . . of my friends tend to confuse cubism and cubism, but they are not all alike. When a fellow critic thus says that the painting of his favourite is 'pure' painting, I see no problem. But to say, further, that the art of Metzinger, that of Gleizes, that of Le Fauconnier, that of Léger, is exclusively pure painting – that is not absolutely correct. And it is however those four painters who, with Delaunay, in 1910 and especially at the 1911 Indépendants, *created*, and truly still are, cubism (in embryo in Cézanne and in Braque-Picasso). Today this historical detail is perhaps too readily forgotten.[107]

Such objections were unable, it would seem, to affect the direction in which the cubist movement was developing. Although Hourcade highlighted tensions within the Puteaux circle that Apollinaire, Raynal and the Salon de la Section d'Or itself glossed over, he could do no more than this; significantly perhaps, this was to be his last critical intervention before the War, in which he was killed. Allard, too, found the critical discourse of cubism slipping away from him, and from this point wrote from the sidelines, displaying, in the series of articles discussed earlier, his increasing exasperation not only with its ascendant axis but also with the market-driven avant-gardism which he saw as a function of it. It is indicative both of how the cubist movement's co-ordinates had shifted, and of Allard's alienation from it after 1912, that these articles were published in periodicals that had little leverage within it – and that he was conspicuous by his absence from the pages of the new magazines that, from that date, were among its cardinal points of reference.

✻ ✻ ✻

Promoting and Positioning Cubism in the *petites revues*

The promotional advantages of having a periodical of their own had been apparent to the salon cubists in late 1911 but, as we have seen, the project was abandoned. As the stakes of avant-garde competition rose, other members or associates of the movement made similar efforts. In the autumn of 1913 Robert Delaunay sought to complement his and Sonia's entrepreneurial initiatives with the purchase of a magazine which was then foundering, writing to Auguste Macke in October that it would provide a firm basis for the international dissemination of their shared aesthetic ideals. Two months later, Gabrielle Buffet-Picabia announced in *Gil Blas* the forthcoming publication of a magazine under the direction of Jean Cocteau; both were as unfruitful as the earlier venture.[108]

Perhaps success in such efforts required a writerly rather than painterly disposition, for each of the three reviews that emerged in 1912–13 to campaign for its own understanding of cubism, among other things – and that drew largely from the habitués of the Puteaux meetings – was founded by a poet rather than a painter. In February 1912 Apollinaire and his friends established *Les Soirées de Paris*; under the editorship of André Billy until its monthly publication was interrupted by lack of funds in June 1913, it began a second series the following November with the poet himself at the helm. Supportive of cubism and of Picasso in particular from the start (the first issue carried Apollinaire's essay 'Du Sujet dans la peinture moderne'), the magazine's partisanship in the new series was made plain with the inclusion in its re-launch issue of photographs (courtesy of Kahnweiler) of five works by Picasso – four recent mixed-media constructions and a 1912 painting, the last of which provided the frontispiece.[109]

In the meantime Henri-Martin Barzun had launched *Poème et drame* in October 1912. Although primarily a vehicle for his own literary ideas, it gave plenty of space to consideration of contemporary art and provided for salon cubism a degree of support equivalent to that of Apollinaire for Picasso, printing an excerpt from Gleizes' and Metzinger's barely published *Du Cubisme* in its first issue.[110] Barzun's avant-gardist ambitions were clearly stated in this issue: the 'programme and goal' of *Poème et drame* were to be no less than to provide the forum for an international 'creative elite' and an anthology of its works. Its bi-monthly appearance was complemented by *les dîners de Passy* – a series of lectures and banquets in honour of revered literary figures of the recent past, sponsored by the magazine; while they were attended by writers and artists of all persuasions, the nucleus of participants came from the post-Abbaye and Puteaux groups.[111]

Hard on the heels of *Poème et drame* came *Montjoie!*, launched by Ricciotto Canudo in February 1913 with a mission statement that rivalled Barzun's magazine in its ambition 'to give a direction to the elite'.[112] From the start, its orientation to the cubist movement was quite plain, although more widely drawn than the other two: the first and second issues carried a two-part article by Gleizes and wood engravings by Villon and de la Fresnaye, and the following issues had regular articles by Apollinaire (including a eulogy of Picasso) and contributions from Raynal, Salmon

and the dealer Adolphe Basler (an associate of Kahnweiler), besides those of Canudo himself and his editorial partner Jacques Reboul. The illustrations in each issue were predominantly of work by artists from the Puteaux group, including Léger, Gleizes, Laurencin and Metzinger.

The partisanship of each of the three magazines is apparent as much, if not more, in the manner of its engagement with the dominant and counter-discourses of the moment as in the roll call of its contributors. Alexandra Parigoris has demonstrated that the form and the content together of the first series of *Les Soirées de Paris* were marked by 'satire and parody, allusion and derision' whose principal targets were the dominant discourse of bellicose nationalism and the stuffy complacency of the established literary reviews. Its columns, she notes, were full of 'word plays, *double entendres* and hidden meanings that barely veil the ferocity of [their] critique'.[113] Thus, for example, André Tudesq mocked the *revanchisme* of Barrès's 1909 novel *Colette Baudoche*, set in Alsace-Lorraine, with a humorous travelogue of the brothels of that region. Yet, as Parigoris suggests, the mockery owed less to any commitment to anti-militarism on Tudesq's part than to a spirit of absurdism for which Jarry was the example. It was in the same spirit that Apollinaire parodied the genre of the newly discovered literary manuscript in an analysis of the handwriting of some letters by Cézanne.[114] The irony and insouciance of these subversions of established ideas and genres was consonant with the aestheticism of Picasso's *papiers-collés*; as Parigoris argues, the magazine's editors wished to give their criticism the same weapons of irony, satire and allusion that those works so tellingly deployed.

The tone of *Poème et drame* contrasted as sharply with these qualities as its point of reference within the cubist movement differed from Apollinaire's. Georges Ribemont-Dessaignes's observation that Gleizes and Metzinger 'sought to establish a kind of legislation of the cubist movement, in order to raise it to the rank of an honourable means of expression, to integrate it into the Eternal and Universal Unity of art',[115] could be extended to Barzun's review, for it was dominated from its outset by his grandiose editorial statements of aesthetic principle. While *Poème et drame*'s contributors were fairly numerous, the most regular of them by far was its founder himself, and his essays coloured it inescapably. The transference of Barzun's avant-gardist ambitions from the political to the aesthetic arena I noted in Chapter 2; perhaps in compensation for this removal from the dominant to the dominated sector of the dominant class, the scope of those ambitions was global and their terms martially masculine: 'It is up to us, in this year of 1912', he declared in the first issue, 'to raise cohorts of athletes and legions of pioneers to plough and seed the ground of this new century, to reveal the new Era, rich in the art of our generation'.[116] The aesthetic corollary of this pseudo-Nietzschean rhetoric was an embrace of the new beauties of the modern world whose ardour rivalled – not without avant-gardist intention – that of the futurists: the beauties of modern science, 'of the senses multiplied by metallic power and speed . . . of collective, continental, global psychologies . . . of an inventive, active love astride the ruins of the love that is contemplative and sentimental.'[117] Beyond the bathos of such declarations lay, how-ever, a commitment to an aesthetic of simultaneity, articulated through dynamic and

dramatic formal contrasts, that Barzun shared both with members of the Puteaux circle such as Léger and with those, such as the Delaunays, who had drifted away from it, and on one level his increasingly desperate encyclicals in *Poème et drame* were a rearguard effort to keep this aesthetic in contention as the terms of cubist discourse narrowed. But the internationalism of his improbable aim to build a global 'creative elite' was at once compromised by a sectarianism that required the excommunication of potential allies, in particular the futurists, and sapped by the rising tide of nationalism.

As *Poème et drame* became increasingly the mouthpiece of a single beleaguered poet, Canudo's *Montjoie!* rode this tide to a position of prominence within the immediately pre-war avant-garde. He posted its politics on its masthead from the start: not only was the very title of the magazine an old royalist rallying cry taken from the *Chanson de Roland*, but its ambition to 'give a direction to the elite', declared Canudo, was defined in turn 'by a racial ambition to impose on the world an essential cultural type'. Like Barzun, its founder maintained close editorial control over its content with a despotism that 'enabled him to obtain from his collaborators a remarkable unity of viewpoint'.[118] From a traditionalist nationalism thus signalled from the outset, and underscored in articles by Reboul (exalting French imperialism as a cultural imperative) and Clouard (on the beneficial discipline of tradition), as well as in Gleizes' 'Le Cubisme et la tradition' already discussed. Canudo then developed the project of encompassing the spectrum of contemporary Parisian artistic practices within a definition of French culture as elitist, anti-decorative and cerebral. This position was articulated most explicitly in his 'Manifeste de l'art cérébriste', published in *Le Figaro* in February 1914 (in conscious emulation of Marinetti whose founding manifesto of futurism had appeared in the same paper exactly five years earlier). Canudo argued that 'the general character of contemporary innovation' lay in 'the transposition of artistic emotion from the *sentimental* to the *cerebral plane*': gathering behind his banner fauvist, cubist, futurist, simultanist and synchromist art, as well as 'post-Mallarméen' poetry and 'post-Debussyiste' music, he demanded 'the possession of painting by painting, and not by the literary or sentimental idea that it has to illustrate'; 'we want', he declared, 'a more noble and purer art, that touches not the heart but the mind, *which does not charm but makes us think*.'[119]

This aesthetic is clearly congruent with that repeatedly articulated by Raynal from the summer of 1912; there is the same emphasis on formalist concerns, the same embrace of classical values, the same rejection of decoration. *Montjoie!* added to the critic's argument, however, a nationalist inflection that offered the means of reconciling the options between which both Raynal and Apollinaire were torn in 1912 – those of insisting upon either the legitimacy or the aestheticist avant-gardism of the cubism that they defined and defended. As he developed this position in *Montjoie!*'s pages from issue to issue, Canudo thus gave an implicit answer to the question posed implicitly by Mourey in 1911: that the cubist project was not only no threat to the French cultural and social order but the very means of imposing its 'essential cultural type' on the modern world. Such a message, from such a magazine, was not without consequence for cubism itself, as we shall see.

Chapter 7

Cubism and Decoration: Tradition and Modernity

Many consider that decorative preoccupations must govern the spirit of the new painters. Undoubtedly they are ignorant of the most obvious signs which make decorative work the antithesis of the picture.

Du Cubisme[1]

The revival of the decorative and the extravagant is symptomatic of the decline of modernism, but it is not an exemplary alternative or antidote. It was modernism's symptomatic shadow from the very beginning. The problem in the end, however, is how to find ways to disentangle and deconstruct the cascade of antinomies that constituted the identity of modernism . . . functional/decorative, useful/wasteful, natural/artificial, machine/body, masculine/feminine, West/East.

Peter Wollen[2]

The Maison Cubiste and the Ruralist Revival

With the above statement in *Du Cubisme*, Gleizes and Metzinger appeared to distinguish unequivocally between the modernist project that cubism had become by the autumn of 1912 and the contemporary discourse of decoration which was gaining increasing purchase on the terms of new art. Yet at the very moment that this declaration was published, some of their pictures at the Salon d'Automne were decorating the walls of a suite of furnished domestic interiors that represented the most ambitious collective venture of the cubist movement to date. Orchestrated by André Mare, the project later known as the Maison cubiste had involved the participation of most of the Puteaux circle, including Léger and the Duchamp brothers, as well as Laurencin and de la Fresnaye, among others. Comprising a porch, hall, *salon bourgeois* and bedroom, the ensemble was as unmissable a feature for visitors to that year's salon as had been the room of cubist paintings the previous year, and gained the salon cubist group greater notoriety than ever. Two weeks after the salon opened,

Roger Allard noted that the Maison cubiste had already received more insults than a cubist painting.[3]

The coincidence of this project with the publication of cubism's first manifesto and its anti-decorative emphasis has seemed paradoxical to historians of the movement; the response has largely been to ignore it. Regarded almost from the first as a curiosity *sans issue*, chronicled with indifference in the standard history as a distraction from cubism's main concerns, the Maison cubiste has been sidelined – where it has not been avoided – in accounts of the movement, with few exceptions.[4] The paradox, however, is of art history's own making, the product of a genealogy for modernism constructed through the cascade of antinomies that Peter Wollen identifies. As I shall argue, the Maison cubiste both demonstrates the inadequacy of such a construction and provides an occasion to contribute to that dismantling of its antinomies for which Wollen calls. Far from being without consequence, it indicates the complexity of the cubist movement, its irreducibility to a single and coherent set of themes and concerns. Indeed, an examination of the Maison cubiste reveals not only the particular tensions and contradictions which the movement encompassed but their heteronomous character, for it can be seen to have stood at the intersection of the dominant discourses of the pre-war period.

Common to those discourses was nationalism, and it certainly set the terms in which the initiative was widely condemned. Viewed through the prism of a hostility to cubism that from 1912 was based increasingly on xenophobia, the innovations of the Maison cubiste were seen by most critics as decidedly outside French tradition, along with other hallmarks of cubist style.[5] Emile Sedeyn's review is representative of many in its rejection of the ensemble as childish, primitive and untutored, and for taking foreign influences to an extreme. 'Decorative art has not only its cubists', he declared, 'it has also its virtuosi, who play with it as a Neapolitan plays a guitar: without having learned how.' Sedeyn and several other critics saw in the ensemble and its contents a disharmony that was opposed to French cultural values, and equated their colours with the barbarities of 'la palette munichoise'.[6]

It is ironic, then, that the Maison cubiste was intended perhaps above all as a positive response to the call for a renaissance of French decorative art that, as I indicated in Chapter 3, was by 1912 being made across the political spectrum. Mare and his co-participants were by no means alone among young anti-academic artists in turning to decorative work; as his friend Ami Chantre noted in an article of the following year:

> There is . . . a close connection between the malaise of which contemporary painting seems unable to rid itself, and the happy vitality of decorative art. Honest artists . . . too prudent to venture along the cubist road, which is rocky and probably leads nowhere, and despairing of finding elsewhere that new classicism which certain devotees, of whom I am one, still await, they are renouncing painting . . . They are picking up the tools abandoned by the artisan in preference for machines, and in place of decorating our walls, they are furnishing our houses.[7]

That the Puteaux group's motivation for collaborating on the project was at least partly nationalist is indicated by an unpublished statement of 1912 by Duchamp-Villon:

> One hears on all sides that we live in the most impoverished epoch of our history [with respect to the decorative arts] . . . We are living on our glorious past like prodigal sons on the accumulated fortunes of their elders . . . There is talk of holding an exhibition of modern decorative art in Paris in 1915. An initiative of this kind is a real contest in which the supremacy of artistic taste is at stake; we shall have to be ready to defend our once unassailable reputation.[8]

Taking up the challenge implicit in Duchamp-Villon's remarks, Mare secured the collaboration of twelve artist friends in the construction and furnishing of an ensemble comprising three interiors and part of a full-scale facade (Figs 40, 41 and 43). The last was the work of Duchamp-Villon himself, who also built a doll's-house-size maquette of the proposed Maison (Fig. 42). Inside, the entrance hall, *salon bourgeois* and bedroom contained among other things furniture (settees, bed, armchairs, occasional chairs and tables) and wallpaper by Mare, with cushions by Gampert, fireplaces and clocks by de la Fresnaye, glassware by Marinot, a tea service by Villon, decorated mirrors by Laurencin and paintings by Léger, Metzinger, Gleizes, de la

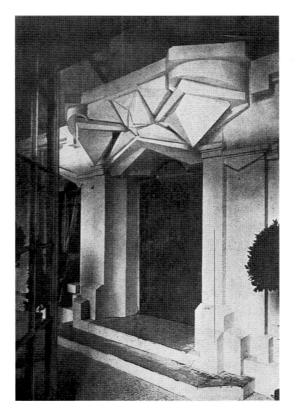

40 Raymond Duchamp-Villon. Entrance to the Maison cubiste. Paris: Salon d'Automne, 1912.

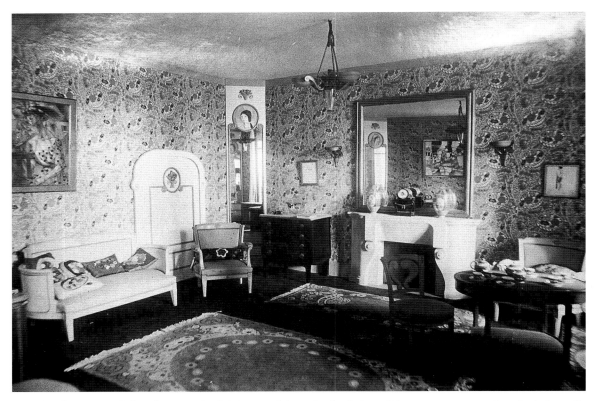

41 André Mare. Salon bourgeois, Maison cubiste. Paris: Salon d'Automne, 1912. On the left wall, above the settee by Mare, is Jean Metzinger's *Femme à l'éventail*; Fernand Léger's *Passage à niveau* is reflected in the fireplace mirror. The fireplace itself was designed by Roger de la Fresnaye, and the tea service on the table, right, by Jacques Villon.

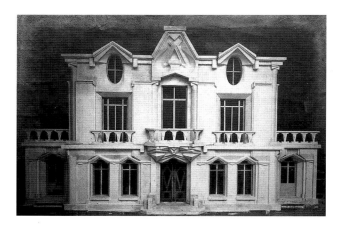

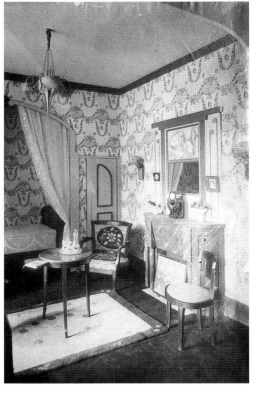

42 (above) Raymond Duchamp-Villon. Model for the façade of the Maison cubiste. 1912. Paris: Collection Mme Simonne Vène.

43 (right) André Mare. Petite chambre, Maison cubiste. Paris: Salon d'Automne, 1912.

Fresnaye and Duchamp (Figs 44–46).[9] Mare was determined to ensure that the Maison Cubiste should offer a clear declaration of commitment not simply to traditional French cultural values but to a particular constellation of these. Writing some notes of guidance to Maurice Marinot, he enumerated the aesthetic features that he hoped the ensemble would display:

> To make above all something very *French*, to remain within tradition = to let ourselves be guided by our instinct which compels us to react against the errors of 1900 and that reaction can consist in this:
>
> 1) Return to lines that are simple, pure, logical and even slightly cold, whereas the period that preceded us was horribly tormented.
> 2) Return to colours that are very fresh, very pure, very daring, whereas that same preceding period was always content with washed-out, discoloured, anaemic tones.
>
> Have a vigorous and naïve drawing style . . . [that is] *gauche* rather than artful . . .[10]

Implicit in this selection of qualities is an allegiance to that provincial, ruralist variant of French classicism that we encountered in the writings of Roger Marx. Its salient features were already evident in Mare's first exhibited furniture. After some anonymous work for an ensemble exhibited by Groult in 1910, he showed a study and a dining room in his own name at the 1911 Salon d'Automne; both were remarked upon by Louis Vauxcelles, for whom the dining room evoked the interior

44 (left) Marie Laurencin. Mirror decoration for salon bourgeois, Maison cubiste. Paris: Salon d'Automne, 1912.

45 (above) André Mare. Bed and bedcover for petite chambre, Maison cubiste. Paris: Salon d'Automne, 1912.

46 Maurice Marinot.
Enamel glassware for
salon bourgeois,
Maison cubiste. Paris:
Salon d'Automne,
1912.

of a Norman farm inhabited by a 'gentleman-farmer artiste' (*sic*), and the critic observed with approval that in this Mare 'had sought to revive the decorative motifs of a provincial tradition unvaried for centuries'. The result was an 'entirely French art, strongly flavoured by its Normandy *terroir*', its sincerity and naïveté suggestive of artisanal qualities, 'the hand of a good workman'.[11] Mare's own major contribution the following year to the Maison cubiste was a development from this ensemble, combining its ruralist qualities with an explicit appropriation of the Louis-Philippe style whose association with the bourgeois orientation of that régime were seen by the Puteaux circle as more adaptable to contemporary tastes and politics than the *ancien régime* styles referenced by art nouveau.[12] Both these qualities and this comparison were remarked upon with approval by sympathetic critics such as Gustave Kahn as characterising the Maison cubiste project as a whole:

> M. Mare has put us back in touch with a traditional art that opposes art nouveau . . . he and his friends have sought inspiration in that provincial aesthetic life of France that used to be everywhere but is now reduced to a few islands . . . have embraced what is left to us of old provincial customs,

wrote Kahn in reviewing the exhibit, and he praised Mare's settees for their origins in popular art and Marinot's glassware for its illustrations of village life.[13] Moreover, he argued for the values implied as being more than a matter of style: the provincial motifs were, he explained, at one and the same time responses on the part of artists to the spirit and needs of the present, and the embodiment of certain aesthetic constants that were themselves constitutive of a tradition.

Thus for its supporters as well as its initiator the Maison cubiste project stood in sympathetic relation to that broadly solidarist ideology that, I have argued, was both

politically and culturally dominant in pre-war France; the aesthetic character that Mare made every effort to give it was consonant with key features of this. And yet it held a contradiction that marked the distance between them. For Roger Marx and the Radicals the stress on a provincial, artisanal tradition went hand in hand with a commitment to *art social* – to the industrialisation of art, the revitalisation of craft *métiers*, the dissemination of beauty. This was not so for Mare, nor for those of the Puteaux circle whose collaboration took the form of interior decoration, furniture and *objets d'art*. Trained as painters, they had little or no decorative craft skills, and did not try to make their own decorative work; it was made by Parisian craft workshops such as that of the *ébéniste* Hazeler. The work they designed for the Maison cubiste was not inexpensive everyday ware suitable for mass production, but luxury ware involving intricate ornamentation and expensive materials such as exotic woods, for the comfortable middle class, and it sold to them: Charlotte Mare's unpublished memoirs note that business was good for her husband from the very start, and many of the components of the Maison had already been purchased, by the couturier Poiret among others. *Un salon bourgeois* was an appropriate description for the main ensemble, as Léger himself noted.[14]

The rejection, implicit in the Maison cubiste, of efforts towards the industrialisation of art and the democratisation of beauty was not only a refusal of that *art social* appeal; it amounted also to an acknowledgement of the pressures of debate within the Puteaux circle from 1912. As the ascendancy of gallery cubism was consolidated in this milieu, and registered in *Du Cubisme* in the efforts made by Metzinger and Gleizes to accommodate it, the elitism of the group's collective venture, too, marked the force of the aestheticist critique of the attempt to democratise art, to efface the distinctions between modernist and popular cultural practices. Yet such was the currency of that populist discourse that critics sympathetic to the Maison cubiste initiative defended this in populist terms. Kahn, while distinguishing its aesthetic from that of art nouveau, claimed for the cubists a similar concern to create beautiful objects for everyday use, while Léandre Vaillat went further, seeing in Mare's economy of means the achievement of 'the chimera of furniture accessible to everyone, furniture that affirms with dignity the moderation of its owner', and describing at length the care with which Mare supervised the work of the *ébénistes*.[15]

From another critical quarter, however, came a sharp though indirect rebuttal of such claims. In late 1912 and early 1913 Charles Le Cour and Jean Lurçat in the pro-syndicalist periodical *Les Feuilles de mai* presented a harsh assessment of the modern style created by the bourgeoisie, and of its consequences for the decorative arts industries.[16] The bourgeoisie had wanted to realise its own modern style that would be the latest ornament to its rule, they argued; ignoring the time-honoured artisanal skills of the people, it had created a class of *dessinateurs* who were neither artists, since they had no independent vision, nor artisans, since they had no trade. The result was modishness for its own sake. Audacity was in the air, the authors observed; cubism was the great novelty of painting, now novelty furniture was needed (a veiled reference, surely, to the *salon bourgeois*). There was a wilful misuse of materials, in the misguided belief that these were only beautiful when they had been carefully

camouflaged or tortured. Artisans, by contrast, never abused their materials; they knew them, as peasants knew their land, and treated them with a sensitivity and honesty that were completely lacking among the decorators.[17]

Despite the harshness of this critique, the artisans of the *métiers d'art* on whose behalf it was made and the *dessinateurs* such as Mare and his collaborators who were its object had a common enemy. At a moment when de-skilling in the Parisian luxury crafts was at its height, as burgeoning consumerism gave department stores and large-scale manufacturers the power to reshape workshop practices to suit their needs, these big firms were the focus of an increasing resentment on the part of craft workers that frequently boiled over into strike action as noted in Chapter 1. At the same time, as we saw in Chapter 3, in the debate over the perceived crisis in the French decorative arts industries, the position of the leading decorative artists' associations was hardening against what they saw as the manufacturers' deliberate avoidance of both modern designs and French craft workers in favour of pastiches of past styles made with foreign labour. Artists and artisans also shared some responses: Mare's championing of provincial classicism matched Le Cour and Lurçat's equation of craft skills with peasant knowledge, each appealing to a pre-industrial, ruralist notion of the popular that stood in implicit opposition to the forces of modernisation. And artisanal attempts to defend the traditional hierarchies of the small workshop were echoed by the opening of decorative arts boutiques – in 1911 Poiret's Atelier Martine, in 1912 Süe's Atelier Français and Francis Jourdain's Ateliers Modernes – whose products, although clearly for an elite clientele, were made in keeping with traditional workshop practices, under the direction of a single artist-decorator.[18]

Such ideological constructions of the popular could not long hold the dyke, however, against the *de facto* redefinition of this in terms of modern consumerism. In the pre-war years mass consumption and merchandising reached their first flood tide, as noted earlier, with an unprecedented range of commodities available in the department stores. In 1912 this range expanded to include modern decorative arts, with the opening by the Au Printemps store of its own *atelier d'art*, Primavera, selling a wide but exclusive range of domestic furnishings. Its promotional material, emphasising its democratic initiative in putting the artist at the service of the people and its seminal role as educator of taste in promoting the modern style to a conservative public, showed clearly the extent to which it had appropriated for the mass market the mission of the boutiques and the *métiers d'art*.[19] Its methods of manufacture were similar to theirs but the department store's economies of scale enabled it to secure cheaper materials and serial production to make cheaper objects, which its more substantial promotional resources then sold to a wider market.[20] Other department stores followed Au Printemps – the War intervening – in the early 1920s, and the development reached its apogee at the 1925 Exposition, where the four major stores each had its own decorative arts pavilion, one at each corner of the site.[21] By 1927 it could be argued that their display windows were 'museums for the people' – a claim that in its appropriation of Roger Marx's fin-de-siècle idea of *musées du soir* registers graphically the extent to which the liberal utopianism of *art social* had been co-opted by commerce, and ideological construction overtaken by economic reality.[22] Such co-

option was under way before the War, however, impelled both by nationalistic sentiment and by recognition of the material benefits that economic modernisation could bring. By early 1914 the debate over the crisis in French decorative art had raised awareness of the success of the Deutscher Werkbund in uniting artists and manufacturers in mass production of modern designs. As Nancy Troy argues,

> [for] virtually every participant in the French decorative arts system, from govern-
> ment administrators and manufacturers to consumers and critics, even many
> artists . . . industrial production and commercialisation appeared to be the only
> realistic solution to the crisis . . . Whereas foreign competition had previously been
> cited as the primary reason for French decorative artists to renew their commitment
> to the nation's luxury craft traditions, now it was seen as the single most important
> factor in the need for French artists to join forces with industry and commerce.[23]

The Maison cubiste initiative was clearly at odds with this new consensus. It was shaped by the tension between a traditionalist nationalism, in which populism increasingly featured, and a pre-war aestheticism, for which the dissemination of beauty by means of the decorative arts signified its banalisation. Thus Mare's ensemble, in its tacitly anti-industrial assumptions, paralleled quite closely the am-bivalence towards modernity that, I have suggested, is evident in the contemporary paintings and writings of Gleizes, Le Fauconnier and Metzinger. As the crisis in the decorative arts industries deepened, these assumptions came increasingly into conflict with the realities of economic competition and modern consumerism.

The rise of consumerism did not only help to redefine the popular in terms of modernity, however; it also gave it a gendered inflection, situating femininity at the heart of the modern in a way that the discourse of industrialisation did not. As Rita Felski observes,

> Not only did the department store provide a new kind of urban public space which
> catered primarily to women, but modern industry and commerce encroached ever
> more insistently on the sanctity of the private and domestic realm through the
> commodification of the household. Although the middle-class woman's responsi-
> bility for the purchase rather than the production of goods seemed to locate her
> outside of the dynamic of social change, in another sense her status as consumer
> gave her an intimate familiarity with the rapidly changing fashions and lifestyles
> that constituted an important part of the felt experience of being modern.[24]

In this context, the Puteaux group's attempt to reinvigorate the luxury craft traditions also had gendered qualities and connotations. Several recent studies have explored the ways in which in the 1890s art nouveau was defined as a 'feminine' style, and in the following decades signified negatively as unbridled – by implication female – excess.[25] In its rejection of art nouveau, Mare's project can be seen as gendered in both stylistic and strategic terms – stylistic, as Troy notes, in that its Louis-Philippe-inspired components displayed, as Mare had insisted, qualities that were self-consciously 'masculine' as well as classical (simplicity, severity, logic, vigour) and that contrasted sharply as such with those which represented what he termed 'the errors

of 1900'.[26] And strategic, in that the decision of the Puteaux artists to collaborate in Mare's venture came when the effort of masculinist revitalisation of French decorative arts was at its height. It was in response to the 1910 Salon d'Automne exhibition of decorative ensembles from Munich that French male artists turned to the decorative arts in growing numbers, and adopted a similar practice of displaying their designs in ensembles, as Le Corbusier later noted,

> the exponents of the *decorative ensemble* wished to show, in making their name and establishing their profession, that male abilities were indispensable in this field: considerations of *ensemble*, organisation, sense of unity, balance, proportion, harmony.

Their initiatives soon reaped benefits, such as the award of the industrialists' prize at the 1912 Salon d'Automne to five men (of whom Mare was one), as against one woman.[27] In its juxtaposition of cubist paintings with decorative objects, the Maison cubiste too can plausibly be seen, Troy suggests, as 'an effort to redefine decorative art itself, and the domestic interior in particular, as appropriate sites for men's artistic activity.'[28] Yet this effort, if such it was, was both compromised by the participation of Marie Laurencin (whose four painted roundels of female heads, one at each corner of the *salon bourgeois*, presided like muses over that ensemble) and vitiated by initiatives such as that of Primavera, which underwrote the conventional feminisation of interior domestic space with the associations and demands of an equally feminised consumer culture.

In the following decade this gendered character of consumerism was to combine with French industry's acquiescence in a logic of international competition that favoured Parisian specialisation in luxury commodities, to construct Paris as a 'woman's city'.[29] In this respect too, the 1925 Exposition was symbolic, prioritising consumption over production and pleasure over utility not only in the commanding positions allocated to the *ateliers d'art* of the *grands magasins*, but also in its central feature, the Alexandre III bridge embellished with a 'street' of forty boutiques displaying French luxury goods, predominantly women's haute couture and fashion accessories. Consequently, it was women's fashion, as opposed to urbanism or industrialisation, that defined *nouveauté*.[30] This emergence of feminised consumerism as a primary signifier of modernity reached its apogee with the Exposition, but it too was prefigured before the War. One of the participants in the Exposition was Sonia Delaunay, with a boutique on the bridge, Simultané, displaying her distinctive fashions, textiles and fashion accessories. This range of products, while it secured her inter-war reputation as a leading designer of luxury goods, was the product of an artistic trajectory that began with her partnership with Robert Delaunay in 1909. Their joint career in the five years before the War is a register of just that double dynamic that I have been tracing – the displacement of a notion of the popular defined as traditionalist, provincial and as implicitly masculine, by one which defined it as modern, metropolitan and consumerist – and in many respects often explicitly feminine. While their starting-point was similar to that of the Maison cubiste project, this trajectory distinguished the Delaunays clearly from their erstwhile companions in the

salon cubist circle, and helped to remove them from it. An examination of their course helps to bring into focus the configuration of the discursive field that shaped the cubist avant-garde, and thus to deconstruct Wollen's 'cascade of antinomies' through which the identity of modernism has been secured.

Sonia and Robert Delaunay: Populism, Consumerism and Modernity

Robert Delaunay's lack of formal artistic education predisposed him from the start to identify with artistic traditions and practices outside the mainstream, just as his unconventional upbringing perhaps fostered his anti-bourgeois postures. The son of a countess whose fashionable and peripatetic way of life consigned him to a child-hood with relatives, he learned to paint by apprenticing himself, first to a theatrical decorator's studio in working-class Belleville, and second – less formally – to the neo-impressionist style he encountered at the Salon d'Automne and the Indépendants. In 1906 he met the painter Henri Rousseau, whose *Charmeuse de serpents* his mother bought from the artist, and in 1909 another painter, Sonia Terk, whose then husband Wilhelm Uhde was among Rousseau's earliest collector-dealers. Sonia's background, while it included some years of formal art training, encompassed at least as much social mobility as his own.[31] For both Robert and Sonia, Rousseau was a close friend and his art a point of reference. After his death in 1910 Robert planned a book on the *douanier*: the incomplete manuscript that survives (fragments of which were pub-lished after his own death) is a moving tribute to a friend and a celebration of the popular *imagier* tradition represented by 'those painters one meets in the suburbs, the countryside'; this art was 'the unaffected and direct expression of those artisans; fairground and barbershop painters, amateurs, milkmen etc'. 'Of all this painting, which has its direct root in the fertile ideas of the people', Robert declared, 'Rousseau was the genius, the precious flower.'[32] He also celebrated – and implicitly identified with – its independence from dominant culture, of whatever fraction: 'this art issuing from the depths of the people, as completely misunderstood in revolutionary as in academic art circles, will be doubly so by virtue of the mastery of its accomplishment.'[33]

Consistent with this celebration of an artisanal and provincial art tradition was Robert's repeated insistence on the importance of *métier*, and his understanding of this in class terms. In his writing of the time he seemed to go out of his way to characterise his art practice as manual, non-bourgeois and anti-intellectual. Writing to Franz Marc in December 1912 he suggested it was because of a tendency to rationalise and philosophise that Marc failed to understand his 'artisan's conscious-ness' and 'workers' language', his *métier*-based attachment to the painting of light. In April 1913 he told Marc that thanks to the influence of Rousseau and his own current efforts 'there is a team coming together now which is overturning intellectualism and taste. *Métier* has a big role to play now.' More explicitly still, he stated in an essay of October 1913 that 'the world is not our representation recreated by reasoning

47 Robert Delaunay. *Fenêtres ouvertes simultanément (1ère partie 3ème motif)*. 1912. Oil on canvas, 45.7 × 37.5 cm. London: Tate Gallery.

(cubism), the world is our *métier*.'[34] Together with the Rousseau manuscript, these assertions convey Robert's deep attachment to a constellation of cultural values that he saw as intrinsically popular and with which we are by now familiar.

These values were also implicit in his and Sonia's art practice, both in the pictures themselves and where they were exhibited. From the spring of 1912 their paintings fell into two seemingly distinct categories: in the first were small paintings whose elements became steadily less representational and through which both artists pursued their shared preoccupation with the constructive pictorial role of light and colour. These, which evolved from Robert's *Fenêtres* series (Fig. 47) and Sonia's *Contrastes simultanés* of 1912 (Fig. 48) through the former's *Soleil, lune* works to his extraordinary *Disque* of 1913–14 (Fig. 50),[35] were exhibited not in Paris but in

48 Sonia Delaunay. *Contrastes simultanés*. 1912. Oil on canvas, 45.5 × 55 cm. Paris: Musée National d'Art Moderne.

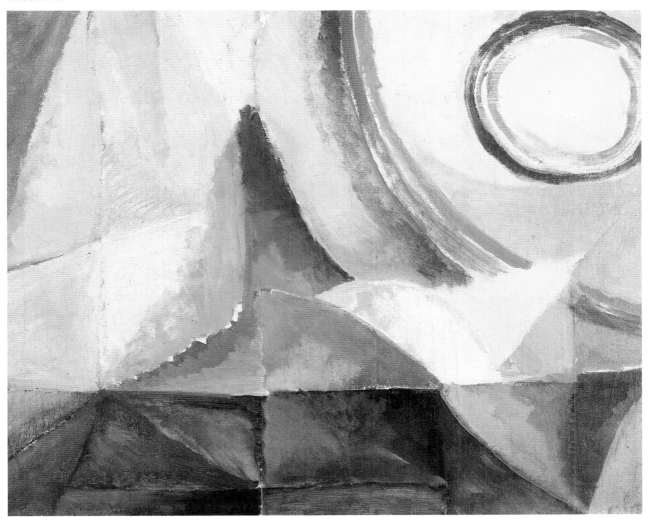

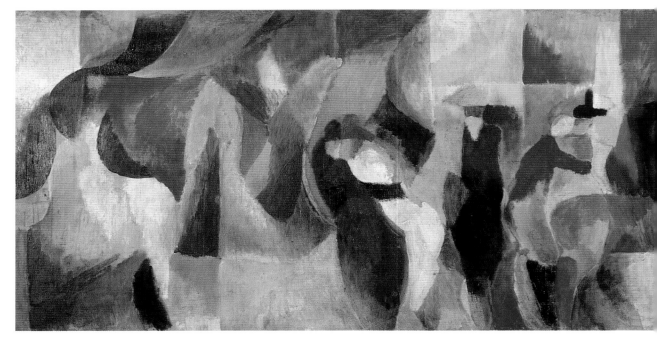

49 Sonia Delaunay. *Bal Bullier*. 1913. Oil on canvas, 97 × 336.5 cm. Paris: Musée National d'Art Moderne.

50 Robert Delaunay. *Le premier disque*. 1913–14. Oil on canvas (tondo), diameter 134 cm. Switzerland: private collection.

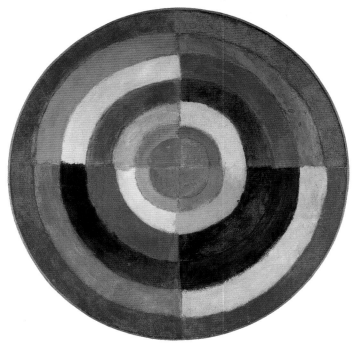

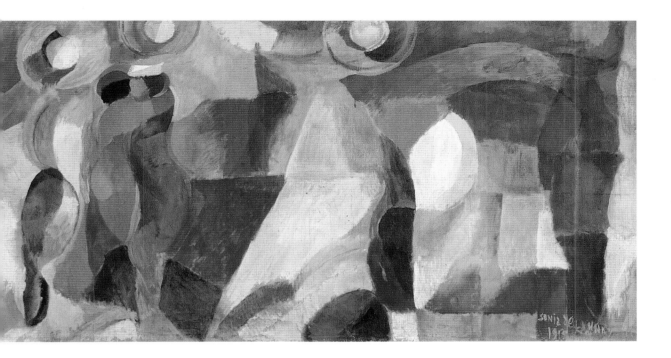

numerous exhibitions on the burgeoning avant-garde circuit across Europe. The second consisted of large paintings of recognisable subjects drawn from popular entertainment or public events; shown annually in Paris at the Indépendants, these included Sonia's *Bal Bullier* of 1913 (based on their visits to this dance hall in Montparnasse) and Robert's *Equipe de Cardiff* of 1913 and *Hommage à Blériot* of 1914 (Figs 49 and 51). Not only distinct in these material respects, the two categories of work seem to represent equally distinct sets of interest, indeed contrary ones in art market terms. The first represents a pictorial practice similar to that of Picasso and Braque in 1910–12 and promoted by the artists by a strategy identical to that pioneered by Kahnweiler; the second is closer to the salon cubism from which Robert had distanced himself and addressed a sector of the market that Kahnweiler actively ignored. The Delaunays, however, saw them as complementary; keenly aware of the inaccessibility of the paintings of the first category, Robert acknowledged the need to assist public comprehension and enjoyment of their work.[36] The salon *machines* appear to have been the means to this, their subject matter deliberately chosen on criteria of topicality, modernity and popular reach, as Sonia later recalled,[37] and exhibited exclusively at the un-juried Salon des Indépendants, to which they remained loyal as a mark of affection for Rousseau, whose preferred salon it was.

Yet their interest in addressing such subjects marks also a development of their populism away from an attachment to that small-town, traditional culture of which they saw the *douanier* as the 'precious flower', towards one which celebrated characteristically modern collective experiences and their representation – team sports, urban dance halls, aviation shows. This engagement with modernity had been a feature of Robert's paintings from the start of his liaison with Sonia, as well as of Rousseau's work – indeed Robert acknowledged his debt to the latter's enthusiasm for the modern, in quoting his self-portrait with the Eiffel Tower in the *Ville de Paris*

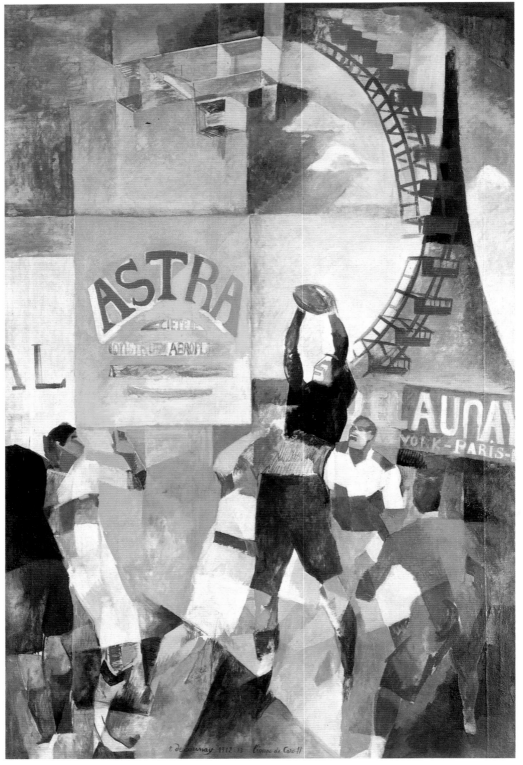

51 Robert Delaunay. *Troisième Représentation. L'Equipe de Cardiff F. C.* 1912–13. Oil on canvas, 326 × 208 cm. Paris: Musée d'Art Moderne de la Ville de Paris.

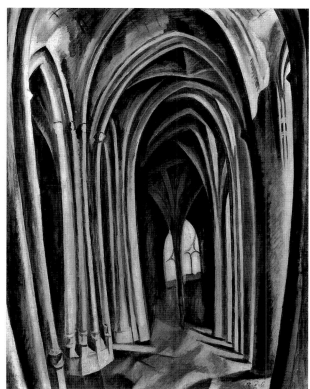

52 (left) Henri Rousseau. *Moi-même, portrait-paysage*. 1890. Oil on canvas, 143 × 110.5 cm. Prague: Narodni Galerie.

53 (right) Robert Delaunay. *Saint Séverin n° 3*. 1909. Oil on canvas, 114.1 × 88.6. New York: Solomon R. Guggenheim Museum. Gift: Solomon R. Guggenheim, 1941.

of early 1912 (Figs 26 and 52), even though his written homage to the old painter made no mention of that enthusiasm.[38] Its original motivations, Virginia Spate suggests, seem to have lain as much in an interest in the pictorial implications of the spatial experience of the modern city, as with the latter as emblematic of modernity: the vertiginous, light-filled perspectives that views of the Eiffel Tower afforded posed pictorial challenges that followed from Robert's exploration of interior space and light in the *St Severin* series of 1909–10 (Figs 53 and 54).[39] If Rousseau provided the painterly precedent and the cultural legitimation for this transcription of his populism into a modern key, it was supported by other contemporary factors, chief among which were Robert's association from 1909 with Jules Romains, whose epic poem 'La Vie unanime' had been published the previous year to wide acclaim, and whose lyric representation of a collective urban consciousness rode on a strong current of enthusiasm for the experience of modernity.[40] The challenge had moreover been thrown down again by the futurist painters with their 1910 'Technical Manifesto', a year after Marinetti's first 'Futurist Manifesto'.

If Robert's populism derived in part, as I have suggested, from his unconventional upbringing and virtually autodidact fine art education – experiences which furnished

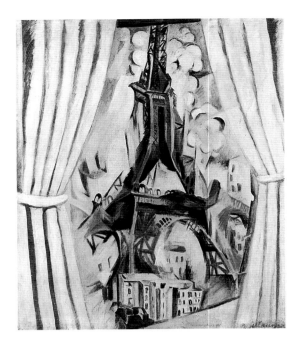

54 (right) Robert Delaunay. *La Tour aux rideaux*. 1910. Oil on canvas, 116 × 96.5 cm. Dusseldorf: Kunstsammlung Nordrhein-Westfalen.

55 (far right) Sonia Delaunay. *Robe simultanée*. 1913–14. Mixed fabric. Destroyed.

him as much with hostility towards bourgeois culture and resentment of the advantages that this gave his colleagues in the cubist avant-garde, as with the means for identification with popular culture both traditional and modern – it was congruent with Sonia's increasing engagement, after 1911, with decorative arts and design practice at the expense of painting (Fig. 55). The reasons for this appear to have been complex. Gender was almost certainly one; although, as I have argued, the growing perception from the turn of the century of a crisis in the French decorative arts industries resulted in their re-masculinisation, there were still factors that gendered the decorative as feminine. The campaign conducted in the 1890s by the Union Centrale des Arts Décoratifs for a return to the *ancien régime*'s tradition of aristocratic women as makers of luxury crafts reinforced both the republican pedagogic policy of gendered differences in art education and assumptions that decorative arts skills were part of the expected accomplishments of young ladies. In this context it is significant that Robert's mother around 1909 was turning her own such accomplishments to financial advantage, designing floral embroidery motifs for sale.[41] For Sonia such factors would have been emphasised both by her position as a woman artist in the Parisian avant-garde and by her personal and artistic partnership. The regressive character of the social relations of sexuality in those milieux excluded fine art work by women from the collective avant-gardist endeavour; in Sonia's case, while her partnership with Robert gave her a prominence that was untypical for a woman, it also constructed her artistic subjectivity. The conventional relationship in male–female artistic partnerships in the twentieth-century avant-gardes has been characterised as a 'double-voiced discourse containing both a "dominant" and a "muted" story'; in that of the Delaunays Robert's was of course constructed as dominant.[42] Gender was not the only factor, however. While neither by background nor ideology do they appear to have been led to respond to the nationalism that informed both the

art social movement and the Maison cubiste initiative, the allegiance to provincial cultural traditions that Sonia and Robert shared with these would have predisposed them to respond favourably to the widespread exhortations to painters to turn their attention to the decorative arts. The arrival in 1909 and immediate success in Paris of the Ballets Russes also fuelled the interest in the decorative and generated a fashion for the peasant crafts of Russia that must have kindled lively memories for Sonia in particular.[43]

The development of Sonia's decorative art activities was, moreover, an extension of the couple's entrepreneurial approach to the promotion of their paintings around the European avant-garde art market. Fostered partly by the climate of support for decorative art initiatives, her innovations in book design – the series of bookbindings that she began in 1913, and especially her pioneering collaboration of that year with Cendrars on the *Prose du Transsibérien* (Fig. 56) – were prototypes for the projects of the business group the Corporation Nouvelle that Sonia established in Portugal in 1916. In the year before the War this orientation to commerce became more pronounced, and kept pace with their increasing pictorial engagement with emblems of modernity. Given the ubiquity of billboards in Paris by 1912, it must have seemed a short step for Sonia from representing and utilising these as constructive elements in paintings such as her *Tango Magic City*, or Robert's *Equipe de Cardiff* (Fig. 51), both of 1913, to designing the advertisements themselves in projects such as her posters for Pirelli (1913) and Dubonnet (1914; Fig. 57) – albeit, it seems, without commercial success – thus from their embrace of commodified popular culture to participation in its production.[44] That Robert and Sonia saw this development as not only in keeping with their attempts to bring the results of their pictorial experimentation to a popular audience but also as a means of doing so, is evident from Robert's later observation that Sonia's boutique Simultané, whose window display he compared to the *Prose du Transsibérien*, was one of the 'new signs' through which the artist could communicate with a mass audience.[45]

By 1914, then, the Delaunays already viewed consumerism in ways that distinguished them clearly from the aestheticism and traditionalism of the Maison cubiste and the Puteaux group: they could see in consumer culture not the threat of banality but a means of disseminating the gains of artistic experimentation. And whereas, in the case of Picasso's engagement with the modern typographical environment, the irony and wit of his *papiers-collés* worked to distance and disarm the challenge posed by popular culture to the autonomy of modernist art, Sonia's application of her pictorial innovations to graphic design and other media sought to realise the opportunities it presented, by collapsing the distinction between them. If it was her initiatives rather than

56 Sonia Delaunay. Coloured edition of Blaise Cendrars's 'La Prose du Transsibérien et de la Petite Jehanne de France'. 1913. Single folded sheet, 2 m long. London: Tate Gallery.

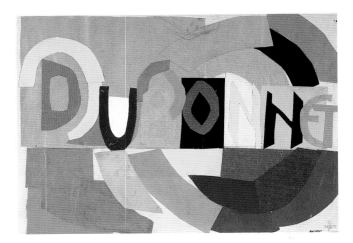

57 Sonia Delaunay.
Projet d'affiche
Dubonnet. 1914.
Coloured papers, 32.5 ×
46.5 cm. Paris: Musée
National d'Art Moderne.

Robert's that registered the developing pre-war commercial orientation, he did later
repeatedly express his support for them as equal in status to paintings or sculptures.[46]
While their artistic practices were distinct in several respects (not least, perhaps, in
Robert's consistent engagement in his salon pictures with masculinist subject matter),
their common denominator was their commitment to modern vernacular and com-
mercial culture. Already by 1913 Sonia had begun to design dresses, but these were
for herself to wear on their visits to the Bal Bullier, and in their use of simultaneous
contrasts of colour they constituted extensions of their joint pictorial explorations
rather than fashion statements. Yet by the end of the decade she had acquired a
wealthy, aristocratic clientele for clothes and accessories that secured her reputation
as an haute couture designer. Such a rapid shift upmarket resulted from several
factors, amongst which were the reinforcement in the wartime and post-war years of
the reputation of Paris as the capital of luxury consumption, and the Delaunays'
experiences in Spain and Portugal between 1914 and 1919, where their straitened
finances intensified their search for commercial success among a new circle of ac-
quaintances. Most important, however – and a result, perhaps, of those efforts – was
the patronage of Diaghilev, whom they met in Madrid in 1917 and who commis-
sioned them to design new sets and costumes for a Ballets Russes production of
Cléopâtre the following year. The success of this in London (it did not play in Paris)
established Sonia as an innovator in costume and fashion, and led immediately to
private commissions from Diaghilev's wealthy camp followers.[47]
 That it should have been the Ballets Russes that were instrumental in Sonia's
commercial advancement is ironic, and not only in that the company and its elite
Parisian audience stood for all that the Delaunays rejected in their pre-war populist
period: more than this, it contributed indirectly to cultural and art market develop-
ments, and the orientation of the cubist movement to these, to which both their
populism and their exhibition strategy stood as an implicit alternative. For
Diaghilev's company had a dynamic effect on the dominant culture of pre-war Paris:

its productions and the responses to them from the various components of their audiences brought together the discourses of nationalism, decoration, tradition and avant-gardism. From 1912, as the crises over Morocco and the Balkans made the threat of war with Germany more real, the Ballets acted as a catalyst to reconcile both these discourses and the different fractions of the dominant culture – accustomising *le tout-Paris* to avant-gardist innovation, and avant-gardists (cubists among them) to the benefits of a wealthy and influential clientele.

The Ballets Russes: From *le tout-Paris* to the Avant-Garde

'In 1912 cubism was still in its infancy. What marked those years above all when we were living them, was the Ballets Russes and Paul Poiret', recalled André Billy in later years, in one of his several memoirs of the Parisian Belle Epoque.[48] Diaghilev's ballet company did indeed illuminate the cultural life of Paris in the pre-war decade, but it did not bedazzle all quarters from the beginning; rather, its ascendancy was achieved in two stages, 1912 marking the transition. An immediate success in its first season in 1909, the company thereafter received a rapturous welcome from *le tout-Paris* on every return (which was annual until 1914, and biennial during the War). The basis of this success was, firstly, the breadth and depth of support that it commanded as a venture: secured on a political level by the Franco-Russian alliance of 1893, under-written on an economic one by the Russian government bonds held by millions of French small savers, the cultural liaison between the two countries was of central importance between the 1890s and the outbreak of war, a fact underscored by the roll call of diplomats and high public officials who presided over Diaghilev's early career in the West.[49] This official support was complemented by that of an haute bourgeoisie assiduously cultivated by Diaghilev and his colleague Gabriel Astruc. The latter, son of a rabbi who ministered to some of the richest and most cultured Jewish families in the city, mustered their financial backing and added to it the prestige of most of the opinion-formers in French high society. The Comtesse Greffuhle, the original of Proust's Duchesse de Guermantes, was perhaps the most powerful woman in an aristocracy for whom the Ballets Russes were a reminder of *ancien régime* traditions, as *Comoedia* immediately noted: 'The time has long gone, in France, when the art of choreography shone in the first rank, supported by an aristocracy that delighted in it, by connoisseurs jealous of their discernment,' its critic remarked on their arrival.[50]

But the Ballets' success was also based on their aesthetic character. Breaking with the sterile academicism into which ballet had dwindled in Russia, Diaghilev brought to its productions an energy and decorative sumptuousness that also rescued it from the debased position it then occupied in France.[51] Calling on artists rather than professional designers to create the Ballets' stage sets and costumes, he gave their work priority over the choreography, and Bakst in particular developed an anti-naturalistic style of design that echoed those produced twenty years before by Denis and the nabis for Lugné-Poë's Théâtre de l'Oeuvre, and had much in common with the *peinture décorative* with which these artists were by now identified. They

reciprocated with immediate enthusiasm, as J.-E. Blanche reported in *Le Figaro*,[52] and their support for the Ballets was cemented by the patronage of another opinion-former, Misia Godebski. Russian-born, Paris-educated, this well-connected Pole had once harboured ambitions of being a concert pianist, but her first marriage to Thadée Natanson instead brought her into the literary and artistic milieu of his magazine *La Revue blanche*. Here she met painters from the nabi group, for whom she became the main attraction. Godebski 'epitomised the social, financial and artistic interests that merged in Diaghilev's audience',[53] and she quickly established herself as Diaghilev's most loyal patron; as such, she linked the artistic achievements of the ex-nabi painters with the social renown of the Ballets.

Diaghilev's company not only captured the decorative mood of the moment, they also augmented it directly through the lavishness of productions that drew increasingly upon a taste for excess, nourished by burgeoning consumerism. The recurrent figure of this taste was an orientalism fuelled by French colonial ambitions: *Cléopâtre* in 1909, *Les Orientales* and, especially, *Schéhérazade* the following year fed the erotic and sado-masochistic fantasies of oriental otherness made more vivid by political anxieties over Morocco.[54] Indirectly, the Ballets disseminated the decorative aesthetic through the boost they gave to the fashion industry, particularly to the career of the couturier Paul Poiret, whose earliest innovations in both dress design and marketing coincided with their pre-war seasons and matched Diaghilev's promotional flair. Poiret picked up the orientalist themes popularised by the Ballets and capitalised upon them in his women's fashions and accessories. Like the Ballets, his activities also served to blur distinctions between fine and decorative arts, in keeping with official and culturally dominant ideology: partly for strategic reasons and partly from a desire for cultural status, he collected contemporary art, encouraged its exhibition and secured the collaboration of fine artists in designing textiles for his fashion house.[55]

If the Ballets thus won the heart of *le tout-Paris* through its decorative panache and ostentation, the same qualities progressively alienated others, however, at both ends of the cultural spectrum. As nationalism and traditionalism grew in the wake of the 1911 Moroccan Crisis, the critic Pierre Lalo of the establishment flagship *Le Temps* developed an argument against the Russian company that distinguished between a popular tradition in which stood its magnificent but fundamentally decorative spectacles, and the high art tradition of French classical ballet. Where the latter was founded on harmony and balance between its constitutive elements, the former subordinated music and choreography to its extravagant decors. Warming to his critique over the course of the 1912 season, Lalo condemned the pleasures of the Ballets as lazy, facile and puerile, of a visual rather than an intellectual order. He equated its popularity with 'the passion for the cinematograph whose invasion has overrun the crowd; in both cases there is a decadence of intelligence and of taste' and concluded with a severe condemnation: 'for all their affectation and refinement, they bear the mark of the barbarian.'[56]

The year after Lalo's invective, a critique of the Ballets which overlapped with it in key respects was mounted from within the aestheticist and pro-cubist avant-garde by

Canudo in his magazine *Montjoie!*. Well connected with *le tout-Paris*, Canudo in 1910 had welcomed Diaghilev's innovations as representing a renewal of the principles of Wagner, the cultural hero both of the social elite and of fin-de-siècle symbolists. By 1913, however, he had changed tack: the lesson which the Ballets had offered had not been useful after all, for 'it has engendered the "glory" of the couturier Poiret and other mountebanks.'[57] Behind the evident disdain for the commercial dimension of the Ballets lay an aestheticist insistence on distinguishing art from decoration that echoed Lalo's argument, and which Canudo elevated to a general principle the following year in his Manifesto of Cerebrist Art: the art which came under this heading was nobler, purer and cerebral.[58] Unspoken though it was, the reference to the Ballets Russes – in a special issue of *Montjoie!* on dance – was clear, and it was underscored by an article that accompanied Canudo's piece, written by the dancer Valentine de Saint-Point, which declared the superiority, because cerebral, of her own *métachorie* over ballet and other so-called artistic dance forms based on feeling.[59]

Common also to all of these arguments against the Ballets was an explicit appeal to national sentiment: Canudo, though Italian by birth, claimed that 'for several decades France has so imperiously led the evolution of modern art that even the most hostile nations have bowed before its domination – a domination that, I stress, has been absolutely cerebral',[60] and Saint-Point declared – lest anyone should doubt it – that 'as a Frenchwoman, I am too proud of my race to have borrowed the least detail of the project that I have attempted, from foreign sources, be they those of the past or the present'; contemporary efforts in dance in other countries, she argued, 'do not appear to me to have profoundly affected our French genius, doubtless because it finds in them neither its traditions nor its ideal of modern art.'[61] What is striking about these condemnations of the Ballets is not merely the coincidence of their terms but that they should come at the same moment both from the conservative and the most adventurous ends of the cultural spectrum and, further, that self-declared avant-gardists such as Canudo and Saint-Point should couple their aestheticist commitment to the modern with an appeal to the values of traditionalist nationalism.

Yet even as these arguments were being made, the Ballets Russes's conquest of pre-war Paris was entering the second of its two stages, in a development that had profound implications for the aestheticist avant-garde, and within it the cubist movement. The increasingly orientalist character of Diaghilev's productions was driven by his willingness to pander to the demands of his Parisian audience, and the sumptuousness of their sets and costumes was both a response and an encouragement to its taste for spectacle. With each succeeding year the need to surpass previous spectacles became more urgent; indeed, to maintain a permanent company it became an economic necessity.[62] Canudo's preview of the 1913 season put it plainly (if also chauvinistically):

If the Russians do not take the trouble to renew themselves . . . [if] they come back to us *identical,* heedless of what it is to be truly new or truly French . . . it would naturally be impossible to find any more use in an aesthetic venture *that no longer astonishes us.*[63]

Diaghilev had already begun to answer the economic imperative: his 1912 season included *L'Après-midi d'un faune*, whose sexually provocative choreography and performance by Nijinsky caused outrage.[64] In 1913, however, came the real turning-point. For that season Diaghilev booked Astruc's new Théâtre des Champs-Elysées, a striking example of modernist architecture designed by Perret, using reinforced concrete for the first time in a public building in Paris and decorated with murals by Denis and Vuillard. Its atmosphere contrasted sharply with the Châtelet or the Opéra, as Cocteau immediately remarked.[65] In this setting the company presented *Le Sacre du Printemps*. The first night of the performance was an uproar, and has since become famous. Its critical reception clearly indicated a changed attitude on the part of balletomanes towards aesthetically radical work, for there were very few condemnations, and the majority of critics for leading newspapers and magazines responded either favourably or cautiously. Calvocoressi of the English *Morning Post* suggested that 'it is in the normal order of things that exceptional performances can disconcert for a while'.[66] Lise-Léon Blum asked, in the fashionable magazine *La Gazette du bon ton*:

> Is it absurd and negligible? Is it an endeavour, a step forward, a new stage of our taste? I dare not conclude: I have seen men of sincere sentiment, true artists, applaud, I have seen an audience divided by two contrary currents; and this division indicates at the very least that we are touching on a dangerous moment for our aesthetic culture . . .[67]

And Georges Pioch voiced in *Gil Blas* the reasoning that lay behind such confusion:

> If M. Igor Stravinsky had not given us a masterpiece, *Firebird*, and that picturesque and charming work *Pétruschka*, I would resign myself to be disconcerted by what I have just heard . . . Let us wait, and always hope. It is very possible that this is, in effect, a new music.[68]

What these and many similar responses reveal is that by 1913 a substantial sector of the social and cultural elite of Paris was prepared to accept, or at least not to ridicule, radically new work, that support for the latter was becoming socially desirable and was challenging former certainties of taste grounded in conservatism, and that Diaghilev's Ballets were a key catalyst in this development. They were able, because of the discursive space they occupied, to reconcile *le tout-Paris* with sectors of the avant-garde which formerly had been, for that society, beyond the pale. It was some years from 1913 to the moment when cubist painting would make its appearance, with *Parade*, on the stage of the Ballets Russes, but the framework for the movement's cultural – and social – assimilation was by then in place.

Indirectly, Diaghilev provided once again the initial momentum for that assimilation, in 1912 famously demanding 'astound me!' of a young Jean Cocteau anxious to make his name with a distinctive contribution to the company's repertoire.[69] Cocteau responded by manoeuvring to secure the best chance of a *succès de scandale*, namely the collaboration of a cubist in a project for a ballet. His means of doing so indicate the cultural and social dynamic in microcosm. Among those he knew well in the affluent circle around Misia Godebski was Juliette Roche, the daughter of a former

minister and god-daughter of the Comtesse Greffuhle, who had studied painting at the Académie Ranson. Invited by her friend Canudo to view the cubist paintings at the 1913 Indépendants, Roche there met Albert Gleizes, whose social position, for all the iconoclasm of his painting, seems to have provided no obstacle to closer acquaintance, for they married two years later. In her unpublished memoirs Roche describes the first encounter of Gleizes and Cocteau, whose portrait she was working on:

> While I was struggling with Cocteau's profile, the doorbell rang. It was Albert Gleizes – I had not expected him.
>
> This unforeseen meeting between Cocteau and a cubist made me nervous. I pronounced their names as indistinctly as I could, hoping that neither of them would hear, and then, preferring not to be present at the perhaps unavoidable clash, I disappeared behind a screen to make tea. When I returned a few minutes later with the teapot, the 'Prince frivole' and the cubist were exchanging visiting cards and telephone numbers and making an appointment.[70]

Out of this meeting came an agreement, elaborated over the months before the Gleizes' mobilisation in August 1914, to mount a production of *A Midsummer Night's Dream* at the Cirque Médrano. Gleizes would design the sets and costumes, the comic parts would be played by professional clowns, and the music would be modern French – Satie was mentioned. Identifiably the *Parade* project in embryo, this venture never came to fruition, but plans did advance quite far: Astruc agreed to produce it in his Théatre des Champs-Elysées, and rehearsals began in the summer of 1915. By this time Gleizes, already demobilised, was making plans to leave Paris for New York, and Cocteau had begun to fish for an introduction to bigger cubist fry, Picasso in particular. When this was secured in late 1915, his interest in the Gleizes project waned.[71]

Ambitious and well connected, his initiatives underwritten by the momentum of the Ballets Russes's innovation, Cocteau was thus an initial agent of cubism's social assimilation by *le tout-Paris*. It was a role he developed after the outbreak of war: his co-editorship with Paul Iribe of a little review, *Le Mot* (which lasted from November 1914 to mid-1915), enabled Cocteau to promote a middle-of-the-road aesthetic that combined patriotism with rejection of the cruder forms of anti-modernist chauvinism, and thus to engineer a cultural reconciliation between the social elite's traditionalism and the modernist avant-garde at large.[72]

He was not the only agent of such reconciliation. While the launch of *Le Mot* was the first of several attempts by non-combatants during the war years to assume direction of an avant-garde formation made rudderless by the removal of many of its leading members, it was also a continuation of that development, discussed earlier, which had seen the emergence of a trio of little reviews closely affiliated to the cubist movement – *Les Soirées de Paris*, *Poème et drame* and *Montjoie!*. These magazines, as I have argued, marshalled support for and against the gallery and salon positions in contention. But in the conjuncture I have been outlining they also had a broader role: alongside Cocteau they effected the rapprochement of hitherto hostile cultural camps and thus contributed, like the Ballets Russes, to that closing of the ranks of the dominant class in the last months of peace, of which the *union sacrée* was such a striking product.

Rapprochements and Reconciliations

Writing a decade later, André Warnod dated to just before the First World War the decisive transference of the centre of gravity of avant-garde artistic activity from Montmartre to Montparnasse, and saw this as the moment when that avant-garde first found social acceptance: 'gone was the time of *rapins*, fierce enemies of the bourgeoisie. Society figures prided themselves on being "up to the minute" and mingled with [these] artists'.[73] The shift from the isolation of La Butte to the more cosmopolitan environment of Montparnasse was indeed accompanied by an extension of the patronage of cubism beyond the tiny circle of Kahnweiler's *dénicheur* clients. From 1913 the patrons of modern art, many of whom lived in Montparnasse, opened their doors to the artists. Gertrude and Leo Stein, in the rue de Fleurus, had been among the first to do so; others included Mme Ricou, Mme Danville and the Baronne d'Oettingen.[74] The role of the Baronne, although less celebrated than that of the Steins, was perhaps more influential. Hélène d'Oettingen and her 'brother' Serge Jastrebzoff were a striking couple, not merely members of the haute bourgeoisie with an interest in the arts but also practising artists and writers. It was they who bought *Les Soirées de Paris* from André Billy in the autumn of 1913 and installed Apollinaire as joint editor with themselves, Hélène contributing a series of poems and essays and Serge art criticism, under various pseudonyms.[75] From 1913 they lived on the boulevard Raspail (whose extension only that year from its junction with the rue de Vaugirard, to cross the boulevard Montparnasse, was inaugurated by President Poincaré in a ceremony that set the seal on the *quartier's* fashionability) where their regular salon was attended by, among others, Picasso, de Chirico, Modigliani, Zadkine and Survage.

D'Oettingen and Jastrebzoff formed part of the more general gravitation of the social elite towards the avant-garde, of which the roll call of guests at the soirées of *Montjoie!* and the purchase of Gleizes' 1911 painting *La Chasse* (Fig. 19) by the dealer Hessel are further indications.[76] By mid-1913 the dealer Adolphe Basler, an associate of Kahnweiler, could declare: 'At last the market has opened to the cubists'.[77] By the end of the year *Les Soirées de Paris*, too, had changed tack in acknowledgement of this shift; the new series, launched that November after a hiatus of four months, was directed at 'a far more wealthy clientèle' than its predecessor:

> In incorporating expensive illustrations – some in colour – and advertisements for limited-edition books, in expanding its space for those for luxury pastimes . . . the directors signalled their wish to offer a quality product. The *Soirées de Paris* would become a monthly artistic event, presenting contemporary art as a fashionable product, worthy of the interest of the collectors of the Parisian (and, better still, international) *beau monde*.[78]

That this effort failed spectacularly, when thirty-four of the magazine's forty subscribers cancelled their orders upon receipt of that November issue with its illustrations of four constructions by Picasso, was, as Parigoris suggests, more the result of a wild misreading by Apollinaire of the *beau monde*'s readiness for such iconoclasm,

than of a desire to shock. The new series was consistently free of the parodic and ironic tone of the old one, its art criticism serious and straightforward in its defence of the new art as respectable, its illustrations of that art careful to indicate its provenance via a prestigious gallery or collection.[79]

Equally revealing of the cultural rapprochement was the evolution of *Montjoie!* in its last issues, published in early 1914. Unable any longer to ignore the success of the Ballets Russes's annual spectacles, that January Canudo devoted an entire issue of his magazine to contemporary dance. Its overriding purpose, as I noted earlier, was to draw a clear line between the high-minded aestheticism of that avant-garde which *Montjoie!* saw itself as representing and the decorative, sentimental pantomime that characterised both current dance – whether that of the ballet or 'so-called artistic dance' – and dominant culture in general.[80] But the publication of this special issue was itself an acknowledgement of the Ballets's influence on that culture and an attempt to appeal to the nationalism of its elite audience. It was followed two months later by a special issue on the decorative arts; once again, running through the several articles – by Salmon on theatre decors, Mare on wallpaper, de la Fresnaye on art of the street, Reboul on women and fashion, among others – was a common thread, which distinguished 'good' decorative art from 'bad'. This common emphasis, indeed, allied French artisans with avant-garde artists in tacit or explicit opposition to bourgeois taste. Thus for Salmon, the emergence of a modern decorative art despite the decorators' obsession with styles was due both to the scrupulousness and patience of French workmen and the fresh vision of artists like Mare, Duchamp-Villon and de la Fresnaye (as noted, partners in the Maison cubiste project). De la Fresnaye argued that with their window dressings, shop assistants had been quicker than decorators to create new forms of beauty. Mare saw a return to the primitive vitality of traditional methods of wallpaper manufacture, and the commissioning of artists to produce designs, as the reason for the resurgence of this art. And Reboul took a lesson in taste from the 'astonishing elegance' of the dressmakers and milliners of Paris, and found encouragement for innovative artists in the almost immediate adoption of their ideas by these women – citing as an example the recent appearance in department stores of children's hats 'inspired by the most authentic "simultanism"'.[81]

As with their engagement with the current vogue for dance, *Montjoie!* and its contributors thus sought a reconciliation with dominant culture, reluctantly acknowledging the momentum of the decorative discourse, but in terms that enabled them to withold acquiescence in all its implications for art practice. In so doing they found themselves reiterating that constellation of principles, in the uneasy space between which the Maison cubiste project had been shaped – those of avant-gardist elitism tempered by respect for popular knowledges and traditions, and of aestheticism harnessed to national purpose. The instability of this position is evident; in this moment before the War, when national rivalries at all levels had brought Europe to the brink of disaster, its collapse into the manichean certainties of the *union sacrée*, and the reduction of the ideals of aestheticist avant-gardism to the crude if simple 'formula for artistic imperialism' of French cultural hegemony, was perhaps unavoidable.[82]

Notes

Introduction

1 P. Anderson, 'Modernity and Revolution', *New Left Review*, 144, March–April 1984, 105.

2 P. Bourdieu, *Distinction: A Social Critique of the Judgement of Taste*, trans. R. Nice, London: Routledge, 1986, 254.

3 From the editorial 'Déclaration', *Montjoie!*, 2 no. 4/5/6 [the final issue], April–June 1914, 2, 'La culture française affirmée partout en dominatrice, voilà la formule de notre impérialisme artistique.'

Chapter 1 Conflicts and Contradictions of the Radical Republic

1 See D. Grojnowski, 'L'Ane qui peint avec sa queue: Boronali au Salon des Indépendants', *Actes de recherche en sciences sociales*, 88, June 1991, 41–7.

2 See e.g. F. Carco, *De Montmartre au Quartier Latin*, Paris: Albin Michel, 1927, 40–43; A. Salmon, *Souvenirs sans fin: Deuxième Epoque (1908–1920)*, Paris: Gallimard, 1956, 113; R. Shattuck, *The Banquet Years*, London: Cape, 1958, rev. 1969, 25.

3 Since R. Poggioli's pioneering text, *The Theory of the Avant-Garde*, (1962), trans. G. Fitzgerald, New York and London: Harper & Row, 1968, there has been too much written on the subject to list here. Among the more recent influential examples of such writing are: P. Bürger, *Theory of the Avant-Garde*, (1974), trans. M. Shaw, Minneapolis: University of Minnesota Press, 1984; R. Krauss, 'The Originality of the Avant-Garde', *October*, 18, Fall 1981, 47–66; T. Crow, 'Modernism and Mass Culture in the Visual Arts', in F. Frascina (ed.), *Pollock and After: The Critical Debate*, New York and London: Harper & Row, 1985; H. Foster, 'What's Neo about the Neo-Avant-Garde?', *October*, 70, Fall 1994, 5–32.

4 While Bürger distinguishes the historic avant-garde from modernism, seeing it as a stage within the latter, he defines it as necessarily opposed to dominant culture (see e.g. *Theory of the Avant-Garde*, 59–63). Others are less clear. Thus Krauss: 'One thing only seems to hold fairly constant in the vanguardist discourse and that is the theme of originality . . . The self as origin is the way an absolute distinction can be made between a present experienced *de novo* and a tradition-laden past . . . modernism and the avant-garde are functions of what we could call the discourse of originality' ('The Originality of the Avant-Garde', 53–8). Crow sees 'a tension or lack of fit between the two terms . . . Modernism as a word carries connotations of an autonomous, inward, self-referential and self-critical artistic practice; our usual use of the term avant-garde is on the other hand much more inclusive, encompassing extra-artistic styles and tactics of provocation, group closure and social survival' (*Modernism and Mass Culture*, 234). Yet in the end for him, too, 'the avant-garde [is] the bearer of modernism' (*ibid.*, 259).

5 C. Charpin (with S. Wilson), 'One Hundred Years Ago: The "Incohérents"', *Art Monthly*, 128, July–August 1989, 7–9.

6 'J'étais littéralement désespéré de voir, l'un après l'autre, mes camarades s'engager dans l'impasse: Albert Gleizes, Juan Gris,

Markous, Pierre Dumont et la délicate Marie Laurencin, et le solide Delaunay, démolisseur de Tours Eiffel', R. Dorgelès, *Bouquet de Bohème* (Paris, Albin Michel, 1947), cited by Grojnowski, 'L'Ane qui peint', 44–5. All translations are mine unless otherwise stated.

7 The social and cultural character of Montmartre around 1910 is discussed in Ch. 2 below. See also L. Chevalier, *Montmartre du plaisir et du crime*, Paris: Laffont, 1980, part III; J.-P. Crespelle, *La Vie quotidienne à Montmartre au temps de Picasso 1900–1910*, Paris: Hachette, 1978.

8 An assumption shared even, despite otherwise fundamental differences, by Bürger (*Theory of the Avant-Garde*, ch. 2) and Poggioli (*The Theory of the Avant-Garde*, ch. 6).

9 A. Warnod, *Les Berceaux de la jeune peinture*, Paris: Albin Michel, 1925, 23–4.

10 A. Billy, *Le Pont des Saints-Péres*, Paris: Fayard, 1947, 17–18.

11 See Ch. 6 below, pp. 154ff.

12 Grojnowski, 'L'Ane qui peint', 45, citing Dorgelès, ch. 11.

13 An assumption made by R. Williams, in an otherwise cogent and valuable analysis of the stages of emergence of the avant-garde. In this emergence Williams identifies, first, 'innovative groups [of artists] which sought to protect their practices . . . These developed into alternative, more radical groupings, seeking to provide their own facilities of production, distribution and publicity; and finally into fully oppositional formations, determined not only to promote their own work but to attack its enemies . . . and, beyond these, the whole social order'. He suggests that 'Modernism can be said to begin with the second type of group . . . while the avant-garde begins with the third', 'The Politics of the Avant-Garde', The Politics of Modernism: Against the New Conformists, ed. T. Pinkney, London: Verso, 1989, 50–51. This analysis, while an advance on most formulations, still fails to address the specificity of the formation.

14 R. Arbour, *Les Revues littéraires: Éphémères paraissant à Paris entre 1900 et 1914*, Paris: Corti, 1956.

15 C. Duncan, 'Virility and Domination in Early Twentieth Century Vanguard Painting', *Artforum*, December 1973, rev. in C. Duncan, *The Aesthetics of Power*, Cambridge University Press, 1993, 94–5.

Following Duncan's insights there has been valuable historical work published on several aspects of the subject. See in particular, D. Silverman, *Art Nouveau in Fin-de-Siècle France: Politics, Psychology and Style*, Berkeley and London: University of California Press, 1989; T. Garb, *Sisters of the Brush: Women's Artistic Culture in Late Nineteenth-Century Paris*, New Haven and London: Yale University Press, 1994; L. Tickner, 'Men's Work? Masculinity and Modernism', in N. Bryson, M. Holly and K. Moxey (eds), *Visual Culture: Images and Interpretations*, Hanover (USA) and London: Wesleyan University Press, 1994, 42–82; G. Perry, *Women Artists and the Parisian Avant-Garde: Modernism and 'Feminine' Art, 1900 to the Late 1920s*, Manchester and New York: Manchester University Press, 1995.

16 M. Orwicz, 'Anti-Academicism and State Power in the Early Third Republic', *Art History*, 14 no. 4, December 1991, 571–9'; M.-C. Genet-Delacroix, 'Esthétique officielle et art nationale sous la Troisième République', *Le Mouvement social*, 131, April-June 1985, 105–20.

17 Orwicz, 'Anti-Academicism', 574.

18 L. Bérard, 'Je suis, en art, partisan d'une politique de moindre intervention . . . ou même de pas d'intervention du tout', *Journal officiel des débats*, 3 December 1912, 2928.

19 Genet-Delacroix, 'Esthétique officielle', 112–13.

20 *Ibid.*, 114.

21 *Ibid.*, 117–18.

22 Bérard, 'Il est clair qu'un régime de travail encore tout empreint d'individualisme ne favorise pas beaucoup l'action directrice de l'Etat'; 'Il s'agit . . . d'imposer à l'industrie la collaboration de l'art', *Journal officiel des débats*, 3 December 1912, 2927.

23 *Ibid.*, 2924. Deputy Breton noted that 9 of the 16-strong jury were foreign artists.

24 *Ibid.*, 2928. Correspondence between Bérard and Jourdain reveals the latter's ready acquiescence in the condemnation both of 'cubists, futurists and other *Convulsionnaires* of St Médard to whom our *placeur* wrongly gave space', and of the preponderance of foreign artists. Archives Nationales, Paris, series F^{21}.4105.

25 T. Kemp, *Economic Forces in French History*, London: Dobson, 1971, 297.

26 R. Kuisel, *Capitalism and the State in Modern France: Renovation and Economic Management in the Twentieth Century*, Cambridge and London: Cambridge University Press, 1981, 26.

27 Between 1870 and 1914 in France not only did the *per capita* consumption of tea treble, of coffee more than double, of alcohol increase by two thirds and of exotic fruits by seven times, but new consumer durables such as automobiles, sewing machines, cheap clocks, electric lamps and other domestic appliances flooded the market. The number of trademarks registered in this period rose from 1,300 to 16,000. See A. Pinard, *La Consommation, le bien-être et le luxe*, Paris: Doin, 1918, 253.

28 M. Miller, *The Bon Marché: Bourgeois Culture and the Department Store 1869–1920*, Princeton University Press, 1981, 53. See also H. Pasdermaijan, *The Department Store: Its Origins, Evolution and Economics*, London: Newman Books, 1954; S. Tize, 'Les Grands Magasins', in D. McFadden *et al* (eds), *L'Art de Vivre: Decorative Arts and Design in France 1789–1989*, New York: Vendome Press, 1989, 72–105.

29 It was after 1900 that the Bon Marché expanded from traditional dry goods into kitchen-ware, cosmetics, telephones, photogoods, musical instruments, paint, and ciné cameras. From 1910 it offered complete installations for modern kitchens; from 1913, a 'Catalogue of Clothing and Goods for Travel and the Automobile, Bicycles & Assorted Accessories, Games for Open Air, Sports'; see Miller, 52, 185.

30 Pinard, *La Consommation, le bien-être et le luxe*, 217–8; C. Rearick, *Pleasures of the Belle Epoque*, New Haven and London: Yale University Press, 1985, 193.

31 On bourgeois ambition, see P. Sorlin, *La Société française 1840–1914*, Paris: Artaud, 1969, 140; on inherited wealth, see L. Berlanstein, *The Working People of Paris, 1871–1914*, Baltimore and London: Johns Hopkins University Press, 1984, 35; on rents see G. d'Avenel, *Le Nivellement des jouissances*, Paris, 160–76.

32 Sorlin, *La Société française*, 123, 134, 'La grande majorité des citadins songe à peu près exclusivement aux moyens d'assurer son existence'; 'le pauperisme a regressé,

mais les écarts sociaux se sont nettement accentués'.

33 E. Hobsbawm, *The Age of Empire*, London: Weidenfeld & Nicolson, 1987, 49.

34 To take one new commodity as an example: automobiles were increasingly popular, their number in France rising from 3,000 in 1900 to nearly 110,000 by 1914, despite the fact that they cost between 8,000 and 20,000 francs each. The lower of these two extremes was equivalent to three times the annual wage of the highest-paid artisans in Paris – the kind of craft worker who would have helped build one. Yet such artisans were among the labour elite, and others were far worse off. See J.-B. Duroselle, *La France de la 'Belle Epoque'*, 2nd edn, Paris: Presses de la Fondation Nationale des Sciences Politiques, 1992, 50.

35 Berlanstein, *The Working People of Paris*, 40.

36 *Ibid.*, 16.

37 *Ibid.*, 83.

38 *Ibid.*, 198–9.

39 *Ibid.*, 82.

40 J. McMillan, *Housewife or Harlot: The Place of Women in French Society 1870–1940*, Brighton: Harvester, 1981, 51–3; M. Perrot, 'The New Eve and the Old Adam: Changes in French Women's Condition at the Turn of the Century', in M. Higgonet *et al* (eds), *Behind the Lines: Gender and the Two World Wars*, New Haven and London: Yale University Press, 1987, 53. By 1914 there were 2547 women in higher education in France (McMillan, 53), and several hundred women doctors, but only about ten women lawyers (Perrot, 53).

41 Perrot, 'The New Eve and the Old Adam', 56.

42 *Ibid.*, 57. McMillan, *Housewife or Harlot*, 57, notes that only 7% of working women were in liberal professions by 1914, most of these being private schoolteachers, and that girls' employment training before 1914 'was intended only to prepare them for the lower reaches of business life – as typists, secretaries, drawing mistresses and so on'.

43 On the widespread dissemination and elaboration of the idea in French writing of the period of the biologically determined inferiority of women, see A. Maugue, *L'Identité masculine en crise*

au tournant du siècle 1871–1914, Paris: Rivages, 1987.

44 B. Mitchell, *European Historical Statistics, 1750–1970*, NYC, 1978, chart A-1: 'Population of Countries at Census', cited in K. Offen, 'Depopulation, Nationalism and Feminism in Fin-de-Siècle France', *American Historical Review*, 89, 1984, 652.

45 Kuisel, *Capitalism and the State in Modern France*, Ch. 1.

46 S. Elwitt, *The Third Republic Defended: Bourgeois Reform in France, 1880–1914*, Baton Rouge and London: Louisiana State University Press, 1986, 4. See also Kemp, *Economic Forces in French History*, 249.

47 Quoted by Kuisel, *Capitalism and the State in Modern France*, 2.

48 *Ibid.*, 1.

49 See *ibid.*, 23.

50 J. Méline, *Le Retour à la terre et la surproduction industrielle*, Paris: Hachette, 1905, 86.

51 Kemp, *Economic Forces in French History*, 242.

52 D. Landes, 'French Business and the Businessman: A Social and Cultural Analysis', in E. Earle (ed.), *Modern France: Problems of the Third and Fourth Republics*, Princeton University Press, 1951, 336.

53 Elwitt, *The Third Republic Defended*, 10; on the Boucicauts, see also M. Miller, *The Bon Marché*, 88–109.

54 See the 1911 report by René Guilleré on behalf of the major artists' associations, reprinted in G.-R. Sandoz and J. Guiffrey, *Exposition française d'art décoratif. Copenhague 1908. Rapport général. Précédé d'une étude sur les arts appliqués et industries d'art aux expositions*, Paris: Comité français des expositions à l'étranger, 1913, CLXXXVI–CCIV. For a résumé of the debate on this issue see N. Troy, *Modernism and the Decorative Arts in France: Art Nouveau to Le Corbusier*, New Haven and London: Yale University Press, 1991, 163–9.

55 T. Zeldin, *France 1848–1945: Taste and Corruption*, Oxford University Press, 1980, 78, 82.

56 Pinard, *La Consommation, le bien-être et le luxe*, 322.

57 C. and H. White, *Canvases and Careers: Institutional Change in the French Painting World*, New York: Wiley, 1965, 97.

58 Orwicz, 'Anti-Academicism and State Power in the Early Third Republic', 574.

59 C. Charle, *Naissance des 'intellectuels' 1880–1900*, Paris: Minuit, 1990, 41–4 and 237.

60 G. Bernier, *L'Art et L'argent*, Paris: Laffont, 1977, 61.

61 A. Mithouard, *Le Tourment de l'unité*, Paris: Société du Mercure de France, 1901, 283.

62 M. Rébérioux, in J.-M. Mayeur and M. Rébérioux, *The Third Republic from its Origins to the Great War 1871–1914*, Cambridge University Press, 1984, 205.

63 Elwitt, *The Third Republic Defended*, 2, 7, 290.

64 *Ibid.*, 295.

65 See Millerand's 1908 book, *Travail et travailleurs*, Paris: Fasquelle, 1908.

66 Elwitt, *The Third Republic Defended*, 7.

67 See L. Mercier, *Les Universités populaires, 1899–1914: Education populaire et mouvement ouvrier au début du siècle*, Paris: Ouvrières, 1986; L. Dintzer, F. Robin and L. Grélaud, 'Le Mouvement des universités populaires', *Le Mouvement social*, 35, April-June 1961, 3–29.

68 Quoted by Mercier, *Les Universités populaires*, 32.

69 G. Deherme, 'Les vieux fanatismes que l'Affaire Dreyfus avait exaspérés, la misère intellectuelle qu'on découvrit, firent sentir fortement à quelques-uns quelle oeuvre urgente d'éducation, de discipline mentale il y avait à entreprendre', *La Coopération des idées*, October 1899, quoted *ibid.*

70 Dintzer *et al*, 4–5.

71 Rébérioux, *The Third Republic*, 213.

72 Mercier, *Les Universités populaires*, 27.

73 A. Kownacki, 'Un masque choisi par les propriétaires et le autoritaires, ligués pour cacher la coopération des intérêts et détourner les masses des idées nouvelles', *Histoire de Douze Ans (1898–1910): Université populaire/Coopération des idées/157 Faubourg St-Antoine, Paris*, Paris: La Cooperation du Livre, 1910, 15.

74 Deherme, 'réunir des ouvriers ... dans un local à eux, et chez eux viendront des penseurs, des écrivains, des professeurs, des artistes, qui leur parleront en camarades de ce qu'ils savent, de ce qu'ils veulent', quoted in *ibid.*, 7.

75 Elwitt, *The Third Republic Defended*, 235.

76 Kownacki, *Histoire de douze ans*, 5, 10; see also Mercier, *Les Universités populaires*, 28.

77 Elwitt, *The Third Republic Defended*, 171. For an analysis of Solidarism see his ch. 5.

78 See ch. 3 below, p. 81.

79 On this general initiative see M.-L. Albertini, 'Les Politiques d'education populaire par l'art en France: Théâtres et musées 1895–1914', unpublished *thèse du troisième cycle d'histoire*, Université de Paris 1, 1983.

80 See, e.g., R. Marx, 'Les Arts décoratifs 1893–4', *La Revue encyclopédique*, 15, February 1894.

81 C. Morineau, *Roger Marx et l'Art social*, unpublished *mémoire de maîtrise*, Université de Paris IV, 1988, 192.

82 J. Mariel, *L'Oeuvre de Jean Lahor*, Paris: Divan, 1912.

83 Elwitt, *The Third Republic Defended*, 182.

84 D. Thompson, *Democracy in France since 1870*, Oxford University Press, 4th edn, 1964, 72–4. See also H. Tint, *The Decline of French Patriotism 1870–1914*, London: Weidenfeld & Nicolson, 1964, 123.

85 P. Monatte, 'Le révolutionnarisme de Guesde, par exemple, n'était plus que verbal . . . Quant aux anarchistes, leur révolutionnarisme s'était réfugié superbement dans la tour d'ivoire de la spéculation philosophique . . . [un syndicat] ne peut et ne doit être ni anarchiste, ni guesdiste, ni allemaniste, ni blanquiste, mais simplement ouvrier', Reprinted in H. Dubief, *Le Syndicalisme révolutionnaire*, Paris: Armand Colin, 1969, 135.

86 R. and E. Herbert, 'Artists and Anarchism: Unpublished Letters of Pissarro, Signac and Others', *Burlington Magazine*, 102, November–December 1960, 472–82, 517–22.

87 Rebérioux, *The Third Republic*, 249.

88 E. Weber, *The Nationalist Revival in France 1905–14*, Berkeley: University of California Press, 1968, 36: 'Seventeen years later, the selfconscious patriots of the prewar years were to date their awareness from July 1905.' H. Massis provided the testimony of a participant in this national moment: 'Ce fut exactement en septembre 1905 que nous sentîmes s'ouvrir sur nous les ailes de la guerre. Cette date marque l'avènement de notre génération', *Evocations, souvenirs (1905–11)*, Paris: Plon, 1931, 183, quoted in C. Digeon, *La Crise allemande de la pensée française 1870–1914*, Paris: Presses Universitaires de France, 1959, 490.

89 Cited in Weber, *The Nationalist Revival*, 58. Max Jacob's conversion in 1909 could be put in this context.

90 R. Girardet, *L'Idée coloniale en France de 1871 à 1914*, Paris: La Table Ronde, 1972, 98.

91 J.-P. Biondi and G. Morin, *Les Anticolonialistes (1881–1962)*, Paris: Laffont, ch. 4.

92 Jaurès quoted by Rebérioux, *The Third Republic*, 265.

93 Quoted in Rebérioux, *ibid.*, 283. The 1907 manifesto is reprinted in C. Nicolet, *Le Radicalisme*, Paris: Presses Universitaires de France, 1957, 48–53.

94 M.-G. Dezès, 'Participation et démocratie sociale: l'expérience Briand de 1909', *Le Mouvement social*, 87, April–June 1974, 109–36.

95 J. Paul-Boncour, *Art et démocratie*, Paris: Ollendorf, 1912. See also E. Antonelli, *La Démocratie sociale devant les idées présentes*, Paris: Rivière, 1911.

96 R. Marx, e.g., 'De l'Art social, et de la nécessité d'en assurer le progrès par une exposition', *Les Idées modernes*, January 1909.

97 Apollinaire's name appears below three articles in the newspaper: one in December 1909 on theatre; another in the same month on 'La Germanisation de l'Allemagne', which although principally about linguistic issues also suggests a nationalistic dimension in warnings about threats posed to Germany's classical culture; a third in July 1912, defending 'la jeune peinture' – but naming no one – entitled 'La Loi de la renaissance'. It has been suggested that his contribution was larger than this and, under the pseudonym 'Polyglot', encompassed reviews of foreign press accounts of economic, political and other issues, thus implying an acute political awareness and engagement on Apollinaire's part: see P. Caizergues, 'Apollinaire et *La Démocratie sociale*', *Archives des Lettres modernes*, 101, 1969, 3–38. This suggestion seems to me far-fetched and unsupported by evidence. 'Polyglot' is surely more likely to have been a catch-all pseudonym for the collective contributions of a range of reviewers than a reference to Apollinaire's linguistic abilities.

98 Unlike most *universités populaires*, this did not disappear with the collapse of the Bloc, although it had its crisis in late 1907, when

many members wished to throw out the intellectuals and allow the working class to *rester entre soi*; from this moment it apparently declined into 'une simple distraction de quartier', Kownacki, *Histoire de douze ans*, 19.

99 See 'La Mutualité des idées', *L'Avenir de la mutualité*, 3 no. 126, 23 December 1905.

100 P. Lagardère, 'Pour les ouvriers: le "Jardin de Jenny" distribue des roses', *Le Petit Parisien*, 24 April 1911, 1. Lagardère notes that on this, their first outing, members of the group distributed from the back of a truck 2500 rosebushes, 3000 pansies and 2000 packets of seeds in the Mouffetard quartier of Paris; that the artists promised to return again soon; and that the event marked 'la communion intime et rare des artistes et du peuple de Paris'.

101 Rebérioux, *The Third Republic*, 278–83; Antonelli, *La Démocratie sociale*, 1911, 6, E. Rey, *La Renaissance de l'Orgueil français*, Paris: Grasset, 1912, 99, 'On a affecté de ne voir dans la politique que cynisme, marchandages, mensonges, exploitation; on s'est habitué à penser du mal du parlementarisme, à représenter tous les députés comme des inutiles ou des vendus'.

102 The 'moderate' Conseil National des Femmes Françaises (CNFF) alone counted 73,000 members in 1906–07; for this figure, and the estimate of parliamentary sympathy, see S. Hause and A. Kenney, *Women's Suffrage and Social Politics in the French Third Republic*, Princeton University Press, 1984, 87, 95. On the periodicals and congresses, see Offen, 'Depopulation, Nationalism and Feminism', 655, who cites E. Sullerot, *La Presse féminine*, Paris, 1966, 9.

103 Offen, 'Depopulation, Nationalism and Feminism', 654. Much of my account of turn-of-the-century feminism is indebted to this pioneering article, whose identified categories of that feminism I have adopted. See also M. Perrot, 'The New Eve and the Old Adam', whose categories overlap closely with Offen's; L. Klejman and F. Rochefort, *L'Egalité en marche: Le Féminisme sous la Troisième République*, Paris: Presses de la Fondation nationale des sciences politiques, 1989; C. Sowerwine, *Sisters or Citizens? Women and socialism in France since 1876*, Cambridge University Press, 1982.

104 Silverman, *Art Nouveau in Fin-de-Siècle France*, 196.

105 On feminism and the socialist movement see Sowerwine, *Sisters or Citizens?*, part II; Hause and Kenney, *Women's Suffrage and Social Politics*, 162–6.

106 Hause and Kenney, 158. The greater priority for many deputies, as regards electoral reform, was the issue of proportional representation; the deeper fear was that so many women voters would follow the instructions of the church that the Republic would be endangered.

107 C. Charle, *Naissance des 'intellectuels'*, 14, 64; see also Ch. 2 below.

108 C. Péguy, 'Notre patrie', *Cahiers de la quinzaine*, 22 October 1905, quoted in Digeon, *La Crise allemande*, 504, 'Comme tout le monde j'étais rentré à Paris le matin neuf heures: comme tout le monde, c'est-à-dire comme environ huit ou neuf cents personnes, je savais à onze heures et demie que dans l'espace de ces deux heures une période nouvelle avait commencée dans l'histoire de ma propre vie, dans l'histoire de ce pays, et assurément dans l'histoire du monde . . . Tout le monde, ainsi compté, tout le monde en même temps connut que la menace d'une invasion allemande est présente, qu'elle était là, que l'imminence était réelle'.

109 D. Lemaire, 'Péguy d'une critique à l'autre', *Scolies*, 2, 1972, 81.

110 The congress closed with this ringing declaration: 'We ask you, citizens, by all you hold sacred, to swear to combat the propagandists of anti-patriotism all round you . . . we are a party of reform, a party of the people; circumstances have compelled us to say that we are also a party of Frenchmen.' Quoted in Rebérioux, *The Third Republic*, 265.

111 A. Briand, 'Au-dessus de l'individu, il y a le groupement; mais aussi il y a et il doit y avoir, seule garantie pour l'individu et pour le groupement lui-même, l'association de tous les citoyens dans la nation'; 'le beau pays de l'avenir sera celui qui sera le plus humain, celui qui aura abordé de sang-froid les problèmes et les aura résolus dans un esprit de liberté et de justice sociale', speech at Neubourg, Normandy, March 1909, quoted in Dezès, 'Participation et démocratie sociale', 127, 124.

112 Briand, 'Il faut que la communication s'établisse entre les républicains dignes de ce nom, non pas seulement dans une

circonscription ou même un département, mais de département à département, et que ce soit en eux le coeur de la France elle-même qui batte', speech at Périgueux, October 1909, quoted *ibid.*, 129.

113 Weber, *The Nationalist Revival in France*, 60.

114 P. Sorlin, 'Words and images of nation-hood', in Tombs, *Nationhood and Nationalism in France* 74–88.

115 *The Daily Telegraphh*, 10 March 1912, 8.

116 'Notes et documents: Renaissance patriotique', *La Vie ouvrière*, 62, April 1912, 151, 'que la grande masse, formée surtout de prolétaires, se laisse gagner par les sentiments et par les idées de la bourgeoisie, voilà qui est dangereux'.

117 Rey, *La Renaissance de l'Orgueil français*, 187, 'La jeunesse a imposé sa foi patriotique à toute la nation.'

118 Agathon (H. Massis and A. de Tarde), *Les Jeunes Gens d'aujourd'hui*, Paris: Plon-Nourrit, 1913, v, 'rien de moins que le voeu d'un Français nouveau, d'une France nouvelle'.

119 'L'action est le critérium de la moralité'; 'Ce Nietzsche de notre race, formé par l'analyse lucide des hommes du 18e siècle, nullement infesté de la métaphysique allemande', *ibid.*, 51, 55.

120 'Ces jeunes le chargent de toute la beauté dont ils sont épris et dont la vie quotidienne les prive', *ibid.*, 35.

121 'Les exploits de nos aviateurs sont pour l'imagination populaire le symbole du courage et de la vitalité toujours ardente de notre race'; 'l'aéroplane est d'abord, aux yeux de la foule, un engin de guerre', *ibid.*

122 On the response of Action Française to Agathon's articles, see N. Portier, 'Nationalisme et classicisme: La Jeunesse de l'Action française', *La Revue universelle des faits et des idées*, 161, 1991, 61–3.

123 The Radical politician Paul-Boncour wrote to Massis reluctantly accepting Agathon's conclusions about student opinion. Weber, *The Nationalist Revival in France*, 110. For a left-wing response, see C. Rappoport, 'Les Jeunes Gens d'Agathon', *Les feuilles de mai*, 2, February 1913, 101–04, and Ch. 3 below, pp. 80–84.

124 G. Rozet, 'Sport et patriotisme', *L'Eclair*, 15 September 1911, 1. J. Bertaut, 'La Jeunesse d'aujourd'hui', *Le Gaulois*, 15 June 1912, 3, 'Nous assistons à un grand, à un profond changement dans l'esprit de la jeunesse actuelle . . . je crois à une sorte de renaissance morale française', declared Bergson in an interview. By 1914 Bergson's chauvinism, like that of most of his compatriots, had strengthened: that August he asserted that 'la lutte engagée contre l'Allemagne est la lutte même de la civilisation contre la barbarie', quoted in A. Kriegel and J. J. Becker, *1914: La Guerre et le mouvement ouvrier français*, Paris: A. Colin, 1964, 149.

125 Weber, *The Nationalist Revival in France*, 113; *Daily Telegraph*, 6 March 1912, 15.

126 See Ch. 6 below, p. 162.

127 G. Hervé, in *La Guerre sociale* 2–8 October 1912, quoted by Z. Sternhell, 'The Political Culture of Nationalism', in Tombs, *Nationhood and Nationalism in France*, 24–5.

128 Sternhell, 'The Political Culture of Nationalism', 30–1. See also M. Baumont, 'Gustave Hervé et la "Guerre sociale" pendant l'été 1914 (1er juillet–1er novembre)', *Information historique*, 1968, no. 4, 155–62.

129 See e.g. P. Monatte in *La Vie ouvrière*, 62, April 1912, 152–3.

130 Kriegel and Becker, *1914*, 65–8, 188 n. 30. See also Ch. 5 n. 26 below.

131 J. Juillard, 'La CGT devant la Guerre 1900–1914', *Le Mouvement social*, October–December 1964, 61.

Chapter 2 A Bold Aesthetic Band

1 In Linda Nochlin's widely-cited article 'The Invention of the Avant-Garde: France 1830–80', in T. Hess and J. Ashbery (eds), *The Avant-Garde*, Art News Annual, XXXIV, 1968, 16, she argued that 'what is generally implied by the term [avant-garde] begins with Manet . . . For implicit – and perhaps even central – to our understanding of avant-gardism is the concept of alienation – psychic, social, ontological . . . For [Flaubert, Baudelaire and Manet], their very existence as members of the bourgeoisie was problematic, isolating them not merely from existing social and artistic institutions but creating deeply felt internal dichotomies as well.' This definition has the effect of collapsing avant-gardism into alienation, and thereby losing sight of its distinctive character and collectivist implications. While alienation

was certainly a fundamental quality of avant-gardist consciousness, they were not one and the same. As I shall argue, the difference is crucial.

2 N. Hadjinicolaou, 'Sur l'idéologie de l'avant-gardisme', *Histoire et critique des arts*, 6 (2ème trimestre 1978), 49–76.

3 *Ibid.*, 51–2.

4 R. Estivals, J.-C. Gaudy and G. Vergez, *'L'Avant-garde': Etude historique et sociologique des publications périodiques ayant pour titre 'L'avant-garde'*, Paris: Bibliothèque Nationale, 1968; cited by Hadjinicolaou, 53–4.

5 *Ibid.*, 52. Hadjinicolaou cites the work of D. Egbert, Poggioli, Nochlin and Tagg in particular; that of Calinescu could be added: see Bibliography here for refs.

6 H. and C. White, *Canvases and Careers: Institutional Change in the French Painting World*, New York: Wiley, 1965.

7 P. Mainardi, *The End of the Salon: Art and the State in the Early Third Republic*, Cambridge University Press, 1993; M. Levin, *Republican Art and Ideology in Late Nineteenth-Century France*, Ann Arbor, Mich: UMI Research Press, 1986; N. Green, '"All the Flowers of the Field": the State, Liberalism and Art in France under the early Third Republic', *The Oxford Art Journal*, 10 no. 1, 1987, 71–84; M. Orwicz, 'Anti-Academicism and State Power in the Early Third Republic', *Art History*, 14 no. 4 (December 1991), 571–92; T. Garb, *Sisters of the Brush: Women's Artistic Culture in Late Nineteenth-Century Paris*, New Haven and London: Yale University Press, 1994.

8 See Ch. 1, n. 15.

9 D. Grojnowski, 'Une Avant-garde sans avancée: Les "Arts Incohérents" 1882–1889', *Actes de recherche en sciences sociales*, November 1981, 73–86.

10 On this milieu see e.g. E. Goudeau, *Dix Ans de Bohème*, Paris: Libraire Illustré, 1888, 95ff.

11 *Ibid.*, 80–1.

12 See J. Seigel, *Bohemian Paris: Culture, Politics and the Boundaries of Bourgeois Life, 1830–1930*, New York and Harmondsworth: Viking Penguin, 1986.

13 *Ibid.*, 218.

14 *Ibid.*, 221.

15 C. Charle, *Naissance des 'intellectuels' 1880–1900*, Paris: Minuit, 1990; see also his *Les Elites de la République 1880–1900*, Paris: Fayard, 1987.

16 Charle, *Naissance des 'intellectuels'*, 11.

17 *Ibid.*, 14.

18 *Ibid.*, 109.

19 *Ibid.*, 63.

20 *Ibid.*, 237.

21 P. Tournier, 'Les Salons d'Automne', *pan*, 3 no. 11, November–December 1910. 'Tant au Cours-la-Reine qu'au Champs-Elysées et dans le voisinage des boulevards nous avons vu, ce printemps, près de quinze mille travaux d'art! Et six mois ne sont pas écoulés qu'une moisson nouvelle est déjà mûre.'

22 The Salon des Indépendants had provided competition since its foundation in 1884, but its unjuried exhibitions were taken less seriously by critics than those of the other salons.

23 H. Bidou, 'Les Salons de 1910', *Gazette des Beaux-Arts*, May 1910, 361.

24 L. Vauxcelles, 'Les Salons de 1911', *Touche à Tout*, 1911, 443–4, 'Et le reste?... Que devient toute cette peinture?... L'artiste, mélancolique, roule sa toile délivrée du cadre et du chassis, la met en pénitence dans un coin poussiéreux. Un beau matin, il la reprend, la retend, l'installe sur son chevalet et repeint dessus.'

25 L. Werth, *La Phalange*, April 1910, 533, 'Que diriez-vous si on vous jouait en même temps 5669 morceaux de musique différents? Et ne prétendez pas qu'il s'agit de 5669 sensations visuelles successives. Je vous affirme, qu'au 5669e, elles sont simultanées.'

26 Vauxcelles, 'Petits salons', *Femina*, from an undated press clipping in Fonds Vauxcelles, Bibliothèque Jacques Doucet (Art et Archéologie), Paris. See also Garb, *Sisters of the Brush*, 20–9.

27 Vauxcelles, 'Les Salons de 1911', 444.

28 Vauxcelles, *Gil Blas*, 29 February 1909, 1, 'un nouveau groupe d'artistes... éminement éclectique... il s'en crée un tous les matins... Quand verrons-nous éclore le groupe vraiment représentatif des tendances modernes, ou se réunirait, par exemple, tous ceux d'aujourd'hui qui vont bénéficier de l'impressionnisme?'

29 G. Pollock, *Avant-Garde Gambits 1888–1893: Gender and the Colour of Art History*, London and New York: Thames and Hudson, 1992, 15, argues that the institutional conditions for the existence of an avant-garde in Paris were in place from the late 1880s, following the formalisation, with the establishment of the Salon des

Indépendants, of an alternative exhibitions strategy to the official salon. More recently M. Ward, *Pissarro, Neo-Impressionism and the Spaces of the Avant-Garde*, Chicago and London: University of Chicago Press, 1996, has charted the evolution of the dealer-critic system with respect to Parisian neo-impressionism of the 1880s and 1890s. Their contributions are indispensable for an understanding of the emergence of avant-gardism. At that time, however, there were too few private dealers in contemporary art to support an avant-garde formation as such; the rapid rise in their numbers and the emergence of a speculative interest in the work of unorthodox and unacademic unknowns took place in the decade after 1900. The diversification that year of the art dealers Bernheim into contemporary postimpressionist art via the establishment of the Galerie Bernheim-Jeune is symbolic of this development.

30 C. and H. White, *Canvases and Careers*, 97.

31 On the market for impressionist painting see A. Distel, *Impressionism: The First Collectors*, New York: Abrams, 1990. On the late 19th-century Paris art market see, among many others, A. Vollard, *Souvenirs d'un marchand de tableaux*, Paris: Club des Librairies de France, 1957; G. Bernier, *L'Art et L'argent*, Paris: Laffont, 1977; R. Moulin, *Le Marché de la peinture en France*, Paris: Minuit, 1967; J. Rewald, *Cézanne and America: Dealers, Collectors, Artists and Critics 1891–1921*, London: Thames and Hudson, and Princeton University Press, 1989; P. Watson, *From Manet to Manhattan: The Rise of the Modern Art Market*, London: Vintage, 1992.

32 On Vollard's prices see A. Level, *Souvenirs d'un collectionneur*, Paris: Club des Librairies de France, 1959. On Wagram's purchase see M. G. de la Coste-Messelière, 'Un Jeune Prince amateur d'impressionnistes et chauffeur', *L'Oeil*, November 1969, 19–27. The *Baigneuses* price is taken from the Bernheim-Jeune stock records for 1907; I am indebted to M. Gilbert Gruet for permitting me to examine these records for the period 1900–14.

33 M. Fitzgerald, 'Skin Games', *Art in America*, February 1992, 72–3.

34 E. Blot, *Histoire d'une collection de tableaux modernes: 50 Ans de peinture (de 1882 à 1932)*, Paris: Editions d'Art, 1934, 54, quoted in Fitzgerald, 'Skin Games', 73; Bernheim-Jeune stock records.

35 On bourgeois incomes in the period, see J.-B. Duroselle, *La France de la 'Belle Epoque'*, 2nd edn, Paris: Presses de la Fondation Nationale des Sciences Politiques, 1992, 54–9.

36 Even Berthe Weill, more sympathetic than most to women artists, showed very few of them in her gallery: only 10, as against 110 men, in the 60 exhibitions she held before the First World War; see G. Perry, *Women Artists and the Parisian Avant-Garde*, Appendix 2, 160–3. For Bernheim-Jeune, the disparity was even greater: work by 161 men, but only 11 women, was shown in its exhibitions between 1900 and 1914; Bernheim–Jeune records.

37 The statutes of the society, drawn up in February 1904, included these aims: '(i) La constitution pendant une période de 10 ans d'une collection de tableaux, principalement d'oeuvres importantes de peintres jeunes ou commençant à peine à arriver à leur notoriété. (ii) La jouissance des dits tableaux dans certaines conditions. (iii) Leur revente aux enchères publiques'; reprinted in G. Habasque, 'Quand on vendait La Peau de l'Ours', *L'Oeil*, March 1956, 17; see also Level's account of the group in his *Souvenirs*. The most complete account of the activities of the society and their consequences for the art market is in Fitzgerald, 'Skin Games'. See also D. Cottington, 'Cubism and the Politics of Culture in France 1905–1914', unpublished PhD thesis, University of London, 1985, 156–7.

38 Fitzgerald, 'Skin Games', 77. The auction grossed over FF100,000, against an expenditure of (at FF3,000 per year) FF30,000. That such a sum was anticipated by Level is indicated by the fact that he secured for the auction the two main rooms of the Hôtel Drouot, which were only given on the seller's declaration that the sale would produce FF100,000 minimum; Level, *Souvenirs*, 29. Among several newspaper accounts of the sale, the most extended and informative is that by A. Warnod in *Comoedia*, 3 March 1914.

39 Tournier, 'Les Expositions', *Pan*, 3 no. 5, May–June 1910, 'Les commerçants organisent volontiers de petites expositions, et les plus troublants d'entre les débutants n'en sont nullement bannis, car

si le nombre des amateurs intelligents n'augmente guère, les spéculateurs et les snobs ont abandonné la prétention de n'admirer qu'après avoir compris.' While this kind of collector was not unknown before 1900 – the impressionists and post-impressionists had been supported in the 1880s and 1890s by a few *amateurs* such as Chocquet and Caillebotte, Tanguy and Le Barc de Boutteville – what was new was their number.

40 W. Uhde, *Von Bismarck bis Picasso*, Zurich: Oprecht, n.d. [1938], 127–8.

41 On Level's buying habits see his *Souvenirs*, 17–18; on Uhde's, see *Von Bismarck bis Picasso*, 127–44. Leo Stein recorded his enjoyment of such personal patronage in *Appreciation*, New York: Crown, 1947, 166–9. Other *dénicheurs* with similar interests included Roger Dutilleul, Olivier Saincère and Georges Aubry.

42 F. Olivier, *Picasso and his Friends*, London: Heinemann, 1964, 49.

43 Level, 'un retour marqué vers la solidité, la composition, la tradition hautement comprise', *Collection de la 'Peau de l'Ours'*, Paris: Hôtel Drouot, 1914, n.p. For similar comments by other *dénicheurs* see Uhde, 'Le Collectionneur', *Style en France*, 5 no. 2, January–March 1947, 61; R. Dutilleul, 'La Parole est aux collectionneurs', *Art présent*, numéro spécial, 'L'Art et l'argent', 1948, 106. Léonce Rosenberg later wrote to Dutilleul, *ibid.*, 68–9, that 'the artists whom we admire remain both traditionalists and revolutionaries, which is what all true continuers of art should be.'

44 If a survey of the exhibitions held at Weill's gallery is any indication.

45 Fitzgerald, 'Skin Games', 77, 79.

46 O. Uzanne, *Parisiennes de ce temps*, Paris, 1910, translated as *The Modern Parisienne*, London: Heinemann, 1912; quoted by Perry, *Women Artists and the Parisian Avant-Garde*, 7.

47 Garb, *Sisters of the Brush*, 84; Duncan, 'Virility and Domination in Early Twentieth Century Vanguard Painting', *Artforum*, December 1973; rev. and reprinted in C. Duncan, *The Aesthetics of Power*, Cambridge University Press, 1993, 103.

48 Duncan, 'Virility and Domination', 106–07.

49 On the cultural character and development of pre-1914 Montparnasse, see in particu-lar A. Warnod, *Les Berceaux de la jeune peinture*, Paris: Albin Michel, 1925; P. Fort, *Mes Mémoirs*, Paris, 1944; A. Billy, *Le Pont des Saints-Pères*, Paris: Fayard, 1947; *idem*, *L'Epoque Contemporaine*, Paris: Tallandier, 1956; A. Salmon, *Montparnasse*, Paris: Bonne, 1950; J.-P. Crespelle, *La Vie quotidienne à Montparnasse à la Grande Epoque 1905–1930*, Paris: Hachette, 1976 (henceforth Crespelle, *Montparnasse*).

50 The sculptor Zadkine lived in La Ruche in 1910, but after 9 months felt the need 'to leave, to flee this little world mouldering in melancholy, and return to Paris'; O. Zadkine, *Le Maillet et le ciseau*, Paris: Albin Michel, 1968, 60.

51 Crespelle, *Montparnasse*, 70.

52 Garb, *Sisters of the Brush*, 78–84; Perry, *Women Artists and the Parisian Avant-Garde*, 16–19.

53 Crespelle, *Montparnasse*, 69.

54 Warnod, *Les Berceaux de la jeune peinture*, 157, '[une] curieuse batisse . . . construite avec des palissades et des matériaux provenant de l'Expo de 1889'.

55 Crespelle, *La Vie quotidienne à Montmartre au temps de Picasso 1900–1910*, Paris: Hachette, 1978, 8, 21 (henceforth Crespelle, *Montmartre*).

56 *Ibid.*, 150. Warnod, *Les Berceaux de la jeune peinture*, 23–4, 'un mélange d'authentiques filous, faussaires, voleurs et pis encore . . . de fillettes perdues et de jeunes gens débauchés fuyant leur respectable famille'. For other first-hand accounts of Montmartre in this period, see A. Salmon, *Souvenirs Sans Fin (1): L'Air de la Butte*, Paris: Nouvelle France, 1945; Uhde, *Von Bismarck bis Picasso*; Level, *Souvenirs d'un Collectionneur*; for Level, Montmartre was at this period 'le centre incontesté des artistes', *ibid.*, 18.

57 Warnod, *Les Berceaux de la jeune peinture*, 165, 'le snobisme du ruisseau'.

58 Crespelle *Montmartre*, 49–50, suggests that it was because the *humoriste* milieu dressed 'à l'artiste' in the style of Murger's bohemians that Picasso soon after settling in the Bateau-Lavoir introduced the 'genre bleu mécano'. Tickner notes the masculinism of such a gesture: 'The appropriation of bits of working class clothing into a rougher masculinity than their families had fitted them for is characteristic of an attempt to modernise the tired particularities of artistic identity', in 'Men's Work? Mas-

culinity and Modernism', in N. Bryson, M. Holly and K. Moxey (eds), *Visual Culture: Images and Interpretations*, Hanover and London: Wesleyan University Press, 1994, 56.

59 The critic Fagus remarked upon it in the *Revue blanche*, cited by J. Warnod, *Le Bateau Lavoir*, Brussels: Connaissance, 1975, 41, no date given. Weill made the same observation in her memoirs, published thirty years later: *Pan! Dans l'Oeil!*, Paris: Lipschutz, 1933, 70. 'La petite mère Weill', as her artists knew her, also played her part in shaping the groups and spaces of this avant-garde; from eclectic beginnings, her exhibition programme from 1902 to 1914 shifted its aesthetic centre of gravity steadily, though cautiously, towards the modernists, bringing together some of the key artists and collectors of pre-war modernism.

60 They are, however, quite well known thanks to a considerable body of work on the dealer. Fundamental contributions are M. Gee, 'Dealers, Critics and Collectors of Modern Painting: Aspects of the Parisian Art Market, 1910–1930', unpublished PhD thesis, University of London, 1977; F. Crémieux and D.-H. Kahnweiler, *Mes Galeries et Mes peintres*, Paris: Gallimard, 1961; *Daniel-Henry Kahnweiler: Marchand, editeur, ecrivain*, Paris: Centre Georges Pompidou, 1984. See also Cottington, 'Cubism and the Politics of Culture', ch. 4.

61 Fitzgerald, 'Skin Games', 74. Crespelle, *Montmartre*, 218, claims that the sum was far less even than this: 'She had come from Alsace some years earlier, and had learned the tricks of the bric-à-brac trade from an antique dealer before setting up on her own on his death, with 375 francs borrowed from his widow for the downpayment on the rent.'

62 Kahnweiler's logbook of acquisitions for the pre-1914 period (for the opportunity to examine which I am indebted to M. Maurice Jardot) reveals, however, a more cautious approach on his part to paintings by cubists than has been claimed. Until 1911, it indicates, his purchases were oriented more heavily towards fauve and post-fauve than towards cubist painting: in 1910 he bought about 45 Vlamincks, 40 Derains and 40 Van Dongens, as against about 60 Picassos and 25 Braques; in 1911 he bought more works by the latter two

(about 45 each) and Vlaminck (30) than by others, and Picasso's primacy was maintained thereafter. For detailed figures and analysis see D. Cottington, 'Cubism and the Politics of Culture', 182–6, 202–03. On his exclusive contracts, see R. Moulin, *Le Marché de la peinture en France*, Paris: Minuit, 1967, 114; W. Spies, 'Vendre des tableaux – donner à lire', in *Daniel-Henry Kahnweiler*, 29–30, comments: 'L'exclusivité signifiait aussi : s'il se déclarait prêt à courir des risques, il voulait en revanche avoir la certitude d'être seul à dominer le marché. C'est dans cet esprit que Kahnweiler devint très vite un marchand "puissant".'

63 Nochlin, 'The Invention of the Avant-Garde', 16.

64 Estivals, Gaudy, Vergez, 'L'Avant-garde', table III, 131–2. Thus the crest of the wave coincided with the years of the Bloc des Gauches. Around half the periodicals were allied not to the Radicals or Socialists as might be expected, however, but to parties of the centre, and another third to those on the right. The explanation for this intriguing phenomenon lies, alas, beyond the scope of my inquiry.

65 As Estivals notes, *ibid.*, 77, 'In the course of the 19th century in fact, to choose the term "avant-garde" would have led the most advanced artists to feel misunderstood, for it would have assimilated them to a system that they did not recognize'.

66 Hadjinicolaou, 'Sur l'idéologie de l'avant-gardisme', 54.

67 C. Mauclair, 'La Réaction nationaliste en art', *La Revue*, 15 January 1905, 156, 'Le public snob qui soutient la *Schola* et les élèves de Franck . . . ce public d'"avant-garde" qui se souci peu de son armée et passe aussi bien à l'avant-garde ennemi'; Vauxcelles, in *Gil Blas*, 30 September 1909, 1, 'ces soi-disant coloristes d'avant-garde'; R. Allard, 'Sur Quelques Peintres', *Les Marches du sud-ouest*, June 1911, 58, 'des peintres contemporains dits "d'avant-garde" par une métaphore puérilement belliqueuse.'

68 Allard, in *La Cote*, 22 October 1912, 'Et d'abord qu'est-ce qu'un art "d'avant-garde"? Ces expressions ne correspond à aucune réalité. L'art est l'art, tout simplement. Pour ce qui est des artistes on peut, si l'on y tient, qualifier peintres d'avant-garde ceux qu'on peut appeler plus

simplement: peintres jeunes ou peintres nouveaux. La jeunesse et la nouveauté sont des réalités.'

69 Allard, 'Les Arts plastiques', *Les Ecrits français*, 1, 5 December 1913, 64, 'A l'aide d'articles de presse, d'expositions savamment organisées, avec conférences contradictoires, polémiques, manifestes, proclamations, prospectus et autre publicité futuriste, on lance un peintre ou un groupe de peintres.'

70 Allard, 'Les Arts plastiques. Futurisme, simultanéisme et autres métachories', *Les Ecrits français*, 3, 5 February 1914, 255–6, 'L'avant-gardisme n'est pas seulement un ridicule, c'est une plaie. Dans le domaine de la peinture où les rivalités d'amour-propre se doublent d'une querelle de gros sous, l'avant-gardisme aboutit à organiser une sorte de terreur où le chercheur sincère n'est plus en sûreté, où le talent indépendant doit se résoudre à adhérer par force à la section de son quartier . . . tant pis pour ceux qui n'ont aucun goût pour les parades de foire et les boniments!' See also his 'L'Avant-gardisme et la critique', *Les Ecrits français*, 5, April 1914. In his valuable account of the reception of the work of the avant-garde in pre-1914 Paris, J. Weiss, *The Popular Culture of Modern Art: Picasso, Duchamp and Avant-Gardism*, New Haven and London: Yale University Press, 1994, 60, states that it was Allard who thus coined the term 'avant-gardism'.

71 See Weiss, *The Popular Culture*, 52–6, for a survey of critical responses to Marinetti's manifesto.

72 *Ibid.*, 53.

73 Mauclair, 'Le Préjugé de la nouveauté dans l'art moderne', *La Revue*, 1 April 1909, 289; see *ibid*.

74 Gleizes, *Souvenirs: Le Cubisme: 1908–1914*, Paris: Cahiers Albert Gleizes, 1957, 20, 'les "ismes" allaient bientôt se multiplier par les volontés d'artistes cherchant plus à attirer l'attention sur eux qu'à réaliser des oeuvres sérieuses.'

75 R. Arbour, *Les Revues littéraires: Ephémères paraissant à Paris entre 1900 et 1914*, Paris: Corti, 1956.

76 See Chs 6 and 7 below.

77 Rosalind Williams, *Dream Worlds: Mass Consumption in Late Nineteenth-Century France*, Berkeley: University of California Press, 1982, 64–5.

78 D. Pope, 'French Advertising Men and the American "Promised Land"', *Historical Reflections*, 5, Summer 1978, 118.

79 C. Bellanger *et al*, *Histoire générale de la presse française*, vol. 3, Paris: Presses Universitaires de France, 1973; K. Varnedoe and A. Gopnik, *High and Low: Modern Art and Popular Culture*, New York: Museum of Modern Art, 1991, ch. 1.

80 Bellanger *et al*, *Histoire générale*, cited in Pope, 'French Advertising Men', 125.

81 *Ibid.*, 126.

82 Varnedoe and Gopnik, *High and Low*, 249.

83 Weiss, *The Popular Culture*, 59–73.

84 Henri-Martin (H.-M. Barzun), *L'Action intellectuelle: notations d'esthétique*, Paris: Rey, 1908, 18, 'l'organe de la littérature jeune . . . le soutien d'une politique réformatrice.' The magazine failed to appear, through lack of funds.

85 See Ch. 3, below, pp. 73–4.

86 H.-M. Barzun, *Poème et drame*, 1 no. 1, November 1912, inside back cover, 'fédérer intellectuellement les jeunes élites créatrices du monde entier'.

87 Barzun, 'Après le symbolisme: L'Art poétique d'un idéal nouveau: Voix, rythmes et chants simultanées', *Poème et drame*, 1 no. 4, May 1913, 13–14, 'des "révolutionnaires" malheureusement égarés en paroles sociales, qui confondent la recherche esthétique avec la lutte des partis'; 'La seule force créatrice *en avant* ne peut surgir que de l'instinct poétique'.

88 Barzun, *Poème et drame*, 1 no. 2, January 1913, 38, 'par les angoisses, les privations, les dangers de leur aventure, par l'hostilité des cités grasses qui les exilent, par la dureté de la conquête qui sera plus tard le patrimoine de tous.'

89 R. Williams, *The Country and the City*, London: Paladin, 1975, 295.

90 See Ch. 6 below.

91 As D. Grojnowski observes in 'L'Ane qui peint avec sa queue: Boronali au Salon des Indépendants', *Actes de recherche en sciences sociales*, 88, June 1991, 43.

Chapter 3 Discourses and Debates

1 M. Barrès, 'Le nationalisme, c'est de résoudre chaque question par rapport à la France. Mais comment faire, si nous

n'avons pas de la France une définition et une idée commune?', *Scènes et doctrines du nationalisme*, Paris, 1902, cited in Z. Sternhell, *Maurice Barrès et le nationalisme française*, Paris: Editions Complexe, 1985, 267.

2 P. Ory and J.-F. Sirinelli, *Les Intellectuels en France, de l'Affaire Dreyfus à nos jours*, Paris: Armand Colin, 1986, 48.

3 C. Maurras, 'La volonté de conserver notre patrie française une fois posée comme postulat, tout s'enchaîne, tout se déduit d'un mouvement inéluctable ... Si vous avez résolu d'être patriote, vous serez obligatoirement royaliste ... La raison le veut', *Enquête sur la monarchie*, cited in R. Girardet, *Le Nationalisme français*, Paris: Seuil, 1983, 197.

4 Ory and Sirinelli, *Les Intellectuels en France*, 49.

5 Barrès, 'Il n'y a même pas liberté de penser. Je ne puis vivre que selon mes morts. Eux et ma terre me commandent une certaine activité', *La Terre et les morts*, lecture of March 1899 published in Barrès, *Scènes et doctrines du nationalisme*, quoted in Girardet, *Le Nationalisme français*, 189.

6 Barrès, 'on ne peut se dispenser quand on est traditionaliste, quand on est soumis à la loi de continuité, de prendre des choses dans l'état où elles se trouvent', quoted in Girardet, *Le Nationalisme français*, 217.

7 Maurras, 'La monarchie héréditaire est en France la constitution naturelle, rationnelle, la seule constitution possible du pouvoir central', *Le Soleil*, 2 March 1900; quoted *ibid.*, 202.

8 Barrès, 'Les procédés d'argumentation régulière donnent l'illusion de la méthode scientifique ... mais il[s] ne mène[nt] nulle part ... Les assises d'une France fondée sur la logique ne me satisfont pas, je les veux sur la sensibilité ... Mes amis (Maurras et Bourget surtout) sont plus amis de leurs systèmes que de la France', *Mes Cahiers*, vol. 2, Paris: Plon, 1930; quoted *ibid.*, 217.

9 Barrès, *Scènes et doctrines du nationalisme*, quoted in Sternhell, *Maurice Barrès*, 275.

10 *Ibid.*, 275–6.

11 *Ibid.*, 216–17.

12 Z. Sternhell, 'The Political Culture of Nationalism', in R. Tombs (ed.), *Nationhood and Nationalism in France from Boulangism to the Great War 1889–1914*, London: HarperCollins *Academic*, 1991, 22.

13 Sternhell, *Maurice Barrès*, 15.

14 H. Bergson, *Introduction to Metaphysics* [1903], trans. T. Hulme, New York: Putnam's Sons, 1912, 7.

15 Bergson, *Creative Evolution* [1907], trans. A. Mitchell, New York: Random House, 1944, 7.

16 On 'five o'clock Bergsonians', see *La Vie parisienne*, 50, 1912, 509, cited in R. Grogin, *The Bergsonian Controversy in France*, University of Calgary Press, 1988, 123. There was surely more to such enthusiasm, however, than the dilettantism of bored society matrons. Grogin quotes Georges Dupeux's suggestion that middle-class women were encouraged in their rejection of 'reason' and 'progress' by fear of the support such concepts gave to the rise of socialism, *ibid.*, 137. It might be as significant that Bergson's intuitionist philosophy valorised what was then widely regarded and disparaged as a characteristically feminine thought process. See Ch. 4 below, pp. 95–6.

17 Grogin, *The Bergsonian Controversy*, 57 and 60, notes that an early 1890s estimate put the number of adherents of occult religions at 20,000 in Paris alone, citing Mgr Baunard, *Espérance*, Paris: Poussielgue, 1892.

18 Sternhell *Maurice Barrès*, 15, notes that in Barrès's idea of a *sens vital* described in his novel *Le Jardin de Bérénice* (1891) the novelist appears to have anticipated Bergson's *élan vital*.

19 Grogin, *The Bergsonian Controversy*, 88, quoting B. Russell, *A History of Western Philosophy*, New York: Simon & Schuster, 1945, and London: Allen and Unwin, 1946, 791. As Grogin notes, Henri Massis joined the Vichy cabinet after 1940. This is not to claim that a straight line can be drawn from Barrésian nationalism to fascism, however. As was stressed by several contributors to the lively debate that followed the publication of Sternhell's *Ni Droite ni gauche: L'Idéologie fasciste en France* in 1983 (Paris: Seuil), the character of the 'family of national reunification ideologies' up to 1914 was too complex to be reduced to such a schema. See A. Pinto, 'Fascist Ideology Revisited: Zeev Sternhell and His Critics', *European History Quarterly*, 16, 1986, 465–83.

20 Agathon's respondents' espousal of action was cited in Ch. 1 above; their en-

quiry quoted *L'Evolution créatrice* in support. For Barrès's equivalent sentiments, see Sternhell, *Maurice Barrès*, 278–9.

21 Agathon, *Les Jeunes Gens d'aujourd'hui*, Paris: Plon-Nourrit, 1913, 16.

22 Etienne Rey's widely read *La Renaissance de l'orgeuil français* (Paris: Grasset, 1912), a middle-of-the-road survey of patriotic feeling, is testimony to this; Rey has warm praise for Action Française's role in awakening the sentiment of patriotism, and views even its violent anti-semitism as evidence only of a 'shocking and admirable partiality' (133–4), but regards its monarchism as fatally anachronistic.

23 Ory and Sirinelli, *Les Intellectuels en France*, 52.

24 *Ibid.*, 54.

25 E. Weber, *The Nationalist Revival in France 1905–1914*, Berkeley: University of California Press, 1959, 66.

26 Ory and Sirinelli, *Les Intellectuels en France*, 56.

27 *Action française*, 1910, quoted by E. Weber, *Action Française: Royalism and Reaction in Twentieth Century France*, Stanford University Press, 1962, 9.

28 Quoted *ibid.*, 77.

29 N. Portier, 'Nationalisme et classicisme: La Jeunesse de l'Action française (1908–1914)', *La Revue universelle des faits et des idées*, vol. 161 (Paris), 1991, 58.

30 On the *petites revues* in general and the situation of young writers see E. Henriot, *A Quoi rêvent les jeunes gens? Enquête sur la jeunesse littéraire*, Paris: Champion, 1913, 5–16, and M. Caillard and C. Forot, 'Les Revues d'avant-garde', *Belles-Lettres*, 6 no. 62, December 1924, 97–105.

31 M. Denis, *Théories 1890–1910: Du Symbolisme et de Gauguin vers un nouvel ordre classique* (1912), 4th edn, Paris: Rouart & Watelia, 1920.

32 See Ch. 6 below, p. 158.

33 M. Décaudin, *La Crise des valeurs symbolistes: Vingt ans de poésie française 1895–1914*, Toulouse: Privat, 1960, 330.

34 C. Mauclair, 'La Réaction nationaliste en art', *La Revue*, 15 January 1905, 151–74; C. Morice, 'Enquête sur les tendances actuelles des arts plastiques', *Mercure de France*, 195–7, August and September 1905.

35 P. Sérusier, 'Qu'une tradition naisse à notre époque . . . c'est de Cézanne qu'elle naitra . . . il ne s'agit pas d'un art nouveau, mais d'une résurrection de tous les arts solides et purs, *classiques*', *Mercure de France*, 196, August 1905, 544.

36 Décaudin, *La Crise des valeurs symbolistes*, 311. For the 'bible' reference, see Portier, 'Nationalisme et classicisme', 59.

37 E. Bernard, 'Le maintien d'une aristocratie est la vie morale de la nation: sans aristocratie, tout devint inutile: l'art, la piété, la vertu, l'étude; il n'y a plus que la force brutale et l'argent qui comptent', *Les Guêpes*, 2, February 1909, 56.

38 Bernard, reply to an enquiry into contemporary art in *La Revue du temps présent*, April 1911, 312.

39 H. Clouard, 'Nous ne sommes pas précisément des traditionalistes . . . puisque tout ce qui nous sommes obligés de détester existe et est dans notre tradition depuis plus d'un siècle', *Action française*, 24 April 1912, and 'la tradition classique n'a pas d'amis plus dangereux que les traditionalistes', *Les Disciplines*, Paris: Marcel Rivière, 1913, 77; cited in Portier, 'Nationalisme et classicisme', 60, 68.

40 Barrès, 'Tant que je demeurerai, ni mes ascendants, ni mes bienfaiteurs ne seront tombés en poussière. Et j'ai confiance que moi-même, quand je ne pourrai plus me protéger, je serai abrité par quelques-uns de ceux que j'éveille . . . Ainsi je possède mes points fixes, mes repérages dans le passé et dans la postérité. Si je les relie, j'obtiens une des grandes lignes du classicisme français. Comment ne serai-je point prêt à tous les sacrifices pour la protection de ce classicisme qui fait mon épine dorsale?', *Scènes et doctrines du nationalisme*, Paris: Plon, 1902; quoted in Girardet, *Le Nationalisme français*, 189.

41 Portier, 'Nationalisme et classicisme', 69.

42 C. Morice, *Mercure de France*, 410, 16 July 1914, 237. The books were *Le Tourment de l'unité*, Paris: Société de Mercure de France, 1901; *Traité de l'occident*, Paris: Perrin, 1904; *Le Pas sur la terre*, Paris: Stock, 1908; *Les Marches de l'occident*, Paris: Stock, 1910.

43 A. Mithouard, 'La continuité s'impose à nous; la durée nous apparaît comme un trait d'union entre des oeuvres successives et solidaires', *Traité de l'occident*, 34.

44 'Parce qu'aussi de se conformer à des traditions lentement établies donne plus de sûreté à nos entreprises et plus de force à nos actions', *ibid.*, 35.

45 'Le monde moderne est devenu breton et il s'en honore', *ibid.*, 5.

46 'Se préoccupe moins de parfaire la silhouette que d'en bien raisonner la charpente', *ibid.*, 91.

47 'Nos oeuvres sont plein du Temps, parce que notre tradition fut toujours de le vaincre sans violence et de l'étreindre sans faiblesse', *ibid.*, 89.

48 'Ne demande plus à la Ville Eternelle qu'une chose: de la sérénité, et cette méthode qui lui est nécessaire pour conduire avec sûreté un génie vigoureux', *ibid.*, 146.

49 'La vérité fut aimée surtout et cherchée . . . comme un point d'appui pour des compositions impitoyablement raisonnées, comme un sol honnête et solide où appuyer des oeuvres visiblement composées, ardemment systématiques, dressées en défense contre le Temps', *ibid.*, 48–9.

50 'Qui soulève passionnément les oeuvres vers le monde'; 'qui les contient dans le dessin des formes', *ibid.*, 76.

51 Morice, *Mercure de France*, 238, 'ce sens inné de l'ordre qui a permis à nos ancêtres les grandes oeuvres collectives, par exemple ces travaux séculaires auxquels s'employait tout un peuple de clercs et d'artisans, les Cathédrales, parce qu'il maintient chaque force à son rang, à toutes les unités imposait la préoccupation de l'ensemble et assujettissait tous les bras au commandement de l'esprit'.

52 Mithouard, *Tourment de l'unité*, 283.

53 Mithouard, 'de ne pas laisser nous échapper, ni affaiblir notre tradition des matières, notre grâce et notre rigueur'. *Les Marches de l'occident*, quoted by Morice, *Mercure de France*, 238.

54 A. Anglès, *André Gide et le premier groupe de la* Nouvelle Revue Française *1890–1910*, Paris: Gallimard, 1978, 128, 149. André Billy, *L'Epoque contemporaine*, Paris: Tallandier, 1956, 102, later wrote that 'their main motto was "autonomy of art and literature".'

55 Anglès, *André Gide*, 176.

56 Thus in the same May 1909 issue Jacques Copeau could speak for the former in valuing hard work more highly than genius, while Jacques Rivière could, proceeding from the same premises, praise the Cézannist paintings of André Lhote.

57 Anglès, *André Gide*, 185. On anti-semitism, see Gide, 'Nationalisme et littérature', *NRF*, 5, June 1909.

58 Denis, *Journal*, vol. 1, Paris: La Colombe, 1957, 222; cited in M. Marlais, 'Conservative Style/Conservative Politics: Maurice Denis in Le Vésinet', *Art History*, 16 no. 1, March 1993, 141, 146. Denis declared, in reply to an enquiry in the *Revue du temps présent*, June 1911, 569, that his political sympathies lay with Action Française because it 'founds the need for order and a monarchy in the present needs of our sick and divided society'.

59 Denis, *Théories 1890–1910*, 92.

60 Denis, 'De Gauguin et de Van Gogh au classicisme', *L'Occident*, May 1909, reprinted in *Théories*, 'un art plus noble, plus mesuré, mieux ordonné, plus cultivé'. Guillaume Apollinaire, *Chroniques d'art 1902–1918*, ed. L.-C. Breunig, Paris: Gallimard, 1960, 76.

61 Denis, 'Le Salon d'Automne de 1905', *L'Ermitage*, 15 November 1905, 'Il faut renoncer à reconstruire un art tout neuf avec notre seul raison. Il faut se fier davantage à la sensibilité, à l'instinct, et accepter, sans trop de scrupules, beaucoup de l'expérience du passé. Le recours à la tradition est notre meilleur sauvegard contre les vertiges du raisonnement, contre l'excès des théories'.

62 Denis, 'Ce qui fonde une renaissance, c'est moins la perfection des modèles qu'on se propose que la force et l'unité d'idéal d'une génération vigoureuse'. 'De Gauguin et de Van Gogh au Classicisme', in *Théories*, 265–6.

63 R. Allard, 'Ainsi naît, aux antipodes de l'impressionnisme, un art qui . . . offre dans leur plénitude picturale, à l'intelligence du spectateur, les éléments essentiels d'une synthèse située dans la durée.' 'Au Salon d'Automne de Paris', *L'Art Libre*, 2 no. 12, November 1910, 442. The first of three articles, this was followed by 'Sur Quelques Peintres', *Les Marches du sud-ouest*, June 1911, and 'Les Beaux-Arts', *La Revue indépendante*, August 1911.

64 Allard, 'Les Beaux-Arts', 138, 'Donc aimer l'oeuvre vivante, à cause des forces de vie qui sont en elle, c'est comprendre et posséder la nature, puisque par le fait du génie, une pensée humaine a su la contenir toute entière.'

65 See Ch. 6 below. The articles were: A. Tudesq, 'Du Cubisme et de ses détracteurs: Une Querelle autour de quelques toiles', *Paris-Midi*, 4 October 1912, 1; A.

Gleizes, reply to an enquiry in *Les Annales politiques et littéraires*, 1536, 1 December 1912; Gleizes, 'La Tradition et le cubisme', *Montjoie!*, nos 1 and 2, February 1913. The quoted phrase is from the last of these, reprinted in Gleizes, *Tradition et cubisme: Vers un conscience plastique: Articles et conférences 1912–1924*, Paris: La Cible, Povolozky, 1924, 22.

66 Mithouard, *Traité de l'occident*, 33–4, 'Et comme on les sent ridicules, tous ces sonores parleurs de progrès qui se grisent d'aller résolument ils ne savent pas où, sans un seul jour se soucier de la beauté des temps dont ils sortent?'

67 C. Mauclair, 'l'amour pour M. Ingres, pour Rameau, pour la *Schola*, pour le vers régulier, pour le pastiche grec ou 17e siècle, va de pair, immanquablement, avec des opinions réactionnaires. Le tout est "bien portée"', 'La Réaction nationaliste en art et l'ignorance de l'homme de lettres', *La Revue*, 54, 15 January 1905, 167.

68 'L'ingérence détestable du nationalisme politique dans la question d'art . . . C'est l'absurde question de la recherche des origines et de la race, où politiciens et artistes prétendent donner leurs airs conjointement, qui est cause de tout le mal', *ibid.*, 162.

69 'Partout se décèle l'attraction réactionnaire, le besoin de "remonter aux origines", l'inquiétude d'être "Français", comme si être Français c'était rétrograder et pasticher', *ibid.*, 160.

70 'Notre classique, c'est la tradition française, et la tradition française, c'est le mépris du pastiche classique, c'est la défense contre les Grecs et les Romains, c'est le jaillissement de la sève autochthone, du réalisme clair et sensitif bousculant le pédantisme, les dogmes d'école', *ibid.*

71 'Je reste persuadé qu'il y a toute une beauté à dégager, absolument distincte de celle qui nous contentait hier, que tout récul est néfaste; que la vraie tradition française est d'aller toujours plus avant, d'aimer l'avenir . . . si la science et la transformation sociale doivent nous proposer un nouvel idéal, voyons-les avec amour, et laissons le passé s'agréger silencieusement à l'histoire. Si l'artiste admet, même un instant, de n'être pas avant tout l'ouvrier d'un monde nouveau, il consent au suicide morale – et le nationalisme lui propose ce suicide', *ibid.*, 174.

72 C. Bouglé, 'Solidarisme et morale scientifique', *La Revue bleue*, 2 September 1905, 310.

73 Several studies on the subject have been published since 1985, from which it is now evident that the disparagement of the decorative that has been characteristic of modernist art history contributed to the misrepresentation and marginalisation of a discourse that was of profound significance for French culture of the period. See in particular D. *Art Nouveau in Fin-de-Siècle France: Politics, Psychology and Style*, Berkeley: University of California Press, 1989; N. Troy, *Modernism and the Decorative Arts in France: Art Nouveau to Le Corbusier*, New Haven and London: Yale University Press, 1991; P. Wollen, 'Out of the Past: Fashion/ Orientalism/The Body', *Raiding the Icebox: Reflections on Twentieth-Century Culture*, London: Verso, 1993, 1–34; R. Benjamin, 'The Decorative Landscape, Fauvism, and the Arabesque of Observation', *Art Bulletin*, 75 no. 2, June 1993, 295–316.

74 Maurice Denis, 'L'Influence de Paul Gauguin', *L'Occident* (1903), cited in R. Benjamin, 'The Decorative Landscape', 299.

75 M. Orwicz, 'Anti-Academicism and State Power in the Early Third Republic', *Art History*, 14 no. 4 (December 1991), 571–92; M. Levin, *Republican Art and Ideology in Late Nineteenth-Century France*, Ann Arbor, Mich: UMI Research Press, 1986; N. Green, ' "All the Flowers of the Field": The State, Liberalism and Art in France under the early Third Republic', *The Oxford Art Journal*, 10 no. 1, 1987, 71–84.

76 J.-E. Blanche, 'Les Décors de l'Opéra russe', *Le Figaro*, 29 May 1909, 1; A. Alexandre, 'L'Age décoratif', *Comoedia*, 14 October 1911, 3. Critical acknowledgement of the trend was universal: see, e.g., Vauxcelles's reviews of the Salon des Indépendants, *Gil Blas*, 20 March 1906, and the Salon d'Automne, *Gil Blas*, 29 September 1908; J. Claude's review of the latter, *Le Petit Parisien*, 30 September 1910; A. Warnod on the Salon des Indépendants, *Comoedia*, 21 April 1911.

77 D. Silverman, *Art Nouveau in Fin-de-Siècle France*, 196; see also Ch. 1 above.

78 T. Garb, *Sisters of the Brush: Women's Artistic Culture in Late Nineteenth-*

Century Paris, New Haven and London: Yale University Press, 1994, 76–7.

79 G. Perry, *Women Artists and the Parisian Avant-Garde: Modernism and 'Feminine' Art, 1900 to the Late 1920s*, Manchester and New York: Manchester University Press, 1995, 116.

80 On Godebski see L. Garafola, *Diaghilev's Ballets Russes*, Oxford University Press, 1989, 279.

81 See Ch. 7 below, pp. 189–90.

82 Wollen, 'Out of the Past', 5.

83 Nancy Troy's *Modernism and the Decorative Arts*, chapter 2, offers a comprehensive account of the condition of the French decorative arts industries at the turn of the century and of the measures taken or recommended in response to international competition, and renders superfluous any attempt to summarise the subject here; my purpose is to map the discursive terrain covered by the debate to which that condition gave rise.

84 'Conseil Municipal de Paris (1908). "Rapport présenté au nom de la délégation envoyée par la Ville de Paris au 2ᵉ Congrès de l'Union Provinciale des Arts Décoratifs à Munich"', *L'Art et les Métiers*, 3, January 1909, 66; cited in Troy, *Modernism and the Decorative Arts*, 61.

85 On responses to the 1910 exhibition see Troy, *Modernism and the Decorative Arts*, 63–7; also K. Silver, *Esprit de Corps: The Art of the Parisian Avant-Garde and the First World War, 1914–1925*, London: Thames and Hudson, 1989, 171–4. On the press campaign, see R. Poidevin and J. Bariéty, *Les Relations franco-allemands 1815–1975*, 2nd edn, Paris: Armand Colin, 1977.

86 It is significant that when in 1912 a group of industrialists offered prizes for the best decorative art work at that year's Salon d'Automne, these went to five men and one woman; see F. Jourdain (with R. Rey), *Le Salon d'Automne*, Paris: Les Arts et le livre, 1926, 73–4. On responses to competition from women for jobs, see M. Perrot, 'The New Eve and the Old Adam: Changes in French Women's Condition at the Turn of the Century', in M. Higgonet *et al* (eds), *Behind the Lines: Gender and the Two World Wars*, New Haven and London: Yale University Press, 1987, 56.

87 G.-R. Sandoz and J. Guiffrey, *Exposition française d'art décoratif. Copenhague 1908. Rapport général. Précédé d'une etude sur les arts appliqués et industries d'art aux expositions*, Paris: Comité français des expositions à l'étranger, 1913, CLII–III.

88 R. Marx, 'De l'Art social, et de la nécessité d'en assurer le progrès par une exposition', *Idées modernes*, January 1909; reprinted in *ibid.*, CLIV–X.

89 *Ibid.*, CLXXIV–V.

90 *Ibid.*, CLXXXVI–CCIV.

91 *Ibid.*, CCVII–XIV, CCXXIV–XLI.

92 Mauclair, 'La Crise des arts décoratifs', *La Revue bleue*, 5, 16 June 1906, 755–9.

93 R. Marx, *L'Art Social*, Paris: Fasquelle, 1913, 54–5.

94 R. Marx, *La Revue*, 15 June 1909, 442, 's'impose comme une nécessité d'ordre économique autant qu'esthétique... le génie français ne connaît point d'autre alternative: il lui faut, selon le mot de Michelet, "inventer ou périr".'

95 Vauxcelles, in a 1910 lecture, 'La Crise actuelle des arts décoratifs en France, et de la leçon de l'étranger', Fonds Vauxcelles, Bibliothèque Jacques Doucet (Art et Archéologie), Paris.

96 J. Paul-Boncour, in *Art et Démocratie*, Paris: Ollendorf, 1912. This widely read and reviewed book was a significant contribution from a key player in the contemporary cultural debate.

97 Sandoz and Guiffrey, *Exposition française d'art décoratif*, CLXXXVIII. See also Troy, *Modernism and the Decorative Arts*, 164–5.

98 Sandoz and Guiffrey, *Exposition française d'art décoratifs*, 101.

99 Camille Mauclair, 'Ou en est notre "Art décoratif"?', *Revue bleue*, 24 April 1909, 520, 'un style extraordinaire, hystérique, bouffon, lamentable, inutilisable... une camelote fantastique et prétentieuse dont les modèles désuets font maintenant les délices des 'bronziers d'art' et du faubourg Saint-Antoine.' See also Marx, 'De l'Art social', 56, and the reply to the enquiry by Frantz Jourdain, architect and President of the Société du Salon d'Automne, in *La Revue*, 15 June 1909, 437–8.

100 Sandoz and Guiffrey, *Exposition française d'Art décoratif*, CCXXV.

101 Denis, 'Réponses aux positions de Roger Marx', *Le Musée*, December 1909; André Véra, 'Le nouveau style', *L'Art décoratif*, January 1912, 21–32.

102 Mauclair, 'Le Besoin d'un art du peuple', *La Revue bleue*, 2 September 1905, 307, 'C'est de lui que tout est sorti, figures gothiques, huches et stalles du XIVᵉ siècle, tapisseries, cuivres, meubles Louis XV et Louis XVI. C'est cet admirable peuple des corporations qui maintint le don de perfection française aux heures d'invasion étrangère.'

103 F. Jourdain, reply to an enquiry by E. Dévérin, 'La Crise de l'art décoratif en France', *La Revue*, 15 June 1909, 437–8, 'il viendra un moment, fatalement, où nous secouerons la léthargie dont nous souffrons et où nous reprendrons enfin la noble et logique tradition de la race française, tradition de bon sens et de vérité qui, à chaque époque, et avec une vision nouvelle, a enfanté des chefs-d'oeuvre.'

104 P. Gsell, 'La Prochaine Exposition des ecoles d'art décoratif', *Les Nouvelles*, 29 January 1909, 4, quoted in transl. by J. Neff, 'Matisse and Decoration: An Introduction', *Arts Magazine*, 49 no. 8, May 1975, 61.

105 L. Werth in Société du Salon d'Automne, *Catalogue des ouvrages de peinture, sculpture, dessin, gravure, architecture et art décoratif*, Paris, 1910, 13; Roblin cited in Sandoz and Guiffrey, *Exposition française d'art décoratif*, CCXXVI.

106 R. Marx, 'De l'Art social', 50–1, 'Quand l'art se mêle intimement à la vie unanime, la désignation 'd'art social' seule peut lui convenir; on ne saurait restreindre à une classe le privilège de ses inventions; il appartient à tous, sans distinction de rang ni de fortune; c'est l'art du foyer et de la cité-jardin, l'art du château et de l'école, l'art du bijou précieux et de la broderie paysanne; c'est aussi l'art du sol, de la race et de la nation'.

107 For examples of this argument see Mauclair, 'Le Besoin d'un art du peuple'; P. Forthuny in *Le Matin*, 14 April 1909; Vauxcelles, 'La Crise actuelle'; A. Blum, *La Crise des arts industriels en France*, Paris, 1911; R. Marx, *L'Art social*.

108 See, for example, Vauxcelles's review of the Salon d'Automne, *Gil Blas*, 4 October 1906; R. Marx's preface to that Salon's catalogue, 54; T. Duret's preface to the catalogue of the 1911 Salon d'Automne, 53–5; A. France's preface to Marx's *L'Art social*, ix.

109 M. Orwicz, 'Anti-Academicism and State Power in the Early Third Republic', *Art History*, 14 no. 4 (December 1991), 571–92.

110 Interviewed by *Le Matin*, 11 April 1911, three ministers – Steeg and Dujardin-Beaumetz of the Beaux-Arts administration and Massé from Commerce – condemned both the aristocratic prejudice that had established such a cultural hierarchy and the disastrous consequences it had had for decorative art.

111 He spoke of the 'solidarité entre tous les arts'; see Silverman, *Art Nouveau*, 174.

112 C. Morineau, *Roger Marx et l'Art Social, mémoire de maîtrise*, Université de Paris IV, 1988, 242–3. For Marx's comments on rural craft traditions see, e.g., *L'Art social*, 33.

113 Marx, *L'Art social*, 12–13.

114 *Ibid.*, 33–6.

115 'Sauf de rares esprits, personne ne calcule combien il est prudent et utile que de nobles prétextes fassent naître l'enthousiasme au coeur des foules. Que ne les invite-t-on à honorer le génie, à glorifier le travail, les métiers, ou même à ex-primer le quiétude qu'autorise l'assistance d'un mutuel appui?', *ibid.*, 44. See Morineau, *Roger Marx et l'Art social*, 201.

116 Vauxcelles, 'La Crise actuelle des arts décoratifs en France'.

117 See R. Williams, 'The Politics of the Avant-Garde', in his posthumous collection of essays, ed. T. Pinkney, *The Politics of Modernism: Against the New Conformists*, London: Verso, 1989.

118 Gleizes and Mercereau were co-founders of the anti-clerical youth group Association Ernest Renan; Duhamel, Arcos and Vildrac taught at the Université populaire du Faubourg St-Antoine. See G. Duhamel, *Cécile parmi nous*, Paris: Mercure de France, 1938, ch. 14; C Sénéchal, *L'Abbaye de Créteil*, Paris: Delpeuch, 1930, 18–19.

119 For a view of it as anarchist-inspired, see e.g., D. Robbins, 'From Symbolism to Cubism: The Abbaye de Créteil', *Art Journal*, 23, Winter 1963–4, 111–16. For an account of the anarchist communes of the *fin de siècle*, see J. Maîtron, *Histoire du mouvement anarchiste en France*, Paris: Maspero, 2nd edn, 1975. The motivations for the Abbaye are clearly indicated in the appeal for financial support launched (with no results) earlier in 1906, and

reprinted in Sénéchal, *L'Abbaye*, 139–40.

120 'Loin de l'utilitarisme . . . et des luttes économiques', *ibid*.

121 'Cette demeure trop haute et trop escarpée pour tous impurs, par laquelle nous échapperons aux bas-fonds', *ibid*.

122 A. Mercereau, *L'Abbaye et le bolchevisme*, Paris: Figuière, n.d. (?1922); A. Gleizes, 'The Abbey of Créteil, a Communistic Experiment', in C. Zigrosser (ed.), *The Modern School* (New Jersey), 5 no. 10, October 1918, 300–15.

123 Barzun, *L'Action intellectuelle*, Paris: Rey, 1908, quoted in; Sénéchal, *L'Abbaye*, 117.

124 For some contemporary responses to the Abbaye, see Sénéchal, *L'Abbaye*, 61–3.

125 M. Raymond, *De Baudelaire à surréalisme* (1933), Paris, Corti, 1985; L. Breunig, 'The chronology of Apollinaire's *Alcools*', *Publication of the Modern Languages Association*, December 1952, 907–22; Décaudin, *La Crise des valeurs symbolistes*.

126 J.-M. Bernard, 'Stéphane Mallarmé et l'idée d'impuissance', *La Société nouvelle* (Brussels), 14 no. 2, August 1908, 177–95; A. Gide, 'Notes: Contre Mallarmé', *Nouvelle Revue Française*, 1 no. 1, February 1909, 96–8.

127 J. Kristeva, *La Révolution du langage poétique*, Paris: Seuil, 1974, 427.

128 See R. Terdiman, *Discourse/Counter-Discourse*, Ithaca, N.Y. and London: Cornell University Press, 1985, 267; Kristeva, *La Révolution du langage poétique*, 430.

129 Terdiman, *Discourse/Counter-Discourse*, 264, 270.

130 *Ibid.*, 272.

131 'Poetry is everywhere in language, except on page 4 of the newspapers', Mallarmé wrote in the mid-1890s; 'Sur l'évolution littéraire', *Oeuvres complètes*, ed. H. Mondor and G. Jean-Aubry, Paris: Gallimard-Pléiade, 1945, 867. Page 4 was the *petites annonces* page.

132 A. Billy, *L'Epoque contemporaine*, Paris: Tallandier, 1956, 133.

133 For a discussion of Apollinaire's interest in symbolism and its relation to his poetry see V. Spate, *Orphism: The Evolution of Non-Figurative Painting in Paris 1910–1914*, Oxford University Press, 1979. On Apollinaire and tradition, see L. C. Breunig, 'Apollinaire et le cubisme', *Revue des lettres modernes: Guillaume*

Apollinaire, 1, 1962, 18. On Apollinaire's art criticism, see Ch. 6 below.

134 The most recent account of Golberg's career is P. Aubéry, *Anarchiste et décadent: Mécislas Golberg, 1868–1907*, Paris: Lettres Modernes, 1978.

135 M. Golberg, *Sur le Trimard*, 1 no. 3, October–November 1895, 'L'élément moteur essentiel de tout mouvement de rénovation sociale . . . guidera la marche des sans-travail vers les contrées meilleures de grandes et sublimes émotions'.

136 Golberg, 'De l'esprit dialectique' [part I], *Revue littéraire de Paris et de Champagne*, February 1905, 61, 'loin de la foule . . . eux-mêmes des *signes* des foules, des signes abstraits, actifs, des signes lumineux'. This essay was never published in a single volume; excerpts from it were serialised in several ephemeral reviews, some of which are untraceable. The essay must therefore be pieced together from extant excerpts, hence the chronological inconsistencies of the following few references.

137 'Le moment de l'esthétique de l'ordre qui naît grace à la paix établie entre le créateur et la vie', *ibid.*, 63.

138 'Se manifeste dans la co-ordination des forces . . . elle remplace Dieu-Esprit ou Dieu-Matière par le principe de la Beauté', 'De l'esprit dialectique' [part 2], *Revue littéraire de Paris et de Champagne*, June 1905, 398.

139 'L'expression la plus parfaite de l'existence, l'expression où toutes les contradictions cessent pour céder place à une forme absolue', 'De l'esprit dialectique' [part 4], *Cahiers mensuels de Mécislas Golberg*, 1900–1901, 92.

140 Quoted by P. Aubéry, 'Mécislas Golberg et l'art moderne', *Gazette des Beaux-Arts*, December 1965, 341.

141 'L'Art, c'est de trouver dans les vérités qui passent leur loi et leur essence', *Lettres à Alexis*, Paris, 1904; quoted in Aubéry, 'Mécislas Golberg', *Les Lettres nouvelles*, July–September 1965, 70.

142 'Je vais essayer de reconstruire l'intellect de la ligne, de chercher dans ces graphiques leur âme verbale, et de formuler quelques lois concernant les mystères de l'âme humaine', *La Morale des lignes*, Paris: Messein, 1908, ix–x.

143 'La notation respectueuse des proportions géométriques d'un objet et de leur rapport avec une Harmonie ou une Emotion . . . créer une oeuvre d'art, c'est d'annoter le

jeu d'équilibre des forces universelles', *ibid.*, 21.

144 'Les choses matérielles s'expriment par des surfaces et des volumes plus précis, les choses de l'esprit s'expriment par des signes de plus en plus simples à mesure qu'elles s'élèvent vers l'abstrait', *ibid.*

145 Aubéry, 'Mécislas Golberg et l'art moderne', 342–4, 'La plupart des théories qu'Apollinaire a répandues et qui ont fait fortune, avec tant de bruit et d'excitation dévergondée, notamment sur les bases propres de l'expression dans le déformation et la spiritualisation des lignes et des plans, sont dans Golberg.'

146 C. Doury, 'Mécislas Golberg', *Le Festin d'Esope*, August 1904, 160.

147 G. Apollinaire, *La Phalange*, 15 March 1908, 859–60, 'Mécislas Golberg avait peu d'amis et beaucoup d'ennemis parce qu'il était pauvre et que sa vie pleine de souffrances fut toute entière consacrée à l'idéal que l'on méconnaît, à la beauté dont rient les imbéciles. J'étais un des amis de Mécislas Golberg et je ne voudrais pas être le dernier à rendre un hommage douloureux, à dire un triste adieu à un homme auquel nous devons quelques-uns des livres les plus élevés et les plus émouvants de notre temps.'

148 *Cahiers de Mécislas Golberg (revue d'art trimestrielle)*, 1–2, January–June 1907, Créteil: Imprimerie de l'Abbaye.

149 Mercereau, 'Sur le Salon d'Automne', *Le Toison d'or*, 1908 no. 10, 70. Mercereau acknowledged his debt to Golberg in a footnote.

150 See Ch. 6 below.

151 Golberg, 'De l'esprit dialectique' [part 4], 94.

152 'Tout est en juste mesure si les yeux savent regarder ... les choses qui existent suivant leur loi ne peuvent qu'être utiles', *ibid.*, 89.

153 'Grâce à l'émotion de l'ordre ... il suffit de vouloir, pour trouver des bienfaits partout, même dans la souffrance, même dans la mort. Le divin, fatal et inaccessible devient alors humain. Il passe du mystère à la beauté', *ibid.*

154 Golberg, *Lettres à Alexis*, 122, 'L'époque de Darwin et Pasteur est passée ... Après la recherche des lois vient la pratique. Après l'analyse vient l'ordonnance ... notre but est de soumettre la vie à la loi'.

155 See Ch. 1 above.

156 'Notes: Notre action (suite) – notre pensée', *Les Feuilles dev mai*, 4, July 1913, 25, 'Nous sommes des artistes, beaucoup de nos amis sont des artistes. Les militants nous ont baptisés: nous sommes des intellectuels. Il y a une certaine angoisse à nous sentir d'avance rejetés des rangs de ceux que nous considérons commes nos plus proches'.

157 J.-R. Bloch, 'De l'utilité en art, et pour en finir avec l'Art pour l'Art', *L'Effort*, March 1912, 348. L. Werth, 'De M. Maurice Barrès', *Les Cahiers d'Aujourd'hui*, 1, October 1912, 19, 'Ils chantaient: "Allons au peuple". Mais c'était un chant mystique ... Le peuple auquel ils voulaient aller était un peuple de figurants de théâtre, de monstres pacifiques et farouches. Ils le croyaient destiné à la fonction de souffrir pour que des artistes délicats exercent à leur tour la fonction de le plaindre.

Un jour ... les esthètes de la bourgeoisie s'aperçurent sans aucune joie que le peuple allait à eux. Ou du moins il allait à leurs pères, directeurs d'usines. Les esthètes ... télégraphièrent aux ministres, pour qu'on leur envoyât des soldats. Et au lieu d'aller au peuple qui ne voulait pas se laisser aimer, ils décidèrent d'aller à l'église et de saluer le drapeau.'

158 *L'Art social*, 1, July 1896, 3, 'de faire cesser le malentendu qui existe entre les ouvriers manuels et les ouvriers intellectuels et de réunir ainsi les uns et les autres ... de contribuer à préciser le courant d'idées qui se manifeste en faveur d'un art auquel puisse s'intéresser le peuple'.

159 F. Pelloutier, *L'Art et la révolte*, Paris, 1897, 7, 26–7, 32, 'dévoiler les mensonges sociaux, dire comment et pourquoi ont été crées les religions, imaginé le culte patriotique, construite la famille sur le modèle du gouvernement'; 'l'art bourgeois fait plus pour le maintien du régime capitaliste que toutes les autres forces sociales réunies: gouvernement, armée, police, magistrature, de même l'art sociale et révolutionnaire fera plus pour l'avènement du communisme libre que tous les actes de révolte inspirées à l'homme par l'excès de sa souffrance'; 'Vous tous, ouvriers, savants, qui avez, avec la haine du mal, le désir du mieux-être, la passion de l'affranchissement matériel et intellectuel, luttez avec nous, car la source de nos misères est commune.'

160 J. Jaurès, 'Art et socialisme' [1900], *La Forge*, January 1918, 11–13, and March 1918, 78–85.

161 Grandjouan, 'L'Art et la misère', *La Guerre sociale*, 8–14 January 1908, 2, 'sous notre belle République l'Art n'est qu'une dérision, et les musées sont une perpetuelle insulte à la misère du peuple … L'Art aujourd'hui gravite autour de la Bourgeoisie. Femmes épanouies dans *son* luxe, pages vibrantes de *son* histoire, émotions visuelles de *ses* loisirs; il n'existe de Beauté que celle qui est à la portée de la classe aisée … Quand je pense que je ne serai jamais l'égal du bourgeois, même devant l'art, et qu'en même temps que le bien-être, ce luxe du corps, vous nous avez volé l'art, ce luxe d'esprit, la colère m'empoigne et je crois que j'irai joindre la troupe des crève-de-faim qui, un beau soir, ira mettre le feu au quatre coins du Louvre.'

162 Grandjouan, 'L'Art et le peuple', *La Guerre sociale*, 11–17 March 1908, 3, 'n'est qu'un cache-misère … L'Art ne se sépare pas du bien-être. L'un est la conséquence nécessaire de l'autre. Conquérez-les ensemble!'

163 J.-R. Bloch, *L'Effort*, Poitiers, 2, 15 June 1910, 4, 'L'Art est toujours une floraison de la classe dominante d'un pays, et il vaut ce que vaut cette classe'.

164 Bloch, *L'Effort*, 5, 7 August 1910, 4, 'Le préjugé bourgeois est nulle part plus enraciné que chez les peintres qui, tous, sortent du petit peuple. Je n'en connais pas un qui 'aime les pauvres', c'est-à-dire qui travaille sur le même plan horizontal qu'eux, avec eux, pour eux … il faut les excuser. Ils se figurent, parce que les riches sont seules à pouvoir acheter mille francs une toile peinte, que les riches sont les seules à comprendre!'

165 'L'Art de tous (et non l'Art *pour* tous) … est notre recherche', *ibid.*

166 'L'Effort veut devenir l'organe de tous ceux qui cherchent un art révolution-naire … l'art de demain sera un art de *rénovation sociale* ou se condeamnera à ne pas être'; 'Au lieu de regarder comme suffisamment fondée, du simple fait du groupement des producteurs en syndicats, la culture morale et intellectuelle du prolétariat, *regardons l'organisation du prolétariat comme le point de départ possible d'une civilisation nouvelle* – la civilisation révolutionnaire'; 'Le but de

L'*Effort* se précisait donc à nouveau. Il fallait reprocher ces deux forces, vaincre la rancune et la méfiance des travailleurs pour l'artiste, dissiper le préjugé aristo-cratique et scolaire de ce dernier', *L'Effort libre*, January 1913, 97, 99. The review changed its name after March 1912 fol-lowing a court action brought by another periodical with the same title.

167 Décaudin, *La Crise des valeurs sym-bolistes*, 459, 462.

168 C. Le Cour and J. Lurçat, 'Une Renais-sance des arts décoratifs', *Les Feuilles de mai*, 1, November/December 1912–January 1913, 16–22, and 'L'Inopport-unité d'un style décoratif français', *Les Feuilles de mai*, 3, May 1913,151–60. For similar views see G. Besson, 'Le Règne de la Hyène', *Les Cahiers d'aujourd'hui*, 1, October 1912, 48–52; M. Pillet, 'A Propos d'un livre', *Les Horizons*, 1 no. 5, 15 No-vember 1912, 130–5. On R. Marx's *L'Art social* see, e.g., G. Vidalenc's review in *La Vie ouvrière*, 92, 20 July 1913, 111.

169 See, e.g., H. Guilbeaux, 'Paul Signac et les Indépendants', *Les Hommes du jour*, 170, 25 April 1911, n.p.

170 M. Rebérioux, 'Avant-garde esthétique et avant-garde politique: Le Socialisme français entre 1890 et 1914', in *Esthétique et marxisme*, Paris: Union Générale d'Editions, 1974, 33.

171 L. Werth, 'Le réveil du patriotisme', *Les Cahiers d'aujourd'hui*, 5, June 1913, 224–5, 'On dit: le pauvre n'a pas de patrie ou sa patrie est la patrie révolutionnaire. Cela est la même chose. La patrie révolutionnaire n'est pas d'un territoire. Elle est un bien moral, semblable au bien que fut jadis la religion. Seulement elle est fondée sur le travail et l'esprit de révolte … Si la patrie est un fait, il dépend, semblablement à tous les faits, de notre interprétation. Il y a en France deux interprétations du fait "patrie": l'interprétation des riches et celle des pauvres, l'interprétation selon la tradi-tion d'autorité et celle selon la tradition révolutionnaire.' See also, e.g., C. Laisant, 'La Conscience syndicale et le pacifisme', *Les Feuilles de mai*, 3, May 1913, 170–75; A. Colomer, 'Nos Compagnons en idéal', *L'Action d'art*, 5, 15 April 1913, 4.

172 C. Rappoport, 'Les Jeunes Gens d'Agathon', *Les Feuilles de mai*, 2, February 1913, 101–4.

173 Werth, 'Le Réveil du patriotisme', 226–7, 'Au patriotisme d'affaires, qui est le

patriotisme nationaliste, quelques esthètes et même quelques artistes substituent une sorte de patriotisme esthétique.'

174 On the tiny minority of wartime pacificist intellectuals and artists see the memoirs of one of them: H. Guilbeaux, *Du Kremlin au Cherche-Midi*, Paris: Gallimard, 1933.

175 Werth, 'Les Néo-Sophistes', *Les Cahiers d'aujourd'hui*, 6, August 1913, 325, 'Nous croyons que l'esprit de la France, c'est l'esprit révolutionnaire.'

Chapter 4 Cubist Painting and the Discourse of Nationalism

1 Between 1910 and August 1914 Le Fauconnier appears to have participated in at least 30 exhibitions in Paris and elsewhere in Europe, more than any other cubist except Picasso, for whom 40 are listed by D. Gordon, *Modern Art Exhibitions 1900–1916*, 2 vols., Munich: Prestel, 1974, vol. 1, 342, 350. See also D. Robbins, 'Le Fauconnier and Cubism', in *Henri Le Fauconnier (1881–1946): A Pioneer Cubist*, New York: Salander-O'Reilly Galleries, 1990, n.p.

2 Robbins, 'Le Fauconnier and Cubism'. Le Fauconnier was a member of several anti-academic art associations ouside France including the Neuekunstler-vereinigung (NKV) in Munich and the Moderne Kunst Kring in Amsterdam, and was sought out on visits to Paris by artists from Europe and the USA, including Klee, Macke, the Italian futurists and members of the Moscow and St Petersburg avant-gardes.

3 As regards the latter assumption I paraphrase H. Foster's critique of P. Bürger, *Theory of the Avant-Garde*, in 'What's Neo About the Neo-Avant-Garde?', *October*, 70, Fall 1994, 6–7.

4 See R. Girardet, *Le Nationalisme français*, Paris: Seuil, 1983, 183.

5 Kahnweiler gathered Spanish and French artists and sold their work to fellow German collector-dealers (Uhde, Flechtheim) as well as Russian, Czech and American collectors. I noted earlier the xenophobic character of the protests of 1912 in the Chambre des Députés at the numbers of foreign exhibitors and the presence of cubist works at that year's Salon d'Automne.

6 See, e.g., that of Gleizes in his *Souvenirs: Le Cubisme 1908–1914*, Paris: Cahiers Albert Gleizes, 1957, 15–18.

7 See Ch. 6 below, pp. 154–5.

8 Gleizes, *Souvenirs*, 14. The painting's elaboration, from partial figure drawings and a full-length study to the final picture, was unusually painstaking for Le Fauconnier. Not that he showed these to all comers, it seems: in an anecdote that reveals the keenness of the artist's competitiveness, A. Warnod, *Les Berceaux de la jeune peinture*, Paris: Albin Michel, 1925, 163–4, related that 'the visitor who knocked on his door had first to wait on the landing while they heard a great commotion and the noise of metallic rings scraping on rails. The painter was hiding behind curtains the paintings that he was working on, so that he could be sure that the visitor would not steal his secrets for their own use' ('le visiteur qui frappait à sa porte devant d'abord attendre sur le palier qu'on vint lui ouvrir, il entendait tout un remue-ménage et le bruit d'anneaux métalliques grinçant sur des triangles. Le peintre cachait derrière des rideaux ses tableaux en train, certain ainsi que le visiteur n'emporterait pas ses secrets pour en tirer parti').

9 In an interview of 1927 Kahnweiler suggested that such abstention was a decision made by the artists themselves, but acknowledged that its advantages, which he described as those of 'not mixing with the crowd, and of maintaining a discreet and aristocratic attitude' ('de ne pas se mélanger à la foule et de garder une certaine attitude discrète et aristocratique'), were part of his design; see E. Tériade, 'Nos Enquêtes: Entretien avec Henry Kahnweiler', *Cahiers d'Art*, 2 no. 2, supplément 'Feuilles volantes', 1, 1927, 1–2.

10 D. Robbins, 'Albert Gleizes: Reason and Faith in Modern Painting', in *Albert Gleizes 1881–1953*, New York: Solomon R. Guggenheim Museum, 1964, 12–25. Like all cubist scholars, I am greatly indebted to Robbins's path-breaking work on Gleizes and Le Fauconnier, which was the first to rescue these artists from undeserved modernist neglect. See also his *The Formation and Maturity of Albert Gleizes*, unpublished PhD thesis, New York University, 1975. Robbins's mapping of this milieu was complemented and

extended by C. Green, *Léger and the Avant-Garde*, New Haven and London: Yale University Press, 1976, and by V. Spate, *Orphism: The Evolution of Non-Figurative Painting in Paris 1910–1914*, Oxford University Press, 1979); most recently M. Antliff's *Inventing Bergson: Cultural Politics and the Parisian Avant-Garde*, Princeton University Press, 1993, has added valuably to the map.

11 On the aesthetics of the Abbaye poets' circle, see Décaudin, *La Crise des valeurs symbolistes: Vingt ans de poésie française*, Toulouse: Privat, 1960. On its rela-tion to the proto-cubism of Le Fauconnier and Gleizes, see Robbins, 'From Symbolism to Cubism: the Abbaye of Créteil', *The Art Journal*, 23 no. 2, Winter 1963–4, 111–16; also Green, *Léger and the Avant-Garde*, ch. 1.

12 The publication in French of Whitman's *Leaves of Grass* in 1909 (translation by Léon Bazalgette, who had published a biography of the poet the previous year) was greeted with wide acclaim; see Décaudin, *La Crise des valeurs symbolistes*.

13 See Green, *Léger and the Avant-Garde*, ch. 1; Antliff, *Inventing Bergson*.

14 See Green, *Léger and the Avant-Garde*, ch. 1.

15 T. de Visan, 'La philosophie de M. Bergson et le lyrisme contemporain', *Vers et prose*, 21, April–June 1910, 138, 'Le symbolisme ou l'attitude poétique contemporaine se sert d'images successives ou accumulées pour extérioriser une intuition lyrique.'

16 G. Duhamel and C. Vildrac, *Notes sur la technique poétique*, Paris, 1910.

17 In the first half of 1911, Mercereau's *Paroles devant la femme enceinte* was first published in *Vers et prose*, 26, July–September 1911, 125–36. In his text Mercereau extolled motherhood in similes that closely resemble Le Fauconnier's visual metaphors: 'You stretch your womb, like a branch, the pulp of whose fruit will suddenly burst out under pres-sure from within, to let fall to the ground the seed of a descent' ('Toi, tu tends ton flanc, comme la branche le fruit dont la pulpe éclatera tout à l'heure sous la poussée du dedans, afin de laisser choir à terre la graine d'une descendance'), *ibid.*, 125.

18 For a discussion of these similarities, see D. Cottington, 'Henri Le Fauconnier's

L'Abondance and its literary background', *Apollo*, February 1977, 129–30. The painter's familiarity with the poets' treatise is indicated by his adoption of a similarly pseudo-technical language in his own aes-thetic statement of 1910, 'L'Oeuvre d'art', see Ch. 6 below, 154 and n. 58.

19 Gleizes, 'Souvenirs', 9.

20 See e.g. Sérusier's reply to Morice's enquiry of 1905, Ch. 3 above, p. 60. and Denis's article 'Cézanne', *L'Occident*, 70, September 1907, 118–32.

21 Le Fauconnier, reply to an *enquête* by J.-C. Holl, 'Sur L'orientation actuelle de la peinture moderne', *Revue du temps présent*, May 1911, 466, 'Cézanne eut . . . ce grand mérite . . . de remonter aux principes intégraux de la tradition picturale en les adaptant à ses moyens propres d'expression . . . Le jour où les amateurs d'art découvriront à nouveau l'*Enlèvement des Sabines* du Poussin, l'*Apothéose d'Homer* d'Ingres, et l'admirable *Sacre* de David, peut-être se rendront-ils compte qu'il y a dans leur époque des peintres qui, loin de tout exotisme, de tout symbolisme, de tout néo-classicisme, oeuvrent en toute sérénité dans la plus profonde tradition française.'

22 R. Allard, 'Au Salon d'Automne de Paris', *L'Art Libre*, 2 no. 12, November 1910, 443, 'Un beau tableau n'est qu'un juste équilibre, c'est-à-dire un accord de poids et un rapport de nombres . . . libre au génie de dilater la tradition dans le sens du classicisme futur!'

23 'Le noble désir de concourir à la restaura-tion d'un canon plastique', *ibid.*

24 *Ibid.*, 442. See p. 64 above, and p. 210n63.

25 This derived specifically from his attempt to respond to Metzinger's use of multiple perspective.

26 Allard, 'Sur Quelques Peintres', *Les Marches du sud-ouest*, 2, June 1911, 64, 'l'anecdote insidieuse, . . . le bric-à-brac de la fausse littérature et du pseudo-classicisme'; 'il faut entendre par là des oeuvres composées, construites, ordonnées et non plus des notations et des pochades où le bluff d'une fausse spontanéité masque le néant foncier.'

27 Allard, 'Les Beaux-Arts', *La Revue indépendante*, August 1911, 137, 'Ainsi les *Bergers d'Arcadie*: pour aboutir à l'arrangement définitif, des mouvements ont décrit d'innombrables orbes enchevê-trés; d'autres arrêtés, semble-t-il, dans leur

trajectoire par une nécessité supérieure, ont, à cet instant, subi une transposition miraculeuse. Tout ce qui était inachevé dans l'espace est désormais achevé dans le temps, et l'objet limité dans la dimension devient infini dans la durée. Mais les forces primitives, après avoir donné l'élan aux mouvements maintenant interrompus, continuent à s'exercer – et la beauté *vivante* de l'oeuvre est faite de la résistance même que leur oppose l'équilibre des volumes.'

28 After 'Sur Quelques Peintres' see Allard's reviews in *La Cote*, 30 September 1911, n.p., 20 March 1912, n.p., and 30 September 1912, n.p.; *La Revue de France et des pays français*, 2, March 1912, 67–70.

29 Only weeks before Allard's article was published, Le Fauconnier was spotted copying the Louvre's new Poussin, as Salmon reported in his gossip column, *Paris-Journal*, 5 July 1911, 4, noting how faithfully he had transcribed the painting's classic values of line and volume.

30 Allard, 'Les Beaux-Arts', 138. See above p. 210n64.

31 Agathon, *L'Esprit de la nouvelle Sorbonne*, Paris: Mercure de France, 1911; R. Grogin, *The Bergsonian Controversy in France 1900–1914*, University of Calgary Press, 1988, 121. Grogin notes (131–2) that republican academics such as C. Bouglé saw the Ligue de la Culture Française as 'an insidious and well-orchestrated attack of right-wing reactionaries'.

32 Bergson, *Creative Evolution* [1907], trans. A. Mitchell, New York: Random House, 1944, 45, 20, 7.

33 *Ibid.*, 295.

34 'By 1912 Bergson had the educational and even the political establishment ranged against him. He drew their fire ... because too many of the more visible enemies of the Sorbonne were self-proclaimed Bergsonians... [who] argued from a political and often anti-democratic position.' Grogin, *The Bergsonian Controversy in France*, 131.

35 See A. Maugue, *L'Identité masculine en crise au tournant du siècle*, Paris: Rivages, 1987. See also Ch. 1 above, pp. 30–31.

36 See e.g. E. Perrier, *La Femme dans la nature*, Paris, 1908, 380; quoted *ibid.*, 25.

37 On anxieties over the French birth rate and the 'woman question', see K. Offen, 'Depopulation, Nationalism and Feminism in Fin-de-Siècle France', *American Historical Review*, 89, 1984, 648–76. On women in employment, see M. Perrot, 'The New Eve and the Old Adam: French Women's Condition at the Turn of the Century', in M. Higgonet *et al.* (eds), *Behind the Lines: Gender and the Two World Wars*, New Haven and London: Yale University Press, 1987, 51–60.

38 E. Zola, *Fécondité*, Paris, 1899, cited in Offen, 'Depopulation', 663–4.

39 Biographical information on Le Fauconnier is principally from two unpublished sources: M.-A. Stalter, *Le Fauconnier et l'expressionnisme, mémoire* for the Diplôme d'Etudes Supérieures d'Histoire de l'Art, Paris: Sorbonne, 1962, and an essay, 'Le Fauconnier, l'homme et l'oeuvre' (n.d.) by the artist's nephew H. Sevin, Collection J. Sevin, Carpentras. See also J. Romains, *Le Fauconnier*, Amiens: Malfère, 1922.

40 C. Morice, "Ploumanac'h", *Paris-Journal*, 4 September 1911, 'Cependant le Breton s'entête à vivre. Il ressemble à ses rochers, il est triste comme eux, comme eux menacé ... on tremble en passant auprès de ces pierres géantes, nues ... cet empire de l'horreur a tenté les touristes. Ce sont des caractères intrépides. Grâce à leur courage, il n'y a plus de 'coins perdus': on les a tous retrouvés, hélas! ... A Ploumanac'h, les touristes sont plus nombreux que les rochers. Avec leurs toilettes, avec leurs autos, avec leur jargon de la ville, avec leurs besoins factices et leur paresse bien réelle, ils ont transformé le pays, qui, du reste, a fait volontiers tous les sacrifices pour plaire à ces passants et pour les retenir.' The article was on the front page, illustrated with a photograph of some of the rocks. On social changes in Brittany during the Third Republic see E. Weber, *Peasants into Frenchmen: The Modernisation of Rural France 1870–1914*, London: Chatto and Windus, 1977. On relations between such changes and artistic representations of Brittany, see G. Pollock and F. Orton, 'Les Données bretonnantes: La Prairie de la représenta-tion', *Art History*, 3 no. 3, September 1980, 314–44.

41 Green, *Léger and the Avant-Garde*, 11, notes that, having worked fitfully on his

ambitious *Nus dans une forêt* for a year, Léger returned to finish it in the winter of 1910–11, 'in the fresh, heady atmosphere' of the group discussions at Le Fauconnier's studio in the rue Visconti, in which he and others witnessed the development of *L'Abondance*; see also A. Gleizes, *Souvenirs*, 14. The *Nus* is articulated by an expressive 'battle of volumes' that anticipates by four years his systematic contrasts of forms. See also D. Vallier, 'La Vie fait l'oeuvre de Fernand Léger', *Cahiers d'Art*, 1954, 2, 133–72.

42 As reported by A. Salmon, 'La Palette', *Paris–Journal*, 5 July 1911, 4.

43 As far as can be read from a poor reproduction, taken from that printed in *Le Fauconnier*, New York: J. B. Neumann, New Art Circle, 1948; the painting's present whereabouts are unknown. The subject, a forest scene with two reclining female nudes, hounds and a child, appears to restate the theme of Diana the huntress.

44 Apollinaire, the chief cultivator of Picasso's critical reputation, appears to have strongly encouraged the salon cubists to visit Kahnweiler's gallery around the time of the 1911 Indépendants; Vallier, 'La Vie fait l'oeuvre de Fernand Léger', 149. Allard wrote twice about the futurists in the summer of 1911: 'Sur Quelques Peintres' 62, and 'Les Beaux-Arts', 138–9. For a detailed assessment of the chronology of the salon cubists' encounter with gallery cubism, and in particular the paintings of Picasso and Braque, see Daniel Robbins, 'Jean Metzinger: At the Center of Cubism' in *Jean Metzinger in Retrospect*, exhibition catalogue, Iowa City: University of Iowa Museum of Art, 1985, 9–23.

45 Plans for the exhibition, eventually postponed to February 1912, were announced by Salmon in his 'La Palette' column in *Paris–Journal*, 5 October 1911.

46 That Allard, who was usually well-informed about the salon cubists, expected a follow-up to *L'Abondance* is evident from his salon review in *La Cote*, 30 September 1911, in which he expressed his disappointment that Le Fauconnier was showing only three landscapes; these were painted in Savoie during his transalpine summer holiday.

47 That Le Fauconnier in early 1912 still led his salon cubist colleagues in such pictorial innovation is indicated by the response of Salmon, never a fan, to *Le Chasseur* at the

Indépendants, in *Paris–Journal*, 25 March 1912, 5, of all the entries, he noted, it was 'the richest in new elements' ('le plus riche d'éléments neufs'), and the painter possessed 'an unrivalled authority . . . over his group' ('un incontestable autorité . . . sur ceux de sa groupe').

48 Gleizes, 'Les Beaux-Arts: A propos du Salon d'Automne', *Les Bandeaux d'or*, November 1911, 48, 'La matière semble considérablement gêner ce bel artiste: il pense plus qu'il ne peint'.

49 In the MOMA study (Fig. 8) a railway signal-post is prominent, although it is missing from the final picture.

50 See Ch. 6 below, pp. 158–65.

51 Several first- and second-hand accounts of the Puteaux meetings exist, chief among them G. Ribemont-Dessaignes, *Déjà Jadis*, Paris, Julliard, 1958, and P. Cabanne, *Entretiens avec Marcel Duchamp*, Paris, Belfond, 1967; in none of them is any mention made of Le Fauconnier. The reason for his absence from the Section d'Or exhibition is not clear, but since the Amsterdam retrospective (at the second Moderne Kunst Kring salon) coincided with this and was followed by another at the Folkwang Museum, Hagen, it seems likely that he opted for these as more advantageous for his career.

52 It was André de Ridder, author of a monograph on the artist (*Le Fauconnier*, Brussels: L'Art Libre, 1919, 14), who claimed that the *Montagnards* was the specific object of the protest launched both within and outside the Chamber against the use of the Grand Palais for exhibiting works by the cubists. Robbins, 'Le Fauconnier and Cubism', n.p., states that 'because it was frequently reproduced', the *Montagnards* 'enjoyed the success of scandal even to being included in a Gaumont newsfilm', but gives no source for this assertion.

53 No evidence exists of a visit by Le Fauconnier to Annecy in 1910; that of the summer of 1911 appears to have been his first.

54 See Robbins, 'Le Fauconnier and Cubism'.

55 *Ibid.*

56 Apart from Le Fauconnier's companion, the painter Maroussia Rabannikoff, who appears not to have participated in the cubist adventure, despite her inclusion in Room 41. Unlike – and yet also like – her compatriot the artist Sonia Terk (Delaunay), her artistic identity seems to

have been a casualty of her relationship with an ambitious male artist. No works by her survive. On Sonia's relationship with Robert Delaunay, see Ch. 7 below, p. 186.

57 Gleizes, *Souvenirs*, 9–10, 'Lignes et volumes, densités et poids, équilibres symétriques des parties entre elles, tels étaient nos soucis et nos aspirations.'

58 For a different symbolic reading see Robbins, *The Formation and Maturity of Albert Gleizes*, 32; he suggests a Bergsonian interpretation of the river in the background landscape, as symbolising time – a figure that Gleizes did indeed employ from 1912 (see below). In terms of its figure subject, composition and restricted space, however, *Femme aux phlox* recapitulates a straightforward family portrait of the previous year, *Portrait de R.G.* (Robert Gleizes, the painter's uncle).

59 Gleizes, *Souvenirs*, 23.

60 Metzinger had lived in Montmartre in 1910 and had met Picasso and Apollinaire, through his friend Max Jacob, in 1907: see (Metzinger, *Le Cubisme était né*, Paris: Présence, 1972, 41–4). His displacement of Le Fauconnier as leading salon cubist was recorded by Salmon: in May the latter was still 'le chef d'école' (La Palette, 'Courrier des Ateliers', *Paris–Journal*, 22 May 1911, 4), while by September the term was reserved for Metzinger ('Le Salon d'Automne', *Paris–Journal*, 30 September 1911, 5). Gleizes, 'L'Art et ses représentants: Jean Metzinger', appeared in *La Revue indépendante*, 4, September 1911, 161–72. See also Ch. 6 below, p. 156.

61 Gleizes, *Souvenirs*, 24–5.

62 P. Sorlin, *La Société française 1840–1914*, Paris: Arthaud, 112–13. See also J. Laux, *In First Gear: The French Automobile Industry to 1914*, Liverpool University Press, 1976; Y. Christ, *Les Métamorphoses de la banlieue parisienne*, Paris: Balland, 1969.

63 See Robbins, in *Albert Gleizes 1881–1953*, Paris: Musée National d'Art Moderne, 1964, 28.

64 Allard, reviewing the 1913 Salon d'Automne, *Les Écrits français*, November 1913.

65 The painting exhibited at the 1913 Salon d'Automne is no longer extant, and is known only through black-and-white photographs (see, for example, *Albert Gleizes 1881–1953*, exh. cat., Paris:

Musée National d'Art Moderne, 1964, Fig. 4). At 220 × 187 cm it was much larger than Fig. 27, which appears to be the final study for it, but in all other respects the two works seem almost identical. See A. Varichon, *Albert Gleizes: Catalogue raisonné*, 2 vols, Paris: Somogy, 1998.

66 See Ch. 1 above and R. Kuisel, *Capitalism and the State in Modern France: Renovation and Economic Management in the Twentieth Century*, Cambridge and London: Cambridge University Press, 1981, ch. 1. Gleizes' paintings have been read by Antliff, *Inventing Bergson: Cultural Politics and the Parisian Avant-Garde*, Princeton University Press, 1993, as celebrating the continuation of tradition by modernisation rather than as ambivalent towards their relation. He offers no evidence, however, for an attitude which would have run against the current both of the discourse of solidarist nationalism and of Gleizes' relation to this.

Chapter 5 Collage and Counter-Discourse: Aestheticism and the 'Popular'

1 Letter from Picasso in Paris to Braque in Sorgues, 9 October 1912, quoted in P. Daix, *Picasso: Life and Art*, trans. J. Cousins, London: Thames and Hudson, 1994, 127, 'Mon cher ami Braque, je emploie tes derniers procédés papieristiques et pusiereux. Je suis en train de imaginer une guitare et je emploie un peu de pusière contre notre horrible toile.' Picasso moved into his new studio in late September or early October; see J. Cousins and P. Daix, 'Documentary Chronology', in W. Rubin, *Picasso and Braque: Pioneering Cubism*, New York: Museum of Modern Art, 1989, 404. The declaration of war on Turkey by Montenegro, Serbia, Bulgaria and Greece on 15 October began the first Balkan War, which ended in May 1913; the second broke out weeks later and lasted until August 1913. Of 31 *papiers collés* that Picasso made in November and December 1912, at least 14 used fragments of reports on the Balkan War. See also P. Leighten, *Re-Ordering the Universe: Picasso and Anarchism, 1897–1914*, Princeton University Press, 1989, 128, who notes that of about 80 collages made in 1912 and 1913,

52 contain newspaper text; of these, about half deal with the Balkan Wars and related political issues: 'Most of the latter were produced in the autumn and winter of 1912, when their production virtually supplanted the activity of painting in Picasso's oeuvre'.

2 R. Rosenblum, 'Picasso and the Typography of Cubism', in J. Golding and R. Penrose (eds), *Picasso 1881–1973*, London: Elek, 1973, 75. The essay was based on a paper given at the College Art Association conference of 1965.

3 For a comprehensively synoptic example of the post-modernist approach, see K. Varnedoe and A. Gopnik, *High and Low* New York: Museum of Modern Art, 1990; for examples of the structuralist/post-structuralist, see the essays by Y.-A. Bois and R. Krauss in W. Rubin and L. Zelevansky (eds), *Picasso and Braque: A Symposium*, New York: Museum of Modern Art, 1992.

4 The exception is Leighten's *Re-Ordering the Universe*; see also her article 'Picasso's Collages and the Threat of War', *Art Bulletin*, 67, December 1985, 653–72.

5 C. Poggi, 'Mallarmé, Picasso and the Newspaper as Commodity', *Yale Journal of Criticism*, 1 no. 1, Fall 1987, 138, 142. A decade earlier R. Johnson, 'Picasso's Musical and Mallarméan Constructions', *Arts Magazine*, 51 no. 7, March 1977, 122–7, proposed a relation between the two, focusing in particular on Picasso's sculptural reliefs.

6 S. Mallarmé, 'Crise de vers', in *Oeuvres Complètes*, ed. H Mondor and G. Jean-Aubrey, Paris: Gallimard, 1945, 366, 'L'oeuvre pure implique la disparition élocutoire du poëte, qui cède l'initiative aux mots'.

7 Poggi, 'Mallarmé, Picasso and the Newspaper as Commodity', 142.

8 R. Krauss, 'The Motivation of the Sign', in Rubin and Zelevansky, *Picasso and Braque*, 281–2. Yve-Alain Bois, *ibid.*, 203, 'The Semiology of Cubism', concurs with Krauss: arguing that the ways in which Picasso and Braque used newspaper text spatially in their *papiers-collés* thereby 'de-instrumentalised' journalistic language, he suggests that this places them 'directly in the wake of Mallarmé' and that "the recourse to the newspaper is a Mallarméan (or formalist) answer to Mallarmé's disdain."

9 Poggi, *In Defiance of Painting: Cubism, Futurism and the Invention of Collage*, New Haven and London: Yale University Press, 1992, 162–3.

10 Poggi, *ibid.*, 129–41, does, however, offer a nuanced analysis of the *papiers-collés*' engagement with contemporary ideas of decoration and tastes in wallpaper.

11 Leighten, *Re-Ordering the Universe*, 125.

12 Leighten, 'Cubist Anachronisms: Ahistoricity, Cryptoformalism, and Business-as-Usual in New York', *Oxford Art Journal*, 17 no. 2, 1994, 99.

13 Leighten, *Re-Ordering the Universe*, 134.

14 J. Weiss, *The Popular Culture of Modern Art: Picasso, Duchamp and Avant-Gardism*, New Haven and London: Yale University Press, 1994, 5–15.

15 *Ibid.*, 36.

16 *Ibid.*, 20, 21.

17 *Ibid.*, 38.

18 N. Staller, 'Méliès "Fantastic" Cinema and the Origins of Cubism', *Art History*, 12 no. 2, June 1989, 202–32.

19 Krauss, 'The Motivation of the Sign', 278.

20 *Ibid.*, 274–6.

21 Leighten, 'Cubist Anachronisms', 95–6.

22 See chapters 3 and 4.

23 W. Uhde, 'Le Collectionneur', *Style en France*, 5 no. 2, January-March 1947, 61; A. Level, *Souvenirs d'un collectionneur*, Paris: Mazo, 1959, 71; R. Dutilleul, 'La Parole est aux collectionneurs', *Art présent*, numéro spéciale, 'L'Art et l'argent', 1948, 68–9.

24 See the well-known letter of 17 June 1912 to Kahnweiler in which Picasso wrote from Céret: 'You tell me that Uhde does not like my recent paintings where I use Ripolin and flags. Perhaps we shall succeed in disgusting everyone, and we haven't said everything yet'; quoted by J. Cousins and P. Daix, 'Documentary Chronology', in Rubin, *Picasso and Braque*, 395. In another letter of 20 June, Picasso wrote defiantly: 'I have just received the photographs and I'm very happy with them. They are beautiful and prove me right. The Ripolin enamel paintings, or Ripolin-like paintings, are the best ones', *ibid.*, 396.

25 F. Ridley, *Revolutionary Syndicalism in France*, Cambridge University Press, 1968, 60. See also Ch. 1 above.

26 See Ch. 1 above, pp. 35–6.

27 On Salmon's *patriotisme esthétique* see Ch. 3 above, p. 84. On Salmon and anarchist milieux, see Leighten, *Re-Ordering*

the *Universe*, 69–73 (though Leighten draws different conclusions from the biographical data here presented).

28 The financial affairs page for that day's *Journal* was p. 7, and the syphilis story was on p. 5.

29 P. Bourdieu, *Distinction: A Social Critique of the Judgement of Taste*, trans. R Nice, London: Routledge, 1986, 282.

30 Level, *Souvenirs d'un collectionneur*, 71, 'il sût découvrir dans les artistes méprisés par les grands marchands parisiens les meilleurs tenants de l'art jeune, indépendant et pourtant traditionnel des premières années du XXe siècle.'

31 R. Allard, 'Sur quelques peintres', *Les Marches du sud-ouest*, 2, June 1911, 60; A. Soffici, 'Picasso e Braque', *La Voce*, 3 no. 34, 24 August 1911, 637. Since both men kept up with gallery cubism, it can be assumed that the works to which they were referring in mid-1911 were those most recently hung on the walls of the rue Vignon gallery.

32 Rubin, Picasso and Braque, 54–5, is dubious about a first-hand acquaintance, arguing that 'Picasso's French, as it stood after five to ten years of his living continuously in Paris, makes it obvious that he could *not* have read' such authors as, for example, Bergson and Poincaré. 'It is even permitted to wonder just what is meant when we read that Picasso "was familiar" with Mallarmé's poetry.' He notes the testimony of Fernande Olivier and Gertrude Stein that Picasso read little; but he also cites that of 'Maurice Raynal, perhaps the least biased of our witnesses' that the many books at Picasso's studio [in the rue Ravignan, i.e. before 1909] included, besides detective and adventure novels, the work of Verlaine, Rimbaud and Mallarmé.

33 T Eagleton, *Criticism and Ideology*, London: Verso, 1976, 48.

34 Kahnweiler's logbook shows that from the beginning of 1909 his acquisitions from Braque and, especially, Picasso increased relative to those from other artists, and he began to buy earlier, protocubist paintings by Picasso that he had previously ignored. See also Ch. 2 no. 62 above.

35 S. Mallarmé, *Oeuvres Complètes*, ed. H. Mondor and G. Jean-Aubry, Paris: Gallimard, 1945, 382–7.

36 From Mallarmé's *Magie* of 1893, quoted by D.-H. Kahnweiler, 'Mallarmé et la peinture', *Les Lettres*, 3 no. 3, 1948, 67, 'Evoquer dans une ombre exprès l'objet tu, par des mots allusifs, jamais directs, se réduisant à du silence égal, comporte tentative proche de créer: vraisemblable dans la limite de l'idée uniquement mise en jeu par l'enchanteur de lettres jusqu'à ce que, certes, scintille quelque illusion au regard. Le vers, trait incantatoire!'

37 Rosalind Williams, *Dream Worlds: Mass Consumption in Late Nineteenth-Century France*, Berkeley and London: University of California Press, 1982, 65.

38 D. Pope, 'French Adevertising Men and the American "Promised Land"', *Historical Reflections*, 5, Summer 1978, 126.

39 The average annual receipts from Paris theatres and spectacles rose from FF31.6 million in 1890–1900, to nearly 59 million in 1911, and to 69 million in 1913; see A. Pinard, *La Consommation, le bien-être et le luxe*, Paris: O. Doin, 1918, 217–18; P. Bonnet, *La Commercialisation de la vie française*, Paris, 1929, 267.

40 Weiss, *The Popular Culture of Modern Art*, 5; see also C. Jouhaud, 'La "Belle Époque" et le cinéma', *Le Mouvement social*, 139, April-June 1987, 107–13; R. Doumic, 'L'Age du cinéma', *Revue des deux mondes*, 15 August 1913, 920; C. Rearick, *Pleasures of the Belle Epoque*, New Haven and London: Yale University Press, 1985, 193.

41 See, for instance, Doumic, 'L'Age du cinéma', 921–2; L. Haugmard, 'L' 'esthétique' du cinématographe', *Le Correspondant*, 215, 25 May 1913, 765; Jouhaud, 'La "Belle Époque" et le cinéma', 109–10; Staller, 'Méliés' "Fantastic" Cinema', 202; Rearick, *Pleasures of the Belle Epoque*, 113. The sociologist Maurice Halbwachs observed, *La Classe ouvrière et les niveaux de la vie*, Paris: 1913, that it was in leisure and consumption that working-class people felt most acutely their relative deprivation.

42 Rearick, *Pleasures of the Belle Epoque*, 190; Staller, 'Méliés' "Fantastic" Cinema', 203.

43 Staller, *ibid.*; Doumic, 'L'Age du cinéma', 919; L. Berlanstein, *The Working People of Paris, 1871–1914*, Baltimore and London: Johns Hopkins University Press, 1984, 127–30.

44 S. Hall, 'Notes on Deconstructing "The Popular"', in R. Samuel (ed.), *People's History and Socialist Theory*, London and

Boston: Routledge & Kegan Paul, 1981, 235.

45 *Ibid.*

46 See P. Sorlin, *La Société française 1840–1914*, Paris: Arthaud, 1969, and Berlanstein, *The Working People of Paris*.

47 M. Talmeyr, 'Café-concerts et music-halls', *La Revue des deux mondes*, 1 July 1902, 159–84, 'un agent de perdition et d'abrutissement populaires'; Haugmard, 'L' "esthétique" du cinématographe', 766 – whose very title telegraphs the author's condescension – 'Le "peuple" est encore un grand enfant à qui il faut, pour lui faire oublier ses misères, un album d'images à feuilleter'; Doumic, 'L'Age du cinéma', 930, 923, 'cinéma, qui est le théâtre pour illettrés'; de Gourmont, 'Revue de la quinzaine: Épilogues – cinématographe', *Mercure de France*, 1 September 1907, 124–7.

48 Staller, ' "Fantastic" Cinema', 207. On Raynal's cubist criticism, see Ch. 6 below, pp. 152–3.

49 *Ibid.*, 207–08; see Raynal in *Les Soirées de Paris*, 2 no. 19, 15 December 1913, 6; no. 21, 15 February 1914, 84.

50 Bourdieu, *Distinction*, 282–3.

51 See 'M. R.', 'Affaires du Jour', *Les Soirées de Paris*, 23, 15 April 1914, 189–91, and 'Chronique cinématographique', *Les Soirées de Paris*, 26–7, July–August 1914, 361–4; See also E. Carmean Jr, 'Juan Gris' "Fantomas" ', *Arts*, 51 no. 5, January 1977.

52 For the former of these two suggestions see, e.g., Rubin, *Picasso and Braque*, 19–20; Varnedoe and Gopnik, *High and Low*, 33–4; for the latter, see Poggi, *In Defiance of Painting*, 153.

53 See Gopnik and Varnedoe, *High and Low*, 32–3.

54 See Poggi, *In Defiance of Painting*, 137, and Leighten, 'Cubist Anachronisms', 102 n. 77. On developments in the wallpaper industry see Pinard, *La Consommation*, 93.

55 M. Bakhtin, *The Dialogic Imagination*, ed. M Holquist, Austin: University of Texas Press, 1981, 271–2.

56 J. Clarke, 'Style', in S. Hall and T. Jefferson (eds), *Resistance Through Rituals: Youth Subcultures in Post-War Britain*, London: Hutchinson, 1976, 177–8 (italics in original).

57 On Picasso's acquaintance with Mallarmé's poetry before 1909, see n. 32

above. On his awareness of 'Un Coup de dés' in particular (first published in 1897 in *Cosmopolis*, an English literary magazine, and not again until 1914), see Rosenblum, 'Picasso and the Typography of Cubism', 35–6 (who was the first to suggest the connection), Varnedoe and Gopnik, *High and Low*, 37–8 (who are sceptical of it); and (agreeing with Rosenblum) Krauss, 'The Motivation of the Sign', 286 n. 53. Given that the degree of Picasso's suggested engagement with the poem required little more than his acquaintance with its title, and that this had some currency in his milieu via Apollinaire, the inference of an intended pun seems reasonable to me.

58 Scholars have suggested numerous private referents for the headline 'La Bataille s'est engagé[e]', including Picasso's rivalries with Braque, Matisse, and the cubists then exhibiting at the Salon de la Section d'Or. For a reprise of these see Rubin and Zelevansky, *Picasso and Braque*, 153, 161–3.

59 P. Daix and J. Rosselet, *Picasso: the Cubist Years 1907–1916*, London: Thames and Hudson, 1979, 128.

60 Mallarmé, 'Crise de vers', *Oeuvres Complètes*, 366, 'par le heurt de leur inégalité mobilisés; ils s'allument de reflets réciproques comme une virtuelle traînée de feu sur des pierreries.'

61 L. Steinberg, 'The Philosophical Brothel', *Art News*, 71 no. 5, September 1972, 20–29 (Part I); 71 no. 6, October 1972, 38–47 (Part II); C. Duncan, 'Virility and Domination in Early Twentieth Century Vanguard Painting', *Artforum*, December 1973, 30–39, rev. in her *Aesthetics of Power*, Cambridge University Press, 1993, 81–108. See also A. Chave, 'New Encounters with *Les Demoiselles d'Avignon*: Gender, Race, and the Origins of Cubism', *Art Bulletin*, 76 no. 4, December 1994, 596–611; M. Rebérioux, 'Ces Demoiselles', *Cahiers crlh-ciraoi*, 5, 1988, 443–55.

62 See Ch. 2 above, n. 58.

Chapter 6 Between Theory and Practice: The Meanings of Cubism

1 It seems to have been published in November of that year, although publication had been announced as early as March and again in October; see the

Revue d'Europe et d'Amérique, 1 March 1912, 383, and *Paris–Journal*, 26 October 1912, 4. An excerpt from it appeared in *Poème et drame*, no. 1, November 1912, 63–9, and it was reviewed by Arsène Alexandre in *Comoedia*, 30 November 1912, 3.

2 A fact which contemporary critics recognised. Léon-Paul Fargue, writing in *La Nouvelle Revue Française* in December 1912, saw the cubists as 'victims of pictorial and literary theory' and argued that 'it would be easy to explain Cubism and Futurism with ten philosophical or scientific systems . . . But then we are no longer speaking of painting'. As J. Weiss, *The Popular Culture of Modern Art: Picasso, Duchamp and Avant-Gardism*, New Haven and London: Yale University Press, 1994, 75, quoting this, observes, 'In many cases, the conclusion was that cubist *painting* seemed strangely beside the point, for painting had been replaced with philosophy.'

3 Gustave Hervé was the editor of the antimilitarist and pro-syndicalist newspaper *La Guerre sociale*; see Ch. 1 above, p. 28.

4 G. Mourey, *Le Journal*, 30 September 1911, 2, 'Les cubistes jouent en effet dans l'art actuel un rôle analogue à celui que tiennent avec tant d'éclat, dans l'ordre politique et social, les apôtres de l'antimilitarisme et du sabotage organisé; et, de même qu'il est évident que les prédications d'un Hervé ont aidé puissamment à la renaissance du sentiment patriotique à laquelle nous assistons, on ne saurait contester que les excès où se sont portés les anarchistes et les saboteurs de la peinture française n'aient contribué à raviver chez les artistes et les amateurs dignes de ce nom le goût de l'art véritable et de la véritable beauté.' A regular contributor to *Le Journal*'s reviews pages, Mourey was also president of the Société Nouvelle, one of the most select of the satellite groupings, or *salonnets*, that orbited the 'official' salons.

5 See also e.g. Eugène Tardieu in the Catholic daily *Echo de Paris*, 21 April 1911, 2; Le Bonhomme de Chrysale, 'Notes de la semaine: Le Fumisme', *Les Annales politiques et littéraires*, no. 1529, 13 October 1912, 1.

6 On the economic and social reasons for this development see M. Ward, 'From Art Criticism to Art News: Journalistic Reviewing in Late Nineteenth-Century Paris', in M. Orwicz (ed.), *Art Criticism and its Institutions in 19th Century France*, Manchester University Press, 1994, 162–81.

7 Weiss, *The Popular Culture of Modern Art*, has surveyed the responses of journalist critics to the early 20th-century Parisian avant-garde in general and cubism in particular; his account of this climate of reception is now indispensable and I am indebted to it, although I take sole responsibility for the argument presented here.

8 See Weiss, *The Popular Culture of Modern Art*, 52–9.

9 Janneau, *Gil Blas*, 20 April 1911, 3; Claude, *Le Petit Parisien*, 23 April 1911, 5; Tardieu, *Echo de Paris*, 21 April 1911, 2, 'le snobisme gobeur qui fait des succès aux plus stupides contresens de l'art de peindre offerts à la badauderie comme des hardiesses géniales'.

10 H. Guilbeaux, 'Paul Signac et les Indépendants', *Les Hommes du jour*, 170, 22 April 1911, n.p., 'des résultats grotesques, ridicules, faits semble-t-il pour épater le bourgeois . . . dont les cubes, les cônes, les pyramides s'étagent, s'écroulent et . . . font rigoler.'

11 L. Vauxcelles, letter of 1910 to the editor of *Excelsior*, in Fonds Vauxcelles, Bibliothèque Jacques Doucet (Art et Archéologie), Paris, 'tous les artistes de Paris, peintres, sculpteurs, graveurs, ornémanistes, potiers'; 'en qui tous les artistes de Paris aient confiance, non seulement pour son clairvoyance mais pour son intégrité.'

12 Vauxcelles, *Gil Blas*, 30 September 1909, 1.

13 Vauxcelles, *Gil Blas*, 30 September 1911, 1, 'Mais vraiment, que d'honneur nous faisons à ces bipèdes du parallélépipède, à leurs élucubrations, cubes, succubes et incubes!'

14 On Vauxcelles, fauvism and the *paysage décoratif* see R. Benjamin's essays 'Fauves in the Landscape of Criticism' in J. Freeman (ed.), *The Fauve Landscape*, London: Guild Publishing, 1990, 241–67, and 'The Decorative Landscape, Fauvism, and the Arabesque of Observation', *Art Bulletin*, 75 no. 2, June 1993.

15 Vauxcelles, *Gil Blas*, 20 March 1907, 'un schématisme vacillant, proscrivant, au nom de je ne sais quelle abstraction picturale, modelés et volumes.'

16 'Les froides extravagances de quelques mystificateurs . . . Nous prennent-ils pour

17 'Géomètres ignares . . . [qui] réduisent le corps humain, le site, à des cubes blafards', *ibid.*, 18 March 1910, 1.

16 des dupes? Se sont-ils suggestionnés eux-mêmes d'abord? Mystère qu'il importe peu d'éclairer. Que M. Metzinger galope à la suite de Picasso, ou de Derain ou de Bracke [*sic*] . . . que M. Herbin salisse brutalement une toile blanche – tout cela porte à faux. Nous ne marchons pas', *ibid.*, 25 March 1909.

17 'Géomètres ignares . . . [qui] réduisent le corps humain, le site, à des cubes blafards', *ibid.*, 18 March 1910, 1.

18 A. Alexandre, 'L'Age décoratif', *Comoedia*, 14 October 1911, 3, 'On ne se souci pas d'autre chose que du décor, de l'ornementation, de l'atmosphère colorée, ou plutôt coloriée, de la vie courante, de la vie superficielle, électrique, matérialiste, tourbillonnante, torrentueuse, trépidante d'impatience, avide de secousses, incapable de receuillement, impropre à la contemplation, hostile à la pensée, qui est ce que nous croyons être notre vie.'

19 'Les peintres sont ignorants de leur propre métier; vous ne voudriez pas qu'ils s'amusent à être des naturalistes comme Pisanello ou Poussin, des mathématiciens comme Léonard?', *ibid.*

20 'Longuement pensées, lentement élaborées, témoignant d'une volonté de perfection semblable à celle qui anime les maîtres de jadis', *ibid.*

21 Alexandre, *Le Figaro*, 30 September 1911, 4, 'qui nous apportent qu'une simple folie sans principe sérieux et sans portée . . . pour l'amusement des badauds, dans les résidues d'écoles'.

22 Vauxcelles, *Gil Blas*, 19 March 1912, 1; G. Lecomte in *Le Matin*, 30 September 1912, 4; Thiébault-Sisson in *Le Temps*, 1 October 1912, 4. For Breton's protest in the Chambre des Députés, see above, p. 1.

23 The claims were those of Vauxcelles and Lecomte, *ibid.*

24 Vauxcelles, *ibid.*, 'Nous avons subi l'assaut du cubisme barbare, la vachalcade de futurisme épileptique. De quoi demain sera-t-il fait, je l'ignore . . . On ne sait plus exactement où l'on est.'

25 *Ibid.*

26 These included the Brussels Indépendants in June 1911, Room 8 at the Salon d'Automne, the exhibition of the Société Normande de Peinture Moderne in November, and the second Knave of Diamonds exhibition in Moscow in January 1912, to name but a few.

27 For Allard's writings see Chs 3 and 4 above. For Apollinaire's art criticism see his *Chroniques d'art 1902–1918*, ed. L.-C. Breunig, Paris: Gallimard, 1960, and – with some differences in the selection of texts – its English translation, *Apollinaire on Art: Essays on Art: Essays and Reviews 1902–1918*, edited by L.-C. Breunig, New York: Viking, and London: Thames and Hudson, 1972.

28 A. Gleizes, *Souvenirs: Le Cubisme 1908–1914*, Paris: Cahiers Albert Gleizes, 1957, 15.

29 Both saw themselves as instrumental in cubism's emergence and development; see Allard, 'Les Beaux-Arts', *La Revue indépendante*, August 1911, 129, and Apollinaire in *L'Intransigeant*, 10 October 1911, in *Chroniques d'art*, 254. Salmon and Mercereau also played a significant, but less ambitious, role in the dissemination and consolidation of cubism, the former in his gossip column for *Paris-Journal*, the latter in his tireless networking across the European avant-gardes.

30 R. Allard, 'Sur Quelques Peintres', *Les Marches du sud-ouest*, June 1911, 58–60.

31 'La violente personnalité de l'un est résolument extérieure à la tradition française et les peintres dont je me préoccupe ici l'ont instinctivement senti', *ibid.*, 58.

32 See e.g. Apollinaire, 'Les Jeunes: Picasso, peintre', *La Plume*, 15 May 1905, in *Chroniques d'art*, 35–9, and 'Les Trois Vertus plastiques', *Catalogue du IIIe Exposition du 'Cercle de l'art moderne' à l'Hotel de Ville du Havre*, June 1908, in *ibid.*, 71–4.

33 G. Apollinaire, preface to *Catalogue de l'Exposition Braque*, Paris: Galerie Kahnweiler, 1908, in *Chroniques d'art*, 76, 'Il ya place maintenant pour un art plus noble, plus mesuré, mieux ordonné, plus cultivé'. In 1910, in 'Exposition Bonnard', *L'Intransigeant*, 10 March 1910, *ibid.*, 88, he wrote with an obvious if not explicit reference to Picasso, 'my taste leans toward more ambitious painters, toward painters who are straining toward the sublime in plasticity and whom even the fear of stumbling does not prevent from reaching for such an elevated art' ('mes préférences vont à des peintres plus ambitieux, qui s'efforcent vers le sublime de la plastique, qui, en faveur d'un art si élevé, ne redoutent pas le trébuchement').

34 'Le Salon d'Automne', *Poésie*, Autumn 1910, *ibid.*, 159.

35 *L'Intransigeant*, 21 April 1911, *ibid.*, 210. On Apollinaire's reputation within avant-garde milieux, see the recollection of Gabrielle Buffet-Picabia, *Rencontres*, Paris: Belfond, 1977, 57, who met him in mid-1912, by which time he had become 'the most sociable, the best-known, the most ubiquitous man of his time. He frequented all the *bohèmes*, all the artists of Paris, from the Place Ravignan to the boulevard Montparnasse, with several stops in the "beaux quartiers"' ...'l'homme le plus sociable, le plus connu, le plus repandu de son temps. Il fréquentait toutes les bohèmes, tous les artistes de Paris, de la Place Ravignan au boulevard Montparnasse, avec quelques haltes dans les "beaux quartiers" ...'

36 Apollinaire, 'ce mal moderne qui fait prendre comme but unique de l'art l'expression de la vie contemporaine', *L'Intransigeant*, 7 June 1910, *Chroniques d'art*, 142; *Catalogue de VIIIᵉ Salon annuel du Cercle d'art 'Les Indépendants' au Musée moderne de Bruxelles*, June–July 1911, *ibid.*, 242.

37 'Reality can never be discovered once and for all. Truth will always be new. Otherwise it is properly speaking only a natural system, and one more miserable than nature' ('Mais on ne découvrira jamais la réalité une fois pour toutes. La vérité sera toujours nouvelle. Autrement, elle n'est proprement qu'un système naturel et plus misérable que la nature'), 'Les Trois Vertus plastiques', *ibid.*, 74.

38 On Apollinaire's poetry in this respect, see F. Carmody, *The Evolution of Apollinaire's Poetics 1909–14*, Berkeley: University of California Press, 1963; L. Breunig, The Chronology of Apollinaire's 'Alcools', *Publications of the Modern Languages Association*, December 1952, 907–22; M. Martin, 'Futurism, Unanimism and Apollinaire', *Art Journal*, Spring 1969, 258–68. Robert Delaunay, *Du Cubisme à l'art abstrait*, (ed. P. Francastel), Paris: S.E.V.P.E.N., 1957, 172, later remarked of his avant-garde activities: 'the reason that Apollinaire brought all tendencies together was understood at the time; he wanted the experiments and questionings of artists to join in a common front in the face of the incomprehension of the public and art lovers' ('La raison d'Apollinaire de rass-embler toutes les tendances était connue à l'époque, il voulait que les inquiétudes et les recherches des artistes fassent une masse, un front unique devant l'incompréhension du public et des amateurs de l'époque').

39 Apollinaire, 'le peintre doit avant tout se donner le spectacle de sa propre divinité et les tableaux qu'il offre à l'admiration des hommes leur conféreront la gloire d'exercer aussi et momentanément leur propre divinité', 'Les Trois Vertus plastiques', *Chroniques d'art*, 72–3.

40 Including chiefly Salmon and Mercereau, but also Joseph Granié, Léon Rosenthal and Michel Puy; see n. 29 above. Apollinaire, "Le Salon d'Automne avant le premier vernissage', *L'Intransigeant*, 10 October 1911, quoted in *Chroniques d'art*, 254, 'je me vois presque seul parmi les écrivains d'art à défendre des artistes dont je connais les efforts et dont j'aime les ouvrages.'

41 The futurists' planned exhibition had been trailed in the art press for some weeks before its eventual postponement. The cubists' gallery debut was at the exhibition of the Société Normande de Peinture Moderne. This, which came into Vauxcelles's category of 'salonnet', was held at the Galerie d'Art Ancien et d'Art Contemporain in the rue Tronchet, 20 November–16 December 1911, and comprised 83 works by 26 artists, including all of the salon cubists of Room 41 except Delaunay.

42 O. Hourcade, 'La Tendance de la peinture contemporaine', *La Revue de France et des pays français*, no. 1, February 1912, 35–41. By contrast, Allard's Bergsonian interpretation drew upon a discourse that was current in his milieu, and did not mention the philosopher by name. Olivier-Hourcade's article was originally given as a talk in late November or early December 1911 at the Société Normande exhibition.

43 As Paul Crowther has demonstrated, in 'Cubism, Kant and Ideology', *Word and Image*, 3 no. 2, April–June 1987, 195–201.

44 Hourcade, 'La Tendance de la peinture contemporaine', 36, 'Schopenhauer enseignait: 'la foule est faite pour obéir aux lois et non pour les dicter'. Il appartient à chaque artiste de dicter les lois d'esthétique par ses oeuvres'.

45 *Ibid.*, 41. Hourcade had founded *Les Marches du sud-ouest* in 1911, and published Allard's 'Sur Quelques Peintres'; he

remained as editor when it became *La Revue de France et des pays français* and acquired an explicitly regionalist programme; see E. Fry, *Cubism*, New York: McGraw-Hill, 1966, 75. While political regionalism was part of the platform of the anti-republican right (and Maurras's roots were in the Félibrige movement which asserted Provençal cultural autonomy), in the years immediately before 1914 cultural regionalism had a constituency among nationalists of whatever colour, from Barrès to Briand; see A.-M. Thiesse, *Ecrire la France: Le Mouvement littéraire régionaliste de la langue française entre la Belle Epoque et la Libération*, Paris: Presses Universitaires de France, 1991.

46 J. Riviére, 'Sur les tendances actuelles de la peinture', *La Revue d'Europe et d'Amérique*, 1 March 1912, 385,' de rendre aux cubistes un peu plus de liberté et d'aplomb, en leur fournissant les raisons profondes de ce qu'ils font. Il est vrai que ce ne pourra pas être sans leur montrer combien jusqu'ici ils l'ont fait mal.' Rivière was also articulating this aesthetic elsewhere at that time, as in 'Poussin et la peinture contemporaine', *L'Art décoratif*, 5 March 1912, 14 no. 167, 133–48.

47 'Sur les tendances actuelles', 393.

48 For a more extensive analysis see my article, 'Cubism, Law and Order: The Criticism of Jacques Rivière', *Burlington Magazine*, December 1984, 744–50.

49 M. Raynal, preface to *Salon de juin: Troisième exposition de la Société normande de peinture moderne*, Rouen, 15 June–15 July 1912, 9–11, reprinted in translation in Fry, *Cubism*, 91–3.

50 Raynal, 'Conception et vision', *Gil Blas*, 29 August 1912.

51 Apollinaire, 'La Peinture nouvelle', in *Apollinaire on Art*, 222–5; the essay was published in two instalments in the April and May issues of *Les Soirées de Paris*, not included in *Chroniques d'art*.

52 Apollinaire, 'De Michel-Ange à Picasso', *Les Marches de Provence*, February 1912, in *Chroniques d'art*, 270; the essay was 'Du Sujet dans la peinture moderne', published in *Les Soirées de Paris*, 1, February 1912, reprinted in *Apollinaire on Art*, 197–8. On comparisons with the futurists, see his reviews of their Bernheim-Jeune exhibition in *L'Intransigeant*, 7 February, and *Le Petit Bleu*, 9 February 1912, in *Chroniques d'art*, 271–9.

53 Apollinaire, 'Vingt lettres de Guillaume Apollinaire à Ardengo Soffici', *Le Flâneur des deux rives*, 4, December 1954, 2, 'Don't you agree that for a new artistic conception to impose itself it may be necessary for mediocre things as well as sublime ones to appear? In this way one can measure the reach of the new beauty. It's for that reason, and on behalf of great artists such as Picasso, that I support Braque and the cubists in my writings'. ('ne croyez-vous pas que pour qu'une conception artistique nouvelle puisse s'imposer, il soit nécessaire aux choses médiocres de paraître en même temps que les sublimes? De cette façon, ont [sic] peut mesurer l'étendue de la nouvelle beauté. C'est pour cela et en faveur des grands artistes comme Picasso, par exemple que je soutienne Braque et les cubistes dans mes écrits').

54 'We defend [cubism's] good purpose', wrote Allard, 'Der Kennseichen der Erneuerung in der Malerei', *Der Blaue Reiter*, Munich, May 1912, 35–54, trans. as 'Signs of Renewal in Painting', in *The Blaue Reiter Almanac*, ed. K. Lankheit, London: Thames and Hudson, 1974, 105, 'against all romantic points of view which deny the sleeper any chance to think and speculate, and in which he is regarded as an inspired dreamer'. For Apollinaire's analytic language see esp. 'La Peinture nouvelle'.

55 On the founding of *Les Soirées de Paris*, see A. Billy, *Le Pont des Saints-Pères*, Paris: Fayard, 1947, 93–6.

56 Allard, 'Signs of Renewal in Painting', 109.

57 Gleizes, *Souvenirs*, 19, 'personne n'aurait pu penser qu'il y eût là objet à scandale. Et nous les premiers qui n'en aurions jamais voulu. A cette époque on avait encore la pudeur de ses actes et le fait d'exposer des peintures, conçues dans un esprit quelque peu différent de celui de l'entourage, n'entraînait nullement l'intention d'ameuter les foules. Aussi, notre surprise fut grande quand, le jour du vernissage, l'explosion se produisit.'

58 H. Le Fauconnier, 'L'Oeuvre d'art', published as 'Das Kunstwerk', in *Neue Kunstlervereinigung, Munchen E. V., II Ausstellung*, Munich: Moderne Galerie, 1910, 'Une oeuvre d'art numérique doit présenter des caractères numériques au titre constructif qui sont l'Ordonnance et l'Expression en général. Dans l'ordonnance le nombre est simple ou

composé. Simple lorsqu'un ensemble de quantités numériques correspond aux mesures des distances planes ou figurées qui existent entre une suite de points... Composé quand il existe un ensemble de surfaces primordiales qui sont à la base de la construction et quand il existe un ensemble de poids qui sont la résultante des différents effets de directions formées par les surfaces primordiales...'. The original French text, only recently rediscovered, was published in *Henri Le Fauconnier: Kubisma en Expressionisme in Europa*, Haarlem: Frans Halsmuseum, 1993. I am indebted for this information to Arnold Ligthardt, who is presently completing a PhD thesis on Le Fauconnier for the University of Amsterdam.

59 Weill is amusing on Metzinger's rapid changes of style, in *Pan! Dans L'Oeil! Ou, Trente ans dans les coulisses de la peinture contemporaine 1900-1930*, Paris: Lipschutz, 1933, 138-9; see also G. Burgess, 'The Wild Men of Paris', *Architectural Record*, May 1910, 399-414.

60 J. Metzinger, *Le Cubisme était né*, Paris: Présence, 1972, 41-4.

61 A. Salmon, *Paris-Journal*, 3 October 1910, 4-5, later wrote of Metzinger's poetry as 'mallarméen', and noted the influence of 'Max Jacob, painter and professor of the Kabbala, by whom Jean Metzinger was initiated into the Great Mysteries' ('Max Jacob, peintre et professeur de kabbale, par qui Jean Metzinger fut initié aux Grands Mystères').

62 See Metzinger, 'Le Dément', *Pan*, July-August 1909, 33-4, and 'La Féerie', *L'Ile Sonnante*, April 1910; see also *Le Cubisme était né*, 60.

63 'Note sur la peinture', *Pan*, November 1910, 649, 652, 'hautement éclairés, ils ne croient à la stabilité d'aucun système'; 'si nous abandonnons le monde antique aux archéologues... il ne suit pas de là, je le répète, que nous prétendions biffer la Tradition. Elle est en nous, acquise à notre inconscient, nous n'avons pas à nous en occuper.'

64 As well as the portrait of Apollinaire, Metzinger showed three landscapes and a *Nu* which Apollinaire himself described as 'solidly constructed', *L'Intransigeant*, 18 March 1910, in *Chroniques d'art*, 96. None are now extant.

65 Metzinger received the lion's share of the critical attention bestowed on the group.

Warnod, *Comoedia*, 11 October 1910, 2, reported a conversation in which the painter explained the metaphysical basis of his art, while Salmon, *Paris-Journal*, 30 September 1910, 5, noted that in the absence of Braque, who was no longer exhibiting in the salons, Metzinger was 'the only one here defending cubism, with a nude and a landscape'; the nude in particular 'merits a special mention'. ('le seul ici à défendre le cubisme avec un *Nu* et un *Paysage*'; 'mérite une mention spéciale'). Apollinaire, however, *Poésie*, Autumn 1910, in *Chroniques d'art*, 159, saw clearly what the artist was up to and was scornful of it, dismissing Metzinger's works as insipid imitations of Picasso, 'a jay in peacock's plumage' ('le géai paré des plumes du paon'). It has generally been assumed that Gleizes and Le Fauconnier were included in this condemnation, but from his review of the latter's work (*L'Intransigeant*, 1 October, in *ibid.*, 155-6) it is clear that his scorn was directed at Metzinger alone.

66 Metzinger, '"Cubisme" et tradition', *Paris-Journal*, 16 August 1911, 5, 'Ils se sont permis de tourner autour de l'objet pour en donner, sous le contrôle de l'intelligence, une représentation concrète faite de plusieurs aspects successifs. Le tableau possédait l'espace, voilà qu'il règne aussi dans la durée.'

67 'Ignore-t-on que l'artiste a pour mission essentielle d'empreindre dans l'esprits d'autrui ses propres conceptions?' 'La gloire des maîtres est, précisément, d'avoir empreint dans les esprits des prototypes si parfaits que nous pouvons dire, après des siècles, beau ce qui s'en approche, laid ce qui s'en éloigne. Ceux qui l'on nomme les cubistes tâchent à imiter les maîtres, s'efforçant à façonner des types nouveaux', *ibid*.

68 A. Gleizes, 'L'Art et ses représentants: Jean Metzinger', *La Revue indépendante*, 4, September 1911, 161-72; 'Les Beaux-Arts: A propos du Salon d'Automne', *Les Bandeaux d'Or*, November 1911, 42-51; A. Arnyvelde, 'Contribution à l'Histoire du Cubisme', *Gil Blas*, 2 January 1912, 3.

69 Gleizes, 'L'Art et ses représentants', 171, 'la tradition française, dont la grandeur, la clarté, l'équilibre et l'intelligence sont les piliers'; 'Les Beaux-Arts', 45, 'le chatoiement des gris colorés, essentiellement français'.

70 'L'Art et ses représentants', 164, 'les indi-
 cations très précieuses de Picasso et de
 Braque ne sortaient pas, malgré tout, d'un
 impressionnisme de la forme'. Gleizes' first
 encounter with the 1910–11 paintings
 of Picasso and Braque to which this
 description corresponds was probably in
 the late spring of 1911, at the instigation
 of Apollinaire; see Cottington, *Cubism
 and the Politics of Culture*, Ch. 6, for
 details.

71 'L'Art et ses représentants', 162–4; 'Les
 Beaux-Arts', 46. On Gleizes' earlier
 activities, see Ch. 1 above, p. 29.

72 The title Les Fauves, distinctly inappropri-
 ate as it now seems, indicates perhaps the
 fluidity of its meaning in that decade, and
 thus should remind historians of the dan-
 gers of assuming the present understanding
 of such avant-garde groupings to have
 been already determinate and final at the
 time of their emergence.

73 Salmon, 'Courrier des Ateliers', *Paris-
 Journal*, 7, 14, 18 September and 4, 17
 October 1911. Metzinger was to be editor-
 in-chief, Gleizes and Le Fauconnier his col-
 laborators; Salmon mentions Nayral and
 Mercereau as other possible contributors.

74 M. Duchamp, 'Le groupe très varié qui
 passait les dimanches après-midi à Puteaux
 était loin d'être homogène sauf dans le
 domaine de l'amitié', quoted by M. Le Bot,
 *Francis Picabia et la crise des valeurs
 figuratifs*, Paris: Klincksieck, 1968, 51. G.
 Ribemont-Dessaignes, *Déjà jadis*, Paris:
 Juillard, 1958, 3, 'des discussions
 passionnés dont il semblait que dût
 dépendre le sort de l'esprit humain'. For a
 further account of the Puteaux meetings
 see, among others, P. Cabanne, *Entretiens
 avec Marcel Duchamp*, Paris: Belfond,
 Ch. 2.

75 A. Gleizes and J. Metzinger, *Du Cubisme*,
 Paris: Figuière, 1912, parts I and IV; in
 English, R. Herbert (ed. and trans.), *Mod-
 ern Artists on Art*, New York: Prentice-
 Hall, 1964, 2–5, 15–16 (henceforth,
 Herbert).

76 *Du Cubisme*, parts II, V; Herbert, 6, 18.

77 See J. Nash, 'The Nature of Cubism: A
 Study of Conflicting Explanations', *Art
 History*, 3 no. 4, December 1980, 435–47.

78 *Du Cubisme*, part IV; Herbert, 14–15.

79 'Geometry is a science, painting is an
 art. The geometer measures, the painter
 savours . . . We seek the essential, but we
 seek it in our personality, and not in a sort

of eternity, laboriously fitted out by
mathematicians and philosophers', *ibid.*,
13.

80 *Ibid.*, 14, 15.

81 *Ibid.*, 15.

82 Nash, 'The Nature of Cubism', 438–43;
 Herbert, 16–17.

83 Herbert, 16.

84 *Ibid.*, 18.

85 *Ibid.*

86 Ribemont-Dessaignes, *Déjà Jadis*, 30, 'une
 sorte de législation du mouvement cubiste,
 afin de le hausser au rang de moyen
 d'expression honorable, de l'intégrer dans
 l'art considéré comme Unité Eternelle et
 Universelle'.

87 See Nash, 'The Nature of Cubism', 441.

88 The device of multiple perspective that *Du
 Cubisme* justifies and that Gleizes first
 adopted in his paintings of summer 1911
 was one that he himself later attributed
 to Metzinger: See M. Antliff, *Inventing
 Bergson: Cultural Politics and the
 Parisian Avant-Garde*, Princeton Univer-
 sity Press, 1993, 40, 194, who cites
 Gleizes, *Souvenirs*, 24.

89 Herbert, 15, 12.

90 *Ibid.*, 11; see V. Spate, *Orphism: The Evo-
 lution of Non-Figurative Painting in Paris
 1910–1914*, Oxford University Press,
 1979, 62–7, 70–74.

91 Herbert, 7; Apollinaire, 'Du Sujet dans la
 peinture moderne'.

92 Quoted by A. Tudesq, 'Du Cubisme et de
 ses détracteurs: Une Querelle autour de
 quelques toiles', *Paris-Midi*, 4 October
 1912, 1.

93 Quoted by Henriquez-Phillipe, 'Le
 Cubisme devant les artistes', *Les Annales
 politiques et littéraires*, 1536, 1 December
 1912, 475, 'la suite naturelle de l'oeuvre
 de ces libérateurs qui nous ramène au
 véritable sens de la tradition française et
 qui s'oppose violémment à la détestable
 influence italienne, triste héritage de la
 Renaissance du seizième siècle, cet attentat
 à notre génie national'; '[les] maîtres
 italiens qui ne sont pas de notre patrimoine
 et dont le génie créateur est inférieur'.

94 Gleizes, 'Le Cubisme et la Tradition',
 Montjoie!, 10 February 1913, 4; 25
 February 1913, 2–3.

95 Although the Delaunays' attendance is not
 mentioned in accounts of the meetings,
 their interest at that time in many of the
 ideas discussed suggests it. Robert's break
 with cubism was implied privately in a

letter to Kandinsky of April 1912, R. Delaunay, *Du Cubisme à l'art abstrait*, ed. P. Francastel, Paris: S.E.V.P.E.N., 1957, 178, and publicly in a letter to *Gil Blas*, 25 October 1912.

96 On plans for the exhibition see G. Buffet-Picabia, *Rencontres*, 67; M. Le Bot, *Francis Picabia*, 52; N. Beaudoin, 'Les Temps Héroïques: à propos du Salon de la Section d'Or', *Masques et visages*, 39, June 1956, 6–7.

97 M. Raynal, 'L'Exposition de la Section d'Or', *La Section d'Or*, 1, 9 October 1912, 2. See also Hourcade's review in *Paris-Journal*, 15 October 1912, 2.

98 Spate, *Orphism*, 27. Mercereau's 1912 pamphlet *La Littérature et les idées nouvelles*, Paris: Figuière, showed a remarkable acquaintance with occultist writings.

99 See L. D. Henderson, *The Fourth Dimension and Non-Euclidean Geometry in Modern Art*, Princeton, 1983. Ribemont-Dessaignes, *Déjà Jadis*, 36–7, noted that 'the golden number so dear to Metzinger . . . seems to have rested on a certain confusion' ('Le nombre d'Or, cher à Metzinger . . . semble avoir reposé sur une certaine confusion'). See also Duchamp's comments in 'Eleven Europeans in America', *Museum of Modern Art Bulletin*, 13 nos 4–5, 1946, 21, and Cabanne, *Dialogues with Marcel Duchamp*, 23–4.

100 G. Apollinaire, 'Jeune Peintres ne vous frappez pas!', *La Section d'Or*, 1, 9 October 1912, 1. (Apparently intended as a periodical, this was however the sole issue.) Much has been speculated as to the origin of the Salon's title: the most judicious and meticulous account is M. Neveux and H. Huntley, *Le Nombre d'Or, Radiographie d'un Mythe, suivi de La Divine Proportion*, Paris: Seuil, 1995. Neveux notes that although Villon in 1957 cited Leonardo as their reference for the golden section it is not this ratio but the related ratio of the root two rectangle which is there discussed; she argues that the likeliest source for ideas about the golden section was Desiderius of Lenz's treatise which, translated by Sérusier as the *Esthétique de Beuron* in 1905, had some currency in the neosymbolist milieus overlapped by Puteaux. See also R. Herz-Fischler, 'Le Nombre d'or en France de 1896 à 1927', *Revue de l'Art*, no. 118, 1997(4), 9–16.

101 See Beaudin, 'Les Temps Héroïques', 6.

102 Apollinaire, 'Le Cubisme', *L'Intermédiaire des chercheurs et des curieux*, 10 October 1912, in *Apollinaire on Art*, 256–8; 'Art et curiosité/Les Commencements du cubisme', *Le Temps*, 14 October 1912, in *Chroniques d'art*, 340–43.

103 M. Raynal, 'L'Exposition de "La Section d'Or"', 2, 'Jusqu'en l'année 1910 les seuls initiateurs du mouvement . . . P. Picasso, J. Metzinger et G. Braque, avaient donné naissance au terme de 'Cubisme' . . . Quelle plus belle idée que cette conception d'une peinture *pure* et qui ne soit par conséquent ni descriptive, ni anecdotique, ni psychologique, ni morale, ni sentimentale, ni pédagogique, ni enfin décorative? Je ne dis pas que ces dernières façons de comprendre la peinture soient à négliger mais on ne peut contester, en effet, qu'elles sont irrémédiablement inférieures. La peinture, en effet, ne doit être qu'un art dérivé de l'étude des formes dans un but désintéressé, c'est-à-dire sans aucun des buts que je viens de citer . . . Que dire de cette riche floraison d'idées nouvelles toujours basées bien solidement sur les meilleurs et les plus purs préceptes des anciens, de leur amour de cette science qui est un critérium de notre sensibilité moderne si raffiné, de cette tendance à tout bien peser et mesurer'.

104 'L'homme qui sait peut-être le mieux peindre à notre époque', *ibid.*, 3.

105 *Ibid.*, 3–4.

106 R. Allard, *La Cote*, 30 September 1912. 'à vrai dire cette précision eut été omise si certaines tentatives, dont nous parlons plus loin, ne commandaient à chacun de prendre nettement ses responsabilités.'

107 O. Hourcade, 'Discussions. A M. Vauxcelles', *Paris–Journal*, 23 October 1912, 4. 'que certains . . . de mes amis tendent à confondre cubisme et cubisme; mais il y a fagot et fagot. Que tel bon critique dise donc que la peinture de son favori est de la peinture 'pure', je n'y vois pas d'inconvénient. Que, pour cela, l'art de Metzinger, celui de Gleizes, celui de Le Fauconnier, celui de Léger, soient exclusivement de la peinture pure, voilà qu'il n'est pas absolument juste. Et ce sont pourtant ces quatre peintres-là qui, avec Delaunay, ont, en 1910 et surtout aux Indépendants de 1911, *crée*, et sont véritablement le cubisme (en germe dans Cézanne et dans Braque-Picasso). On

108 oublie peut-être trop ce détail d'histoire aujourd'hui.'

108 R. Delaunay, letter to Macke in Fonds Delaunay, Bibliothèque Nationale, Paris. Buffet-Picabia, announcement in *Gil Blas*, 31 December 1913, cited in W. Camfield, *Picabia*, Princeton University Press, 1979, 62–3, n. 16. On the Delaunays' activities see Ch. 7 below.

109 On the two series of the magazine see A. Parigoris, 'Les Constructions cubistes dans 'Les Soirées de Paris': Apollinaire, Picasso et les clichés Kahnweiler', *Revue de l'art*, 82, 1988, 61–74. On Apollinaire's essay see above, p. 148.

110 *Poème et drame*, 1, November 1912, 63–9. A further excerpt was reprinted in the third issue, March 1913.

111 Reports of the *dîners* were given in each issue. In early 1914 Barzun, *Poème et drame*, 2 no. 7, January–March 1914, 84, noted proudly that at the end of the magazine's first year its six issues had run to 450 pages by 35 different contributors, that 16 lectures had been organised and over 4,000 'spécimens de propagande' disseminated across the world.

112 *Montjoie!*, 1, 10 February 1913, 1, 'donner une direction à l'élite'. The magazine appeared fortnightly until June 1913, but only quarterly thereafter, until its demise after the issue of April–June 1914.

113 Parigoris, 'Les Constructions cubistes', 64, 63.

114 *Ibid*; A. Tudesq, 'Deux Nuits en Alsace-Lorraine', *Les Soirées de Paris*, 1, February 1912, 9; Apollinaire, 'Cézanne: 4 lettres sur la peinture', *Les Soirées de Paris*, 2, March 1912, 42.

115 See n. 86 above.

116 H.-M. Barzun, 'D'un art poétique moderne: du lyrisme au dramatique', *Poème et drame*, 1, November 1912, 83, 'Il nous faut, en cet an 1912, lever des cohortes d'athlètes et des légions des pionniers pour défricher et ensemencer ce siècle neuf, pour révéler l'Ere nouvelle, riche de l'art de notre génération.'

117 Barzun, 'Génération des temps dramatiques et la beauté nouvelle', *Poème et drame*, 1 no. 2, January 1913, 36, 'celle des sens multipliées par la puissance métallique et par la vitesse … celle des psychologies collectives, continentales, terrestres … celle de l'amour agissant et créateur sur les ruines de l'amour contemplatif and sentimental.'

118 R. Canudo, *Montjoie!*, 1, 10 February 1913, 1, 'Défini par l'ambition de la race qui veut imposer au monde un type essentiel de culture'. On the title's derivation see P. Genève, 'Une Heure chez les cérébristes', *L'Opinion*, 28 February 1914; also N. Blumenkrantz-Onimus, '*Montjoie!* ou l'héroïque croisade pour une nouvelle culture', in L. Brion-Guerry (ed.), *L'Année 1913*, 3 vols, Paris: Klincksieck, 1971–3, vol. 2, 1105.

119 R. Canudo, 'Manifeste de l'art cérébriste', *Le Figaro*, 9 February 1914, published concurrently in *Montjoie!*, 2 no. 1–2 (special issue on dance), January–February 1914, 9, 'Le caractère général de l'innovation contemporaine est dans la transposition de l'émotion artistique du *plan sentimental* dans le *plan cérébral* … la jouissance de la peinture par la peinture, et non par l'idée littéraire ou sentimentale qu'elle doit illustré … nous voulons un art plus noble et plus pur, qui ne touche pas le coeur, mais qui remue le cerveau, *qui ne charme pas, mais qui fait penser*' (italics in original).

Chapter 7 Cubism and Decoration: Tradition and Modernity

1 A. Gleizes and J. Metzinger, *Du Cubisme*, Paris: Figuière, 1912; in English, R. Herbert (ed. and trans.), *Modern Artists on Art*, New York: Prentice-Hall, 1964, 5.

2 P. Wollen, 'Out of the Past: Fashion/Orientalism/The Body', *Raiding the Icebox: Reflections on Twentieth-Century Culture*, London: Verso, 1993, 29.

3 R. Allard, "La Vie Artistique/Le Salon d'Automne (suite): Les ensembles décoratifs', *La Cote*, 14 October 1912, 8. The ensemble was literally unmissable this time, as its entrance was also that for the salon's decorative arts section itself.

4 See J. Golding, *Cubism: A History and an Analysis 1907–1914*, London: Faber & Faber, 1968, 171–2. The exceptions are: M.-N. Pradel, 'La Maison cubiste en 1912', *Art de France*, I (1961), 177–86; W. Agee and G. Hamilton, *Raymond Duchamp-Villon 1876–1918*, New York: Walker, 1967, 64–9; N. Troy, *Modernism and the Decorative Arts in France: Art Nouveau to Le Corbusier*, New Haven and London: Yale University Press,

1991, 79–102; and C. Amano, 'Cubisme, décor et tradition vers 1912', *Histoire de l'art*, 16, December 1991, 81–95. See also Troy, 'Domesticity, Decoration and Consumer Culture: Selling Art and Design in Pre-World War I France', in C. Reed (ed.), *Not at Home: The Suppression of Domesticity in Modern Art and Architecture*, London: Thames and Hudson, 1996, 113–29.

5 It was the exhibition of cubist works at that year's Salon d'Automne that incurred the patriotic wrath of the Paris councillor Lampué and the subsequent debate in the Chambre des Députés discussed in Ch. 1 above.

6 E. Sedeyn, 'Au Salon d'Automne', *Art et décoration*, 16 no. 10, November 1912, 144, 'L'art décoratif n'a pas seulement ses cubistes, il a aussi ses virtuoses, qui en jouent comme un napolitain joue de la guitare, sans avoir appris.' 'La palette munichoise' was a reference to the notorious exhibition of decorative art from Munich at the 1910 Salon d'Automne: see Ch. 3 above, p. 68.

7 A. Chantre, 'Les Relieurs d'André Mare', *L'Art décoratif*, December 1913, 251, 'Il y a … d'étroites relations entre le malaise dont n'arrive pas à se débarrasser la peinture d'aujourd'hui et la joyeuse vitalité de l'art décoratif. Les artistes probes … trop prudents pour s'engager dans les chemins rocailleux, et probablement sans issue, du cubisme, et désespérant de trouver ailleurs ce classicisme nouveau que quelques fervents, dont je suis, attendent encore, ils renoncent à peindre … Ils ramassent les outils abandonnés par l'artisan qui préfère conduire des machines, et au lieu de décorer nor mûrs, ils meublent nos maisons.'

8 R. Duchamp-Villon, 1912, published in Pradel, 'La Maison cubiste en 1912', 179, 'On s'est aperçu tout à coup de toutes parts que nous vivions dans l'époque la plus pauvre de toute notre histoire artistique à ce point de vue … Nous vivons sur un passé glorieux comme les prodiges sur la fortune accumulée par leur aïeux … On parle d'ouvrir à Paris en 1915 une exposition d'art décoratif moderne. Une manifestation de ce genre est un véritable concours où la suprématie du goût est en jeu; il faut que nous soyons en mesure de défendre notre réputation, jusqu'alors inattaquable.'

9 A detailed description of the ensemble and its contents is given in Troy, *Modernism and the Decorative Arts in France*, 79–90.

10 A. Mare, letter to Marinot, 20 February 1912, 'Faire avant tout quelque chose de très *français*, rester dans la tradition = nous laisser guider par notre instinct qui nous force à réagir contre les erreurs de 1900 et cette réaction peut consister en ceci:
–1– Revenir à des lignes simples, pures, logiques et même un peu froides alors que la période qui nous a précédé était horriblement tourmenté.
–2– Revenir à des couleurs bien franches, bien pures, bien hardies, alors que toujours, cette même période précédente, s'est complue dans des tons lavés, décolorés, anémiés.
Avoir un dessin vigoureux et naïf … être plutôt gauche qu'habile.' André Mare archives, Paris. I am most grateful to Mme Simonne Vène for her generosity in providing access to, and material from, these archives.

11 L. Vauxcelles, 'Au Salon d'Automne (II): L'Art décoratif', *L'Art décoratif*, November 1911, 253, 256, 'André Mare est d'une juvénile audace … Son art est dru, sain, loyal … Art tout français, et qui sent son terroir normand … La salle à manger, en merisier, évoque l'intérieur d'une ferme normande, où habiterait un gentleman-farmer artiste. Mare a cherché à raviver des motifs décoratifs provinciaux, et dont le thème n'a pas varié depuis des siècles. Tout cela, qui sent la main d'un bon ouvrier, est naïf et sincère'.

12 Mare's note of guidance to Marinot stressed the positive qualities and contemporary potential of the Louis-Philippe style, echoing the argument presented by his friend André Véra in an article published a month earlier: Mare, letter to Marinot, 20 February 1912; A. Véra, 'Le Nouveau Style', *L'Art décoratif*, January 1912, 21–32.

13 G. Kahn, 'La Réalisation d'une ensemble d'architecture et de décoration', *L'Art décoratif*, 29, February 1913, 92, 95, 'Nous sommes mis par M. André Mare au courant d'un art traditionnel qui entre en lutte avec l'art nouveau … [M. Mare] et ses amis ont … cherché leurs éléments dans la vie provinciale française, vie esthétique autrefois générale et aujourd'hui reduit à des îlots … ils se sont ralliés surtout à ce que l'ancienne vie

provinciale leur avait laissé de général et de communément usuel.'

14 From the Maison cubiste Poiret bought a clock designed by de la Fresnaye, the same artist's painting *Joueurs de carte* and the 4 oval paintings of female heads by Laurencin; see Pradel, 'La Maison cubiste en 1912', 85. Charlotte Mare's memoirs, and Léger's observation, from a letter to Mare of 7 August 1912, are in the André Mare archives, Paris.

15 L. Vaillat, 'L'Art décoratif. André Mare', *L'Art et les artistes*, 113–4, August–September 1914, 293–4, 'Je crois que là se trouve réalisée la chimère du mobilier accessible à tous, le mobilier qui affirme dignement la modestie de son possesseur'.

16 C. Le Cour and J. Lurçat, 'Une Renaissance des arts décoratifs', *Les Feuilles de mai*, 1, November/December 1912–January 1913, 16–22, and 'L'Inopportunité d'un style décoratif français', *Les Feuilles de mai*, 3, May 1913, 151–60.

17 *Ibid.*, 156.

18 On these boutiques see S. Tise, 'Les Grands Magasins', in D. McFadden (ed.), *L'Art de Vivre: Decorative Arts and Design in France, 1789–1989*, New York: Vendome Press, 1989, 96–9.

19 See Tise, 'Les Grands Magasins', 96–7.

20 See Troy, *Modernism and the Decorative Arts*, 172.

21 The Galeries Lafayette's *atelier d'art*, Maîtrise, was established in 1921, the Bon Marché's Pomone and the Grand Magasin du Louvre's Studium the following year; see Tise, 'Les Grands Magasins', 98; Troy, *Modernism and the Decorative Arts*, 177. On the 1925 Exposition pavilions, see T. Gronberg, 'Cité d'Illusion: Staging Modernity at the 1925 Paris Exposition Internationale des Arts Décoratifs et Industriels Modernes', unpublished PhD thesis, Open University, 1994.

22 *Présentation 1927*, Paris, 1927, cited in Tise, 'Les Grands Magasins', 98. On *musées du soir* see Ch. 3 above, p. 72.

23 Troy, *Modernism and the Decorative Arts*, 172–3.

24 R. Felski, *The Gender of Modernity*, Cambridge, Mass., and London: Harvard University Press, 1995, 61–2. The gendered character of turn-of-the-century consumerism has been the subject of much relatively recent research: see esp. R. Bowlby, *Just Looking: Consumer Culture in Dreiser,* *Gissing and Zola,* New York and London: Methuen, 1985; Rosalind Williams, *Dream Worlds: Mass Consumption in Late Nineteenth-Century France*, Berkeley: University of California Press, 1982.

25 See e.g. D. Silverman, *Art Nouveau in Fin-De-Siècle France: Politics, Psychology and Style*, Berkeley and London: University of California Press, 1989, 186–206; Troy, 'Domesticity, Decora-tion and Consumer Culture', 116–7; Gronberg, 'Cité d'Illusion', 30–1. Contemporary critics spoke of the 'macaronic exaggerations' of art nouveau; see G.-R. Sandoz and J. Guiffrey, *Exposition française d'art décoratif. Copenhague 1908. Rapport général. Précédé d'une Etude sur les Arts appliqués et industries d'art aux expositions*, Paris: Comité Français des Expositions à l'Etranger, 1913, CI, and Camille Mauclair, 'Ou en est notre 'Art décoratif'?', *Revue bleue*, 24 April 1909, 520, dismissed it as a 'hysterical, comical, lamentable, useless style . . . pretentious and fantastic trash whose obsolete models the Faubourg St Antoine now revels in'.

26 Troy, 'Domesticity, Decoration and Consumer Culture', 117–18.

27 Le Corbusier, *The Decorative Art of Today* (1925), Cambridge, Mass: MIT Press, 134, quoted in Gronberg, 'Cité d'Illusion', 382–3. On the 1912 prize see F. Jourdain (with R. Rey), *Le Salon d'Automne*, Paris: Les Arts et le Livre, 1926, 73–4, and Ch. 3 above, n. 86.

28 Troy, 'Domesticity, Decoration and Consumer Culture', 116–17.

29 On this development and this construction see Gronberg, 'Cité d'Illusion', ch. 1.

30 See *ibid.*, 59.

31 For biographical information on R. Delaunay see G. Vriesen and M. Imdahl, *Robert Delaunay: Licht und Farbe* Cologne: Dumont, 1967. On Sonia, see S. Buckberrough, 'A Biographical Sketch: Eighty Years of Creativity', in *Sonia Delaunay: A Retrospective*, Buffalo, NY: Albright-Knox Art Gallery, 1980, 13–100.

32 R. Delaunay, *Extrait de H R le douanier: sa vie, son oeuvre, la critique*, unpublished manuscript of 1911, Paris: Bibliothèque Nationale, Fonds Delaunay, dossier 18, 5 bis, 'ces peintres que l'on rencontre dans les banlieues, les campagnes . . . expression naïve et directe de ces artisans, peinture de foire, de coiffeurs, amateurs, de laitiers etc.'

Toute cette peinture de source directement des idées touffues du peuple, Rousseau en a été le génie, la fleur précieuse.'

33 R. Delaunay, 'Mon ami Henri Rousseau', part 1, *Les Lettres françaises*, 7 August 1952, 9, 'Cet art sorti des profondeurs du peuple, complètement incompris dans les centres artistiques aussi bien des révolutionnaires que des académiques, le sera encore par sa haute réalisation.'

34 The December 1912 letter is reprinted in P. Francastel (ed.), *Robert Delaunay: Du Cubisme à l'art abstrait*, Paris: S.E.V.P.E.N., 1957, 181–3. Letter to Marc of April 1913, *ibid.*, 160–1, 'il arrive maintenant une équipe qui renverse l'intellectualisme, le goût. Le métier joue maintenant un grand rôle.' 'Représent-ation et métier', *ibid.*, 115, 'le monde n'est pas notre représentation recrée par la raisonnement (cubisme), le monde est notre métier'. In her memoirs, *Nous irons jusqu'au soleil*, Paris: Laffont, 1978, 64–5, Sonia described Robert as 'a rebel who was determined to resist the bourgeoisie's in-trusion into art' ('un révolté qui voulait s'opposer à l'intrusion de la bourgeoisie dans l'art').

35 V. Spate offers a convincing argument on the dating of this and related works in *Orphism: The Evolution of Non-figurative Painting in Paris 1910–14*, Oxford University Press, 1979, Appendix C.

36 In a letter of April 1912 to Kandinsky, reprinted in Francastel, *Robert Delaunay*, 178–9, Robert wrote: 'As for our work, I think . . . the public has made an effort to get used to it. It can only do so slowly because it is stuck in its old habits. On the other hand there is a lot for the artist still to do . . . for them these are, for the moment, unintelligible realities. I am sure, moreover, that this is my own fault. The primitive stiffness of the system is still for the public a stumbling-block in the way of its enjoyment. ('Pour ce qui concerne nos oeuvres, je pense . . . que le public est forcé de s'accoutumer. L'effort qu'il doit faire est lent, car il est noyé dans les habitudes. D'un autre côté, l'artiste a beaucoup à faire . . . ce sont des réalités inintelligibles pour eux, pour le moment. Je suis sûr aussi qu'il y a de ma faute. La raideur primitive du système est encore pour le public une pierre peu attirante pour son besoin de plaisir'.)

37 Recounted in F. Meyer, 'Robert Delaunay, Hommage à Blériot', *Jahresberichte der Öffentlichen Kunstsammlungen*, Basel, 1962, 68.

38 In his unpublished appreciation of 1911 Robert discussed Rousseau's genius exclusively, and repeatedly, in terms of his class inheritance and his pictorial technique. On Rousseau's influence as regards modern subject matter, see B. Dorival, 'Robert Delaunay et le cubisme', *Travaux IV: Le Cubisme*, St Etienne: C.I.E.R.E.C., 1973, 96, and P. Rousseau, 'La Construction du simultané: Robert Delaunay et l'aéronautique', *Revue de l'art*, 113, 1996–3, 20–1.

39 Spate, *Orphism*, 166–7.

40 On literary engagement with modernity in pre-1914 Paris, P. Bergman, '*Moder-nolatria*' et '*Simultaneità*', Stockholm: Scandinavian University Books, 1962, remains the most comprehensive account.

41 See Buckberrough, 'A Biographical Sketch', 21. On the Union Centrale campaign, see Silverman, *Art Nouveau in Fin-de-Siècle France*. On republican art education for women, see M. Nesbit, 'The Language of Industry', in T. de Duve (ed.), *The Definitively Unfinished Marcel Duchamp*, Cambridge, Mass: MIT Press, 1991, 351–84, and T. Garb, *Sisters of the Brush: Women's Artistic Culture in Late Nineteenth-Century Paris*, New Haven and London: Yale University Press, 1994.

42 S. L. Suleiman, *Subversive Intent: Gender, Politics, and the Avant-Garde*, Cambridge, Mass., and London: Harvard University Press, 1990, 27, citing G. Orenstein, 'To-wards a Bifocal Vision in Surrealist Aes-thetics', *Trivia*, 3, Fall 1983, 72. The quoted phrase is from E. Showalter, 'Femi-nist Criticism in the Wilderness', in E. Abel (ed.), *Writing and Sexual Difference*, Uni-versity of Chicago Press, 1980. Suleiman relates it both to Bakhtinian dialogism and, via Orenstein, to anthropology. Buckberrough, 'A Biographical Sketch', 21, suggests that Robert's dislike of com-petition was a factor in Sonia's engage-ment with decorative art. On the Delaunays' artistic partnership see also W. Chadwick, 'Living Simultaneously: Sonia and Robert Delaunay', in W. Chadwick and I. de Courtivron, *Significant Others: Creativity and Intimate Partnership*, Lon-don and New York: Thames and Hudson, 1993, 31–48. On the sexism of the

avant-garde, see Duncan, 'Virility and Domination in Early Twentieth Century Vanguard Painting', *Artforum*, December 1973, rev. in C. Duncan, *The Aesthetics of Power*, Cambridge University Press, 1993, 81–108.

43 The 1913 Salon d'Automne featured an exhibition of Russian popular arts.

44 One advertisement project that did come to fruition was the prospectus that Sonia designed for the *Prose du Transsibérien* in 1913; its appearance was noted in the press, e.g. A. Salmon in *Gil Blas*, 11 October 1913.

45 R. Delaunay, 'The Art of Movement' (1938), Eng. trans. in A. Cohen (ed.), *The New Art of Color: The Writings of Robert and Sonia Delaunay*, New York: Viking, 1978, 140; cited in Gronberg, 'Cité d'Illusion', 136. The boutique to which Robert was referring was shown at the 1924 Salon d'Automne, not the 1925 Exposition. On Sonia's 'dream of advertising as an extension of modern painting' see D. Abadie, 'Sonia Delaunay, à la lettre', in *Art et Publicité 1890–1990*, Paris: Centre Georges Pompidou, 1990, 344–57.

46 For instance, he wrote in 1924 that this 'absolutely new principle in all its possible developments (posters, fashion, textiles, furniture, architecture, *urbanism*) is going to regenerate, or enliven every domain of visuality' ('le principe absolument nouveau dans tous les développements possibles (affiche, mode, tissus, meubles, architecture, *urbanisme*) va régénérer ou donner la vie à tout ce qui est de la visualité'), and in 1938 that Sonia's dresses 'were no longer a piece of fabric arranged in the current fashion, but a composite seen together as an object, like a living painting, so to speak' ('n'étaient plus un morceau d'étoffe drapé selon la mode courante, mais un composé vue d'ensemble comme un objet, comme une peinture pour ainsi dire vivante', reprinted in Francastel, *Robert Delaunay*, 87, 202.)

47 See Buckberrough, 'A Biographical Sketch', 45–53. Sonia later recalled, *Nous irons jusqu'au soleil*, 78, that the Russian Revolution removed their only regular source of income, which had been her legacy from St Petersburg, and as a result, 'we were going to have to re-establish contact with society and look for ways of applying our discoveries to decorative art' ('il va falloir reprendre contact avec la société

et chercher les applications de nos découvertes à l'art décoratif'). Abadie, 'Sonia Delaunay, à la lettre', 350–51, notes that one result of this stronger commercial orientation was Sonia's accentuation of the legibility of the lettering in her poster projects of the War years.

48 A. Billy, *Le Pont des Saints-Pères*, Paris: Fayard, 1947, 121–2, 'En 1912, le cubisme n'en était guère qu'à ses débuts. Ce qui marquait surtout ces années-là quand nous les vivions, c'était les Ballets russes et Paul Poiret'.

49 L. Garafola, *Diaghilev's Ballets Russes*, Oxford University Press, 1989, 274. More than a quarter of the capital exported from France from 1898 to 1914 went to Russia, her 'privileged ally and first customer': see M. Rebérioux, *La République radicale 1898–1914*, Paris: Seuil, 1975, 123.

50 *Comoedia Illustré*, 1909, 6, 'Le temps n'est plus, en France, où l'art choréographique, soutenu par une aristocratie qui en faisait ses délices, par des connoisseurs jaloux de leur compétence, brillait au premier plan'. The critique of the political present implicit in such observations occasionally surfaced explicitly, as in the comment of the same year by the critic for the centrist *Gil Blas*, 20 May 1909, 3, that if Paris itself were to produce such beautiful ballets 'a dancer would have to be found who could return us to the tradition of elegant postures and expressive physiognomies. But we have other concerns and a time in which the unions are in violent conflict with society is doubtless not a favourable one for such a reform' ('il faudrait engager un danseur qui nous rapporte la tradition des attitudes élégantes et des jeux de physiognomie expressifs. Mais nous avons d'autres soucis et l'époque où les syndicats luttent violemment contre la société n'est sans doute pas favorable à cette réforme').

51 Garafola, *Diaghilev's Ballets Russes*, 274.

52 J.-E. Blanche, 'Les Décors de l'Opéra russe', *Le Figaro*, 29 May 1909, 1, 'A ma droite, Maurice Denis s'écrie: "Voilà de la couleur, voilà de vrais décors"' ('On my right, Maurice Denis exclaimed: "That's what colour is, those are true décors").

53 Garafola, *Diaghilev's Ballets Russes*, 279.

54 On Parisian orientalism and the Ballets Russes see Wollen, 'Out of the Past', esp. 1–16.

55 Poiret worked assiduously, as he acknowledged, *En Habillant l'Epoque*

(1930), Paris: Bernard Grasset, 1987, 69, 'to "receive" artists' at his home 'and to create a movement around myself.' He and his wife 'frequented antiquarian galleries and museums, and we worked ceaselessly to enrich our culture and sharpen our sensibility' ('recevoir des artistes et de créer autour de moi un mouvement. Nous fréquentions les antiquaires, les musées, et nous travaillions sans cesse à enrichir notre culture, à aiguiser notre sensibilité'). He was friendly with the fauve painters, especially Vlaminck and Derain, from the turn of the century, and patronised Picabia in the latter's early, impressionist period. He also collected paintings by de Segonzac and bought furniture from the Maison cubiste, as noted earlier. He owned the premises of the Galerie Barbazanges, where Robert Delaunay and Marie Laurencin shared an exhibition in February 1912. Among his leading designers were Dufy (1909–12) and Iribe (from 1908). See also *Poiret le Magnifique*, Paris: Musée Jacquemart-André, 1974.

56 P. Lalo, 'La Musique: La Saison Russe', *Le Temps*, 28 May 1912, 3, and 11 June 1912, 3, 'la passion envahissante de la foule pour le cinématographe; ici et là, c'est une décadence de l'intelligence et du goût'; 'malgré toute leur recherche et leur raffinement: la marque du Barbare est sur eux.'

57 R. Canudo, 'Une Leçon des Spectacles russes', *La Phalange*, 50, 20 August 1910, 168–76, and 'Cave Canem', *Montjoie!*, 7, 16 May 1913, 3, 'Elle a engendré la 'gloire' du couturier Poiret et autres faiseurs'.

58 Canudo, 'Manifeste de l'art cérébriste', *Montjoie!*, 2 no. 1–2 (special issue on dance), January–February 1914, 9: see Ch. 6 above, p. 168 and n. 119.

59 V. de Saint-Point, 'La Métachorie', *ibid.*, 5–7. Reference to Diaghilev's company was once again conspicuously absent.

60 Canudo, 'Manifeste de l'art cérébriste', 'depuis quelques dizaines d'années, la France est si impérieusement à la tête de l'évolution artistique moderne, que les nations les plus hostiles s'inclinent devant sa domination. Cette domination est, on l'a dit, absolument cérébrale.'

61 Saint-Point, 'La Métachorie', 7, 'Française, je suis trop fière de ma race, pour avoir, dans la réalisation que j'ai tentée, emprunté un détail, si minime soit-il, à l'étranger, du passé ou du jour'; 'ne m'ont

pas paru émouvoir profondément notre génie français, sans doute parce qu'il n'y retrouve aucune de ses traditions, ni, non plus, son idéal d'art moderne'.

62 See Garafola, *Diaghilev's Ballets Russes*, 292.

63 Canudo, 'Cave Canem', 'si les Russes ne se donnent point la peine de [se] renouveler . . . [s']ils nous reviennent *identiques*, insouciants de ce qui peut être vraiment nouveau ou vraiment français . . . il nous serait naturellement impossible de profiter à présent d'un apport esthétique *qui ne nous étonne plus*' (his italics).

64 F. Steegmuller, *Jean Cocteau: A Biography*, London: Constable, 1970, 78, notes that the scandal of *L'Aprés-midi*'s first night saved the Ballet's 1912 season, after a dull start. Diaghilev's biographer Lifar, *Serge Diaghilev: His Life, His Work, His Legend. An Intimate Biography*, London: Putnam, 1940, 262, wrote that 'If the years 1911 and 1912 have much in common, no less great are the differences . . . [the] basic difference between the preceding years and that year of combat, 1912, . . . was the fact that, whereas before Diaghilev had been content merely to reveal the *achievements* of Russian art, thereafter he was to begin his searchings for *new forms in art*.'

65 See Steegmuller, *Jean Cocteau*, 85. See also Garafola, *Diaghilev's Ballets Russes*, 297–8.

66 Quoted in *Comoedia Illustré*, 1913, 106, which also noted the universal uncertainty as to how to respond to the ballet.

67 L.-L. Blum in *La Gazette du bon ton*, 1913, 247, 'Est-ce absurde et négligeable? Est-ce un effort, un pas en avant, un stage nouveau de notre goût? Je n'ose conclure: j'ai vu des hommes de sentiment sincère, des artistes vrais applaudir, j'ai vu une salle divisée par deux courants contraires: et ce partage tout au moins indique que nous touchons à un moment dangereux pour notre culture esthétique'.

68 G. Pioch in *Gil Blas*, 30 May 1913, 3–4, 'Si M. Igor Stravinski ne nous avait pas donné un chef d'oeuvre: L'*Oiseau de feu*, et cette oeuvre pittoresque et charmante: *Petrouchka*, je me résignerais à être déconcerté par ce que je viens d'entendre . . . Attendons, en espérant toujours. Il est très possible que voici, en effet, une musique nouvelle.'

69 See Steegmuller, *Jean Cocteau*, 82.

70 J. Roche, quoted in *ibid.*, 115.

71 On the *Dream* project, its fate and Cocteau's meeting with Picasso see *ibid.*, 131–7.

72 See K. Silver, *Esprit de Corps: The Art of the Parisian Avant-Garde and the First World War, 1914–1925*, London: Thames and Hudson, 1989, 43–51. See also Steegmuller, *Jean Cocteau*, 126–31.

73 A. Warnod, *Les Berceaux de la jeune peinture*, Paris: Albin Michel, 1925, 186, 'le temps était fini des rapins, farouches ennemis des bourgeois. Les gens du monde se piquaient d'être 'à la page' et se mêlaient aux artistes'.

74 See *ibid*. Mme Ricou was listed in the catalogue of the Salon de la Section d'Or as owning a *marine* by Metzinger.

75 The couple have been described by one historian of Montparnasse, J. Crespelle, *La Vie quotidienne à Montparnasse à la grande epoque, 1905–30*, Paris: Hachette, 1976, 53, as 'refined, intelligent souls, a little obsessed with intellectualism – in short, very Russian' ('des êtres fins, intelligents, quelque peu affolés d'intellectualisme; bref, très russes'), and Hélène d'Oettingen in particular as 'orchestral player, writer, poet, theatre lover, painter, decorator, horsewoman and . . . woman of the world' ('femme d'orchestre, écrivain, poète, amateur dramatique, peintre, décorateur, écuyère et . . . femme du monde'), and their pseudonyms identified as, for Hélène, Léonard Pieux (poems), Roch Grey (essays and novels) and Françoise Angibout (paintings); for Serge, Jean Cerusse (criticism) and Serge Férat (paintings). See also J. Richardson, *A Life of Picasso, vol. 2: 1907–1917*, London: Cape, 1996, 260–64, who states that Hélène had been the mistress of Serge's father.

76 In 1914 *Montjoie!*, 2 no. 2, January–February 1914, 18, listed among the over a hundred 'personnalités mondaines qui s'intéressent aux manifestations d'art les plus avancés' presented at its regular 'lundis' a score of counts, countesses and other members of *le tout-Paris*. Hessel was one of the most conservative of contemporary art dealers, who sometimes partnered Bernheim-Jeune in the purchase of work by old and new masters; he was listed as the owner of Gleizes' painting in the tenth (1913) edition of Apollinaire's *Les Peintres cubistes*.

77 A. Basler, 'Les Arts plastiques', *Montjoie!*, no. 9–10, 14–29 June 1913, 12, 'Enfin le marché s'est ouvert aux cubistes'. M. Gee, 'Dealers, Critics and Collectors of Modern Painting: Aspects of the Parisian Art Market 1910–30', unpublished PhD thesis, University of London, 1977, 2 vols, vol. 1, 213, notes that he was referring to the gallery cubists.

78 A. Parigoris, 'Les Constructions cubistes dans 'Les Soirés de Paris': Apollinaire, Picasso et les clichés Kahnweiler', *Revue de L'art*, 1988, 68.

79 *Ibid*. On the cancelling of subscriptions, see the catalogue of the exhibition *Les Soirées de Paris*, Paris: Galerie Maeght, May–June 1958.

80 Saint-Point, 'La Métachorie', 5, 'Sur la scène . . . [la danse] copie en attitudes convenues, les gestes de la vie ordinaire qu'emploieraient pour s'exprimer un silencieux ou un muet, et c'est la pantomime . . . au lieu d'une subtilisation artistique'; Canudo, 'Manifeste de l'art cérébriste', 9, 'Cet art [cérébriste] marque la borne funéraire de tout l'art sentimental: banal, facile, enfin intolérable parce qu'insuffisant.'

81 A. Salmon, 'L'Art décoratif et le décor au théâtre'; R. de la Fresnaye, 'L'Art dans la rue'; A. Mare, 'Le Papier peint'; and J. Reboul, 'La femme: élément d'art décoratif'; all in *Montjoie!*, 2 no. 4/5/6, April–June 1914.

82 See Intro. above, n. 3.

Selected Bibliography

Abadie, Daniel. 'Sonia Delaunay, à la lettre', in *Art et Publicité 1890–1990*, exhibition catalogue, Paris: Centre Georges Pompidou, 1990, 344–57.

Agathon (Henri Massis and Alfred de Tarde). *L'Esprit de la nouvelle Sorbonne*, Paris: Mercure de France, 1911.

—. *Les Jeunes Gens d'aujourd'hui*, Paris: Plon-Nourrit, 1913.

Agee, William C., and George H. Hamilton. *Raymond Duchamp-Villon 1876–1918*, exhibition catalogue, New York: Walker, 1967.

Albertini, Marie-Laure. 'Les Politiques d'éducation populaire par l'art en France: Théâtres et Musées 1895–1914', unpublished *thèse du troisième cycle d'histoire*, Université de Paris 1, 1983.

Alexandre, Arsène. 'L'Age décoratif', *Comoedia*, 14 October 1911, 3.

Allard, Roger. 'Au Salon d'Automne de Paris', *L'Art libre*, vol. 2 no. 12, November 1910, 441–3.

—. 'Sur Quelques Peintres', *Les Marches du sud-ouest*, June 1911, 57–64.

—. 'Les Beaux-Arts', *La Revue indépendante*, August 1911, 127–40.

—. 'Les Arts plastiques', *Les Ecrits français*, 1, 5 December 1913, 64.

—. 'Les Arts plastiques: Futurisme, simultanéisme et autres métachories', *Les Ecrits français*, 3, 5 February 1914, 255–6.

—. 'L'Avant-gardisme et la critique', *Les Ecrits français*, 5, 5 April 1914.

Amano, Chika. 'Cubisme, décor et tradition vers 1912', *Histoire de l'Art*, 16, December 1991, 81–95.

Anderson, Perry. 'Modernity and Revolution', *New Left Review*, 144, March–April 1984, 96–113.

Anglès, Auguste. *André Gide et le premier groupe de la* Nouvelle Revue Française *1890–1910*, Paris: Gallimard, 1978.

Antliff, Mark. *Inventing Bergson: Cultural Politics and the Parisian Avant-Garde*, Princeton University Press, 1993.

—. 'Organicism against itself: Cubism, Duchamp-Villon and the contradictions of Modernism', *Word & Image*, vol. 12 no. 4, October–December 1996, 366–88.

Antonelli, Etienne. *La Démocratie sociale devant les idées présentes*, Paris: Rivière, 1911.

Apollinaire, Guillaume. 'Vingt lettres de Guillaume Apollinaire à Ardengo Soffici', *Le Flâneur des deux rives*, 4, December 1954, 1–11.

—. *Anecdotiques*, Paris: Gallimard, 1955.

—. *Chroniques d'art 1902–1918*, ed. L.-C. Breunig, Paris: Gallimard, 1960.

—. *Apollinaire on Art: Essays on Art: Essays and Reviews 1902–1918*, ed. by L.-C. Breunig, London: Thames and Hudson, 1972.

Arbour, Roméo. *Les Revues littéraires: Ephémères paraissant à Paris entre 1900 et 1914*, Paris: Corti, 1956.

Arnyvelde, André. 'Contribution à l'histoire du Cubisme', *Gil Blas*, 2 January 1912, 3.

Aubéry, P. *Anarchiste et décadent: Mécislas Golberg, 1868–1907*, Paris: Lettres Modernes, 1978.

Barrer, Patrick F. *Quand l'art du XXᵉ siècle était conçu par des Inconnus . . .*

L'Histoire du Salon d'Automne de 1903 à nos jours, Paris: Arts et Images du Monde, 1992.

Barzun, Henri-Martin. 'Après le symbolisme: L'Art poétique d'un idéal nouveau: Voix, rythmes et chants simultanées', *Poème et drame*, 1 no. 4, May 1913, 13–14.

Baumont, Michel. 'Gustave Hervé et la 'Guerre sociale' pendant l'été 1914 (1er juillet-1er novembre)', *Information historique*, no. 4, 1968, 155–62.

Beauduin, Nicolas. 'Les Temps héroïques: à propos du Salon de la Section d'Or', *Masques et visages*, 39, June 1956, 6–7.

Benjamin, Roger. 'The Decorative Landscape, Fauvism, and the Arabesque of Observation', *Art Bulletin*, LXXV no. 2, June 1993, 295–316.

Bergman, Par. '*Modernolatria* et '*Simultaneità*': *Recherches sur deux tendances dans l'avant-garde littéraire en Italie et en France à la veille de la première guerre mondiale*, Stockholm: Scandinavian University Books, 1962.

Bergson, Henri. *Introduction to Metaphysics* (1903), trans. T. Hulme, New York: Putnam's, 1912.

—. *Creative Evolution* (1907), trans. A. Mitchell, New York: Random House, 1944.

Berlanstein, Lenard R. *The Working People of Paris, 1871–1914*, Baltimore and London: Johns Hopkins University Press, 1984.

Bernier, Georges. *L'Art et l'argent*, Paris: Laffont, 1977.

Bidou, Henri. 'Les Salons de 1910 (premier article)', *Gazette des Beaux-Arts*, May 1910, 361–78.

Billy, André. *Le Pont des Saints-Péres*, Paris: Fayard, 1947.

—. *L'Epoque Contemporaine*, Paris: Tallandier, 1956.

Biondi, Jean-Pierre, and Gilles Morin. *Les Anticolonialistes (1881–1962)*, Paris: Laffont, 1992.

Blanche, Jacques-Emile. 'Les Décors de l'Opéra russe', *Le Figaro*, 29 May 1909, 1.

Bloch, Jean-Richard. 'Examen de conscience', *L'Effort libre*, January 1913, 85–100.

Bouglé, Chistian. 'Solidarisme et morale scientifique', *La Revue bleue*, 2 September 1905, 310.

Bourdieu, Pierre. *Distinction: A Social Critique of the Judgement of Taste* (1979), trans. R. Nice, London: Routledge, 1986.

Breunig, Lery C. 'The Chronology of Apollinaire's *Alcools*', *Publication of the Modern Languages Association*, December 1952, 907–22.

Brion-Guerry, L. (ed.). *L'Année 1913. Les Formes esthétiques de l'oeuvre d'art à la veille de la première guerre mondiale*, 3 vols, Paris: Klincksieck, 1971–3.

Buckberrough, Sherry A. 'A Biographical Sketch: Eighty Years of Creativity', in *Sonia Delaunay: A Retrospective*, exhibition catalogue, Buffalo, N.Y: Albright-Knox Art Gallery, 1980, 13–100.

Buffet-Picabia, Gabrielle. *Rencontres*, Paris: Belfond, 1977.

Bürger, Peter. *Theory of the Avant-Garde* (1974), trans. M. Shaw, Minneapolis: University of Minnesota Press, 1984.

Burgess, Gelett. 'The Wild Men of Paris', *Architectural Record*, May 1910, 399–414.

Cabanne, Pierre. *Entretiens avec Marcel Duchamp*, Paris: Belfond, 1967.

Caillard, Maurice, and Charles Forot. 'Les Revues d'avant-garde', *Belles-Lettres*, 6 no. 62, December 1924, 97–105.

Calinescu, Matei. *Five Faces of Modernity*, Durham, N. Carolina: Duke University Press, 1987.

Canudo, Ricciotto. 'Une Leçon des spectacles russes', *La Phalange*, 50, 20 August 1910, 168–76.

—. 'Cave Canem', *Montjoie!*, 7, 16 May 1913, 3.

—. 'Manifeste de l'Art Cérébriste', *Montjoie!*, 2 no. 1–2, January–February 1914, 9.

Carco, Francis. *De Montmartre au Quartier latin*, Paris: Albin Michel, 1927.

Carmean, E. A., Jr. 'Juan Gris' "Fantômas"', *Arts Magazine*, 51 no. 5, January 1977, 116–19.

Charle, Christophe. *Naissance des 'intellectuels' (1880–1900)*, Paris: Minuit, 1990.

—. *Les Elites de la République (1880–1900)*, Paris: Fayard, 1987.

Charpin, Catherine (with Sarah Wilson). 'One Hundred Years Ago: The "Incohérents"', *Art Monthly*, 128, July–August 1989, 7–9.

Chave, Anna C. 'New Encounters with *Les Demoiselles d'Avignon*: Gender, Race, and the Origins of Cubism', *Art Bulletin*, 76 no. 4, December 1994, 596–611.

Chevalier, Louis. *Montmartre du plaisir et du crime*, Paris: Laffont, 1980.

Christ, Yvan. *Les Métamorphoses de la banlieue parisienne*, Paris, Balland, 1969.

Clausen, Meredith L. *Frantz Jourdain and the Samaritaine*, Leiden: Brill, 1987.

Cohen, Arthur A. *The New Art of Color: The Writings of Robert and Sonia Delaunay*, New York: Viking, 1978.

Coste-Messelière, M. G. de la. 'Un Jeune Prince amateur d'impressionnistes et chauffeur', *L'Oeil*, November 1969, 19–27.

Cottington, David. 'Cubism and the Politics of Culture in France 1905–1914', unpublished PhD thesis, University of London, 1985.

—. 'Cubism, Law and Order: The Criticism of Jacques Rivière', *Burlington Magazine*, 126, December 1984, 744–50.

Cowling, Elizabeth. 'The fine art of cutting: Picasso's *papiers collés* and constructions in 1912–14', *Apollo*, November 1995, 10–18.

—, and Jennifer Mundy (eds). *On Classic Ground: Picasso, Léger, de Chirico and the New Classicism, 1910–1930*, exhibition catalogue, London: Tate Gallery, 1990.

Crespelle, Jean-Paul. *La Vie quotidienne à Montparnasse à la grande epoque 1905–1930*, Paris: Hachette, 1976.

—. *La Vie quotidienne à Montmartre au temps de Picasso 1900–1910*, Paris: Hachette, 1978.

Crow, Thomas. 'Modernism and Mass Culture in the Visual Arts', in F. Frascina (ed.), *Pollock and After: The Critical Debate*, New York and London: Harper & Row, 1985.

Crowther, Paul. 'Cubism, Kant and Ideology', *Word & Image*, 3 no. 2, April–June 1987, 195–201.

Décaudin, Michel. *La Crise des valeurs symbolistes: Vingt ans de poésie française 1895–1914*, Toulouse: Privat, 1960.

Delaunay, Robert. *Du Cubisme à l'art abstrait*, ed. P. Francastel, Paris: S.E.V.P.E.N., 1957.

Delaunay, Sonia. *Nous irons jusqu'au soleil*, Paris: Laffont, 1978.

Denis, Maurice. *Théories (1890–1910): Du Symbolisme et de Gauguin vers un nouvel ordre classique* (1912), 4th edn, Paris: Rouart & Watelin, 1920.

Desanges, Paul. 'Chronique d'une communauté militante: Les Forgerons (1911–1920)', *Le Mouvement social*, 91, April–June 1975, 35–58.

Dezès, Marie-Geneviève. 'Participation et démocratie sociale: L'Expérience Briand de 1909', *Le Mouvement social*, 87, April–June 1974, 109–36.

Digeon, Claude. *La Crise allemande de la pensée française 1870–1914*, Paris: Presses Universitaires de France, 1959.

Dorgelès, Roland. *Bouquet de Bohème*, Paris: Albin Michel, 1947.

Doumic, René. 'Revue dramatique. L'Age du cinéma', *Revue des deux mondes*, 15 August 1913, 919–30.

Dubief, H. *Le Syndicalisme révolutionnaire*, Paris: Armand Colin, 1969.

Duncan, Carol. *The Aesthetics of Power*, Cambridge University Press, 1993.

Duroselle, Jean-Baptiste. *La France de la 'Belle Epoque'*, 2nd edn, Paris: Presses de la Fondation Nationale des Sciences Politiques, 1992.

Dutilleul, Roger. 'La Parole est aux collectionneurs', *Art Présent*, numéro spécial, 'L'Art et l'Argent', 1948, 106.

Egbert, Donald Drew. *Social Radicalism and the Arts: Western Europe*, New York: Knopf, 1970.

Elwitt, Sanford. *The Third Republic Defended: Bourgeois Reform in France, 1880–1914*, Baton Rouge and London: Louisiana State University Press, 1986.

Estivals, Robert, Jean-Charles Gaudy and Gabrielle Vergez. *L'Avant-garde: Etude historique et sociologique des publications périodiques ayant pour titre 'L'avant-garde'*, Paris: Bibliothèque Nationale, 1968.

Felski, Rita. *The Gender of Modernity*, Cambridge, Mass., and London: Harvard University Press, 1995.

Fitzgerald, Michael C. 'Skin Games', *Art in America*, 80 no. 2, February 1992, 71–82 and 139–41.

Foster, Hal. 'What's Neo about the Neo-Avant-Garde?', *October*, 70, Fall 1994, 5–32.

Fry, Edward. *Cubism*, New York: McGraw-Hill, 1966.

Gamwell, Lynn. *Cubist Criticism*, Ann Arbor: UMI Research Press, 1980.

Garafola, Lynn. *Diaghilev's Ballets Russes*, Oxford University Press, 1989.

Garb, Tamar. *Sisters of the Brush: Women's Artistic Culture in Late Nineteenth-Century Paris*, New Haven and London: Yale University Press, 1994.

Gee, Malcolm. 'Dealers, Critics and Collectors of Modern Painting: Aspects of the Parisian Art Market 1910–1930', unpublished PhD thesis, University of London, 1977.

Genet-Delacroix, Marie-Christine. 'Esthétique officielle et art nationale sous la Troisième République', *Le Mouvement social*, 131, April–June 1985, 105–20.

Girardet, Raoul. *L'Idée coloniale en France de 1871 à 1914*, Paris: Table Ronde, 1972.

Gleizes, Albert. 'L'Art et ses représentants: Jean Metzinger', *La Revue indépendante*, 4, September 1911, 161–72.

—. 'Les Beaux-Arts: A propos du Salon d'Automne', *Les Bandeaux d'or*, November 1911, 42–51.

—. 'Le Cubisme et la Tradition', *Montjoie!*, 1, 10 February 1913, 4; and 2, 25 February 1913, 2–3.

—. 'The Abbey of Créteil, a Communistic Experiment', in C. Zigrosser (ed.), *The Modern School* (New Jersey), 5 no. 10, October 1918, 300–15.

—. *Tradition et Cubisme: Vers un conscience plastique: Articles et conférences 1912–1924*, Paris: La Cible, Povolozky, 1927.

—. *Souvenirs: Le Cubisme 1908–1914*, Paris: Cahiers Albert Gleizes, 1957.

—, and Jean Metzinger. *Du Cubisme*, Paris: Figuière, 1912.

Golan, Romy. *Modernity and Nostalgia: Art and Politics in France Between the Wars*, New Haven and London: Yale University Press, 1995.

Golberg, Mécislas. *La Morale des lignes*, Paris: Messein, 1908.

Goudeau, Emile. *Dix Ans de Bohème*, Paris: Librairie Illustré, 1888.

Green, Christopher. *Léger and the Avant-Garde*, New Haven and London: Yale University Press, 1976.

Green, Nicholas. '"All the Flowers of the Field": The State, Liberalism and Art in France under the early Third Republic', *Oxford Art Journal*, 10 no. 1, 1987, 71–84.

Grogin, R. C. *The Bergsonian Controversy in France*, University of Calgary Press, 1988.

Grojnowski, Daniel. 'Une avant-garde sans avancée: Les 'Arts Incohérents' 1882–1889', *Actes de recherche en sciences sociales*, November 1981, 73–86.

—. 'L'Ane qui peint avec sa queue: Boronali au Salon des Indépendants', *Actes de recherche en sciences sociales*, 88, June 1991, 41–7.

Gronberg, Tag. 'Cité d'Illusion: Staging Modernity at the 1925 Paris Exposition Internationale des Arts Décoratifs et Industriels Modernes', unpublished PhD thesis, Open University, 1994.

Guilbeaux, Henri. 'Paul Signac et les Indépendants', *Les Hommes du Jour*, 170, 22 April 1911, n.p.

—. *Du Kremlin au Cherche-Midi*, Paris: Gallimard, 1933.

Habasque, Guy. 'Quand on vendait La Peau de l'Ours', *L'Oeil*, March 1956, 16–21.

Hadjinicolaou, Nicos. 'Sur l'idéologie de l'avant-gardisme', *Histoire et critique des arts*, 6 (2ème trimestre 1978): 49–76.

Haugmard, Louis. 'L'"esthétique" du cinématograph', *Le Correspondant*, 215, 25 May 1913, 762–71.

Hause, Steven C., with Anne R. Kenney. *Women's Suffrage and Social Politics in the French Third Republic*, Princeton University Press, 1984.

Henri-Martin (Henri-Martin Barzun). *L'Action Intellectuelle: Notations d'esthétique*, Paris: Rey, 1908.

Henriot, Emile. *A Quoi rêvent les jeunes gens? Enquête sur la jeunesse littéraire*, Paris: Champion, 1913.

Henriquez-Phillipe. 'Le Cubisme devant les artistes', *Les Annales politiques et littéraires*, 1536, 1 December 1912, 473–5.

Herbert, Robert L. (ed.). *Modern Artists on Art*, New York: Prentice-Hall, 1964.

—, and Eugenia Herbert. 'Artists and Anarchism: Unpublished Letters of Pissarro, Signac and Others', *Burlington Magazine*, 102, November–December 1960, 472–82, 517–22.

Hertz-Fischler, Roger. 'Le Nombre d'or en France de 1896 à 1927', *Revue de l'Art*, no. 118, 1997(4), 9–16.

Hobsbawm, Eric J. 'Socialism and the Avant-garde in the Period of the Second International', *Le Mouvement social*, 111, April–June 1980, 190–99.

Holl, J.-C. 'Enquête sur l'orientation actuelle de la peinture moderne', *Revue du temps présent*, April, May and June 1911, 307–26, 456–70, 569–75.

Hourcade, Olivier. 'La Tendance de la peinture contemporaine', *La Revue de France et des pays français*, 1, February 1912, 35–41.

—. 'Le Mouvement pictural. Vers une école française de peinture', *La Revue de France et des pays français*, 5, June 1912, 254–8.

—. 'Discussions. A M. Vauxcelles', *Paris-Journal*, 23 October 1912, 4.

Johnson, R. Stanley. *Cubism & La Section d'Or: Reflections on the Development of the Cubist Epoch, 1907–1922*, Chicago/Dusseldorf: Klees/Gustorf, 1991.

Jouhaud, Christian. 'La "Belle Epoque" et le cinéma', *Le Mouvement social*, 139, April–June 1987, 107–113.

Jourdain, Frantz, with R. Rey. *Le Salon d'Automne*, Paris: Les Arts et le Livre, 1926.

Juillard, Jacques. 'La CGT devant le problème de la guerre (1900–1914)', *Le Mouvement social*, 49, October–December 1964, 61.

Kahn, Gustave. 'La réalisation d'un ensemble d'architecture et de décoration', *L'Art décoratif*, 188, February 1913, 89–102.

Kahnweiler, Daniel-Henry, with Francis Crémieux. *Mes Galeries et mes peintres*, Paris: Gallimard, 1961.

Kaspi, A. and A. Marés (eds). *Le Paris des étrangers depuis un siècle*, Paris: Imprimerie nationale, 1989.

Kemp, Tom. *Economic Forces in French History*, London: Dobson, 1971.

Klejman, Laurence, and Florence Rochefort. *L'Egalité en marche: Le Féminisme sous la Troisième République*, Paris: Presses de la Fondation Nationale des Sciences Politiques, 1989.

Krauss, Rosalind. 'The Originality of the Avant-Garde', *October*, 18, Fall 1981, 47–66.

Kriegel, Annie, and Jean-Jacques Becker. *1914: La Guerre et le Mouvement ouvrier français*, Paris: Armand Colin, 1964.

Kristeva, Julia. *La Révolution du langage poétique*, Paris: Seuil, 1974.

Kuisel, Richard F. *Capitalism and the State in Modern France: Renovation and Economic Management in the Twentieth Century*, Cambridge and London: Cambridge University Press, 1981, 26.

Lalo, Pierre. 'La Musique: La Saison Russe', *Le Temps*, 28 May 1912, 3, and 11 June 1912, 3.

Landes, David S. 'French Business and the Businessman: A Social and Cultural Analysis', in E. M. Earle (ed.), *Modern France: Problems of the Third and Fourth Republics*, Princeton University Press, 1951.

Laux, James M. *In First Gear: The French Automobile Industry to 1914*, Liverpool University Press, 1976.

Lebovics, Herman. *True France: The Wars over Cultural Identity 1900–1945*, Ithaca, N.Y: Cornell University Press, 1994.

Le Cour, Charles, and J. Lurçat. 'Une Renaissance des arts décoratifs', *Les Feuilles de mai*, 1, November/December 1912–January 1913, 16–22.

Le Cour, Charles, and J. Lurçat. 'L'Inopportunité d'un style décoratif français', *Les Feuilles de mai*, 3, May 1913, 151–60.

Le Fauconnier, Henri. 'L'Oeuvre d'art', in *Henri Le Fauconnier: Kubisma en Expressionisme in Europa*, Haarlem: Frans Halsmuseum, 1993.

—. 'La sensibilité moderne et le tableau', in *Catalogue des ouvrages de peinture, sculpture, dessin, gravure, exposé au Musée municipal Suasso, Amsterdam, du 6 October au 7 November 1912*, exhibition catalogue, Amsterdam: Moderne Kunst Kring, 1912, 17–27.

Leighten, Patricia. 'Picasso's Collages and the Threat of War', *Art Bulletin*, LXVII, December 1985, 653–72.

—. *Re-Ordering the Universe: Picasso and Anarchism, 1897–1914*, Princeton University Press, 1989.

—. 'Cubist Anachronisms: Ahistoricity, Cryptoformalism, and Business-as-Usual in New York', *Oxford Art Journal*, 17 no. 2, 1994, 91–102.

Level, André. *Souvenirs d'un collectionneur*, Paris: Club des Libraires de France, 1959.

Levin, Miriam. *Republican Art and Ideology in Late Nineteenth-Century France*, Ann Arbor, Mich: UMI Research Press, 1986.

McMillan, James. *Housewife or Harlot: The Place of Women in French Society 1870–1940*, Brighton: Harvester, 1981.

Mainardi, Patricia. *The End of the Salon: Art and the State in the Early Third Republic*, Cambridge University Press, 1993.

Maîtron, Jean. *Histoire du mouvement anarchiste en France*, 2nd edn, Paris: Maspero, 1975.

Mallarmé, Stéphane. *Oeuvres complètes*, ed. H. Mondor and G. Jean-Aubry, Paris: Gallimard–Pléiade, 1945.

Mandell, Richard D. *Paris 1900: The Great World's Fair*, University of Toronto Press, 1967.

Mariel, Jean. *L'Oeuvre de Jean Lahor*, Paris: Divan, 1912.

Marlais, Michael. 'Conservative Style/ Conservative Politics: Maurice Denis in Le Vésinet', *Art History*, 16 no. 1, March 1993, 125–46.

Martin, Marianne. 'Futurism, Unanimism and Apollinaire', *Art Journal*, Spring 1969, 258–68.

Marx, Roger. 'Les Arts décoratifs 1893–4', *La Revue encyclopédique*, 15, February 1894.

—. 'De l'Art social, et de la nécessité d'en assurer le progrès par une exposition', *Les Idées modernes*, January 1909.

Mauclair, Camille. 'La Réaction nationaliste en art et l'ignorance de l'homme de lettres', *La Revue*, 54, 15 January 1905, 151–74.

—. 'Le besoin d'un art du peuple', *La Revue bleue*, 2 September 1905, 306–10.

—. 'La Crise des arts décoratifs', *La Revue bleue*, 5, 16 June 1906, 755–9.

—. 'Le Préjugé de la nouveauté dans l'art moderne', *La Revue*, 1 April 1909, 289–302.

—. 'Ou en est notre "Art décoratif"?', *La Revue bleue*, 8, 24 April 1909, 520–24.

Maugue, Annelise. *L'Identité masculine en crise au tournant du siècle 1871–1914*, Paris: Rivages, 1987.

Mayeur, Jean-Marie, and Madeleine Rebérioux. *The Third Republic from its Origins to the Great War 1871–1914*, Cambridge University Press, 1987.

Méline, Jules. *Le Retour à la terre et la surproduction industrielle*, Paris: Hachette, 1905.

Mercereau, Alexandre. *La Littérature et les idées nouvelles*, Paris: Figuière, 1912.

—. *L'Abbaye et le bolchevisme*, Paris: Figuière, n.d. (1922?).

Mercier, Lucien. *Les Universités populaires, 1899–1914: Education populaire et mouvement ouvrier au début du siècle*, Paris: Ouvrières, 1986.

Metzinger, Jean. 'Note sur la peinture', *Pan*, November 1910, 649–52.

—. '"Cubisme" et tradition', *Paris–Journal*, 16 August 1911, 5.

—. 'Alexandre Mercereau', *Vers et prose*, 27, October–December 1911, 122–9.

—. 'Interview de Jean Metzinger sur le cubisme, par Tristan Tzara', *391*, 14, November 1920, 8.

—. *Le Cubisme était né: Souvenirs*, Paris: Présence, 1972.

Meyer, Franz. 'Robert Delaunay, Hommage à Blériot', *Jahresberichte der Öffentlichen Kunstsammlungen*, Basel, 1962, 67–78.

Miller, Michael B. *The Bon Marché: Bourgeois Culture and the Department Store 1869–1920*, Princeton University Press, 1981.

Mithouard, Adrien. *Le Tourment de l'unité*, Paris: Mercure de France, 1901.

—. *Traité de l'occident*, Paris: Perrin, 1904.

—. *Le Pas sur la terre*, Paris: Stock, 1908.

—. *Les Marches de l'occident*, Paris: Stock, 1910.

Monod-Fontaine, Isabelle, with Claude Laugier and Sylvie Warnier. *Daniel-Henry Kahnweiler: Marchand, éditeur, écrivain*, exhibition catalogue, Paris: Centre Georges Pompidou, 1984.

Morice, Charles. 'Enquête sur les tendances actuelles des arts plastiques', *Mercure de France*, August and September 1905, 195–7.

Morineau, Camille. *Roger Marx et l'art social*, unpublished *mémoire de maîtrise*, Université de Paris IV, 1988.

Moulin, Raymonde. *Le Marché de la peinture en France*, Paris: Minuit, 1967.

Nash, John. 'The Nature of Cubism: A Study of Conflicting Explanations', *Art History*, 3 no. 4, December 1980, 435–47.

Nesbit, Molly. 'The Language of Industry', in Thierry de Duve (ed.), *The Definitively Unfinished Marcel Duchamp*, Cambridge, Mass: MIT Press, 1991, 351–84.

Nicolet, Claude. *Le Radicalisme*, Paris: Presses Universitaires de France, 1957.

Nochlin, Linda. 'The Invention of the Avant-Garde: France, 1830–80', in T. Hess and J. Ashbery (eds), *The Avant-Garde*, Art News Annual, XXXIV, 1968, 11–18.

Offen, Karen. 'Depopulation, Nationalism and Feminism in Fin-de-Siècle France', *American Historical Review*, 89, 1984, 648–76.

Olivier, Fernande. *Picasso and his Friends*, London: Heinemann, 1964.

Orwicz, Michael. 'Anti-Academicism and State Power in the Early Third Republic', *Art History*, 14 no. 4, December 1991, 571–92.

Ory, Pascal, and Jean-Francois Sirinelli, *Les Intellectuels en France, de l'Affaire Dreyfus à nos jours*, Paris: Armand Colin, 1986.

Parigoris, Alexandra. 'Les Constructions cubistes dans 'Les Soirées de Paris': Apollinaire, Picasso et les clichés Kahnweiler', *Revue de l'art*, 82, 1988, 61–74.

Pasdermaijan, Henry. *The Department Store: Its Origins, Evolution and Economics*, London: Newman Books, 1954.

Paul-Boncour, Joseph. *Art et démocratie*, Paris: Ollendorf, 1912.

Perrot, Michelle. 'The New Eve and the Old Adam: Changes in French Women's Condition at the Turn of the Century', in M. Higgonet *et al.* (eds), *Behind the Lines: Gender and the Two World Wars*, New Haven and London: Yale University Press, 1987.

Perry, Gill. *Women Artists and the Parisian Avant-Garde: Modernism and 'Feminine' Art, 1900 to the Late 1920s*, Manchester and New York: Manchester University Press, 1995.

Pinard, Adolphe. *La Consommation, le bien-étre et le luxe*, Paris: Doin, 1918.

Pinto, A. C. 'Fascist Ideology Revisited: Zeev Sternhell and His Critics', *European History Quarterly*, 16, 1986, 465–83.

Poggi, Christine. 'Mallarmé, Picasso and the Newspaper as Commodity', *Yale Journal of Criticism*, 1 no. 1, Fall 1987, 133–51.

—. *In Defiance of Painting: Cubism, Futurism and the Invention of Collage*, New Haven and London: Yale University Press, 1992.

Poggioli, Renato. *The Theory of the Avant-Garde* (1962), trans. G. Fitzgerald, New York and London: Harper & Row, 1968.

Poidevin, Raymond, and Jacques Bariéty. *Les Relations franco-allemands 1815–1975*, 2nd edn, Paris: Armand Colin, 1977.

Poiret, Paul. *En Habillant l'Epoque* (1930), Paris: Bernard Grasset, 1987.

Pollock, Griselda. *Avant-Garde Gambits 1888–1893: Gender and the Colour of Art*

History, London and New York: Thames and Hudson, 1992.

—, and Fred Orton, 'Les Données bretonnantes: La Prairie de la représentation', *Art History*, 3 no. 3, September 1980, 314–44.

Pope, Daniel. 'French Advertising Men and the American "Promised Land"', *Historical Reflections*, 5, Summer 1978, 117–38.

Portier, Nicolas. 'Nationalisme et classicisme. La Jeunesse de l'Action française', *Revue universelle*, 161, 1991, 61–3.

Pradel, Marie-Noëll. 'La Maison cubiste en 1912', *Art de France*, I, 1961, 177–86.

Rappoport, Charles. 'Les Jeunes Gens d'Agathon', *Les Feuilles de mai*, 2, February 1913, 101–4.

Raymond, M. *De Baudelaire au surréalisme* (1933), Paris: Corti, 1985.

Raynal, Maurice. Preface for *Salon de juin: Troisième exposition de la Société normande de peinture moderne*, exhibition catalogue, Rouen, 15 June–15 July 1912, 9–11.

—. 'Conception et vision', *Gil Blas*, 29 August 1912.

—. 'L'Exposition de *La Section d'Or*', *La Section d'Or*, Paris, 9 October 1912, 2–5.

Rearick, Charles. *Pleasures of the Belle Epoque*, New Haven and London: Yale University Press, 1985.

Rebérioux, Madeleine. 'Avant-garde Esthétique et avant-garde politique: Le Socialisme français entre 1890 et 1914', in *Esthétique et marxisme*, Paris: Union Générale d'Editions, 1974.

—. 'Culture et militantisme', *Le Mouvement social*, 91, April–June 1975, 3–12.

—. 'Ces Demoiselles', *Cahiers CRLH–CIRAOI*, 5, 1988, 443–55.

Rey, Etienne. *La Renaissance de l'orgueil français*, Paris: Grasset, 1912.

Ribemont-Dessaignes, Georges. *Déjà Jadis*, Paris: Julliard, 1958.

Richardson, John. *A Life of Picasso, vol. 2: 1907–1917*, London: Cape, 1996.

Ridley, F. F. *Revolutionary Syndicalism in France*, Cambridge University Press, 1968.

Rivière, Jacques. 'Sur les tendances actuelles de la peinture', *La Revue d'Europe et d'Amérique*, 1 March 1912, 384–406.

—. 'Poussin et la peinture contemporain', *L'Art décoratif*, 5 March 1912, 133–48.

Robbins, Daniel. 'From Symbolism to Cubism: The Abbaye de Créteil', *Art Journal*, 23, Winter 1963–4, 111–16.

—. 'Albert Gleizes: Reason and Faith in Modern Painting', in *Albert Gleizes 1881–1953*, exhibition catalogue, New York: Solomon R. Guggenheim Museum, 1964, 12–25.

—. *The Formation and Maturity of Albert Gleizes*, unpublished PhD thesis, New York University, 1975.

—. 'Jean Metzinger: At the Center of Cubism', in *Jean Metzinger in Retrospect*, exhibition catalogue, University of Iowa Museum of Art, 1985.

—. 'Le Fauconnier and Cubism', in *Henri Le Fauconnier (1881–1946): A Pioneer Cubist*, exhibition catalogue, New York: Salander-O'Reilly Galleries, 1990, n.p.

Rosenblum, Robert. 'Picasso and the Typography of Cubism', in John Golding and Roland Penrose (eds), *Picasso 1881–1973*, London: Elek, 1973.

Rubin, William. *Picasso and Braque: Pioneering Cubism*, exhibition catalogue, New York: Museum of Modern Art, 1989.

—, and Lynn Zelevansky (eds). *Picasso and Braque: A Symposium*, New York: Museum of Modern Art, 1992.

Saint-Point, Valentine de. 'La Métachorie', *Montjoie!*, 2 no. 1–2, January–February 1914, 5–7.

Salmon, André. *La Jeune Peinture française*, Paris: Messein, 1912.

—. *Souvenirs sans fin (1): L'Air de la butte*, Paris: Nouvelle France, 1945.

—. *Montparnasse*, Paris: A. Bonne, 1950.

—. *Souvenirs sans fin: Deuxième Epoque (1908–1920)*, Paris: Gallimard, 1956.

Sandoz, G.-Roger, and Jean Guiffrey. *Exposition française d'art décoratif. Copenhague 1908. Rapport général. Précédé d'une Etude sur les arts appliqués*

et industries d'art aux expositions, Paris: Comité français des expositions à l'étranger, 1913.

Sartre, Jean-Paul. 'L'Engagement de Mallarmé', *Obliques*, Paris, 18–19, 1979, 169–94.

Seigel, Jerrold. *Bohemian Paris: Culture, Politics and the Boundaries of Bourgeois Life, 1830–1930*, New York and Harmondsworth: Viking Penguin, 1986.

Shattuck, Roger. *The Banquet Years*, London: Cape, 1958, rev. 1969.

Silver, Kenneth E. *Esprit de Corps: The Art of the Parisian Avant-Garde and the First World War, 1914–1925*, London: Thames and Hudson, 1989.

Silverman, Debora L. *Art Nouveau in Fin-de-Siècle France: Politics, Psychology and Style*, Berkeley and London: University of California Press, 1989.

Sorlin, Pierre. *La Société Française 1840–1914*, Paris: Artaud, 1969.

Sowerwine, Charles. *Sisters or Citizens? Women and Socialism in France since 1876*, Cambridge University Press, 1982.

Spate, Virginia. *Orphism: The Evolution of Non-Figurative Painting in Paris 1910–1914*, Oxford University Press, 1979.

Staller, Natasha. 'Méliès' 'Fantastic' Cinema and the Origins of Cubism', *Art History*, 12 no. 2, June 1989, 202–32.

Stalter, Michel-André. *Le Fauconnier et l'expressionnisme*, mémoire for the Diplôme d'Etudes Supérieures d'Histoire de l'Art, Paris: Sorbonne, 1962.

Steegmuller, Francis. *Jean Cocteau: A Biography*, London: Constable, 1970.

Stein, Leo. *Appreciation*, New York: Crown, 1947.

Sternhell, Zeev. *Maurice Barrès et le nationalisme française*, Paris: Editions Complexe, 1985.

Stone, Judith F. *The Search for Social Peace: Reform Legislation in France 1890–1914*, New York University Press, 1985.

Suleiman, Susan L. *Subversive Intent: Gender, Politics, and the Avant-Garde*, Cambridge, Mass., and London: Harvard University Press, 1990.

Sund, Judy. 'Fernand Léger and Unanimism', *Oxford Art Journal*, 7 no. 1, 1984, 49–56.

Tagg, John. 'The Idea of the Avant-Garde', *Artery*, 12, Spring–Summer 1977, 4–10.

Terdiman, Richard. *Discourse/Counter-Discourse: The Theory and Practice of Symbolic Resistance in Nineteenth-Century France*, Ithaca, N.Y., and London: Cornell University Press, 1985.

Thiesse, Anne-Marie. *Ecrire la France: Le Mouvement littéraire régionaliste de la langue française entre la Belle Epoque et la Libération*, Paris: Presses Universitaires de France, 1991.

Thompson, David. *Democracy in France since 1870*, 4th edn, Oxford University Press, 1964.

Tickner, Lisa. 'Men's Work? Masculinity and Modernism', in N. Bryson, M. Holly and K. Moxey (eds), *Visual Culture: Images and Interpretations*, Hanover and London: Wesleyan University Press, 1994, 42–82.

Tint, Herbert. *The Decline of French Patriotism 1870–1914*, London: Weidenfeld & Nicolson, 1964.

Tize, Suzanne. 'Les Grands Magasins', in D. McFadden *et al.* (eds), *L'Art de Vivre: Decorative Arts and Design in France 1789–1989*, New York: Vendome, 1989, 72–105.

Tombs, Robert (ed.). *Nationhood and Nationalism in France: From Boulangism to the Great War 1889–1918*, London: Harper Collins, 1991.

Tournier, Pierre. 'Les Expositions', *Pan*, 3 no. 5, May–June 1910.

—. 'Les Salons d'Automne', *Pan*, 3 no. 11, November–December 1910.

Troy, Nancy J. 'Towards a Redefinition of Tradition in French Design 1895–1914', *Design Issues*, 1 no. 2, Fall 1984, 53–69.

—. *Modernism and the Decorative Arts in France: Art Nouveau to Le Corbusier*, New Haven and London: Yale University Press, 1991.

—. 'Domesticity, Decoration and Consumer Culture: Selling Art and Design in Pre-World War I France', in Christopher Reed

(ed.), *Not at Home: The Suppression of Domesticity in Modern Art and Architecture*, London: Thames and Hudson, 1996, 113–29.

Tudesq, André. 'Du Cubisme et de ses détracteurs: Une Querelle autour de quelques toiles', *Paris-Midi*, 4 October 1912, 1.

Uhde, Wilhelm. *Von Bismarck bis Picasso*, Zurich: Oprecht, n.d. [1938].

—. 'Le Collectionneur', *Style en France*, 5 no. 2, January–March 1947, 61–4.

Université de Saint-Etienne. *Travaux IV: Le Cubisme*, Saint-Etienne: C.I.E.R.E.C., 1973.

Vaisse, Pierre. 'La Troisième République et les Peintres: Recherches sur les rapports des pouvoirs publics et de la peinture en France de 1871 à 1914', unpublished *thèse de doctorat d'état*, Université de Paris IV, 1980.

Varnedoe, Kirk, and Adam Gopnik. *High and Low: Modern Art and Popular Culture*, exhibition catalogue, New York: Museum of Modern Art, 1991.

Vauxcelles, Louis. 'Les Salons de 1911', *Touche à tout*, 1911, 443–4.

Véra, André. 'Le Nouveau Style', *L'Art décoratif*, January 1912, 21–32.

Vollard, Ambroise. *Souvenirs d'un marchand de tableaux*, Paris: Club des Libraries de France, 1957.

Ward, Martha. 'From Art Criticism to Art News: Journalistic Reviewing in Late Nineteenth-century Paris', in Michael Orwicz (ed.), *Art Criticism and its Institutions in 19th Century France*, Manchester University Press, 1994, 162–81.

—. *Pissarro, Neo-Impressionism, and the Spaces of the Avant-Garde*, Chicago and London: University of Chicago Press, 1996.

Warnod, André. *Les Berceaux de la jeune peinture*, Paris: Albin Michel, 1925.

Watson, Peter. *From Manet to Manhattan: The Rise of the Modern Art Market*, London: Vintage, 1992.

Weber, Eugen. *Action française: Royalism and Reaction in Twentieth Century France*, Stanford University Press, 1962.

—. *The Nationalist Revival in France 1905–14*, Berkeley: University of California Press, 1968.

—. *Peasants into Frenchmen: The Modernisation of Rural France 1870–1914*, London: Chatto and Windus, 1977.

Weill, Berthe. *Pan! Dans l'Oeil! Ou, Trente ans dans les coulisses de la peinture contemporaine 1900–1930*, Paris: Lipschutz, 1933.

Weiss, Jeffrey. *The Popular Culture of Modern Art: Picasso, Duchamp and Avant-Gardism*, New Haven and London: Yale University Press, 1994.

White, Cynthia A., and Harrison C. *Canvases and Careers: Institutional Change in the French Painting World*, New York: Wiley, 1965.

Williams, Raymond. *The Country and the City*, London: Paladin, 1975.

—. *The Politics of Modernism: Against the New Conformists*, ed. Tony Pinkney, London: Verso, 1989.

Williams, Rosalind. *Dream Worlds: Mass Consumption in Late Nineteenth-Century France*, Berkeley: University of California Press, 1982.

Wollen, Peter. *Raiding the Icebox: Reflections on Twentieth-Century Culture*, London: Verso, 1993.

Zadkine, Ossip. *Le Maillet et le Ciseau*, Paris: Albin Michel, 1968.

Zeldin, Theodore. *France 1848–1945: Taste and Corruption*, Oxford University Press, 1980.

Photograph Credits

In most cases photographs and transparencies have been provided by the owners or custodians of the works and are reproduced with their permission. Illustrations for which further credit is due are listed below.

© Succession Picasso/DACS 1998: Frontispiece, 30, 31, 32, 33, 35, 39 (Photo Bob Kolbrener).

Collection Haags Gemeentemuseum/Beeldrecht Amstelveen: 1, 3, 4, 7, 9, 12, 13.

© ADAGP, Paris and DACS, London 1998: 2, 5, 6, 15, 16, 17, 18, 19, 21, 38, 25, 28, 29, 37, 38.

© 1997 The Museum of Modern Art, New York: 8.

© 1999 The Museum of Modern Art, New York: 10.

© Centre Georges Pompidou, Paris, and ©ADAGP, Paris and DACS, London 1998: 11, 20.

Photo source: Yvan Christ, *Les Métamorphoses de la Banlieue parisienne* (Paris, Balland, 1969): 22.

Photo source: Albert Dauzat and Fernand Bournon, *Paris et ses Environs* (Paris, Larousse, 1925): 23.

© Photothèque des Musées de la Ville de Paris, and ©ADAGP, Paris and DACS, London 1998: 24.

© RMN and © L & M Services B.V. Amsterdam 971201: 26.

© RMN and © Succession Picasso/DACS 1998: 34.

Photo source: Bibliothèque Nationale, Paris, and © ACRPP: 36.

Photo source: Archives André Mare, Paris: 40, 42, 46.

Photo source: Archives André Mare, Paris, and © ADAGP, Paris and DACS, London 1998: 41, 43, 44, 45.

© L & M Services B.V. Amsterdam 971201: 47, 48, 49, 50, 54 (Photo Walter Klein), 56, 57.

© Photothèque des Musées de la Ville de Paris, and L & M Services B.V. Amsterdam 971201: 51.

© The Solomon R. Guggenheim Foundation, New York (FN 41.462) and L & M Services B.V. Amsterdam 971201: 53 (Photo Robert E. Mates).

Photo source: SD archives, Bibliothèque Nationale, Paris, and © L & M Services B.V. Amsterdam 971201: 55

Index